THE
BOOKS
THAT
SHAPED
ART
HISTORY

Edited by Richard Shone and John-Paul Stonard

THE
BOOKS
THAT
SHAPED
ART
HISTORY

from Gombrich and Greenberg
to Alpers and Krauss

54 illustrations

Thames & Hudson

First published in 2013 in hardcover in the United States of America by Thames & Hudson Inc., 500 Fifth Avenue, New York, New York 10110

thamesandhudsonusa.com

Library of Congress Catalog Card Number 2012932200

ISBN 978-0-500-23895-0

Printed and bound in China by Everbest Printing Co. Ltd

Contents

5 PREFACE
 Richard Shone

7 INTRODUCTION
 John-Paul Stonard

20 CHAPTER 1
 Emile Mâle
 *L'art religieux du XIIIe siècle en France: Etude sur l'iconographie
 du Moyen Age et sur ses sources d'inspiration*, 1898
 ALEXANDRA GAJEWSKI

30 CHAPTER 2
 Bernard Berenson
 *The Drawings of the Florentine Painters Classified, Criticised
 and Studied as Documents in the History and Appreciation
 of Tuscan Art, with a Copious Catalogue Raisonné*, 1903
 CARMEN C. BAMBACH

42 CHAPTER 3
 Heinrich Wölfflin *Kunstgeschichtliche Grundbegriffe:
 Das Problem der Stilentwicklung in der neueren Kunst*, 1915
 DAVID SUMMERS

54 CHAPTER 4
 Roger Fry
 Cézanne: A Study of His Development, 1927
 RICHARD VERDI

66 CHAPTER 5
Nikolaus Pevsner
*Pioneers of the Modern Movement from William Morris
to Walter Gropius*, 1936
COLIN AMERY

76 CHAPTER 6
Alfred H. Barr, Jr.
Matisse: His Art and His Public, 1951
JOHN ELDERFIELD

88 CHAPTER 7
Erwin Panofsky
Early Netherlandish Painting: Its Origins and Character, 1953
SUSIE NASH

102 CHAPTER 8
Kenneth Clark
The Nude: A Study of Ideal Art, 1956
JOHN-PAUL STONARD

116 CHAPTER 9
E.H. Gombrich
*Art and Illusion: A Study in the Psychology of Pictorial
Representation*, 1960
CHRISTOPHER S. WOOD

128 CHAPTER 10
Clement Greenberg
Art and Culture: Critical Essays, 1961
BORIS GROYS

140 CHAPTER 11
Francis Haskell
*Patrons and Painters: A Study in the Relations Between
Italian Art and Society in the Age of the Baroque*, 1963
LOUISE RICE

150 CHAPTER 12
Michael Baxandall
*Painting and Experience in Fifteenth Century Italy: A Primer
in the Social History of Pictorial Style,* 1972
PAUL HILLS

164 CHAPTER 13
T.J. Clark
Image of the People: Gustave Courbet and the 1848 Revolution, 1973
ALASTAIR WRIGHT

176 CHAPTER 14
Svetlana Alpers
The Art of Describing: Dutch Art in the Seventeenth Century, 1983
MARIËT WESTERMANN

190 CHAPTER 15
Rosalind Krauss
The Originality of the Avant Garde and Other Modernist Myths, 1985
ANNA LOVATT

202 CHAPTER 16
Hans Belting
*Bild und Kult: Eine Geschichte des Bildes vor dem Zeitalter
der Kunst,* 1990
JEFFREY HAMBURGER

216 NOTES
231 BIBLIOGRAPHICAL ESSAYS
258 AUTHOR BIOGRAPHIES
260 CREDITS
261 INDEX

Preface

RICHARD SHONE

ALL BUT ONE OF THE CONTRIBUTIONS to this volume originally appeared in *The Burlington Magazine* as part of the series 'Art History Reviewed'. The inspiration for this came from a set of articles *The Burlington* had carried some years previously about influential art critics of the past. The dozen or so essays came out intermittently between 1952 and 1975, an eclectic selection with little sense of order. Wishing to vary the more usual contents of the magazine, I had the idea for a series of articles that would reassess those books that, over the twentieth century, had significantly shaped the discipline of art history and influenced the wider appreciation of works of art. Each book was to be reviewed by a writer prominent in the field covered by the selected publication.

Building on an initial list of about thirty volumes selected with the help of John-Paul Stonard, whose enthusiasm for the series ensured that it was finally launched, and aided by the other editors of the magazine, Jane Martineau and Bart Cornelis, a refined selection of sixteen books was produced, each of which in our collective view stands as a significant touchstone. Of the many worthy books first suggested, several necessarily had to be dropped: some appeared to repeat or be too close to the achievements of ones that had definitely made the grade; some belonged too much perhaps to the taste of a particular period.

Reflecting the variety of the selected books, the essays in this volume cover painting, drawing, architecture and design, from the minutiae of connoisseurship to the broader canvas of theory and aesthetics. They tackle aspects of biography, reception history and patronage and include revealing descriptions of how and why the publications under review came to be written. All the chosen books, however, are characterised by a passionate engagement with and visionary inter-rogation of the subject, with, in many cases, a strong polemical intent. This, at least in part, is what has ensured their survival and continuing significance in the twenty-first century – why they are books that have helped to shape art history.

Introduction

JOHN-PAUL STONARD

THIS BOOK IS A COLLECTION of essays on sixteen of the most influential books of art history published during the twentieth century. Written by a range of leading scholars and curators, the essays reconsider these major texts and, taken together, offer a pathway through the often daunting bibliographic maze of literature on art; a roadmap of sorts for reading art history.

The books were chosen for their trailblazing qualities, for the way in which they forged entirely new ways of seeing the history of art. Their subjects range from medieval architecture to the work of Matisse, from Byzantine icon painting to postmodernism. Whereas many books introducing art history do so from the perspective of theories and methods, this volume alights rather on the landmark publications that have shaped the subject, as well as the personalities and stories behind those texts.

Great books have lives of their own that grow over time, through translations, new revisions and editions, and above all through reading and re-reading by generations of scholars and art lovers. Re-reading is the crucial step towards grasping the character of a book, what it stands for, and what we think of it, be that a matter of admiration or antagonism. Re-reading can also bring to light the disputes and debates between books, intellectual conflicts that can consolidate positions as well as create completely new ways of seeing and describing. Re-reading may also remind us of when we first became fascinated by art, not just as a matter of visual pleasure but also of intellectual nourishment, and may in addition help us to recall our developing awareness of the strange and elusive concept of art itself.

The earliest book considered in this volume is Emile Mâle's magisterial study of thirteenth-century French art, *L'art religieux du XIIIe siècle en France: Etude sur l'iconographie du Moyen Age et sur ses sources d'inspiration*, first published in 1898. The great innovation of this text, as Alexandra Gajewski writes, was to elucidate the meaning of the French Gothic cathedral by relating it to the liturgical texts of the time. Mâle pioneered an 'iconographic' approach to this task,

which involved finding the textual sources for images and using these to unlock their narrative or their spiritual meaning. Although lurking in the background was the importance of asserting the French-ness of medieval art – thus his focus on the 'glorious' thirteenth century – the *Geist* of Mâle's book is not overtly nationalistic, but rather Catholic, and the true works of art liturgical – the *Stabat Mater*, the liturgy of Holy Week, the Gospels, authentic and apocryphal – which find themselves naturally mirrored in the Gothic cathedral, that 'encyclopae-dia in stone'. At the end of his book, Mâle proposes the cathedral as a refuge, an indestructible ark, against whose walls 'the storm of life breaks'; 'no place in the world fills men with a deeper feeling of security'. Mâle's book, as it went through multiple editions into the twentieth century, was to be a time capsule itself for his iconographic, literary method, from which he was unable to depart in favour of the broader cultural–historical approach of those such as Aby Warburg, or indeed any of the other scholarly–scientific methods that evolved in the new century.

No greater contrast could be found to Mâle's book than Bernard Berenson's *The Drawings of the Florentine Painters Classified, Criticised and Studied as Documents in the History and Appreciation of Tuscan Art, with a Copious Catalogue Raisonné*, first published in two volumes in 1903. It had in fact been written at around the same time as Mâle's volume, but was delayed by six years for publication. It remains a primary work of reference for Renaissance draw-ings to this day – a remarkable achievement considering the amount of books published in the area. This is in part because it was the first book on the subject, as well as being the first scholarly catalogue that had been written about a school of drawing. It was, as Carmen Bambach's essay claims, 'groundbreaking for the sheer novelty of its subject' – simply put, nobody else had thought of compiling such an authoritative catalogue. It is very likely that at the time nobody else could complete so daunting a task. Berenson provides text and catalogue entries on a corpus of artists working in Florence, beginning with the achievements of the earliest Florentine painters such as Fra Angelico and Benozzo Gozzoli, through to a powerful description of Leonardo's drawings and those of Michelangelo (one of the most problematic chapters, in Bambach's view), and ending with a descent from Olympus, as Berenson puts it, to the Mannerism of Pontormo and Rosso. As Bambach writes, Berenson's method of connoisseurship, which privileged the intelligent eye over the intelligible document, has by no means been eclipsed by more recent, more overly 'intellectual' approaches to the description of old-master drawings.

Berenson's heroic cataloguing efforts, applied to the relatively untouched and undervalued field of old-master drawings, may be set against the excitement of Mâle's book and his strong belief in the importance and innovation of his comprehensive, accurate method. Both happily dispense with vast swathes of previous literature. The Swiss art historian Heinrich Wölfflin, in his 1915 book *Kunstgeschictliche Grundbegriffe* (*Principles of Art History*), also gives the sense of a door opening onto a whole new epoch of study and thought – although his target is much wider, and his brief more philosophical. In his analysis of the transition of the formal language of art from the Renaissance to the Baroque, Wölfflin calls for a 'descriptive art history', scrutinising and comparing works of art on the basis of style, expressed in terms of fundamental concepts. Wölfflin's may be the most challenging text in this volume for readers over one century later; even for the specialist, his abstract argument is frequently difficult to grasp. Yet in some senses Wölfflin was ahead of his time, particularly in terms of the technical tools at his disposal. He often laments the inadequacy of reproductions to illustrate his point – if only the photographer of Sansovino's St James had stood five feet to the right, his point about the classic silhouette effect would be perfectly clear. Yet, as David Summers shows, Wölfflin's identification of five incredibly simple paired concepts to demonstrate the transition to Baroque art had a universal relevance and powerful legacy, particularly for a type of art history based on hard sober looking and formal analysis. He is one of the great initiators of discourse in the field – prophetic even; much subsequent art-historical writing is in effect a selective reading of Wölfflin's 1915 classic.

Roger Fry once wrote that Wölfflin 'begins where most art historians leave off', examining the formal structures of works of art in relation to the 'mental conditions' in the mind of the artist who produced them.[1] It is precisely this ability to see deeply into the creative process that makes Fry's own study of the work of Cézanne 'arguably still the most sensitive and penetrating of all explorations of Cézanne's pictures', as Richard Verdi writes. *Cézanne: A Study of His Development* was published in English by the Hogarth Press in 1927, after first appearing in French in the magazine *L'Amour de l'Art*. Fry was pioneering not only in his championing of Cézanne as a master on a par with Rembrandt, but also in his sustained scrutiny of his paintings and the refined nature of his formulations in describing them. Aside from its piercing intellectual qualities, it is a beautifully written book, a testament to the pleasures of looking and thinking about works of art. Although his earlier collection of essays, *Vision and Design* (1920), might also be considered a strong contender for classic status for its continuing impact, particularly

on artists, the volume on Cézanne remains the most succinct statement of Fry's formalist approach, and is the text that shows him most thrillingly absorbed by, and in tune with, his subject.

The German-born architectural historian Nikolaus Pevsner was more directly influenced by Wölfflin, having studied under the Swiss art historian in Munich before completing a doctorate in Leipzig. Pevsner emigrated to England in 1935 as a result of Nazi anti-Jewish employment laws, and it was there that he wrote *Pioneers of the Modern Movement from William Morris to Walter Gropius* (1936), which, as Colin Amery describes in this volume, has been received as a 'gospel' of modernism. Pevsner's genealogy of modern architecture and design, showing how the utopianism of William Morris became the utilitarianism of Walter Gropius, could not in truth be further from Wölfflin's deeply felt philosophical relativism, and bears more the imprint, as Amery demonstrates, of Pevsner's doctorial supervisor Wilhelm Pinder, whose notion of *Zeitgeist*, a spirit-of-the-times explanation of artistic style, dominates Pevsner's volume. *Pioneers* is itself a pioneering book, the result of an extraordinary task of information-gathering that looks forward to Pevsner's later architectural guides, *The Buildings of England*. Like many trailblazing books (and as such it may be compared with Alfred Barr's monograph on Matisse), its value is due less to its definitive nature than to the freshness of its approach. Pevsner's comments on Impressionism and Art Nouveau are now curiosities; the true value of his book lies in its discussion of nineteenth-century engineering and in the incisive nature of Pevsner's architectural writing, capable as it is of characterising and animating the structures and façades of the buildings of Charles Voysey, Charles Rennie Mackintosh and Peter Behrens. It is also representative of the study of modern architecture and design in the crucial decade of the 1930s. David Watkin's attack on Pevsner's moralising approach in the former's 1977 book *Morality and Architecture* is well known, but from a later perspective it has become important to see Pevsner's writing in context, particularly as the work of a German émigré with an ambiguous relation to his native country. For its authoritative and opinionated analysis, *Pioneers* remains one of the most readable and provocative guides to modern architecture, written by someone, in addition, who could draw on personal correspondence with some of its key protagonists, notably Gropius and Henry van de Velde.

For his now legendary monograph *Matisse: His Art and his Public* (1951), Alfred H. Barr, Jr. was also able to make use of correspondence, in his case in the form of endless questionnaires to the artist and his family. By contrast with Fry's *Cézanne*, Barr's book is a factual–historical account of Matisse's work, drawing on

a range of documents and aspiring to scientific exactitude, for example by providing a chronology of paintings rather than a deep understanding of the artist's creative process. The enduring excitement of this book arises from the manner in which Barr wove together this fresh research, in many cases writing the first account of certain periods of Matisse's life or of groups of paintings, or reproducing major works for the first time, for example *Luxe, calme et volupté* (1904–05), which for forty years had hung in Paul Signac's dining room until it was photographed in 1950 at the Paris retrospective of Matisse's work.[2] Barr recognised that such information-gathering was a crucial new impulse in art history of the modern period; in 1941 he reminded graduate students that while they could not contact the old masters, 'they can air-mail Maillol or Siqueiros and write or phone for an appointment with Wright, André Breton, Stieglitz', giving urgency to this statement by adding that it was already too late to try Paul Klee or Edouard Vuillard in this manner.[3] Barr's account of Matisse was hailed on publication as one of the greatest monographs of any modern artist, and in this volume John Elderfield describes how Barr's pioneering documentary approach 'moved the literature on Matisse from criticism to art history'. It was certainly the last moment to get the facts straight with Matisse himself, who died three years after Barr's volume appeared. With the exception of the late collages and cut-outs, *Matisse: His Art and His Public* is a complete account of Matisse's life and work (and was for this reason selected for inclusion here over Barr's 1946 monograph on Picasso).

If any book of art history deserves to be considered monumental, it is Erwin Panofsky's *Early Netherlandish Painting: Its Origins and Character*. First published in America in 1953, more than a decade after the author emigrated from Germany, it was Panofsky's last major book, and the culmination of a life engaged with Renaissance culture, particularly that of the northern Renaissance. It was also a lasting statement of Panofsky's iconographic method. As Susie Nash points out, where Mâle's iconography dealt largely with questions of liturgical sources, Panofsky considers a much broader historical perspective, tracing the evolution of individual styles as much as the development of a whole tradition of painting. He locates the origins of Early Netherlandish painting in fourteenth-century French and Flemish illuminated manuscripts and in 'pre-Eyckian' regional schools of painting in the Netherlands around 1400, before moving on to what he describes as the main subjects of his book, 'Hubert and Jan van Eyck, the Master of Flémalle, and Rogier van der Weyden'. Panofsky's descriptions are often mesmerising: gazing at Van Eyck's paintings is likened to being 'hypnotized by precious stones', or 'looking into deep water'. But it is his demonstration of the integration

of Christian symbolism and painterly realism, and his seemingly endless expansion of ideas in footnotes, that give the book its majestic gravity. Dense, brilliant and controversial, *Early Netherlandish Painting* is also a monument to the pleasures of reading and humanistic scholarship, and is possessed of a 'narrative drive', as Nash puts it, derived from Panofsky's ability to arrange the facts (and sometimes bend them slightly) to tell an engaging story.

Kenneth Clark likewise considered writing about art as the opportunity to tell a very good story. In his own work, he freely confessed, the truth was occasionally sacrificed for the sake of a well-turned sentence, justified by his observation that in the end the history of art is largely 'an agreed fable'.[4] Perhaps this is the case for all writers, but for Clark it resulted in a unique combination of great writing and serious scholarship. Of all his publications, *The Nude: A Study of Ideal Art* is the book that most memorably draws together his innovative approach to scholarship and ability to crystallise his response to works of art in unforgettable formulations. It was not by chance that Fry, as an early mentor, was a clear influence on Clark's literary style. *The Nude* was first given as a series of Mellon lectures at the National Gallery of Art, Washington, DC, in 1953, and published three years later. That Clark could cover the entire history of art in seven short chapters was due not only to his economy with words, but also to the training in connoisseurship that he had received as an assistant to Berenson, an experience that helped him build up a vast mental library of works of art that could be summoned in the process of writing. Yet *The Nude* was not written in a Berensonian mould; Clark's quality of style marks a deep intellectualism, strongly influenced by the type of art history being pursued at the Warburg Institute, a resource Clark had drawn on heavily for his earlier monograph on Leonardo da Vinci.[5] He was a long-term correspondent of Fritz Saxl, Gertrude Bing, E.H. Gombrich and others, and realised the advance their scientific methods had made over the intuitive approach of Berenson. It was his ability to transform the often abstruse enthusiasms of the Warburg scholars into books with general appeal that gives Clark's writing, and *The Nude* in particular, its enduring power.

E.H. Gombrich's *Art and Illusion: A Study in the Psychology of Pictorial Representation* (1960) also began life as a series of lectures given at the National Gallery of Art in Washington, DC, in 1956, under the title 'The Visible World and the Language of Art'. Like Clark, Gombrich understood the importance of epitomising his argument with a simple slogan, but where Clark's distinction between 'naked and nude' was in fact a mere attention-grabber, Gombrich's formula 'making precedes matching' distilled the essence of his series of lectures into

a compelling philosophical statement. As Christopher Wood writes, Gombrich constructs a 'powerful case' against the concept of the 'innocent eye' by showing how all representation is inflected by mental concepts and cultural circumstances. Simply put, *Art and Illusion* is an exploration of the question as to why artists rely on conventions of representation to depict the world, rather than simply copying what they see. The resulting paradox is that, as Gombrich writes at the end of his book, 'the world can never quite look like a picture, but a picture can look like the world'. In his essay, Wood shows how influential and also how controversial Gombrich's argument was to become, and how his treatment of broad questions of culture, nature, psychology and representation were to have an impact beyond art history, not least in the field of *Bildwissenschaft*, or 'visual studies', and on the more general theories of images that have arisen in the 'altered conditions of modernity'. Despite these wider ambitions, Gombrich's book remains vivid, enlivened by numerous poetic examples – in contrast to a portrait by Fantin-Latour, he writes, Manet's *Madame Michel-Lévy* must have appeared to its first viewers 'as harsh and glaring as sunlight looks to the deep-sea diver'.

In the introduction to *Art and Illusion* Gombrich expresses the hope that his book could be considered as a 'much-needed bridge between the field of art history and the domain of the practising artist'. The same might be said of Clement Greenberg's *Art and Culture: Critical Essays* (1961), the first collected volume of his reviews and articles, which had a seismic impact, initially on the New York art world but also much further afield, for at least a decade following publication. It was read avidly by artists who, if they did not use it as a vade mecum, found that their work was being judged negatively in terms of Greenbergian criticism. He may not have been the only critic to have evolved a solid philosophical underpinning for the evolution of modern art, based on Hegelian notions of self-fulfilment and truth to the medium, but he was the only one to express it in a prose style that can be ranked among the finest art writing. Like Kenneth Clark he was able to draw his deep observations up to clear air in limpid formulations that seem to define once and for all the matter in question. As Boris Groys argues, Greenberg's description in the famous essay 'Avant-Garde and Kitsch' of modernist art as an 'imitation of imitating' rather than as an imitation of nature also makes a fascinating point of comparison with Gombrich's notion of 'making and matching' in *Art and Illusion*. Both identify technique as a crucial question, with its own logic of development distinct from the need to transcribe natural appearances. Unlike Clark and Gombrich however, Greenberg argues from a strongly

partisan viewpoint, and proposes a connection between the philosophical analy-
sis of artistic form and a political viewpoint as the basis for art criticism.

From a different perspective, the relationship between art and society also
underpins Francis Haskell's *Patrons and Painters: A Study in the Relations Between
Italian Art and Society in the Age of the Baroque* (1963). Haskell's study of the
patronage of Baroque painting, sculpture and architecture spanning two centuries
and moving from Rome to Venice is a pioneering work that consolidated a new
type of documentary art history, based on meticulous interrogation of archival
sources. As Louise Rice describes, Haskell presents an alternative to the ideo-
logically driven Marxist approach of Frederick Antal and Arnold Hauser, shying
away from any theoretical underpinning of his findings, animating them rather
through the personalities and historical circumstances within which Baroque art
evolved. A long book (it could have been two, on Rome and Venice, Rice sug-
gests), *Patrons and Painters* looks forward to Haskell's equally important volumes
Taste and the Antique (co-authored with Nicholas Penny, 1981) and *History and
its Images: Art and the Interpretation of the Past* (1993), both of which are based
on a similar archival impulse. Enlivened by Haskell's own extremely vivid prose
and his ability to bring to life a character or a setting, this trio of works remains
an inspiring lure to the antiquarian, archival approach to art-historical writing –
one quite foreign to those such as Panofsky and Clark, who depended instead on
the existing literature and the works of art themselves. As Rice outlines, Haskell's
research has since been updated and revised, and his method questioned by those
who prefer a little more complexity, at least for the sake of argument. None of this,
however, detracts from the towering importance of *Patrons and Painters*, which
remains, as Rice puts it, a 'prolegomenon to a branch of art history that was still in
its infancy'. This sapling was soon to grow into one the most profoundly original
approaches to art history: the social history of art.

By the late 1970s the question of what makes art history was being asked
with renewed vigour by many art historians. The rise of the social history of art
entailed a rethinking of the relationship between art and history, and forwarded
the claim that a work of art could be a piece of history, like any other histori-
cal event, and could be analysed as such.[6] Two major publications in the field of
social art history appeared early in the decade: Michael Baxandall's *Painting and
Experience in Fifteenth Century Italy: A Primer in the Social History of Pictorial
Style* (1972) and T.J. Clark's *Image of the People: Gustave Courbet and the 1848
Revolution* (1973). The opening sentence of Baxandall's book – 'a fifteenth century
painting is a deposit of social relationships' – was as good as a slogan for the new

approach. Yet as Paul Hills argues, it has tended to mask the book's truly innovative nature, its close attention to the way in which the style of a painting can be read in relation to its historical context. Baxandall focuses on the connection between fifteenth-century Italian painting and the economic and religious circumstances of its time, taking close readings of certain works in relation to contemporary mentalities. He achieved what all art historians wish for: the coining of a phrase that is used across fields, in this case the notion of the 'period eye', which suggests that we must understand how things were seen at a certain moment in history to begin to comprehend how they were designed. Wölfflin's edict that 'vision itself has a history' finds in Baxandall one of its most engaging elaborations. Baxandall's book seems to draw the psychological arguments of Gombrich together with Haskell's meticulous research on patronage, resulting in a pithy, readable book that embodies the new art history at its most sophisticated.

Baxandall was reluctant to be termed a 'social art historian', and once wondered if he was not simply 'doing Roger Fry, you know, in a different way'. He was indeed held to account by those for whom it was imperative to see art as an instrument of political will, and for whom the 'aestheticism' of Fry's arguments about artistic form were no longer valid. In the scintillating first chapter of his *Image of the People*, which was drawn (like Mâle's study of thirteenth-century French art) from his doctoral dissertation, T.J. Clark sets out his ambitious goals for a social history of art on such a basis. He stresses the importance of moving beyond a simple scenario of 'influence' – history as 'background', biography as 'context' – to evolve instead a language that is able to say more about the complex political interaction of art and history. As Alastair Wright notes, Clark's neo-Marxist position was a criticism not only of Hauser's *Social History of Art* (1951), but also of Gombrich's concept of the 'pictorial schemata' in *Art and Illusion*, which implied that our notion of art necessarily blinded us to nature; for Clark, the blinkers we wear are always ideological. Clark takes as his subject the works of Courbet during the Second Republic (1848–51) and his preoccupation with republican politics, moving beyond questions of patronage and psychology to weave a complex web of references that bring to life Courbet's great works from this period, such as *Burial at Ornans* (1849–50). Wright shows how Clark's densely argued account places the idea of destabilisation at the heart of Courbet's imagery, treating this as the source of his political engagement. The polemical power of Clark's argument arose without doubt from the fact that he was writing as a Marxist in the aftermath of 1968 about another failed revolution, that of 1848. It is the combination of time and place, as well as Clark's own unrivalled sense

both of history and theory, that makes *Image of the People* one of the formative books in the field.

The restlessness with traditional methods of art-historical analysis that characterises Clark's book appears in even greater measure in Svetlana Alpers's *The Art of Describing: Dutch Art in the Seventeenth Century* (1983). Where Clark's introduction lays out a manifesto, of sorts, for a social history of art, Alpers provides a similar argument for a method that takes a step further away from tradition, an approach she describes with the phrase (borrowed from Michael Baxandall) 'visual culture'. To renew the study of seventeenth-century Dutch art, Alpers contends, it is necessary to move away both from the stylistic analysis of Wölfflin and the iconographic method of Panofsky, for the simple reason that they are rooted in the study of Italian art, and therefore unable to address the particular nature of Northern art in general and Dutch painting in particular. As Mariët Westermann writes, the 'visual culture' of Dutch painting for Alpers was 'a capacious matrix of seeing and picturing that includes optical magnification, camera obscura projection, educational drawing, map making, inscriptions in or as images, and theoretical models of images projected onto the human retina'. Her book opens out Dutch painting onto this world, like so many windows flung wide, creating a vivid context that was no longer dependent on theories generated elsewhere and at different times. Of the connections she makes, the most famous hinges on the 'mapping impulse' in Dutch art, for which she acknowledges the important influence of Gombrich as a teacher. Maps are a golden example of how life can flow into art and vice versa – it is a question of 'mapping as picturing, painting as participating in a cartographic moment', as Westermann puts it. *The Art of Describing* remains a powerful statement of the multiplicity of ways in which 'art' and 'history' fit together, despite the impossibility of ever reducing one to the other.

This question – about the relation of art and history – was addressed by Rosalind Krauss in a very different way at the beginning of her remarkable collection of essays written from 1973 to 1983 and republished together in 1985 as *The Originality of the Avant-Garde and Other Modernist Myths*. As Krauss makes clear, both the model for and the target of her writing is the critical approach of Greenberg as it appeared in his 1961 *Art and Culture*. In a series of essays devoted first to paragons of modernism, including Rodin, Picasso and Giacometti, and then moving to the post-War American art of Jackson Pollock, Sol LeWitt and Richard Serra, Krauss proposes a 'radical inversion' of the premises of Greenbergian formalism on the basis of structuralist and poststructuralist philosophy. As Anna

Lovatt argues, Krauss's pioneering use of French theory had an extraordinary impact on art history as an academic discipline, ferociously questioning many of its underlying assumptions, and introducing a new critical term, postmodernism, into the field. The myths that Krauss attacked – principally those of authorship and originality – were often myths that had arisen in the context of curatorial scholarship and essays in exhibition catalogues, but her target was the far wider problem in art history of unexamined appeals to biography as a source of aesthetic explanation. Yet it would be wrong to see Krauss as an outright opponent of academic art history, or indeed her book as one that has 'de-shaped' the subject. As Lovatt points out, the 'art history without proper names' that Krauss advocates – 'questions of period style, of shared formal and iconographic symbols', as she puts it[7] – in fact looked back to the founding texts of art history, of style (Wölfflin) and interpretation (Panofsky and Alois Riegl), as models to follow, and as the basis for new theories of representation. In her rejection of biography Krauss also stands in curious comradeship with Berenson. Krauss's enduring legacy lies in the power of thinking that she applied to this theoretical work, as well as in her polemical stance that introduced an entirely new level of critical passion and dispute into the study of art.

Hans Belting's *Bild und Kult: Eine Geschichte des Bildes vor dem Zeitalter der Kunst* was first published in 1990, with an English translation appearing four years later as *Likeness and Presence: A History of the Image Before the Era of Art*. Its wide-ranging ambition and potential to redefine the subject of art history place it among the most radical and provocative texts discussed in the present volume – a notable achievement for a book about Byzantine art. As the title suggests, Belting's extended account of holy images – icons of Christ – stretching back to early Christian times is set within a broader conceptual argument about the reach of conventional art history and the status of images that have traditionally fallen outside the remit of 'art'. The 'Era of Art' noted in Belting's subtitle begins, conveniently enough, around 1500, and is therefore coeval with the Italian Renaissance; this book is about what came before 'art' in this sense, and is (like Alpers's text) a challenge to art history formed by the study of the Italian Renaissance. Belting goes much further though, and may be more closely allied with Krauss in his severe challenge to the limits of traditional art history and in raising the possibility of a new discipline of the study of images. Although it may be too soon to assess its true impact, Jeffrey Hamburger nevertheless recalls the 'refreshing shock' Belting's book conveyed to the young art historian 'eager to think in terms of the function, not simply the attribution, dating and iconography, of medieval

images'. *Bild und Kult* opened up the study of medieval painting by bringing together methods and evidence from a variety of disciplines, not least in its synthetic account of Eastern and Western traditions of icon painting. Belting's more recent work on modern and contemporary art suggests how a focus on the 'image', rather than 'art', can allow study of a much broader range of artefacts and overcome traditional art-historical prejudices. Hamburger points to two other books, David Freedberg's *The Power of Images* (1989) and W.J.T. Mitchell's *Picture Theory* (1994), both of which make the claim for a 'pictorial turn' – that is, a move towards the study of 'images' rather than 'art' – yet, as Hamburger also explains, on divergent grounds. It may be that a survey of the books that shaped 'art history' in the twenty-first century – if indeed such an old-fashioned term continues to be used – would take Belting's book and cognate volumes as the foundational texts for a much-expanded and infinitely more nuanced discipline.

* * *

In shortlisting the books discussed here as a proposed canon of twentieth-century art-historical literature, many important texts, regrettably, had to be left in the wings. There are pragmatic reasons for this: it is easier to bring together sixteen rather than sixty books, although the latter may offer a more realistic, though less detailed and instructive, picture of art history as a whole. The criterion 'book' should not, furthermore, be taken for granted. Outstanding lectures do not always find their way into print, just as influential articles and reviews are not always anthologised. Sometimes great art history is not published at all, but exists in the form of an inspiring individual whose method is so strange and original that it can only really be apprehended in the publications of their pupils and followers. Aby Warburg's *Gesammelte Schriften* appeared in 1932, a bad year for scholarship in Europe, and was only translated into English more than sixty years later. Warburg's influence was largely through his innovative methods, such as the famously unfinished 'Mnemosyne Atlas', an 'image-atlas' of art history, and through the teaching institute that he founded in Hamburg, and which was later to move to London; it is for this reason that his contribution is traced here only in the many texts that he influenced.

Certain landmark texts are frequently referred to in this book and could well have been included on an expanded list. Julius von Schlosser's *Die Kunstliteratur: Ein Handbuch zur Quellenkunde der neueren Kunstgeschichte* (1924), Rudolf Wittkower's *Architectural Principles in the Age of Humanism* (1949) and John

Shearman's *Mannerism* (1967), among others, provided the giant's shoulders on which Baxandall stood to gain the depth of vision to write his *Painting and Experience* – as well as Wölfflin's *Classic Art* (1899). Riegl's *Spätromisches Kunstindustrie* (1901) appears as a constant point of reference, although, as Gombrich points out in *Art and Illusion*, this dense volume is 'hard to read and even harder to summarize'. Alongside Barr one could place John Rewald's pioneering *The History of Impressionism* of 1946. And why not Clive Bell's *Art* (1913), George Kubler's *The Shape of Time* (1962) or Anthony Blunt's *Poussin* (1967)? A reassessment of these volumes would be as interesting to read as of Michael Fried's *Absorption and Theatricality: Painting and Beholder in the Age of Diderot* (1980). Art history as a subject is thriving today, and significantly more books are being published than at any other moment; professionalisation continues apace and more topics are being covered in more depth than ever before. Recent titles however have not yet been subject to the re-reading and engagement that is the necessary path to being considered a 'classic'.

And it is of course easier to propose a canon of foundational books than to state what actually 'shaped' art history. What are the fundamental themes that hold together a subject wide enough to take in proto-geometric Greek art and poststructuralist film? The question becomes even more pressing in a global age, and one, moreover, in which the texts of art history are so readily available in a digital format. As noted above, some compelling recent accounts take the basic category of 'images' to be common currency for all art historians; yet perhaps more truthful would be to say 'photographic images', for it is on the basis of photography that most works of art are known and compared, a point frequently made by contributors to this volume. But can objects really be known in this way? Photography is a poor substitute for physical encounter. The variety of objects and approaches to art history may lead us to the conclusion that there is no golden thread drawing the subject together neatly as a 'discipline'.

Perhaps, to adapt the phrase of one great practitioner, there is really no such thing as art history, there are only art historians. And in the long run there are only the books that they write. Some of the best of those books are gathered together here not just as a core library of art history, but also as a demonstration of the diversity of the subject and its openness to redefinition as a living and certainly very youthful intellectual endeavour. Together they provide a picture of the field, and an argument for its vital importance in changing times as a way of understanding and preserving the most important objects in human history.

Emile Mâle delivering an official discourse at the
Ecole française de Rome, c.1930.

Emile Mâle

L'art religieux du XIIIe siècle en France: Etude sur l'iconographie du Moyen Age et sur ses sources d'inspiration, 1898

ALEXANDRA GAJEWSKI

ORDER, DISCIPLINE AND EDUCATION governed the life of Emile Mâle (1862–1954), born in the village of Commentry (Allier), the son of a mining engineer. Graduating from the *lycée* at nearby Saint-Etienne with flying colours, he gained entry to the prestigious Ecole normale supérieur in Paris in 1883. In the following years, while teaching as a professor of rhetoric at provincial *lycées* and later in Paris, he worked on his doctoral thesis on medieval French iconography. In 1898, at the age of thirty-six, he submitted 'L'art religieux du XIIIe siècle en France: Etude sur l'iconographie du Moyen Age et sur ses sources d'inspiration',[1] which was published under the same title that year and dedicated to Georges Perrot, his former professor at the Ecole normale.[2] A German translation came out in 1907, one in English in 1913 and others were to follow.[3] In the book, Mâle offered his readers the first systematic key to understanding medieval images, a knowledge he felt had been lost since the Reformation. Underlying Mâle's unaffected and subtle prose is the carefully argued theory that medieval art, and especially the thirteenth-century French cathedral, offers the viewer an encyclopaedic account of medieval Christian knowledge and represents a comprehensive vision of the intellectual and emotional world of the Middle Ages, indeed of its soul.[4] This was the first of three books on iconography, but it remains the one that is best known and most often republished, retaining a firm place on university reading lists.[5]

Mâle was not the first French scholar to treat iconography as a separate field of scholarly inquiry. In mid-nineteenth-century France, a pioneering group of archaeologists – many of them clergymen – wrote studies on the subject, based on

textual research and extensive travels, foremost among them Adolphe-Napoléon Didron (1806–67), whose *Iconographie Chrétienne: Histoire de Dieu* of 1843 was the first of a never-realised, multi-volume compendium, and Augustin-Joseph Crosnier (1804–80), who published a textbook, *Iconographie Chrétienne*, in 1848.[6] The circumstances that motivated these authors still echo in Mâle's study. In the early nineteenth century, the unabated destruction of French medieval buildings galvanised individuals, writers such as Victor Hugo and government officials alike, to support and control the conservation of monuments, leading to the creation of the Commission des Monuments Historiques in 1837 and to the foundation of numerous antiquarian societies.[7] Their founders, such as Arcisse de Caumont (1801–73), advocated an archaeological approach to medieval architecture.[8] At the same time, the Catholic revival also sparked an interest in medieval art, boosted by the public success of François-René de Chateaubriand's *Génie du christianisme*, first published in 1802. The century's most famous convert to Catholicism revealed how the beauty of nature and art, especially Gothic art, could inspire religious sentiment and the reminiscence of a more idyllic past.[9] Recovering the lost insight into medieval traditions of Christian religious imagery seemed essential to the enthusiastic faithful and the clergy alike.[10] Crosnier, a canon at Nevers and curé at Donzy, as well as Inspecteur des Monuments for the Nièvre region, who dedicated his *Iconographie Chrétienne* to the bishop of Nevers, described archaeology without iconography as a body without a soul, and his handbook aimed as much at instructing as inspiring religious thought.[11] Crosnier knew Didron's book, published five years earlier. Didron, a sometime candidate for the priesthood, later became what Elisabeth Emery calls a liberal neo-Catholic. The publication he founded, *Les Annales Archéologiques*, was financed by Catholic patrons, including A.W.N. Pugin.[12] His *Iconographie Chrétienne* was proofread by a theologian, and was intended as an aid for clergymen interested in Christian archaeology.[13]

Mâle acknowledged his debt to these writers, but also emphasised their short-comings. For him, they belonged to another, more romantic and amateurish age.[14] Undoubtedly, Mâle's own approach was more methodical and systematic. In the fifty years that had passed, art history had developed into an academic discipline and Mâle's intended audience was an art-historical one.[15] Also, the 1870 Franco-Prussian War and the loss of Strasbourg with its cathedral had focused the minds of Mâle and his generation of French scholars on the national importance of their art treasures.[16] Furthermore, as Emery argued, in *fin-de-siècle* France, riven apart by religious, political and artistic disputes, the cathedral was becoming a symbol of a harmonious and united society, 'the synthesis of the country'.[17] Thus, Mâle, in

L'ART RELIGIEUX

DU XIIIᵉ SIÈCLE

EN FRANCE

ÉTUDE SUR L'ICONOGRAPHIE DU MOYEN AGE
ET SUR SES SOURCES D'INSPIRATION

PAR

Émile MÂLE

ANCIEN ÉLÈVE DE L'ÉCOLE NORMALE, PROFESSEUR DE RHÉTORIQUE AU LYCÉE LAKANAL

Ouvrage illustré de 96 gravures dans le texte ou hors texte

PARIS

ERNEST LEROUX, ÉDITEUR

28, RUE BONAPARTE, 28

—

1898

Title-page to Emile Mâle, *L'art religieux du XIIIe siècle en France: Etude sur l'iconographie du Moyen Age et sur ses sources d'inspiration*, 1898.

contrast to earlier writers who had extended their inquiries in time and distance, saw fit to concentrate his study on thirteenth-century France since 'it was in France that the doctrine of the Middle Ages found its perfect artistic form' and 'thirteenth-century France was the fullest conscious expression of Christian thought'.[18] In fact, most of his study concerns the cathedrals of north-eastern France that novelists such as Hugo, from the earlier generation, and Mâle's contemporaries Zola, Huysmans and Proust were celebrating.[19] Clearly, the agenda had changed. Unlike the earlier generation of iconographers, Mâle's foremost objective in providing a guide to Christian imagery was neither to emphasise the importance of Christianity nor to gather empirical data as a basis for scholarly study, though both of these were important to him. The imperative was rather to find the key to reading the cathedral as it represented a period when French civilisation was pre-eminent. The last line of Mâle's book asks: 'When shall we understand that in the domain of art France has accomplished nothing greater?'[20]

Yet despite this shift in attitude Mâle was deeply influenced by the earlier authors, especially by Didron. Like them, he believed in the central importance of Christian art, and it was from Didron that Mâle developed some of his most fundamental concepts, especially his belief in the heuristic quality of Christian art. Furthermore, Mâle borrowed from Didron the idea of basing the structure of his book on the four volumes of the thirteenth-century *Speculum maius*, or *Great Mirror*, of the Dominican Vincent of Beauvais (d.1264), the *Specula naturale*, *doctrinale*, *morale* and *historale*,[21] an immense florilegium of ancient and medieval texts, intended as a compendium of all the knowledge of its time.[22] However, in contrast to Didron's incapacity to discipline the subject, Mâle's ability for synthesising is evident from the way he adapted the ponderous structure of the *Speculum maius* to his own designs. He devoted one chapter to each of Vincent's *Specula*, using its overarching idea as an inspiration, and always taking images and objects as the starting point for his discussion.

The book starts with a chapter on the general character of medieval iconography, in which we learn that art was tightly governed by a set of immutable rules compared by Mâle in turn to a script, a calculus and a symbolic code. Next, in 'The Mirror of Nature', a commentary on the seven days of creation in Vincent's *Speculum*, Mâle discusses the possible meaning of the plants, animals and monsters that decorate cathedrals. He affirms the importance of the twelfth-century *Speculum ecclesiae* by Honorius Augustodunensis for the representation of a specific type of symbolic animal, such as the lion, the eagle and the phoenix, ultimately derived from bestiaries. In general, however, he sees in the representation of flora

and fauna an area free of symbolic meaning – almost the only area where the artists were allowed to use their own imagination. In 'The Mirror of Instruction' he takes the cue from Vincent's declaration in the preface to the *Speculum doctrinale* that man can redeem himself from the Fall by instruction (*doctrina*).[23] He thus analyses images of the labours of the months, which reflect the lived experience of medieval man, as well as the seven liberal arts and philosophy, their representation being based on late antique texts by Martianus Capella and Boethius. The *Speculum morale* is apocryphal, but Mâle considered that it formed part of Vincent's original project.[24] In 'The Mirror of Morals', he discusses the early Christian *Psychomachia* of Prudentius, the Vices and Virtues and active and contemplative life. This is one of the few occasions when Mâle signifies changes in types of imagery: the battle scenes of the *Psychomachia* become less frequent from the late twelfth century onwards and give way to representations of the theological and cardinal virtues. Finally, 'The Mirror of History', which takes up about two thirds of the whole book, presents the story of man according to Vincent's view that history is the story of those chosen by God. It is divided into sub-chapters on the Old Testament, the Gospels, apocryphal stories, the saints and the Golden Legend, Antiquity and secular history, and finishes with the Apocalypse and the Last Judgment, thus guiding us 'from the awakening of the first man under the hand of the Creator to his eternal rest in the heart of God'.[25]

For Mâle, as for Didron before him, the adoption of Vincent's structure was more than a clever literary device. Both believed that the imagery of the medieval cathedrals was itself arranged according to the order of the *Speculum* and that its fullest expression was to be found on the north and south transept portals at Chartres from the first third of the thirteenth century, making Chartres an encyclopaedia in stone.[26] The metaphor of the 'cathedral as a book' was popular at the time, especially since it had been used to great success by Hugo in his *Notre-Dame de Paris* of 1831,[27] as Mâle acknowledged in his conclusion.[28] Like Hugo, Mâle saw the cathedral as an expression of society's aspirations, but while Hugo regarded book and cathedral as alternative expressions, arguing that the book had superseded the cathedral,[29] Mâle perceived a relationship between the two in which the rules and contents of text governed art.[30] This relationship was not necessarily a direct one. It did not matter whether the 'men of genius' who conceived the ensemble at Chartres had known the *Speculum*. A more general common factor united the intellectual cathedral and the cathedral in stone, pointing to a higher level of consciousness.[31] According to Mâle, in the thirteenth century both literature and art reflected the thought of the Middle Ages, and it was the thought that worked

Emile Mâle with students of the academic programme at the Ecole française de Rome, c.1930–31.
Front row, left to right: J. Rouset, Emile Mâle, Suzanne Vitte, Jean Seznec.
Back row, left to right: H.E. Marrau, A. Dupront, Michel de Boüard, Sony Lattés.

within the material and fashioned it.[32] Sustained by common thought, art and other forms of human expression were infinitely translatable from one to the other. The art of the cathedral was therefore both 'theology and liturgy embodied in concrete form',[33] and the laws that governed the creation of images could be compared to music.[34] Equally, the drama of the liturgy and of mystery plays manifested the same thought as the cathedral.[35] However, Mâle's 'thought of the time' was no abstract entity in the sense of a Hegelian *Zeitgeist*. It could perhaps best be described as the intellectual framework of the day, which he believed to have reached a high point in the thirteenth century, an era that was above all intellectual.[36]

By insisting on the importance of thought in art, Mâle distanced himself in another way from Hugo. For the novelist, the cathedral was an expression of secular society, and created by lay artists. As a Catholic, Mâle objected to the anti-clericalism underlying this argument.[37] Mâle criticised Hugo for having portrayed medieval artists as proto-revolutionary free-thinkers, and was at pains to demonstrate that the thirteenth century was dogmatic, a finished system, a time when artists obeyed the rules set in place by the church. Despite these

differences, Mâle praised the novelist in a lecture given at the Sorbonne in 1908 as the first to have understood the genius of the Middle Ages, which the learned Benedictines had previously misjudged.[38] In *L'art religieux*, the term 'genius of the Middle Ages' is used repeatedly, and it seems to denote a broader concept than 'thought', including not only the *eruditi* but the whole of society.[39] For Mâle, in fact, the artist, so important to Hugo, played a central role in the creation of art, despite (or, as we shall see, because of) his limited possibilities of self-expression. Although Mâle envisaged that the order and types of images were generally devised by theologians, nonetheless, the obedient and faithful artist was 'just as skilful in spiritualising material objects as the theologians'; he animated the work and invested it with his love.[40] The synergy existing between theologian and artist made the creative process possible and established unity and a profound harmony.[41] The genius, therefore, included the artist who set the thought free, revealing the spiritual soul of the Middle Ages.

While thus anchoring his notion of artistic creation firmly in the people, both theologians and artists, Mâle presented the French cathedral as a total work of art; not only in the sense that it combined different media – sculpture, stained glass and architecture – but also in that it is 'the sum of revelation. In it all the arts combined, speech, music, the living drama of the Mysteries and the mute drama of sculpture'.[42] The concept of the total work of art had some currency in *fin-de-siècle* Paris where it had been inspired by Wagner's idea of the *Gesamtkunstwerk* and gained popular appeal through Baudelaire, the Symbolists and Huysmans.[43] Like Zola, Huysmans and Proust in their novels, it is at the end of his book that Mâle offers the final key to understanding the importance of the cathedral. In his haunting concluding passage he develops a utopian vision in which he invites the reader to enter a virtual cathedral, leaving all the worries of this world behind. The cathedral's broad flanks offer safety; it is the indestructible ark, and acts as a purifying sacrament. For Mâle, it promises redemption. The cathedral had been possible because of the inherent virtue and deep spirituality of medieval man, especially the artist, who was pure, austere and respectful and who understood the symbolic nature of the world. For Mâle, as for Zola, Huysmans and Proust, it was the representation of an ideal society, and the model for such a society in the future. It was egalitarian in that it addressed all men, at all levels of life, and was communal. When the congregation became one in the body of Christ, society came closest to tasting the everlasting joy of heavenly Jerusalem.[44]

The importance of Mâle's publication was quickly recognised in France and abroad. In 1928, Mâle's first three books on iconography were warmly received

by the German iconographer Karl Künstle, who acknowledged Mâle's lucid pres-
entation of the subject-matter and the originality of his approach.[45] However,
Künstle's own study of Christian iconography is now considered to have been
obsolete by the time it appeared in 1928.[46] For while Künstle insisted on the supe-
riority of Christian art as a subject for art history and refused to apply the method
to a wider range of images, a new generation of scholars in Hamburg, among
them Erwin Panofsky and Fritz Saxl, was busy developing the broader and more
inclusive methods of a cultural history pioneered by Aby Warburg since the late
nineteenth century.[47]

Despite his own lifelong specialisation in Christian themes, Mâle has on the
whole escaped such harsh judgment. Even his critics acknowledge the ground-
breaking achievement of *L'art religieux* and its importance for the discipline of
art history on the one hand and for the study of iconography on the other.[48] By
the time his book was published, art historians in and outside France began to
realise the value of iconography, and Mâle remained the torch bearer for the
subject.[49] Furthermore, in 1912, six years after the separation of Church and
State in France, Mâle was offered a chair in art history at the Sorbonne to teach
Christian medieval art.[50] He introduced to the academic world of France his sys-
tematic approach to images and sources, as well as his ideas, thus shaping a new
generation of art historians.[51]

Nonetheless, some of the central precepts of Mâle's study have been the
object of intense discussion, above all the nationalism of his Franco-centric view.
Furthermore, the idea of the medieval image as a bible for the illiterate has been
refined by paying closer attention to the distribution of literacy among the different
social classes of medieval society. Mâle's theory of the immutable and unchange-
able quality of medieval art that left little freedom for the creativity of the artist has
been contradicted, for example, by projects such as the Index of Christian Art at
Princeton University; the large corpus of images in the Index has highlighted the
diversity among image types. Finally, it has been pointed out that Mâle neglects
questions of politics, patronage and social context while his emphasis on the
thought that fashions art dematerialises the object, turning it into an accessory.[52]

It seems futile, however, to try to distinguish between the still useful and the
outdated elements of *L'art religieux*. Mâle's belief in the superiority of French art,
the importance he attached to thought and his subtle but complex view of the role
of the artist form the framework of his study and cannot be removed at leisure in
order to enjoy the rest. Indeed, what makes *L'art religieux* outdated in comparison
with current scholarship is also its greatest strength. His interest in the anonymous

artist and the emotional quality he brought to art, which he further developed in *Religious Art in France: The Late Middle Ages* (1908), foreshadows the methodological approach of *histoire de mentalité*.[53] Even more important, Mâle's *fin-de-siècle* cathedral utopia, which brings to light what he saw as the genius of the Middle Ages, also enriches the study far beyond the investigation of the symbolic content of images; like Warburg and Panofsky slightly later, Mâle was essentially interested in the history of ideas.

By adopting the structure of Vincent of Beauvais's *Speculum*, Mâle entered the intellectual process of its creation, writing himself an encyclopaedia that had the twofold function of the medieval *Speculum*: it served as a mirror to show what the (medieval) world was and, by reflecting back on the reader, pointed out what he or she should be.[54] Historiography has shown us that the mirror also reflects back on the author and his time. Mâle's hybrid work – an academic study with utopian and semi-autobiographical elements – is, of course, itself a cathedral and a total work of art, which assigns it to its time but also ensures its enduring appeal.

Bernard Berenson at the Villa I Tatti, Settignano, Florence, 1903.

Bernard Berenson

The Drawings of the Florentine Painters Classified, Criticised and Studied as Documents in the History and Appreciation of Tuscan Art, with a Copious Catalogue Raisonné, 1903

CARMEN C. BAMBACH

RARE IS THE AUTHOR whose books on a specialised subject are published and republished over the course of fifty-eight years, and rarer still is the fact that an author's voice and analytical method in such a publication should speak to a field and its specialists, not infrequently with enormous persuasion, more than a century after it was first heard. Bernard Berenson's *The Drawings of the Florentine Painters* is such a work, first published in two volumes in 1903[1] and reissued in greatly revised, expanded editions of three volumes in 1938 and 1961 (in Italian).[2] It is without doubt his most remarkable and lasting contribution as an art historian and remains 'the basis of all our knowledge [. . .] undertaken when the subject was virgin soil', to quote the then editor of *The Burlington Magazine* in 1955,[3] words still valid today. While the prestige of connoisseurship was said to have been in decline by 1932, being superseded by iconographical studies,[4] this was certainly not true of the field of old-master drawings, for until even two decades ago, connoisseurship was the exclusive analytical tool in the study of Italian drawings, and continues to be one of the dominant methods today. Berenson died on 6th October 1959 aged ninety-four, before the publication of the third Italian edition, *I disegni dei pittori fiorentini*, in 1961. In its preface, written at his beloved Villa I Tatti in Settignano on 10th April 1958, Berenson recounted his joyful emotion on being asked by Dario Neri and Paola Moroni of Electa Editrice in Milan to produce this Italian edition of his magisterial opus: 'Wrongly or rightly, I believe that these volumes contain some of the happiest and most lasting fruits of my work; the thought saddened me that these should remain so little known in a country where my books are read and

appreciated more than elsewhere, and not only by art historians, but also by edu-
cated general readers'.[5] He conceded with touching honesty that his thinking had
evolved towards the side of caution, particularly in regard to the issue of quality
as the sole criterion of authorship which he and other connoisseurs[6] often upheld
as paramount: 'And with Horace, I am ready to admit that even Homer occasion-
ally sounds shrill. Today, I would be less certain that the inferior quality of some
drawings is sufficient proof to exclude the possibility that they were executed by
Castagno, or by Pollaiuolo, or by Michelangelo himself. I would be more inclined
today to doubt that that formidable genius always possessed certain good taste'.[7]

In 1903, when Berenson published the first edition of *The Drawings of the
Florentine Painters*, he possessed no such intellectual humility. He chose a
format for the book that he had explored in his other texts on Italian paint-
ing, *The Venetian Painters of the Renaissance* (1894) and *The Florentine Painters
of the Renaissance* (1896). One volume contained monographic essays and the
second was arranged alphabetically by artist with brief catalogue entries; in most
cases, attributions were pronounced rather than reasoned. His volume on the
Central Italian Painters of the Renaissance was republished in 1903 (first edition
1897), some months before *The Drawings of the Florentine Painters*, but he had
laid the groundwork for his method in both texts with his revolutionary essay,
'The Rudiments of Connoisseurship (A Fragment)', written around 1894. While
it was conceived as the first section of a book on the 'Methods of Constructive
Art Criticism', unfortunately never published, he incorporated it into *The Study
and Criticism of Italian Art* (published in London in 1901 and again in September
1902), an anthology that included memorable essays on non-Florentine artists
such as Mantegna and Raphael, among others.[8]

Berenson's methods of connoisseurship for Italian paintings have been well
analysed,[9] but his system in regard to drawings has been discussed only rarely. He
had succinctly defined connoisseurship in 'Rudiments' as 'the comparison of works
of art with a view to determining their reciprocal relationship. Connoisseurship is
based on the assumption that perfect identity of characteristics indicates identity
of origin – an assumption, in its turn, based on the definition of characteristic as
those features that distinguish one artist from another'.[10] The term 'science' for the
process of attributing paintings and drawings, although employed by Berenson
repeatedly in 'Rudiments' and by Giovanni Morelli (Ivan Lermolieff) before him,
was abandoned in *The Drawings of the Florentine Painters* and, by the 1961 edition,
Berenson only alluded to '*nostra sensibilità*' and '*finezza delle nostre percezioni*',
rather than to '*scienza*' in making an attribution; the association of 'science' with

connoisseurship, save for one or two exceptions, is wisely no longer made in present-day drawings scholarship.[11] Berenson acknowledged in the 1938 edition that collectors and dealers especially might find his attempted description of the methods of connoisseurship unsatisfactory for its caveats and imprecisions ('this is scarcely the answer that will satisfy the collector Jacob and his brother the dealer Esau, but disinterested students should know that no other answer is permissible').[12] In contrast to his activity as a specialist of Italian paintings, his expertise on drawings was untainted by secondary interests, unlike a number of his near contemporaries (such as Morelli, Richter or Frizzoni).[13] Not only did Berenson not collect drawings, but he was also not involved in this aspect of the art market (dealing or expertise in drawings in the first half of the twentieth century were hardly lucrative).

While the 'scientific' method of visual comparison had been applied to the study of paintings in the late eighteenth century and throughout the nineteenth – by Luigi Crespi, Luigi Lanzi, Joseph Arthur Crowe and Giovanni Battista Cavalcaselle, Morelli, Richter, Frizzoni and Berenson himself – it presented immensely greater difficulties in the analysis of drawings. Technical or scientific research as evidence was undervalued by connoisseurs even two and three generations younger than Berenson.[14] Kenneth Clark, Berenson's research assistant for the 1938 edition of *The Drawings of the Florentine Painters*, recollected in his obituary: 'If there was one thing that bored the young Berenson more than documents it was technique.'[15] Like his magisterial volumes on Italian Renaissance paintings, Berenson's *Study and Criticism* was almost immediately published at Leipzig in a German translation. He began the manuscript of *The Drawings of the Florentine Painters* in 1896, finishing it in 1897, and the six-year delay in publication was allegedly due to the machinations of his formidable nemesis and competitor in the business of acquiring early Italian paintings, Wilhelm Bode (1845–1929; von Bode after 1914), later director of the Berlin museums, who may have been partially responsible for the delay in the printing of Berenson's illustrations.[16] In any case, by 1903 Berenson had entirely reformed the study of early Italian drawings, imposing a unified method of critical inquiry over a cacophony of inconsistent attributions, his choice of subtitle shedding light on his method. Like the 'scientific' connoisseurs of the ottocento, Berenson preferred to start anew, putting little credence on actual archival documents (despite the subtitle of his *opus*), Giorgio Vasari's *Lives* and other early written sources.

Berenson also ignored tradition[17] in the contributions of drawings collectors, dealers and connoisseurs who had eruditely laboured in the seventeenth

and eighteenth centuries. The latter had certainly shaped the field of old-master drawings, but it is doubtful that Berenson read, for example, Pierre-Jean Mariette or the seminal works of Jonathan Richardson, and he made only very occasional references to William Young Ottley's *The Italian School of Design* (1808–23) by way of citing illustrations.[18] But connoisseurship, like collecting, is formed by the history of taste, being also subject to the ravages of the 'period eye'; the nineteenth century's activities were no exception.[19]

Berenson reacted most immediately to contemporary scholarship.[20] At first he followed Morelli especially closely (the chapter on connoisseurship in Berenson's *Study and Criticism* is entirely Morellian) but, by the 1938 edition, ample evidence exists of his independence as his unique eye for drawings grew in refinement. Richter was perhaps the scholar who first made Berenson aware of the nuanced philological study of drawings; in Richter's case, this was informed by his monumental analysis of Leonardo's manuscripts, and his opinions about the attribution of Leonardo's drawings in 1883 (still accepted today) were followed by Berenson almost without question.[21] Herbert P. Horne, the unparalleled scholar of Botticelli,[22] was a collector himself, as was Richter. Pasquale Nerino Ferri, the drawings curator of the Galleria degli Uffizi, befriended Berenson, who was frequently to be seen, wrapped in shawls to keep warm, in the Uffizi's Gabinetto Disegni e Stampe, the greatest repository of early Italian drawings. Ferri's 1890 Uffizi catalogue, although less widely known today, provided a major starting point for Berenson; he referred repeatedly to the articles in which Ferri successfully collaborated with Emil Jacobsen on Michelangelo's drawings.[23] Adolfo Venturi, whose magisterial criticism on Italian art included paintings and drawings,[24] was to lead the Commissione Vinciana in publishing Leonardo's drawings and manuscripts (1928–41).

Berenson also reacted to an even more particular aspect in the history of attributions of Italian drawings. 'Tradition' – to rely on this term in the Morellian and Berensonian sense[25] – existed largely by the accretion of attributions, based on the antiquarian habits of early collectors since Vasari's time of inscribing artists' names indiscriminately on individual sheets of drawings or their mounts as if these represented veritable signatures. Berenson underlined his further mistrust: 'signatures and dates require even more careful criticism than other documents, because they have been more attractive to the forger.'[26]

The chief success of Berenson's method was the principle of objective and precise visual comparison of works – of drawings to the final paintings for which they were preparatory and of drawings with other drawings of a suggested corpus.

Interior spread discussing the work of Alunno de Domenico, with a plate showing a drawing by Andrea del Verrocchio. From Bernard Berenson, *The Drawings of the Florentine Painters Classified, Criticised and Studied as Documents in the History and Appreciation of Tuscan Art, with a Copious Catalogue Raisonné,* 1903.

He was, however, curiously laconic as regards his method in *The Drawings of the Florentine Painters*, and the reader must tease out such content from his asides. In this he was no exception, as most drawings connoisseurs seem to have felt little desire to articulate questions of method in general terms. Why destroy the magic that accompanies the intuitive moment of eureka, which is perhaps beyond words? The example that comes to mind is Philip Pouncey (1910–90), the most celebrated attributionist after Berenson, who can lay just claim to being the most accurate eye of the twentieth century, but who wrote with telegraphic brevity.[27] Pouncey himself published two articles honouring Berenson's ninetieth birthday in 1955, and insightfully reviewed his *I disegni dei pittori fiorentini* in 1964.[28] To the present author's mind, the single – published – alternative view to Berenson on the larger questions of method and connoisseurship of Italian drawings was offered by Bernhard Degenhart in his learned article of 1937, 'Zur Graphologie der Handzeichnung'. This argued for the attentive examination of drawings as embodying a form of handwriting in the sense of individual expression and regional school. Its scope has still not been surpassed, for it discussed

even Northern European drawings, but Berenson does not seem to mention it in the 1938 or 1961 editions of *The Drawings of the Florentine Painters*, preferring instead to quote Degenhart's opinions in his monographic articles on Lorenzo di Credi, Fra Bartolomeo and 'Tommaso'.[29] Degenhart, with the collaboration of Annegrit Schmitt, was to prove the most erudite scholar of early Italian drawings since Berenson, even if his attributions are less convincing.[30]

Berenson's achievement seems all the more monumental, in fact heroic, if one considers that drawings must be adequately studied in the original and that for the 1903 edition he was working before the Gernsheim Photographic Corpus of Drawings was founded. The Archives Photographiques d'Art et d'Histoire, the Gabinetto Fotografico della Soprintendenza di Firenze and Braun were for a long time the exceptional repositories of photographs and were amply cited in Berenson's editions. Photographs of the vast majority of Italian drawings, however, did not exist until the advanced decades of the twentieth century.[31] Drawings were rarely the subject of orderly publications and, certainly during the early part of Berenson's career, could only be identified in museums or libraries through various manuscript catalogues, in boxes or portfolios under any given artist's name, in bindings or albums of pasted material, or in boxes of mixed anonymous drawings. While he was one of the first scholars to understand the full potential of working from photographs in assembling the corpuses of individual artists, he also presciently emphasised the pitfalls, and his words to this effect in the introduction to the 1938 edition (repeated in the 1961 edition, but absent in that of 1903) deserve to be engraved in the consciousness of every modern connoisseur:

> A carefully printed photograph of a picture suffices to refresh our memory of the original and even to present us with a fair sense of its quality. But in drawings, line and chiaroscuro are all in all, and no mechanical process can reproduce them. Every negative and every printing after the same negative yields a different result, thereby proving that no single one is necessarily reliable. Reproductions can serve only to identify the object discussed in many of its details but can seldom offer adequate means for judging the quality. And it is quality only that decides whether a given drawing is an original, a copy, or an imitation. On the other hand, it is scarcely possible for any normal memory to recall clearly enough all the drawings one has seen to be able to dispense with reproductions.[32]

Today, a careful look through the volumes of plates in the editions of 1903, 1938 and 1961 reveals, through the comparisons, the great extent to which the

illustrated *œuvres* of individual artists gained in objectivity and visual coherence in Berenson's work over time. The most generously illustrated of the editions, that in Italian of 1961, also included related frescos and panel paintings, as well as some sculptures. Yet on the whole, Berenson underestimated the evidence that the techniques and functions of drawings contribute to the history of style; the argument developed by Robert Oertel in 1940, seeking the origins of Renaissance exploratory drawing in the use of *sinopie* in the underlying *arriccio*, or rough plaster in a fresco, went unheeded,[33] as did the proposals by historians of medieval manuscripts that the underdrawings in unfinished illuminations provided the missing link in the reconstruction of the origins of early Renaissance exploratory drawing. The *sinopie* and other types of mural drawings, as well as some cartoons (full-scale drawings) on paper, prove beyond doubt that the criteria of quality are different from those of small-scale drawings, as the large expressive gesture and functionality are of paramount importance.[34] Berenson's references to *sinopie*, mural drawings and fragments were largely incorporated in the posthumous 1961 edition for the first time, thus at last giving Andrea del Castagno his due as a draughtsman (BB 658 A, 1961 ed.).

Yet Berenson's persistent indifference to documents in *The Drawings of the Florentine Painters* as relevant complementary evidence in the work of connoisseurship stands in detrimental contrast to the ground-breaking monograph by Hans Tietze and Eva Tietze-Conrat on Venetian drawings published in 1944, in which a thoughtful consideration of Venetian artists' wills led to a profound evaluation of the functions of drawings among artists of La Serenissima, highlighting the pre-eminence of the '*simile*' (pattern drawing) in Venetian artistic practice.[35] The Tietzes's catalogue entries were also in a much more complete format, even if one may disagree today with their attributions.

The classification of 'drawings by Florentine painters' is a vexed one, for painters were often sculptors and architects and, while Berenson understandably omitted architectural and technological drawings, with extremely rare exceptions,[36] it should not go without saying that such works, in being mostly unrendered line drawings, pose the ultimate test for the eye of the connoisseur. In dispensing with a consideration of sculptors' drawings (the draughtsmen Donatello, Andrea Sansovino, Bandinelli, Cellini and Ammannati, not just Michelangelo, defined '*fiorentinità*' in many respects), the qualities of '*disegno*' (design, specifically in relation to drawing) and '*rilievo*' (depth, or the illusion of it), which in Vasari's conception defined what was glorious about Tuscan art, eluded Berenson in his overriding quest for attributions ('Vasari is the only straw

to which we can cling; but unfortunately the drawings labelled by him that can still be identified are few, and, besides his attributions prove reliable only in the case of his own contemporaries and their recent predecessors').[37] Nor did he concern himself with the theoretical underpinnings of the debates on *disegno* in sixteenth-century Florence, and perhaps here lie the roots to his gravest misunderstanding of the *œuvres* of certain later cinquecento artists.

In assessing the impact of Berenson's three editions in a more detailed manner, however, the temptation must be resisted to speak in terms of what he got wrong. Such judgments can be made precisely today because of historical hindsight on a field that Berenson largely founded. In retrospect, the 1903 edition is the most groundbreaking for the sheer novelty of the subject, while the 1938 edition brought about greater depth, much-needed corrections and numerous informative changes of opinion. The posthumous 1961 edition did not attempt the nearly impossible task of integrating the findings and literature in a field which had assumed monumental proportions. Nevertheless, Berenson's essays in the first volumes of all his editions, together with the catalogue lists in the second volumes, often amount to eloquent monographs on individual artists, while any new research on a Florentine Renaissance artist's drawings must begin with what may have been said by Berenson in 1903, 1938 and 1961.

As a connoisseur, Berenson at times tended to separate unduly the author-ship of rectos and versos in the case of double-sided sheets with drawings, and in his publications, as is true of much of the literature on Italian drawings until recent years, drawings remained significant as single sheets with little sense of the context of original bindings and of loose pages which originally belonged within sketchbooks or modelbooks.[38] As sketchbooks were relatively understudied by Berenson, mention of the numerous sheets from a '*libro di bottega*' by Francesco di Simone Ferrucci and his workshop (the 'Verrocchio sketchbook') is upgraded from a footnote in the 1938 edition to the text in the 1961 edition, but in both editions the work does not merit catalogue entries. Following his conviction in creating groups of drawings based on their consistent techniques and aesthetic approaches, if he rejected one sheet, he tended to reject the related body of works as well, and if he accepted one, he often accepted much of the pertinent rest. This holistic method is among Berenson's most influential contributions, and it espe-cially shines in his analysis of the drawings by the greatest artists.

Berenson understood with sensitivity the effects of a master on the style of his pupils – as in the case of Verrocchio and the young Leonardo[39] – but noted also the influence of Pollaiuolo on the earliest of Leonardo's drawings.[40] While apparently

little, if any, sense of chronology informs his analysis of Leonardo's development and use of different media, he understood almost perfectly well his left-handedness, following Morelli closely in this.[41] Most presciently, Berenson noted the fact that left-to-right strokes in areas of modelling with parallel hatching are not enough to uphold the authenticity of Leonardo's drawings, and rightly singled out a number of copies and freer studies with imitation 'left-handed' hatching, listing eleven such examples (BB 1261A–1266).[42] The discussion of Leonardo as a draughtsman is among his most successful, and his attributions to him are acceptable, with very few exceptions, among them the expressive study of a tree in pen and ink at Windsor (BB 1237), which is drawn with right-handed, parallel hatching by Cesare da Sesto, while the attribution of the Venice *Last Supper* (BB 1107) was already debated in Berenson's lifetime.[43]

Famously Berenson gathered corpuses of drawings under the invented names of Amico di Sandro, Alunno di Benozzo (BB 1866–1883; some of these are by the Longhian 'Maestro Esiguo'), the Master of the Castello Nativity,[44] Tommaso (BB 2759–2764) and the Alunno di Domenico (in 1938 at least two different artistic hands hid under his name; BB 36A–40A), whom Berenson himself accepted to be Bartolomeo di Giovanni in the 1961 edition.[45] 'Amico di Sandro', with a reconstruction of an *œuvre* of drawings and paintings, was the most ambitious of all Berenson's created artistic personalities, but is perhaps also regarded as his critical failure, even meriting mention in Berenson's obituary by Clark.[46] His two attributions to Piero della Francesca (BB 1863F and 1863H), of course, are no longer tenable, while no illustrations of Piero's *De prospectiva pingendi*, which are autograph, are mentioned. His reconstruction of Fra Bartolomeo holds up relatively well and he rightly lavished attention on Luca Signorelli, born in Cortona, who in his eyes was an honorary Florentine but who had been omitted from the 1903 edition. Signorelli was presciently understood as the pupil of Piero della Francesca.[47]

Berenson's judgments of the 'linear masters', especially Botticelli, were on the whole much too harsh, with a number of demotions based on a perceived weakness of quality. In discussing the *œuvre* of Maso Finiguerra, he mentioned previously attributed sheets, but rejected them, leaving this artist as a phantom figure (his attribution to Finiguerra of a flying angel [BB 1848] is unpersuasive).[48] Some of Finiguerra's drawings were instead given to the school of Antonio del Pollaiuolo (BB 1910–1936) and Alessio Baldovinetti (BB 190–196A). The proposed *œuvre* of Baldovinetti himself is not convincing (BB 193–200), while that of Domenico Ghirlandaio ('the painter for the superior philistine', as Berenson called him) is coherently reconstructed.[49]

Although Berenson's treatment of Michelangelo's drawings contains some of his most brilliant insights and thoughtful ruminations, in retrospect it is perhaps the most problematic assessment. His courageous decisions should be empha-sised, such as his inclusion among autograph drawings of the large group of studies in red chalk at the Teylers Museum in Haarlem (see BB 1463–1474A); he also acknowledged the mural drawing fragment at Villa Michelangelo, Settignano (BB 1462A; 1961 ed.). Among his worst misjudgments was his attribution of the Oxford Sketchbook to the phantom Silvio Falconi: 'The sketches in question are at Oxford (my 1702 and 1703, fig.810). That they ever could have been attributed to the great master witnesses to a sad state of ignorance regarding his manner and style as a draughtsman.'[50] Bugiardini, rather than Michelangelo, was inexplicably credited with the magnificent *Madonna and Child* cartoon at Casa Buonarroti (BB 607), while the young Michelangelo is given sheets that more properly belong with Ghirlandaio and his workshop (BB 1475A). The large Louvre portrait in pen and ink, attributed to Michelangelo by Berenson (BB 1598D), has been recently attributed to Baccio Bandinelli and identified as a portrait of Michelangelo with compelling reasons.[51] Listed merely as a 'memory sketch after Michelangelo', the Albertina sheet after the central episode of the Bathers in the *Battle of Cascina* (BB 1748) is now recognised to be by Perino del Vaga. Although the Uffizi drawing (BB 1645A) is given to 'Michelangelo (?) and follower', it is without doubt auto-graph, and the *Rape of Ganymede* also at the Uffizi (BB 1634) is presented as a 'copy after Michelangelo'.

Attributed to Michelangelo by Berenson, the man in bust-length, surely a cartoon fragment (BB 1568B), was recognised by John Gere as by Taddeo Zuccaro[52] for the Frangipani Chapel frescos, while the Uffizi autograph sheet was dismissed by Berenson as the presentation drawing of the *Furia* made for Gherardo Perini, in favour of the Windsor copy (BB 1619). While Berenson unconvincingly assigned to Aristotile da Sangallo, rather than to Michelangelo, the *Design for the tomb of Pope Julius II* at the Uffizi (BB 1632), he astutely recog-nised Aristotile's hand in some sheets, such as that in the Louvre with a spirited recreation of Michelangelo's *Tomb of Giuliano de' Medici* (BB 1734A, 1961 ed.).[53] It is vexing that Berenson reattributed to Sebastiano del Piombo large parts of the Michelangelo corpus (he believed in a very reduced corpus of Michelangelo drawings due to accidents of survival; '*quel Michelangelo mutilo e appassito che le opere superstiti ci presentano*'). Drawn in red chalk on white paper, a relatively rare medium in Renaissance Venice but extremely common in central Italy, the draw-ings for the *Resurrection of Lazarus* wrongly attributed to Sebastiano included

BB 2474B, 2483 and 2484. Among Berenson's convincing attributions to Sebastiano is the British Museum *Christ at the column* for the Borgherini Chapel (BB 2488), together with the traditionally accepted sheet of the *Visitation* (BB 2497), the pen-and-ink *Satyr playing the pipes* (BB 2481), the *Madonna and Child* (BB 2499) and the figure sketches (BB 2505A).[54] Berenson was not willing to change his mind about the Sebastiano question even in the 1961 edition (*'mi accorgo, quasi con rammarico, che ho ben poco da modificare'*),[55] and this despite Johannes Wilde's analysis and drastic revision of the Michelangelo corpus in 1953,[56] a magnificent work of scholarship which went largely unacknowledged by Berenson. According to Berenson, Michelangelo's most talented follower was 'Andrea di Michelangelo', to whom he attributed the *Zenobia* at the Uffizi (BB 1626) and the *Cleopatra* at the Casa Buonarroti (BB 1655), not to mention many other sheets of disparate qualities, high and low. Bandinelli, who is defined merely as a satellite of Michelangelo, is given a number of incorrect sheets (BB 1681 and 1677), but the reconstruction of the *œuvre* of the left-handed Raffaello da Montelupo was, however, one of Berenson's great discoveries. His inability to appreciate Bronzino as a draughtsman – in 1903, 1938 and 1961 – amounts to an egregious blind spot; in 1903 he gave him thirteen sheets out of a possible sixty that can be accepted today, and he treats Bronzino and Battista Naldini in the same breath as pupils of Pontormo in an essay which takes up less space than that of a printed page.[57]

Yet, if one considers the enormous body of works that Berenson analysed and wrote about – almost 3,500 sheets by 1961 – his ratio of discoveries and of convincing attributions is simply staggering, whether for a connoisseur of his time or of today. With rare exceptions, his passionate knowledge of drawings shines through in his monographic essays and lists in the 1903, 1938 and 1961 editions, true to his declaration in 'Rudiments' (even as one may disagree with him) that 'the work of art itself' – not contemporary documents or historical tradition – 'is the event, and the only adequate source of information about the event'.[58]

Heinrich Wölfflin photographed by Rudolf Dührkoop, 1914.

Heinrich Wölfflin

Kunstgeschichtliche Grundbegriffe: Das Problem der Stilentwicklung in der neueren Kunst, 1915

DAVID SUMMERS

HEINRICH WÖLFFLIN'S *Kunstgeschichtliche Grundbegriffe* (*Principles of Art History*)[1] begins with the story, derived from Ludwig Richter, of four painters who set out to depict the same landscape at Tivoli, each following nature as closely as possible. Despite their resolve not to deviate from appearances, the result was 'four totally different pictures', in styles that reflected the differing personalities of the four artists. In telling this story Wölfflin emphasises not that the objective transcription of nature is impossible, but rather that works of art have their own stylistic and historical reality apart from the appearances they imitate. Seen from a historical distance, Wölfflin comments, the four Tivoli landscapes seem in fact rather similar, in the '*nazarenisch*' manner. On this basis Wölfflin develops his theory of the 'double root of style', referring on the one hand to the artistic sensibility, seen within a historical context, and on the other to something deeper and more philosophical. For Wölfflin, the style of the 'drawing of a mere nostril' expressed individual temperament, and paintings expressed the style of a 'school' (or movement), just as they did for Giovanni Morelli or Bernard Berenson, whose studies in connoisseurship appeared in the 1890s. Like many of his contemporaries, Wölfflin also assumed that works of art expressed the style of 'the country, the race', and together, these four 'expressions' (temperament, school, country, race) constituted one of the 'double roots of style'. Wölfflin's important innovation was the definition of the other, second root, to be found in 'the most general representational forms' (*allgemeinsten Darstellungsformen*), which he consistently characterised as 'optical'. 'A deeper stratum of concepts may be discovered

comprising representation (*Darstellung*) as such, and it is possible to imagine a developmental history of occidental seeing for which differences of individual and national character are no longer of great significance.' These 'optical' forms, Wölfflin says, develop internally, are simply and literally abstract, and are never manifest in themselves; they are always 'bound to a specific expressive content', and so are separated only with difficulty from the expressions of the first root of style.

Wölfflin wrote exclusively about European art, and traced the change from Renaissance to Baroque in terms of five related pairs of 'most general forms of representation'. The first pair, closest to the perceptual psychological basis of his scheme, was the transition from linear to painterly (*malerisch*), corresponding to the difference between apprehension by touch (definition by continuous line) and apprehension by sight (definition by areas of light, dark and colour). Because he was concerned with 'occidental seeing', Wölfflin could assume both optical naturalism and the typical rectilinear formats of European painting, and described pictorial space in terms of his second pair of concepts: plane and recession. While Renaissance artists organise their spaces (and their 'linear' forms) transversally with respect to the base of their format, Baroque artists organise their space in relation to orthogonals, continuous but foreshortened quantities. This leads to the third pair, closed (tectonic) and open (a-tectonic). Renaissance paintings are self-contained in relation to their rectilinear formats, with many horizontals and verticals; Baroque paintings use the format as a frame, implying a surrounding space for both painting and viewer. Since 'linear' forms are apparently sculptural, their compositions are additive in comparison with the continuous and unified light, dark and colour of 'painterly' forms, yielding the fourth pair – multiplicity and unity. Taken altogether, themes in Renaissance art (as well as forms) are presented with absolute clarity, as opposed to the relative clarity of the painterly Baroque – the fifth of Wölfflin's comparative categories.

Wölfflin's *Grundbegriffe* was some years in preparation, and was published just as the First World War engulfed Europe. Although he was appalled by jingoistic reactions to the outbreak of war,[2] and his history of 'occidental seeing' might seem to suggest a principle of Western unity (even if it immediately excluded 'seeing' everywhere else in the world), Wölfflin maintained that the 'schemata of seeing' are refracted by national differences. In fact, the definition of a common 'optical stratum' will make it possible to define national differences more precisely, and this clarification will, he writes, be of great value to future historians. 'There is', he says, 'a definite type of Italian or German imagination which asserts itself,

Front cover to Heinrich Wölfflin, *Kunstgeschichtliche Grundbegriffe:
Das Problem der Stilentwicklung in der neueren Kunst*, 1915.

always the same in all centuries'. Soon 'the historical record of European architecture [and presumably of art in general] will no longer be merely subdivided into Gothic, Renaissance, and so on, but will trace out the national physiognomies which cannot be effaced'.

Such physiognomies meant that Wölfflin's categories, particularly the attribute 'painterly', could acquire nationalist dimensions. In the conclusion to *Grundbegriffe*, and in *Die Kunst der Renaissance: Italien und das deutsche Formgefühl*, published in 1931, the unclassical, limitless 'painterly' is presented as the expression of the northern spirit. But as a characteristic of Baroque art, which Wölfflin is often credited with having brought into the disciplinary sequence of art-historical periods, this valorisation of the 'painterly' required a major intellectual reversal by Wölfflin, involving a progressive abandonment of the Classical. His *Renaissance und Barock* (1888) began from the 'consensus' among art historians

that Baroque architecture is essentially 'painterly'. Since at this point Wölfflin did not distinguish Baroque from Mannerist, nor did he distinguish the retinal and sensate from the fantastic, as if the double meaning of the Greek *phantasia* – what appears in the light, but also in the possibly irrational imagination – fused in his mind to spark a kind of Platonic revulsion at anything non-linear or irrational. *Renaissance und Barock* is a study 'in the disintegration of the Renaissance', an investigation of 'symptoms of decay', of 'capriciousness and the return to chaos'. Ancient art had perished with the same symptoms, which 'we must try to diagnose'.[3] A quarter of a century later, however, when he wrote his *Grundbegriffe*, the Baroque had become the style of a period, perhaps in a way analogous to Alois Riegl's Hegelian rehabilitation of the 'decadent' art of Late Antiquity as essential to the formation of the modern subject, and certainly in a way consistent with the 'physiognomic' emergence of the painterly as distinctively northern.

Wölfflin's *Grundbegriffe* is thus a document of its time, and, as a 'classic' text, it may still sanction what E.H. Gombrich termed 'physiognomic' inferences of the most questionable kind.[4] Erwin Panofsky responded to *Grundbegriffe* in the year that it was published (although he did so on the basis of a lecture he had heard four years earlier), arguing that Wölfflin had compressed too much into his concept of 'vision', undercutting the possibility of the contextual–historical interpretation of art.[5] Wölfflin might simply have meant to link his 'optical' forms of representation to a theory of style, but he might also be suspected of suggesting that actual vision, rather than having a universal physiological base with a great variety of culturally shaped variants, differs from one 'nation and race' to another. This would be the historiographic corollary of his famous claim that 'vision in itself [*das Sehen an sich*] has a history'. In the last paragraph of *Grundbegriffe*, Wölfflin writes that a general history of seeing (which he calls *Vorstellungsgeschichte*) will reach beyond art; differences in national 'eyes', he says, are more than matters of taste; they are both 'conditioned' (by what, he does not say) and conditioning, thus forming 'the basis for the whole world-picture of a people'.

It is in this way that Wölfflin's *Grundbegriffe* relates to the millennial narratives of continuity defined by Riegl, via the transformation of ornamental motifs, in his *Stilfragen* (1893), a vision that was to assume the full dimensions of neo-Hegelian cultural history in his *Die spätrömische Kunstindustrie* (1901). Yet Wölfflin's comparative method was perhaps more closely linked, albeit against his own intentions, to the definition of art as 'form' that took shape on a broad front in the late nineteenth and early twentieth centuries. Wölfflin himself showed little interest in the modernist art emerging around him, to which his categories were

in any case hardly relevant, and was more inclined to use the adjective 'modern' in relation to Baroque art. In principle, however, the definition of art as form not only cast the art of the past in a new light, but was compatible with a future history of art without representation. We need only recall the modernist narrative from Manet's *Olympia* of 1863 to Frank Stella and, as formalism advanced, Wölfflin's *Grundbegriffe* provided a powerful historical basis for formal analysis and inference, as well as for the idea of the 'visual arts'. When formalism was defended against rising contextualism in the 1960s and 1970s, it was often lamented that, without formalism, 'art itself' was lost.

The theoretical arguments of Wölfflin's *Grundbegriffe* are terse, and leave some knotty questions unsolved. Critics, from Walter Benjamin to Gombrich, have objected to Wölfflin's Hegelian cultural totalisation and universalisation, continuing the long tradition of objections to the writings of Hegel himself. Benjamin, echoing the objections of the second Vienna school of art history, saw the solution to what Gombrich called 'Romantic historiography' in closer monographic historical studies, focusing on the gaps, breaks and contradictions in the putative continuity of universal history, and a more material 'esteem for the insignificant'.[6] In his *Art and Illusion* (1960) Gombrich looked to a historicised version of Gestalt psychology, and to the intellectual, social and institutional explanation of art. Both Benjamin and Gombrich may be considered in the light of a contextual social art history that rejects Hegelian assumptions of cultural and stylistic unity (the harmonious Renaissance, the exuberant Baroque), as well as the uniform diachronic development of culture and style, in favour of the more synchronic study of art in relation to cultural and socio-economic circumstances.

If critics have rejected Wölfflin's cultural–historical generalisations on the basis of style, his categories are persuasively formulated and have remained useful, perhaps reflecting his clear intention to consider the history of art on a more scientific basis. He argued that *Stimmung*, or 'feeling', was an inadequate art-historical critical response, and dismissed the 'subjectivity' and 'disastrous one-sidedness' of the neo-idealist view of art as 'intuition' and 'expression', perhaps best exemplified by Benedetto Croce in his *L'Estetica* (1902), but broadly current (as it still is). Wölfflin followed the sculptor Adolf Hildebrand in observing that Hippolyte Taine, who championed the art of Ancient Greece and the Italian Renaissance as ideal confluences of race, milieu and moment, had only succeeded in bringing the discussion of art to the point at which form, and thus true art-historical problems, had begun to come into view. It is important, however, that Wölfflin did not question Taine's categories, and might be seen to

have offered a variant of the latter's positivism. His 'art history without names' has been linked with Auguste Comte's 'history without names',[7] and the degree to which Wölfflin was seen to have put art history on a more closely objective basis contributed greatly to the success of his *Grundbegriffe*. In 1959, Herbert Read, echoing Wölfflin's own words and the belief of many art historians after him, wrote that Wölfflin had 'invented a morphology of form', and in the five paired categories of *Grundbegriffe* had posited 'a law of development *within* the formative imagination, a cyclic theory to account for the parallelism to be discerned between the visual arts of any self-contained period'.[8]

The 'optical strata' that underpin Wölfflin's vision of art history imply geological or archaeological metaphors. That the task of the art historian is to develop laws of formal transformation further evokes evolutionary biology, due to the fact that human psychology 'is subject to natural law in the same way as physical growth'. The psychological necessity of Wölfflin's formal development raised, however, a serious problem. In the final pages of *Grundbegriffe*, Wölfflin says that throughout he had had in mind 'the problem of recommencement' (*Neu-Anfangen*). Why, he asks, was there a renewal of style around 1800, when a new 'linear' mode of vision appeared 'with extraordinarily penetrating definiteness'? Such an 'unnatural' reversal of 'seeing' must be attributed to a 'revaluation of being in all spheres'. The history of spirit trumps the development of 'seeing', and the impulse to abrupt reversal must be external to art itself.

When Roger Fry reviewed the fourth edition of *Grundbegriffe* in *The Burlington Magazine* in 1921,[9] he praised it as an analysis especially congenial to artists. Indeed, an essential element of Wölfflin's enterprise was provided by Hildebrand who, writing in close collaboration with Konrad Fiedler, published his *Das Problem der Form in der bildenden Kunst* in 1893, at the peak of his career.[10] Wölfflin reviewed it in the *Allgemeine Zeitung* on 11th July of the same year (his review was entitled 'Ein Künstler über Kunst'). Hildebrand's book, which quickly went through many editions, put forward the argument that 'positivist', 'mechanically retinal' vision (Impressionism) is possible only at birth, after which ongoing experience and imagination form a conception of our own spatiality. But just as we think little about sight or hearing unless they fail us, so we in effect forget the bodily 'sense' we have formed of ourselves. Only artistic intuition is able to reawaken this primordial spatial awareness.

The art Hildebrand advocated was based on a classical 'principle of relief', with compositions of generously scaled images in successive planes parallel to the plane of a given format. This, he argued, is the only arrangement of virtual space

in which nature may be 'formed to match our visual imagination'; it is 'the vessel in which the artist creates and holds nature', and at once 'the mark of artistic sensibility and the expression of unchanging laws'. Adjusting these ideas to his own historical and critical purposes, Wölfflin wrote *Die klassische Kunst*, published in 1899, which, as an extension of Hildebrand's idea of a noble style, had the effect of elevating the aristocratic and the Raphaelite above the 'primitive' Pre-Raphaelite, still much in vogue.

As we have seen, Wölfflin wrote of a 'history of seeing', but he also wrote of a history of 'artistic' vision. The implications of the two are quite different: words about seeing, imagination and representation do not have simple meanings in the tradition of German idealism to which Hildebrand and Wölfflin adhered. For an idealist, the primary, deepest 'representation' (usually *Vorstellung*) is the continuous activity of mind (or spirit) in encounter and interaction with the world of 'things in themselves'. This primary representation is a universal act of 'imagination', and Hildebrand's artistic intuition is, so to speak, a representation of that representation, serving at once to indicate this constitutive human activity and to ground artistic intuition in its universality. Artistic vision was thus at once psychologically based and revelatory. This second representation is crucial for the whole formalist enterprise.

Hildebrand's artistic intuition provided a foundation for the type of classical composition which, he argued, is only realised when art achieves a higher form of excellence. Such intuition was based on a Kantian theory of consciousness, and was aesthetic in the Kantian sense that it affords pleasure through its consonance with our own imaginative powers. If we think of Wölfflin's 'forms of representation' as an extension of Hildebrand's classical intuition, however, development from linear to painterly raises very different questions about the relation between this development and individual invention. Hildebrand's neo-Kantian classicism provided a firm definition of artistic intuition, but what if this intuition itself inevitably and autonomously changes? This raises the further question of the relation between artistic intuition (*Anschauung*) and collective world view (*Weltanschauung*). As if to deflect the inference that world view determines artistic intuition, Wölfflin states at one point that the sequence can be interrupted, and, against the internal development from Classic to Baroque proposed by others (including Jacob Burckhardt), argued that form must pass 'from hand to hand' and occupy the imagination long enough 'to make it yield up its baroque possibilities'. He immediately notes, however, that this cannot mean that the Baroque style is not the 'expressive organ of the *Zeitstimmung*'.

Jan van Goyen

I.

Ludwig Richter erzählt in seinen Lebenserinnerungen, wie er in Tivoli einmal als junger Mensch, zusammen mit zwei Kameraden, einen Ausschnitt der Landschaft zu malen unternahm, er und die andern fest entschlossen, von der Natur dabei nicht um Haaresbreite abzuweichen. Und obwohl nun das Vorbild das gleiche gewesen war und jeder mit gutem Talent an das sich gehalten hatte, was seine Augen sahen, kamen doch drei ganz verschiedene Bilder heraus, so verschieden unter sich wie eben die Persönlichkeiten der drei Maler. Woraus dann der Berichterstatter den Schluß zog, daß es ein objektives Sehen nicht gäbe, daß Form und Farbe je nach dem Temperament immer verschieden aufgefaßt werden würden.

Für den Kunsthistoriker hat diese Beobachtung nichts Überraschendes. Man rechnet längst damit, daß jeder Maler „mit seinem Blute" male. Alles Unterscheiden der einzelnen Meister und ihrer „Hand" beruht im letzten Grunde darauf, daß man solche Typen individueller Formgebung anerkennt. Bei gleicher Orientierung des Geschmackes (u n s würden jene drei Tivolilandschaften zunächst wahrscheinlich ziemlich gleich, nämlich nazarenisch vorkommen) wird die Linie hier mehr eckigen, dort mehr rundlichen Charakter haben, hier mehr stockend und langsam, dort mehr strömend und drängend in der Bewegung empfunden sein. Und wie die Proportionen bald

Die doppelte Wurzel des Stils

1 Wölfflin, Grundbegriffe

1

First page of Heinrich Wölfflin's *Kunstgeschichtliche Grundbegriffe: Das Problem der Stilentwicklung in der neueren Kunst*, 1915, with an illustration by Jan van Goyen.

Comparing Gerard ter Borch and Bernini to illustrate the breadth and depth of his categories, Wölfflin writes that *Darstellungsformen* may also be regarded as *Anschauungsformen*, by which I take him to mean that 'forms of representation' are also the means by which the world is made by artists to appear to others in one way or another. For Wölfflin, both Renaissance and Baroque were 'optical', but he also suggested a basis for change in 'continuity of life-feeling'. 'What seems living today is not quite completely living tomorrow' for artist and observer alike. This recalls Adolf Goeller's theory of style,[11] which, as Wölfflin wrote in the conclusion to *Grundbegriffe*, explained change in terms of the 'palling' of visual interest and the consequent need for its continual 'stimulation'. It also recalls Wölfflin's own early interest in empathy. In his dissertation (1886) he had argued that continuity of life-feeling made both pointed arches and pointed shoes manifestations of the Gothic.[12] In the virtual dimension, formal development must be worked out in successive, persuasively 'living' solutions. (Here it may be noted that formal innovation emerges as a criterion of quality.) Titian is Wölfflin's example of such working-out.

At crucial points, Wölfflin gives importance to the 'decorative', and it may be suggested that he, like many contemporaries with a variety of interests in the arts, adapted the ongoing discussion of ornament and its history to the characterisation of form apart from representation. Wölfflin opposed decoration to imitation, associating the first with a sense of beauty, the second with a sense of truth. He identified 'decoration' closely with his 'forms of representation', to the degree that 'the history of painting is not incidentally, but wholly and essentially, a history of decoration'. That is why, Wölfflin says, paintings have more to do with earlier paintings than with the appearances they imitate. All artistic intuition 'is bound to certain decorative schemata [. . .] visibility is crystallized for the eye under certain forms. But in every new form of crystallization a new aspect of the world's content also comes to light'.

This last metaphor, repeated several times in Wölfflin's conclusion, deserves closer attention; crystals had a significant ancestry stemming from Kant's dynamic conception of matter, and the philosopher Friedrich Schelling opposed crystals to organic form, placing them among Nature's spontaneous generations of three-dimensional order, variations of symmetry antecedent to those of plants and animals. In his *Historische Grammatik der bildenden Künste* (1966), Riegl argued that 'man's artistic production is essentially crystalline',[13] a view he claims to have shared with Wölfflin's teacher, Jacob Burckhardt. The 'geometric-crystalline', following Riegl, is also essential to Wilhelm Worringer's *Abstraktion und Einfühlung* (1908).

The conceptual relations among Wölfflin, Riegl and Worringer would repay further study, but suffice it to say that I understand Wölfflin to have meant that decoration was not only geometric, but also stereometric, or three-dimensional. 'The content of the world', Wölfflin writes, 'does not crystallize for *Anschauung* in unchanging form [. . .] *Anschauung* is not just a mirror [. . .] but a living power of apprehension which has its own inner history and has passed through many stages.' Wölfflin does not describe these stages, but, however many there might be, for Wölfflin there were only two 'crystals', or perhaps one, its growth defined by his five polar categories. He thought there might be more, but could not find them.

The metaphor of crystallisation is important because Wölfflin's enterprise is limited to a specific, 'occidental' tradition of virtual space. Like most writers about style after him, Wölfflin chose painting as his representative art, not least because imagination itself has been assumed to be pictorial. The Classical and Neo-classical periods of Western painting were explicitly optical, and both ancient *skenographia* and the Renaissance painter's perspective are 'planar' in Wölfflin's terms. Both entail a point of view. The geometric representation of space for individual vision is a marker of the Western pictorial tradition, and by the same token a marker by which this tradition may be set among other traditions, especially those of pictorial space. The geometric tradition of Western pictorial space may be considered in terms of a regular, crystalline structure: transversals are parallel to the base of a rectilinear picture format and to the plane of the picture surface itself, and perspectival orthogonals show continuous recession along a virtual plane, that is, into the picture space. Wölfflin's 'crystals', in short, might be seen as endless narrative invention and variation on these themes. In his review of *Grundbegriffe*, Roger Fry observed that once painters have solved a problem 'they tend to retain this power', and this observation might be applied to spatial imagination. In the preface to one of the later editions of *Die klassische Kunst*, Wölfflin wrote that a 'history of artistic vision' should include studies of the development of drawing, chiaroscuro, perspective and the representation of space', the whole system of optical naturalism. The 'perspective question', which began with Panofsky's essay 'Die Perspektive als "Symbolische Form"', published in 1924,[14] nine years after the first publication of *Grundbegriffe*, fulfilled one of Wölfflin's anticipated contributions, and might have made 'occidental seeing' as culturally specific as these words imply had it not been set in the terms defined by Ernst Cassirer's *Philosophie der symbolischen Formen* (1923–29).

Interest in the once-central art-historical idea of style has declined steeply in the last forty years. Yet it remains the case that artefacts may be categorised

on the basis of resemblance, and it is of crucial importance how these series and resemblances are explained. Styles are subject to many factors, some of which favour their continuation and others of which necessitate their change. In the nineteenth and twentieth centuries, style was a major theme in the ideology and rhetoric of nationalism,[15] and Wölfflin shared this widespread concern about style as a guarantee of national authenticity and legitimacy. In the introduction to the first edition of *Grundbegriffe* Wölfflin wrote that the history of art preserves the memory of times when styles were unified, in contrast to the heterogeneous din of contemporary fashion and consumer culture.[16] This highly questionable fantasy about the past has become increasingly contrary to the contemporary world, in which the relative isolation that permitted and tended to preserve the autonomy of cultures has become historical, giving way to continual contact, communication and commerce. In this context, both the production and the enactment of styles present very different historical and art-historical problems than those to which Wölfflin addressed himself.

Roger Fry photographed by A.C. Cooper, 28th February 1918.

Roger Fry

Cézanne: A Study of His Development, 1927

RICHARD VERDI

'THE TIME MAY COME when we shall require a complete study of Cézanne's work, a measured judgment of his achievement and position', wrote Roger Fry in *The Burlington Magazine* in 1917, reviewing Ambroise Vollard's recently published biography of the artist, adding that 'it would probably be rash to attempt it as yet'.[1] Less than ten years later, Fry himself had done just that and produced a landmark book which is arguably still the most sensitive and penetrating of all explorations of Cézanne's pictures. Written at a time when Cézanne was still not widely accepted in Britain as a modern master, and when the only published studies of him had been largely biographical and anecdotal, Fry's study breaks new ground, peering over the artist's shoulder to recreate his works, as though witnessing their very inception. 'If one would understand an artist, one must sooner or later come to grips with the actual material of his paintings', asserted the critic, 'since it is there, and nowhere else, that he leaves the precise imprint of his spirit'.[2] In so far as any writer could fathom the richness and complexity of Cézanne's achievement, Fry succeeded; and his book on the artist remains the supreme introduction to a painter he justly regarded as the 'greatest master of modern times'.[3]

Given its subsequent renown, Fry's *Cézanne* could hardly have had a more inauspicious beginning. Originally written in French, it was first published in 1926 in *L'Amour de l'Art* and intended as an introduction to the paintings by Cézanne in the Pellerin Collection in Paris, the most comprehensive of all holdings of the artist's works. Although it reads effortlessly and contains some of the most memorable passages on the painter ever written, it cost the author much labour.

Virginia Woolf records Fry's exasperation with its progress in her biography of him: 'O Lord, how bored I am with it [. . .] it seems to me poor formless stuff and I should like to begin it all over again.'[4] Further hampered by the difficulty of obtaining photographs of some of the works in Pellerin's collection, Fry earned nothing from the French edition but a few presentation copies and in 1927 translated and recast it for publication in English by Leonard and Virginia Woolf's Hogarth Press. It was illustrated by fifty-four plates which are discussed largely in numerical order but not laid out accordingly, the reader having constantly to shuffle through them to follow the argument. But this is a small price to pay for the quality of the insights and the range of works encompassed, which amount to a comprehensive survey of the artist's paintings and works on paper.

Little in Fry's early background had anticipated his later championing of Cézanne, though it undoubtedly enriched and extended his perspective on the artist. Educated at Clifton College, Bristol, and King's College, Cambridge, where he read natural sciences, he subsequently trained as a painter – which he was always to regard as his principal profession – spending two months at the Académie Julian, Paris, in 1892, where (he later confessed) he 'never once heard the name of the recluse of Aix'.[5] A year earlier he had visited Italy, where his lifelong passion for early Italian painting took root, eventually leading to his first major publication, a monograph on Bellini of 1899. With his appointment in 1906 as Curator of European Painting at the Metropolitan Museum of Art, New York, Fry was inevitably encouraged to embrace a much wider field, purchasing works by Jan Steen, Goya and Renoir in addition to Crivelli and Giovanni di Paolo. From this year, too, dates the first evidence of his burgeoning interest in Cézanne, which followed his encounter with two of the artist's works at the International Society's exhibition at the Grafton Galleries, London. 'We confess', admitted Fry, 'to having been hitherto sceptical about Cézanne's genius but these two pieces reveal a power which is entirely distinct and personal, and though the artist's appeal is limited, and touches none of the finer issues of the imaginative life, it is none the less complete.'[6]

Two years later, writing in response to a denigrating article on modern French art in *The Burlington Magazine* – which Fry himself had been instrumental in founding in 1903 – he wrote a long and reasoned rejoinder (March 1908, pp.374–75). Praising the decorative qualities of the art of Cézanne and Gauguin especially, he dubbed both men 'proto-Byzantines' for their synthetic approach to design, which Fry deemed superior to the mere naturalism of Monet.[7] Although still conceding that neither painted 'great masterpieces' or was a 'great genius', Fry

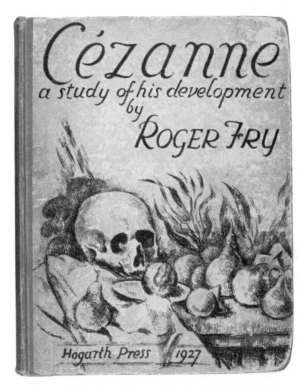

Front cover to Roger Fry, *Cézanne: A Study of His Development*, 1927.

had taken a major step forward in his conversion to recent French art and soon became the first British critic to champion Cézanne, publishing a translation in 1910, also in *The Burlington*, of one of the key early assessments of his art by the latter-day disciple of the master, Maurice Denis.[8]

Denis's essay is the first to examine Cézanne's art in relation to that of his own time and of the past. Recognising that, like many of his contemporaries, Cézanne was dedicated to the study of nature, he is seen as exceptional among his generation in his efforts towards *style*; and, for Denis, style means the classicism of the old masters. 'Spontaneously classic' is his description of the artist, whom he calls 'the Poussin of Impressionism', to which Fry, in his introduction to the article, widens the range of connections to encompass such seemingly unrelated masters as Rembrandt and even El Greco.

Fry's advocacy of modern French painting reached a much wider public in the same year as his translation of Denis's essay with the exhibition *Manet and the Post-Impressionists*, which he staged at the Grafton Galleries and

which made him (in his own words) 'the centre of a wild hurricane of news-paper abuse'.[9] Included in it were twenty-one paintings by Cézanne in addition to works by Van Gogh, Gauguin and their followers. Assaulted by the critics, who were deeply affronted by this attack upon civilised Edwardian taste, Fry staunchly defended his position, comparing the monumentality of Cézanne's portraits with those of Piero della Francesca or Mantegna and, of his still lifes, with those of Chardin.

In 1912 Fry mounted a successor to this exhibition, which included more works by living French artists – among them Picasso, Matisse and Braque – in addition to their British and Russian contemporaries. There were also five paintings and six watercolours by Cézanne (the latter augmented in a late rehang of the show), who by this time had ceased to shock the critics, leaving Fry himself to establish the master's unassailable position as the key figure in modern French painting.

In October 1919 Fry visited Aix, where the magnificent countryside, dominated by the Mont Ste-Victoire, not only inspired him to paint it but soon led him to declare Cézanne 'a pure naturalist', so wondrous did the hues of the surrounding landscape seem. Of Cézanne himself, nothing appeared to be known save that he 'came and went and left no trace on the little bourgeois life of the place'.[10] But on a visit to the Jas de Bouffan, he did discover two early works by the master, though the gardener himself had never heard of Cézanne, who was apparently only remembered by a few local artists and connoisseurs.

One year later, Fry's collection of essays *Vision and Design* was published, including his review of Vollard's biography of Cézanne and a 'Retrospect', in which he avows his veneration for the artist as a painter who wedded 'the modern vision with the constructive design of the older masters',[11] an idea he was to develop much further in his forthcoming book.

By early 1925 Fry was visiting the Pellerin Collection and had embarked on his essay on Cézanne. As the title indicates, it was intended as an account of the artist's stylistic development – the first ever to appear. He begins by observing that, by the 1920s, Cézanne's style had become an academic convention, parodied in the art of a Vlaminck or a Friesz, who had adopted it purely decoratively and with an assurance unknown to the master; for as Fry was later to assert, Cézanne's art was the antithesis of the abstraction of Cubism, constantly questing instead to explore the inner face of nature.[12] In this respect, Cézanne is for Fry 'nearer [. . .] to Poussin than to the Salon d'Automne'. One of the central tenets of the book, this is both visually and historically justifiable and accounts for Cézanne's seemingly

contradictory position as an artist caught between the study of nature and the act of contemplation.

Fry continues with a discussion of Cézanne's early life and art, which acknowledges his initial attraction to the most diverse influences – from the meticulous technique of Kalf and Ingres to the brusque manner of Courbet, and from the Arcadian visions of Giorgione to their modern reincarnations in the art of Manet. But his prevailing view is that the young Cézanne was a visionary who was ultimately inspired by the art of Delacroix and by his models, above all Veronese and Rubens, rather than by the art of his own day. His ensuing account of the figure paintings of Cézanne's early years is the first to tackle these; Fry acknowledges their awkwardness and intractability, conceding that the artist had not been gifted with the powers of invention or visualisation of Rubens or the great Venetian decorators. Focusing on the *Banquet*, with its maladroit figures and compositional incongruities, he concludes that this is an inept exercise in the manner of Tintoretto or Veronese which is, however, entirely redeemed by the artist's mastery of colour – and colour not as it clothes an already preconceived form but as it actually creates it.

As Fry rightly asserts, Cézanne's colour sense is 'the one gift which never failed him' and 'remains supremely great under all conditions'.[13] This is among the critic's chief contributions to our understanding of the artist and beggars words, but never praise. Whether extolling the 'unspeakable richness' of Cézanne's colour, or recognising how its subtle variations correspond to changes in plane, Fry acknowledges the artist's powers as a colourist as among the supreme aspects of his genius – a judgment with which few would disagree.

Aside from the quality of the artist's colour, however, Fry is aware of the compositional and imaginative shortcomings of these early works, which aspire to the Baroque tradition of grandiose figure paintings but are utterly deficient in the pretensions and artificialities of that style and reveal instead 'the simplicity and directness of the peasant and the artisan' in their lack of flamboyance or inventiveness. Although Cézanne was soon to abandon such imaginative flights of fancy in favour of an art founded upon the study of nature, Fry's advocacy of these powerful works is pioneering and revelatory.

Fry's discussion of the portraits of this period is no less full of insights and already reveals the complex – and even contradictory – nature of Cézanne's creative personality. Here, faced with a live model and absorbed in his sensations, the artist turned not to the extravagance of the Baroque but to the simplicity of Byzantine art. Symmetry, frontality and a wilful austerity characterise these

works, which are always enlivened by Cézanne's infallible sense of colour but otherwise emotionally intransigent. In his analysis of these, Fry concedes that the artist remains more plastic than psychological and points to one of the greatest strengths of his portraiture: namely, that it is concerned constantly not to explore and lay bare any peculiar quirks of character or personality but to distance itself from the individual and focus instead upon the human condition.

Considering a third group of Cézanne's early pictures – his bacchanalian subjects featuring figures in a landscape – Fry broaches the other great source of his youthful inspiration, which was grounded neither in fantasy nor direct experience but in a preoccupation with what he calls the 'Museum picture'. Here the artist's principal models are deemed to be Titian and his fellow Venetians, as well as Rubens, and their most recent followers, above all Manet. But Fry also astutely acknowledges the importance of Dutch art for the painter's early genre pictures, such as *Alexis reading to Zola*, with its indebtedness to de Hooch. These multiple allegiances and affinities lead him to another of the central themes of his book, that Cézanne's art encompasses the most diverse styles in earlier painting and that it brings much of Western art with it – from the Primitives to Poussin, Tintoretto to Rubens and Delacroix to Daumier. Who else but the artistically omnivorous Fry could, after all, link Cimabue, El Greco and Cézanne, as he does at one point in his career?[14] Through all of this, however, the critic asserts the authenticity and humility of the artist's vision together with 'the desperate sincerity of his work'. In so doing, he underlines the very focus of Cézanne's creative dilemma, caught between being utterly himself and subsuming so much of the past.

Around 1870, the artist had begun to abandon the extravagant inventions of his early figure paintings and (in Fry's words) 'take advantage of his real gift, the extraordinary sensibility of his reaction to actual vision'.[15] In contact with Camille Pissarro and his fellow Impressionists, Cézanne gradually came to submit himself to the vagaries of pure sensation but, unlike them, he was already armed with a rigour and discipline gained from his early 'apprenticeship' to the old masters. 'The revelation of Impressionism was decisive and complete', observes Fry, 'but it was not sufficient'. Architecture and logic were also essential, for, as he rightly admits, 'the intellect is bound to seek for articulations'. Armed with an allegiance to these seemingly opposing goals, 'from this moment' – Fry exclaims, with remarkable candour and empathy – 'begins the thrilling drama of this determined explorer'.

At the heart of Fry's book is his own masterly exploration of Cézanne's journey through this uncharted terrain. This begins with an analysis of those works in which nature and structure are held in equal measure – the still lifes. 'Dramas

Interior spread from the plate section to Roger Fry, *Cézanne: A Study of His Development*, 1927, showing Cézanne's *Still life with fruit basket*, 1895 (above) and *Winter landscape*, 1894 (below).

deprived of all dramatic incident', which are at times 'tragic, menacing, noble or lyrical', these are implicitly recognised as the central achievement of the artist's career and the fullest manifestation of his genius.

Fry begins with a lengthy investigation – the most extended in the entire book – of one of the most concentrated and resolved of the artist's still lifes of his early maturity, the *Still life with compotier* of c.1880.[16] Never questioning how the objects depicted arrived there or in that particular arrangement, he reveals one of the major omissions in his consideration of the artist. After all, Cézanne exercised choice over the composition of his pictures, a crucial stage in the creative process. But it is not one that Fry addresses. Even now, a reasoned account of Cézanne's selection of motifs in relation to his artistic aims has not been attempted; yet it is undeniable that, for the master himself, this was the first and most important decision. What to paint inevitably preceded how to paint.

For Fry, the 'idea' of the picture is tacitly accepted and the 'material quality' welded to it. In the latter, the critic insists, the idea comes alive; and it is this, ultimately, that conveys the artist's inner feeling. Only through it can the viewer confront the physical reality of the painting. And here Cézanne equals the very greatest masters, excelling even Chardin in his accentuation of all parts of the

paint surface so that none of it appears lifeless or inert, and is comparable instead, in his expressive use of materials, to Rembrandt.

Having acknowledged that Cézanne's seemingly crude handling is justifiable and now 'so universally accepted', the critic then moves on to consider the organisation of the composition itself. Here, he notes, the artist exhibits 'a constant tendency towards the most simple and logical relations'; and in one of his most memorable passages he declares: 'One has the impression that each of these objects is infallibly in its place, and that its place was ordained for it from the beginning of all things, so majestically and serenely does it repose there.' Noting how few and formally related the objects are in *Still life with compotier*, Fry then observes Cézanne teasing out even closer harmonies among them through a sequence of unconscious deformations in which circles become ovals and ovals acquire rounded ends, entering into a hidden compact with the rest of the picture. In this web of interrelations Fry concedes, somewhat embarrassedly, that he cannot explain the prominent shadow cast by the half-opened drawer at the bottom centre of so otherwise perfect a design. Without this stabilising compositional plumb line, however, the entire arrangement would slip inexorably towards the lower right.

Concluding what Fry deems 'this tiresome analysis of a single picture' – in truth, the fundamental key to Cézanne – he considers more summarily a number of the master's other still lifes before apologising for devoting so much time to them. Yet, as the critic admits, they embody the formal principles that govern the painter's designs which, as Cézanne indicated, constantly strive after the geometric regularity of the sphere, the cone and the cylinder.

To quote such phrases is one thing; to demonstrate them is another. And it is the greatest strength of Fry's study that it dissects Cézanne's pictures, relentlessly encouraging the reader to scrutinise them, and examine their interrelations of form and colour, in a way that was later adopted by such formalist critics as Erle Loran and Meyer Schapiro, but was pioneered by Fry. In pursuing this approach, he admittedly neglects almost entirely to investigate the artist's subjects. Thus, Cézanne's late preoccupation with skulls – which may well have vanitas connotations – is explained purely by the fact that the shape of a skull resembles that of a sphere and accords with the geometric concerns of his art. (How different from later interpretations of the opposite extreme which link Cézanne's fondness for painting apples with the theme of original sin!) But such a bias ignores the emotional power and terror of these works and does no justice to the profound humanity of Cézanne's art, a feature which Fry addresses especially when discussing the self-portraits.

Ever conscious of the contending currents of Cézanne's creative aims, Fry deals fairly and astutely with these throughout, noting the artist's inclination towards balanced, often rigidly symmetrical compositions marked by a central line or gap and often dominated by a strictly parallel disposition of objects. But this desire for an inherent stability is then enlivened by infinite gradations of colour, which render the skeletal structural simplicity of the picture indescribably rich and pulsating with life. 'A perfect synthesis of opposing principles' is how Fry describes this quest to wed 'the data of Impressionism with – what he regarded as an essential to style – a perfect structural organization'.[17]

How the artist succeeded in clothing the objects before him with all the richness and complexity of nature without resort to mere description is among the wonders of his art. And this forms the focus of one of the most illuminating passages in Fry's book. Writing of the so-called *Houses in Provence* (R438) of c.1880, he observes:

> We may describe the process by which such a picture is arrived at in some such way as this: – the actual objects presented to the artist's vision are first deprived of all those specific characters by which we ordinarily apprehend their concrete existence – they are reduced to pure elements of space and volume. In this abstract world these elements are perfectly co-ordinated and organized by the artist's sensual intelligence, they attain logical consistency. These abstractions are then brought back into the concrete world of real things, not by giving them back their specific peculiarities, but by expressing them in an incessantly varying and shifting texture. They retain their abstract intelligibility, their amenity to the human mind, and regain that reality of actual things which is absent from all abstractions.[18]

As far as anyone could recreate the process by which Cézanne transformed ordinary things into pure pictorial elements and then back into the multifarious world of nature, Fry has done so here.

Discussing the artist's mature works, the critic devotes relatively little time to the bathers paintings and somewhat unconvincingly finds a lyrical intensity comparable to Giorgione's pastorals in so austere and intimidating a work as the great Barnes Foundation *Bathers*. But he is much more convincing in his account of a previously neglected aspect of the artist's achievement – his mastery of watercolour and its effect on his oil-painting technique of the later years.[19]

Rightly observing that the transparency of this medium led Cézanne to regard the paper itself as an ever-visible support, Fry notes that the artist treated

the paint surface as an unbroken sequence of coloured touches. These possess a freedom, fluency and lightness of handling that Cézanne had not attained in his early paintings but was increasingly to emulate in his later works in oil. Here the pulsating rhythms which came naturally to his watercolours are also apparent, resulting in a weft of animated strokes of colour which accord equal emphasis to all areas of the canvas – a blank wall being as rich and diverse in hue as a commanding figure. In this unparalleled technique the entire picture surface is imbued, Fry asserts, with 'the vibration and movement of life'.

Fry demonstrates this superbly in extended accounts of two of the artist's late portraits, one of Mme Cézanne (R655) and the other of Gustave Geffroy.[20] In the intricate and ambitious portrait of Geffroy, the critic marvels at the silent drama created between the pose of the sitter and the arrangement of the books on the shelves behind him. Together these conspire to hold all in a state of dynamic equilibrium that Fry concludes was arrived at solely by the artist's sensibility and intuition rather than by any *a priori* scheme. In this he confesses that Cézanne differs from the moderns, who contrive such complex constructions rather than discover them. This concordance of intellect and sensibility is, for Fry, 'something of a miracle' which occurs only rarely in the history of art. No one could deny this, but it is characteristic of Fry's approach to pay no heed to Cézanne's crucial historical position as an artist who straddled both the naturalism of his own age and the more conceptual art that was to succeed it.

After Fry's probing investigation of Cézanne's mature works, it is something of a disappointment to confront his account of the artist's last years. This is relatively cursory and bypasses a number of important works that were to be seen in the Pellerin Collection. However, he does examine two versions of the *Cardplayers* and the three large late *Bathers*. In his consideration of the former, their gravity and monumentality leads Fry to invoke two of his favourite comparisons – the Italian Primitives and Rembrandt. Both are justified, if surprising, seldom recurring in later discussions of Cézanne's art. But it is wholly in keeping with Fry's widespread familiarity with the whole of Western art that the early Italians – his own once-chosen field – should be repeatedly cited in comparison with the fixity and finality of Cézanne's art, and that Rembrandt is the one old master most often cited as possessing a profundity and richness of interest comparable to his. Ignoring the fact that Cézanne's copies after the old masters tell a very different story – with those after Rubens, the Venetians and works of sculpture of all periods predominating – Fry cites Rembrandt seven times in his book as the one artist who comes immediately to mind when contemplating Cézanne's complexity and intensity.

In his treatment of the late *Bathers*, Fry is less sympathetic and rightly detects a wilfulness and conscious contrivance, together with a fear of the live model, that deprives these works of the spontaneity of his paintings based on nature. His reservations about these reveal him as a child of his time, for they still persisted in the 1960s, when the acquisition by the National Gallery, London, of its late *Bathers* gave rise to a public outcry in the press.

Much more ahead of his time is the theme with which Fry concludes his study: namely, that of Cézanne's attitude towards women. But rather than adopting a proto-feminist approach, he admits the artist's inhibitions – even terror – and yet attraction to such subjects and confines his discussion of a handful of Cézanne's depictions of the female nude solely to formal matters.

With this, Fry's study tails off and, as before, testifies to his fundamental indifference to the artist's choice of subject-matter – one which has been redressed by many more recent critics, although not always convincingly. Inevitably reflecting its pioneering status, Fry's study also fails to embrace in detail matters of chronology, pictorial sources or the relationship between paintings and works on paper. When he does broach these, however, he is invariably astute, suggesting that an early Cézanne landscape (R184) resembles a Pissarro without realising that it is actually a copy of one, and comparing the early *Lazarus* with Tintoretto or El Greco, unaware that it derived from a painting by their near-contemporary, Sebastiano del Piombo.

When Fry was writing, such fine points all lay in the future, awaiting later scholars, cataloguers and compilers. But what did not await them was the challenge of providing an illuminating introduction to the range, depth and magnitude of Cézanne's achievement. That Fry had already done in his now classic study, which explores and elucidates the master's art with a clarity and penetration that have continued to set a standard for all later studies of the artist – and with a humility worthy of Cézanne himself, who remains unfathomable to Fry from the start to the finish of his book and who he was later to proclaim with reverence and awe as 'the purest artist that has ever been'.[21] 'To describe Cézanne's works', he confesses at the beginning, 'I find myself, like a medieval mystic before the divine reality, reduced to negative terms. I have first to say what it is not'. And in his concluding sentence he admits of his hero, 'in the last resort we cannot in the least explain why the smallest product of his hand arouses the impression of being a revelation of the highest importance, or what exactly it is that gives it its grave authority'.

Nikolaus Pevsner photographed in the garden of his home in Birmingham, 1936.

Nikolaus Pevsner

Pioneers of the Modern Movement
from William Morris to Walter Gropius, 1936

COLIN AMERY

NIKOLAUS PEVSNER, who was born in Leipzig, Saxony, came from a family of *haute bourgeoisie* Jewish merchants of Russian origin. Pevsner himself renounced his Jewish roots and became at the age of nineteen a convert to Evangelical Lutheranism. His academic training was carried out at the universities of Leipzig, Munich (under Heinrich Wölfflin) and Berlin (under Adolph Goldschmidt), and in Frankfurt am Main, where he studied with Rudolf Kautzsch. For his doctorate he returned to Leipzig to be supervised by the influential Wilhelm Pinder and wrote his thesis, *Leipziger Barock, Die Baukunst der Barockzeit in Leipzig* (*Baroque Merchant Houses of Leipzig*), published in Dresden in 1928; in the previous year he had published a study of Italian Mannerist and Baroque painting, *Die italienische Malerei vom Ende der Renaissance bis zum ausgehenden Rokoko*. From 1925 to 1928 he was an unpaid assistant keeper in the Gemäldegalerie in Dresden and then took up a post in 1928 as a lecturer in the history of art and architecture at the University of Göttingen. It was here that he became particularly interested in English art, design and architecture and in 1930, like Karl Friedrich Schinkel before him, he travelled extensively in England to learn by observation on the ground. This relatively unusual specialisation was encouraged by Professor Hans Hecht at Göttingen's English Department, who sent Pevsner to collect material in England for a course of lectures on English art.

Pevsner's academic career in Göttingen came to an end with the rise of the Nazis, and he left Germany to settle in England in 1933. He had a network of academic friends and many Quaker contacts, and with their help he secured a research

post at the University of Birmingham in the Department of Commerce. In 1935 he was also a fabric buyer and in charge of quality control for Gordon Russell Ltd., the pioneering firm of furnishers and designers. His work for Russell is not particularly well recorded but he would have had considerable contact with the Royal College of Art, London, which also influenced his thinking about art and industry and the rise of the modern movement. At the same time, his enforced exile in England gave him the opportunity to study the practical aspects of industrial design and to relate his great admiration for William Morris to the sociology of art.[1]

Pevsner's preparatory work for *Pioneers of the Modern Movement from William Morris to Walter Gropius* was carried out in Germany before he left to live in England, and his tracing of the evolution of twentieth-century architecture through a variety of sources naturally culminated in the Bauhaus with Walter Gropius and his colleagues. He firmly believed that they were the heirs of Morris, the Arts and Crafts Movement, Art Nouveau and of Victorian engineering. While he was writing and researching *Pioneers* he was also working on his book *Academies of Art, Past and Present* (finished in its first German version before he left Germany)[2] and his research in Birmingham led to the publication in 1937 of his *An Enquiry into Industrial Art in England*, which attempted to introduce the philosophy behind the Bauhaus to the English manufacturing industry and promote ideas of functionalism, technological competence and truth to materials.[3]

In these works contemporary with *Pioneers*, Pevsner formulated his deep interest in art as a social activity and aired his worry that the artists and architects of his own time had become too much divorced from their public. In an earlier article Pevsner had categorised Le Corbusier as an architect and artist whose paramount aims were aesthetic and whose architecture displayed no interest in the functional and social aspects of building, an attitude redolent of art for art's sake.[4] This was completely contrary to Pevsner's emerging thinking about the origins of modern architecture and his wish to promote the non-individualistic collegiate approach of the Bauhaus that was producing housing and industrial architecture for the wider community.

Pevsner's concept of a 'modern movement' took shape from 1931 onwards, enabling him to arrive at the basic idea behind *Pioneers*. This derived from an art historian's concern to establish a provenance of ancestors for modern architecture and design. At the time of its publication, and subsequently, the book was received by scholars and architects as the 'gospel' of modernism. It achieved that extraordinary status simply by looking back at the pedigree of Walter Gropius and the International Style. By linking the Bauhaus to the Deutscher Werkbund, to the

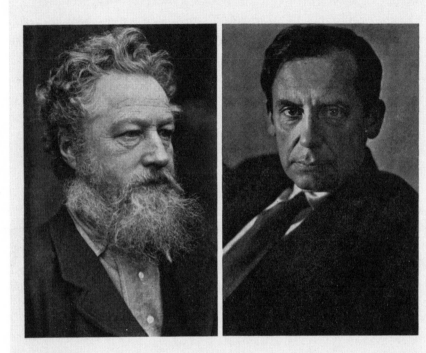

PIONEERS OF THE
MODERN MOVEMENT

FROM WILLIAM MORRIS
TO WALTER GROPIUS

BY NIKOLAUS PEVSNER

LONDON: FABER & FABER

Title-page to Nikolaus Pevsner, *Pioneers of the Modern Movement
from William Morris to Walter Gropius*, 1936.

writings of Hermann Muthesius (author of *Das Englische Haus*, 1904) and to the work of Morris and the Arts and Crafts Movement, Pevsner became responsible for legitimising the modern movement and providing it with a basis of historical authenticity. At the same time, as Robin Middleton suggested in his obituary of Pevsner in *The Burlington Magazine*, the book was also 'a piece of propaganda [. . .] for the establishment, in particular, of the modern movement in England'.[5] There have been several editions of the book (and various translations).[6] Its first publisher, Faber & Faber, was then a young firm and itself keen to be seen as pioneering.[7] Richard de la Mare, a director at Faber, played a significant role in the book's inception and appreciated the value of this émigré author's entirely new approach to architectural history. The second edition was published in 1949, twelve years after the original, by the Museum of Modern Art in New York under the new title *Pioneers of Modern Design*. Pevsner's modifications were minor, but the book was far more richly illustrated and Alfred H. Barr and Philip Johnson, among others, are thanked in his foreword. The third edition, with many small corrections, appeared in 1960 as a Pelican Book; and in 2005 Yale University Press produced a lavishly illustrated fourth edition with an introduction and commentary by Richard Weston. The continuing significance of the book is not in doubt: it remains on the syllabus and is still widely read more than six decades since it first appeared. But its authority and status have been questioned. While Pevsner's extraordinary achievement in producing the *Buildings of England* series is universally acknowledged, the lasting reputation of his *Pioneers* is more fragile.

Pevsner wrote (p.42) that the aim of his book was

> [. . .] to point out that the new style, the genuine and adequate style of our century, was achieved by 1914. Morris had started the movement by reviving handicraft as an art worthy of the best men's efforts, the pioneers by about 1900 had gone further by discovering the immense, untried possibilities of machine art. The synthesis, in creation as well as in theory, is the work of Walter Gropius (born in 1883) [. . .]. At the end of 1914, he began preparing his plans for the reorganization of the Weimar Art School, of which he had been elected principal by the Grand Duke of Saxe-Weimar. The opening of the new school, combining an academy of art and a school of arts and crafts, took place in 1919. Its name was Staatliches Bauhaus, and it was to become for more than a decade, a paramount centre of creative energy in Europe [. . .] It comprised, in an admirable community spirit, architects, master craftsmen, abstract painters, all working for a new spirit in building. Building to Gropius is a term of wide import. All art, as long as it is sound and healthy, serves building.

This paragraph tells us much about Pevsner's thinking, why his approach to architectural history became controversial and why in many ways he has become a problematic figure for many British architectural historians. The paragraph contains his mission statement: Pevsner apparently wanted an end to individualism and independent artistic creativity; architecture had to conform to the *Zeitgeist*, or 'spirit of the age', and to demonstrate rationality and unity within the social system. His reiteration of Wilhelm Pinder's theory of *Zeitgeist* dominates the book, alongside a firm belief that art and architecture reflect national character. The 'spirit of the age' was held to influence every aspect of life in a given period of time and to produce similar ideas, behaviour and forms.[8] This theory allowed Pevsner to make generalisations about people and places and to indulge in a colloquial expression of national characteristics. Pinder's susceptibility to an instinctive understanding of art also carried him along with contemporary political ideas in Germany, and he became increasingly focused on the superiority of German art and the German *Volk*. Pevsner, too, was not unenthusiastic about the reordering of the German state under the Nazis. In *Pioneers* his language can sound ominously like that of a dictator:

> [. . .] the artist who is representative of this century of ours must needs be cold, as he stands for a century cold as steel and glass, a century the precision of which leaves less space for self-expression than did any period before.
>
> However the great creative brain will find its own way even in times of overpowering collective energy, even with the medium of this new style of the twentieth century which, because it is a genuine style as opposed to a passing fashion, is totalitarian (p.206).

When the book was republished in 1949, either Pevsner or an editor toned down some of the more extreme phraseology, and his pro-Nazi sympathies from the early 1930s never surfaced after he was exiled to Britain. Like many German intellectuals he wanted to rescue his country from chaos, but in Britain he was politically discreet.

Some of the views expressed in *Pioneers* are surprisingly ill informed. Pevsner's attack on Impressionism is highly simplistic; he generalises painfully about the Reformation; and he never fails to be judgmental. Comparing in the second chapter (p.60) a shawl from the Great Exhibition of 1851 with Morris's *Honeysuckle* textile design, he does not hesitate to judge: 'It is a thoughtless concoction of ornament and realism as opposed to Morris's logical unity of composition.' His

Interior spread discussing Victor Horta and Art Nouveau. From Nikolaus Pevsner,
Pioneers of the Modern Movement from William Morris to Walter Gropius, 1936.

chapter entitled 'Eighteen Ninety in Painting', dealing with Post-Impressionism
and Symbolism, reads now as a peculiar attempt to summarise the quali-
ties that distinguish the artists of the 1890s from their predecessors. He also
attempts to justify his views on the period's painting by trying to 'find an echo
in contemporary architecture and decoration'. Beyond praising Cézanne,
Gauguin and Rousseau for their preference for the 'unbroken flat surface'
and Hodler, Munch and Toorop for their 'rhythmically drawn outline',
Pevsner seems at a loss to relate art to architecture and is, in fact, oddly disap-
pointed that artists do not fit into his theoretical framework by leading the way
into a new aesthetic spirit of the age.

The chapter on Art Nouveau must have seemed original when it was written,
particularly in its analysis of the style as a link between historicism and the
modern movement, but Pevsner's contention that the development of such
an extreme style 'cleared the way for the coming development' is now seen as
a curious argument. While pointing out the qualities of the work of Van der
Velde, Horta and Mackmurdo, it is almost as though they were necessary as an
emetic to provoke a purge before the arrival of Gropius and the clarity of undec-
orated architecture.

When Pevsner comes to examine the role of engineers in the development of the modern movement he is on safer ground, and his enthusiasm for structural honesty and directness is satisfied by the work of the great nineteenth-century railway engineers and their use of iron and steel. His writing about engineering is much more confident and the reader can sense the author's strong convictions. Engineers fit his arguments more easily than artists. Writing about Brunel's Clifton suspension bridge in Bristol he becomes positively lyrical: 'the soul of iron is laid bare; all future possibilities of modern architecture are revealed. This is building without weight [. . .] Pure functional energy swings out in a glorious curve across a deep valley' (p.123). Carried away by his enthusiasm, Pevsner compares Telford and Brunel to the builders of the cathedrals of Amiens, Beauvais and Cologne. But he also admires the anonymity of these medieval buildings, seeing them as products of enlightened guilds of thoughtful individuals, building together for a greater purpose. He likes the fact that engineers are not as well known as architects and blames the romantic conception of the artist for the glorification of the genius of individual architects. But the chapter on engineers really does stand the test of time in its highlighting of the early skyscrapers and the development of cast-iron technology. It is almost as though he is relieved not to have to make any subjective aesthetic judgments. Reluctantly, he returns at the end of this chapter to the *Zeitgeist* in a realisation that the engineers of the nineteenth century had been 'too absorbed in their thrilling discoveries to notice the social discontent accumulating around them, and to listen to Morris's warning voice. Owing to this antagonism, the two most important tendencies in nineteenth-century art and architecture could not join forces. The Arts and Crafts kept their retrospective attitude, the engineers their indifference to art as such' (p.137).

The last two chapters of *Pioneers* look at what Pevsner calls the 'Modern Movement'. Voysey and Mackintosh are the only two British architects whom he is willing to discuss in any detail. He is almost sentimental in his enjoyment of the simple *joie de vivre* he finds in Voysey's textile and furniture designs. He sees a Europe weary of the licence of Art Nouveau and welcomes the elegance and simplicity of designers such as Ernest Gimson and Ambrose Heal. Despite his enthusiasm for Morris it is these newer designers that thrill the puritan Pevsner because the 'close atmosphere of medievalism has vanished. Living among such objects we breathe a healthier air' (p.149). As he looks at the later houses of Voysey and Baillie Scott, we sense Pevsner the architectural writer at his best. He is at his most illuminating when he writes as an observer giving opinions rather than

when he writes as a theorist. In these later chapters we have a premonition of the Pevsner who was to open the eyes of a whole country to its architecture in *The Buildings of England*.

When Pevsner turns to the work of Charles Rennie Mackintosh in Glasgow, one senses his relief that he can at last justifiably link British design to Continental Europe and the spirit of Art Nouveau. In his examination of the Glasgow School of Art, he takes obvious pleasure in being able to write without compunction: 'Not a single feature here is derived from period styles' (p.158). Of course his enthusiasm for Mackintosh undermines his earlier conviction that architecture should not express personality or be art for art's sake. Intellectual consistency has been temporarily shelved. Pevsner admits that Mackintosh's work is of a strongly personal nature, but as he is writing a kind of *post hoc* account of the route to the Bauhaus, he is happy to praise Mackintosh. His enthusiasm is for his spatial genius ('the transparency of pure space') and for the fact that he clearly leads us into the twentieth century. He compares Mackintosh with Le Corbusier and applauds the fact that both of them aspire to create poetry. Not content with comparing him favourably with Le Corbusier, he goes on to write that building in his hands is comparable to the genius of Borromini, Guarini and Neumann (p.160), comparisons which make one question his earlier stress on the *Zeitgeist*.

In his sweep through the world to establish the foundations of the modern movement, Pevsner ends *Pioneers* with a dismissal of work from most countries c.1900 except for Germany. Le Corbusier, who is little studied in the book, is seen as a man making his own myth and too fond of personal showmanship. Pevsner is kinder to Frank Lloyd Wright, praising him because no one else (not even Adolf Loos) had by 1900 come so near to 'the style of today'. Peter Behrens and Hans Poelzig in Germany and Loos, Josef Hoffmann and Joseph Maria Olbrich in Austria are singled out for their contributions but they are not enough for Pevsner's survey: 'the art historian has to watch national as well as personal qualities. Only the interaction of these with the spirit of the age produces a complete picture of the art of any epoch' (p.188). Pevsner then moves on to Gropius, whose work he sees as fulfilling all the requirements of a modern style for the twentieth century. He is lyrical about the success of Gropius's planning and the fact that calculation and vision work together to produce cathedrals of modernism. Admiring the fact that this achievement leaves less space for self-expression, he simultaneously recommends many of Gropius's buildings in Germany for being 'triumphant over matter'.

In his preface to the third edition of *Pioneers*, published in 1960, Pevsner writes that the growth of research into the birth of modernism since his book's

first publication had not shaken the foundations of his original thesis. He felt that only two additional architects needed to be examined to elevate them from the footnotes: Antonio Sant'Elia and Antoni Gaudí. Even so, he saw them both as freaks and their buildings as 'fantastical rantings'. They were forerunners of the 'fantasts and freaks' of the 1950s who wished to question 'the validity of the style [. . .] to whose prehistory' *Pioneers* was dedicated.

It is difficult to read Pevsner's book today without an awareness of the intensely personal criticism of him by one of his pupils. David Watkin's *Morality and Architecture: The Development of a Theme in Architectural History and Theory from the Gothic Revival to the Modern Movement* (1977) is an attack on the role of moralising in architectural criticism from Pugin to Pevsner. Watkin writes with an animus against Pevsner and the very idea of delineating a coherent *Zeitgeist* in any historical period. When Watkin was writing it was fashionable to place all the blame for much bad contemporary architecture at the feet of the man who, forty years earlier, had attempted with great success to predict the future of modernism. But there was so much more to Pevsner. He was the formidably erudite and energetic recorder of the entire architectural heritage of England; he was Chairman of the Victorian Society, where he was active in securing changes in the procedures for listing buildings; and during his editorship in the War years of the *Architectural Review* he pioneered an appreciation of the Picturesque movement and its effect on the English landscape and its application to 'townscape', bringing the aesthetics of landscape gardening into urban planning. The theories of romantic gardening and hard line modernism do not sit easily together and Pevsner had no wish to discuss this interesting paradox in his thinking.[9] As his long career developed he was both a hands-on architectural critic and a historian, but remained a robust defender of his approach to the principles of functionalism and rationalism in architecture. Our understanding of his early views may be enhanced by knowledge of the work of his many pupils; Reyner Banham's *Theory and Design in the First Machine Age* (1960), for example, is a useful revisionist counterpoint to Pevsner's *Pioneers* and brings in the Expressionists and the Futurists to broaden the Pevsnerian view. But pluralism for Pevsner could never represent progress. *Sachlichkeit* remained for him the authentic style for the twentieth century, and to a large extent we still live with the results of his thinking as first propounded in *Pioneers of the Modern Movement*.

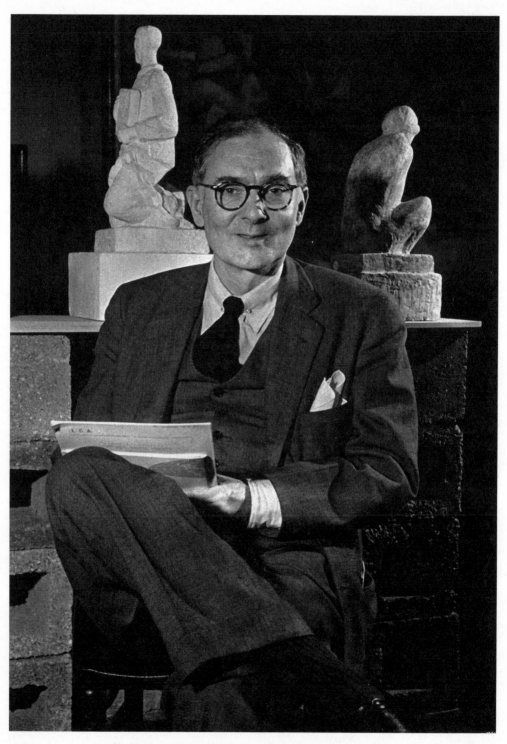

Alfred H. Barr, Jr. photographed for an article in *Life* magazine, 1948.

Alfred H. Barr, Jr.

Matisse: His Art and His Public, 1951

JOHN ELDERFIELD

WHEN ALFRED H. BARR, JR. was appointed founding director of the Museum of Modern Art, New York, in 1929, he abandoned his Harvard dissertation, 'The Machine in Modern Art'. After being fired from that job in 1943 he changed the topic of his thesis and, three years later, Harvard accepted his book *Picasso: Fifty Years of His Art* as the first doctorate on a living artist to be researched and written in the United States.

Although deeply influential, the Museum's publications had traditionally been expanded exhibition catalogues, of which Benedict Nicolson fairly observed: 'The narrative jumps abruptly from picture to picture, as though the reader were being conducted by an expert guide around the exhibition and had to make do with whatever happened to get hung on the walls.'[1] Barr's Picasso book was more than this, yet its 314 pages still bore signs of having begun as the 207-page catalogue of the Museum of Modern Art's 1939 exhibition *Picasso: Forty Years of His Art*. This was apparently to become a pattern, for Barr next began work 'with the modest intention of revising and bringing up to date the catalog of the Matisse exhibition held at the Museum of Modern Art in 1931'.[2] But that sixty-one-page catalogue grew into a nearly six-hundred-page book. Picasso apparently was annoyed at how small it made his monograph seem. He meant, in size; in fact, the Matisse book made preceding studies of any modern artist seem smaller also in ambition and authority. 'This book is a paragon', wrote the then-anonymous *Times Literary Supplement* reviewer John Richardson, 'and quite the best monograph on a modern painter which has yet been published.'[3] It may still be.

Publications on Matisse began on 25th April 1896, when Roger Marx singled out the twenty-six-year-old student of Gustave Moreau for favourable mention in a review of that year's Salon du Champs-de-Mars. But not until 1920, when Matisse was fifty and very famous, did the first monograph appear, a short study by his long-time friend and patron Marcel Sembat. The delay itself is not so worthy of comment: young artists were not then receiving mid-career retrospectives with lavish publications; even Picasso had to wait until 1921 for his first book, by Maurice Raynal. Nor should the timing be a surprise: if the First World War had inhibited art publishing in France, the years that followed saw it expand to the task of anointing national cultural achievement. What is pertinent to Matisse's critical reputation is that growth of the monographic literature on this perhaps greatest modernist painter coincided with his forsaking where his radicalism had carried him. For, while the heroic period of early modernism closed for everybody at the end of the First World War – for Picasso and his followers as well as for Matisse and his – the change in Matisse's art became its most public face.

Matisse argued, with backing first from Sembat, that he had reshaped rather than abandoned his modernism; yet his paintings of the early 1920s were not only condemned by avant-garde members of the artistic community, but also welcomed by the more traditional. And the embrace was worse than the rebuff. Matisse's work had long been disparaged by establishment critics – often as ugly because incompetent, or affectedly ugly from a desire to shock – but now they loved what he was doing, and the avant-garde disliked it, because it was beautiful. Description of Matisse's critical vicissitudes was to be among the novelties of Barr's book, yet he knew that the great septuagenarian and his family would scrutinise his text; a clearer grasp of this particular subject now requires consulting Catherine Bock-Weiss's indispensable *Henri Matisse: A Guide to Research* of 1996[4] and Jack Flam's well-chosen anthology of critical writings.[5] Both authors agree that Matisse's own early statements affirming the clarity and composure of his art contributed to his critical diminishment, especially the famous remark in 'Notes d'un peintre' of 1908: 'What I dream of is an art of balance, of purity and serenity, devoid of troubling or depressing subject matter [. . .] a soothing, calming influence on the mind, something like a good armchair that provides relaxation from physical fatigue.'[6]

The problems had begun before the First World War, when some in Picasso's circle, André Salmon notably, sought to ingratiate themselves with him by attacking Matisse as a modiste decorator. Picasso would have none of it, especially as Matisse's paintings equalled his in austerity during the War years. However, the grandest of these had never been shown in public. Therefore, in 1926, as he began

to set aside his post-War détente, Matisse made a bold gesture: having broken with his long-time dealer Bernheim-Jeune, he exhibited three unseen paintings at Paul Guillaume's gallery – *Branch of lilacs* and the magisterial *The piano lesson* and *Bathers by a river* – as if to declare his avant-garde pedigree. Unfortunately, this move proved insufficient to counter the talk of hedonistic beauty, especially when he failed to pay proper attention to the laudatory yet dismal picture books 'with perfunctory prefaces and haphazard illustrations',[7] as Barr would describe them, which multiplied around the artist's sixtieth birthday. Matters came to a head in 1931, when – revitalised by work on his *Dance* mural for the Barnes Foundation – Matisse discovered too late that he had neglected the preparations for his massive retrospective exhibition at the Galerie Georges Petit – owned by the Bernheims, whose unsold stock of paintings from the early 1920s overloaded the show. It was at this low moment that the twenty-nine-year-old director of the new Museum of Modern Art appeared, and, before the year was out, reshaped what he saw into the smaller, much more rigorous first one-person exhibition of any artist at the Museum.

Barr was not alone in seeing through the popular lightweight view of Matisse that settled into place after the Georges Petit show. For example, Roger Fry's influential article of 1930, which Barr knew, joined Cézanne's name to Matisse's – rather than Picasso's, as was becoming commonplace – and observed that the artist was returning to the premises of his 'stark, structural' work of 1910–17.[8] Barr's 1931 catalogue – and his book twenty years later – agreed that Matisse's masterpieces came between 1905 and 1917, and revealed his own attachment to the starkest and most structural, those of 1913–17. Despite the 1926 Paul Guillaume display and the warm response to Barr's 1931 exhibition, this weighting of value across the artist's career was a minority opinion. It increasingly became so in France, as memory faded of the great paintings seen there only briefly, if directly at all, and now in the museums and private collections of Germany, Scandinavia, Russia and the United States – and, conversely, as illustrations proliferated of 'graceful young women reclining on *chaises longues*' in paintings that may have once seemed audacious but had come to seem as tame and pretty as their subjects. Nicolson, from whose review of Barr's book I quote, wished that its author had allowed himself more than brief and guarded criticism of such works. Since, even as late as 1987, Norman Bryson was complaining of Matisse being a mere 'decorator and hedonist', he may have been right.[9] However, Barr's weightings are pretty obvious, and acknowledgment of the opposite sides of Matisse's art was critical to his project.

Matisse, in Barr's 1931 reading, developed in cycles, from a Chardin-influenced, orderly monochrome of 1895 into a higher-keyed, Impressionist palette and more unruly designs, then back to ochre, sienna and structure around 1900, when the whole cycle repeated, returning with Fauvism to bright colour and informal layouts. In 1913 orderliness and a darker palette reappeared, again to give way, by 1918, to lighter tones and Impressionist influence, until signs of a return to structural sobriety appeared in the mid-1920s. This was all a bit forced, and even as ameliorated in 1951, it divided Matisse's *œuvre* into too many watertight compartments: for example, Pointillism (1898–99), the proto-Fauve period (1899–1901), the dark period (1901–04), Neo-Impressionism (1904–05) and Fauvism (1906–07). 'Do these "periods" accord with the facts?' Richardson asked, and correctly replied: 'The answer is no.'[10]

Barr's desire to over-clarify did obfuscate at times, and his wish to counter the popular, light Matisse by emphasising his favoured austere artist created an implausible early dark period and disconnected the paintings of the First World War from his preceding as well as, more reasonably, his succeeding production. Nonetheless, Barr's inaugural reading of Matisse, which survived twenty years later, of an artist pulled to the structural, abstract and decorative on the one hand, and the perceptual, realist and Impressionist on the other, was not only sound but also offered a good, pragmatic way of recasting and contextualising the observations, widely publicised in the later 1920s, that there were two different Matisses, modern and traditional. However, where most writers saw discontinuity between the two, Barr was interested in how one artist called Matisse could grow and gain through antithesis. Whether there are one or two Matisses is a question that continues to vex the study of the artist.

Although Matisse more or less disappeared from Barr's radar screen for the remainder of the 1930s, his interest in theorising artistic development in a broadly dialectical manner did not, producing the renowned 1936–37 exhibitions *Cubism and Abstract Art* and *Fantastic Art, Dada, Surrealism*. The now wearily over-examined genealogical chart he devised for the catalogue cover of the former makes him seem as neo-Darwinian as any palaeontologist of that period. However, still disentangling its knotted lines as Europe closed down in conflict, he seems finally to have realised that theoretical mapping had to be accompanied, indeed directed, by inductive study.

The maturity of art history in the United States after the First World War had been aided, as Erwin Panofsky pointed out in a famous study of this subject, by its cultural and geographical distance from Europe, which took the place of historical

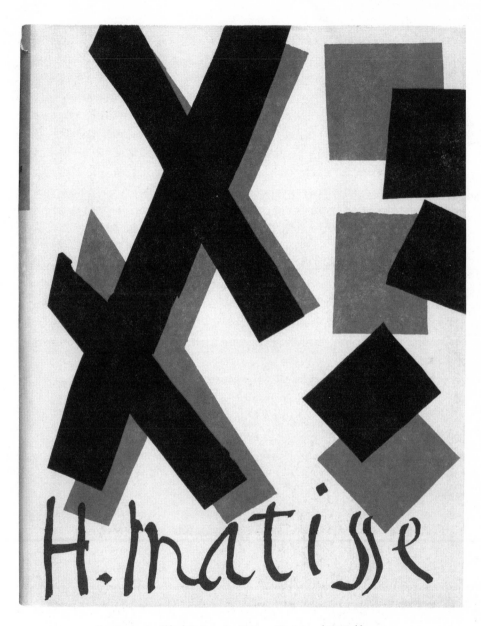

Front cover to Alfred H. Barr, Jr., *Matisse: His Art and His Public*, 1951.

distance.[11] This fostered objective discussion of European art unhampered by national rivalries and, in the case of modern art, stylistic allegiances. Barr's highly schematic 1931 understanding of Matisse was made possible by the objectivity of distance. Returning to Matisse, he sought to maintain it, even while bridging that distance for the objectivity of first-hand information necessary to inductive study. It is no coincidence that his new campaign began in 1945, with the end of the Second World War in Europe, or that it accompanied a broad return to European subjects in academic art history in the United States after a retreat to concentrate on American art during the period of the War. Thus, as Barr was working on his book, there were in progress three doctoral dissertations on Cubism and one on Matisse. The Matisse dissertation, completed by Frank Trapp in 1952,[12] was overwhelmed, even as it was being written, by the appearance of Barr's monograph. How Trapp must have felt on first seeing it hardly bears imagining. Far more than any previous publication, Barr's book on Matisse brought the big guns of North American institutional scholarship – with its special access to artists, archives, galleries, collectors and teams of researchers – to bear on a modern subject for the first time, to a deeply unsettling effect that continues to reverberate more than half a century later.

Barr largely dictated his book. (The Museum of Modern Art's archives have the 'Audiograph Electronic Soundwriter' records, but warn us: 'Machine on which to play these NOT available'.) This is, perhaps, why it comprises so many compartments – I count almost 350 separate units of text – which seem not to have been written in sequence. However, all are clearly labelled in the seven-page contents and organised in a logical, hierarchical manner: collected into sections, each devoted to a period of Matisse's life, art or critical reputation, which are themselves arrayed within nine big, chronologically sequential parts. Pages of documentary photographs and three sets of seven-colour plates with analyses appear within the text. Following it are some four hundred monochrome plates (half of works up to and including 1916), endnotes, ten documentary appendices, the first substantial bibliography on Matisse (by Bernard Karpel), and notes on the shortcomings of some illustrations ('lines between tiles are too black', 'sky too blue', and so on). This may all sound exhausting, but the book is actually a charm to use.

It now seems incredible that, before Barr, major paintings like *Luxe, calme, et volupté* and *Conversation* were unknown, most of the illustrated books were undiscussed, the work in the decorative arts neglected and fully half of the sculptures unpublished – even the critical *Back* and *Jeanette* series only incompletely

and ineptly. Moreover, the great compositions then locked away in Moscow and Merion remained virtually unexamined, as more easily accessible but much less significant works were illustrated time and again. And even the most rudimentary archival research had not been attempted. As Barr rightly said: 'Even if one brought together the thirty books already published on Matisse one could not get a complete or well-proportioned view of his work as a whole.'

Barr's key achievements were threefold. First, he presented in one place Matisse as artist and man and his critical reception, across almost his entire career. Second, in doing so, he uncovered previously unknown pieces in the story of the whole – aggregating vast amounts of unrecorded, obscure or uncorrelated documentation as well as works of art and entire bodies of work that had been neglected, even that had unaccountably vanished – and compounded the pieces with extraordinary judiciousness and good sense. Third, he effected the necessary remedial task of illuminating the fundamental areas of confusion and ignorance about Matisse's life and work, while providing an often month-by-month documented chronology of both. He thus moved the literature on Matisse from criticism to art history – and elevated it there above any previous study of any modern artist.

The book was widely reviewed in an overwhelmingly positive way. Those accustomed or expecting to read art criticism, not art history, found it forbidding, and there were complaints of its impersonality, even monotony, and its stress on descriptive fact over analysis. On the other hand, Nicolson's review from London intrepidly asserted: 'It is characteristic of the best recent American writing on modern art that it hesitates to go beyond documentation. This is a reaction against the distressing situation in Europe where the wildest statements, based on no historical evidence, are allowed to go unchallenged, because, in Europe, modern art is not normally treated as an academic study and everyone claims the right to give vent to his personal feelings.'[13] Strong stuff, yet he proved the point in his own, increasingly far-fetched digression on Matisse and Gide before applauding Barr's 'refusal to be lured into the speculation in which I have been indulging'. In fact, Barr did indulge in speculation, as his descriptions branch into judgments, analyses and interpretations. Only, these branches are grafted to the stock of facts that allow the book to be used as an encyclopaedia.

Specialists as well as generalists praised the book for its orderliness, completeness and virtual freedom from error. Barr, however, had insisted that it was 'far from definitive. Its scholarship is only partially controlled and is therefore tentative; unquestionably much new material will eventually come to light[. . .]'.

Alfred H. Barr, Jr., Philip Johnson and Margaret Scolari Barr photographed in Cortona, 1932.

There was, indeed, a good scatter of minor slips and omissions (Richardson's review caught some), and Barr was right; new material does continue to appear. But no author can be faulted for that, or for his book not covering the three years that its subject had yet to live. The sheer authority of his book has proved misleading in a few critical areas where Barr misread, or was misled by, his evidence, requiring from later scholars (including the present writer) some unnecessary mental gymnastics to accommodate facts that turned out to be wrong. Perhaps the most vexing of these was Barr's proud publication of two letters of 1909 and 1912 from Shchukin to Matisse on his commissions for *Dance* and *Music*, of which Pierre Matisse had provided photographs. Unfortunately, someone switched the second sides of the two letters, and it was not until 1983 that Beverly Kean set matters straight.

Rereading the book and perusing its reviews reinforces how novel was the weight afforded to documentation extremely imminent to the creation and creator of the works of art under examination. This had recently become a point of principle for Barr; in November 1941, he published a prominent defence of it to open the first issue of the College Art Association of America's *College Art*

Journal. 'It is our century', he proclaimed, 'we have made it and we've got to study it, understand it, get some joy out of it, *master* it [. . .] And what opportunities are being lost! Graduate students can't correspond with [. . .] van Eyck, Masolino or Vasari to clear up scholarly problems but they can air-mail Maillol or Siqueiros and write or phone for an appointment with Wright, André Breton (and so on)'.[14] One demurring respondent thought that this would produce 'documentation of a dubious sort'; another that a documented history is much easier to produce after artists are dead, since they will not change their minds or talk back.[15]

Setting such objections aside, Barr launched his Matisse project with a sequence of detailed questionnaires, transmitted to the artist through his son Pierre, others through his wife and daughter, and yet others through the art historian John Rewald, through one of Barr's assistants, that assistant's mother and so on. (Barr's own command of the French language was poor.) The results are soberly recorded in his book's endnotes; however, inspection of the completed questionnaires themselves and their related correspondence in the Museum of Modern Art's archives reveals a process far less orderly and, on occasion, highly contingent. It increasingly became clear that Matisse and his family disliked the very specific questions coming across the Atlantic; they were unaccustomed to being grilled and were to remain far more comfortable with critical than with art-historical commentators. (It is no accident that the biggest book on Matisse is now the more than 750-page volume by Pierre Schneider (1984), who explicitly states that history is a 'latent menace [. . .] that will constantly have to be warded off'.)[16] While Barr generally drew sound conclusions from the questionnaires, at times he was whistling in the dark. One reviewer alone picked up on this, and given what he was up to in the early 1950s, it is intriguing that his name was Anthony Blunt.

Blunt's review, in the December 1953 issue of *The Burlington Magazine*,[17] began adamantly: 'Mr Barr's book is a warning to all art historians on the value of contemporary evidence and on the difficulty over settling the chronology of an artist's work. Reading Mr Barr makes us more indulgent towards the incompleteness and unreliability of Vasari.' The review softened, yet held fast to an otherwise unmentioned problem: memories are fallible. Matisse could not remember when many paintings were made. He, his family and friends regularly disagreed about the date of events they had witnessed. Hence, 'even with the closest collaboration and the best scholarship, errors of up to five or six years are liable to creep in'. In 'the crucial and difficult period 1911–16', the dates of less than twenty-five works can reliably be verified by external facts. The historian is, therefore, thrown

back upon stylistic evidence, which caused Blunt to wonder whether at times 'the chronology proposed by Mr. Barr has not in some way gone wrong'. Some paintings seem to 'jump' in Barr's sequences, that is to say, 'seem to bear no relation to their immediate neighbours in time'.

This is a reasonable argument, yet it depends upon our sharing Blunt's conviction of the futility of asking pointed questions and his insistence that proposed inconsistencies of action have to be mistakes. (And we now know, of course, that he was writing after interrogation by MI5 about the defection of Guy Burgess and Donald MacLean in the very year that the book he was reviewing appeared.) But evidence of Matisse's intransigence under questioning and the overall orderliness that Barr nevertheless created may well have led him along these paths. Barr's Matisse does seem as precise and reasonable as Barr himself was, and it has been one of the tasks of later scholars to uncover the greater extent to which Matisse's method allowed him to be inconsistent, to be not always a paragon of bourgeois respectability, to make big inductive leaps into the unknown, to be dark in spirit while light in his painting, to be distrustful of certainty and keep on taking different routes to get to the same place. Still, even though Barr's book became, in this respect, a hurdle to be surmounted by new generations of scholars, by that same count it became the yardstick against which everything would be measured. It remains a great historical monument, as inseparable from our idea of Matisse – even if that idea is no longer Barr's idea – as Coleridge's *Lectures* are inseparable from our idea of Shakespeare.

Barr's book raised the standards of Matisse scholarship, enlarged expectations of careful scrutiny of his art and its sources and created an appetite for yet more information and analysis. As a result, even the least ambitious of the succeeding publications, if meritorious, were greedily welcomed, while even the finest of them seemed anticlimactic. Clearly, Barr's big book was taking time to assimilate. What finally re-energised Matisse studies, it is broadly accepted, were the big retrospectives: the centenary exhibition at the Grand Palais, Paris, in 1970 and the even larger exhibition at the Museum of Modern Art in 1992. Both motivated more specialised publications and exhibitions on individual periods and media within Matisse's work. They encouraged the production of catalogues raisonnés (but not yet for the paintings and drawings), museum collection catalogues, editions of the artist's writings and statements and of some of his correspondence, and at last a reliable biography. And they attracted new generations of scholars who continue to expand our understanding of Matisse, asking questions about (for example) colonialism, feminism, iconography, nationalism, orientalism,

patronage, primitivism and psychoanalysis that Barr could not have imagined asking and Matisse even trying to answer. Meanwhile, Barr's 'formalism' and careful documentation seem newly relevant as studies in Matisse's artistic methodology increase.

Barr's bibliography comprised 218 items; Bock's 1996 bibliography, just one short of 1,400 works. The literature on Matisse must now be about ten times the size it was when Barr started writing. It is, ironically, probably due to rather than despite this huge increase that there has not been any monograph with the same claim of completeness published since Barr's in 1951. Flam's major 1986 publication, *Matisse: The Man and His Art, 1869–1918* may justifiably make that claim for the crucial and difficult period that it covers, and it is to be regretted that its anticipated companion volume was never produced. Of course, it too now requires some revision after more than twenty years, yet anybody coming new to Matisse could do no better than to begin by setting Barr's and Flam's books beside each other on a nearby shelf. Unfortunately, both of them are out of print.

Erwin Panofsky photographed by Emil Bieber, 1932.

Erwin Panofsky

Early Netherlandish Painting:
Its Origins and Character, 1953

SUSIE NASH

ERWIN PANOFSKY'S *Early Netherlandish Painting: Its Origins and Character* has undoubtedly been the most influential study on the art of this period yet written, inexorably shaping everything that came after it, whether subsequent scholars followed its methods and arguments or railed against them.[1] Where Panofsky's work is neither discussed nor cited (a rarity, since there is hardly a publication on the subject after 1953 that does not refer to it), it is still often a discernible influence and remains a stimulus to investigation or rebuttal. Although more nuanced and contextualised models for exploring the complex visual strategies of Netherlandish painters have replaced his much-debated concept of 'disguised symbolism', and a mass of new evidence from technical examination and the investigations of social, economic and cultural historians have made Panofsky's book potentially increasingly less relevant, his astonishingly broad and ambitious synthesis retains remarkable authority and remains a central monument in the historiography of Netherlandish art. Moreover, despite the fact that the book itself has been out of print in English for many years (the last English edition was published in 1977), it has recently enjoyed a revival in continental Europe, having been translated into French in 1992, Spanish in 1998, and into German in 2001, the same year as the first Japanese edition; a very compact one-volume paperback in French was reprinted in 2010.[2] Nearly sixty years after its publication, a consideration of the genesis and impact of this work, aided by the recent publication of Panofsky's vast correspondence, seems opportune, and might help us understand its continued influence and almost hypnotic power.[3]

Early Netherlandish Painting was published when the author was sixty-one years old. It was his longest and most ambitious book, the fruit of many years of teaching and research, a project he referred to by the time of its completion as his opus maius or, more endearingly, as 'my big Flemish book'.[4] When submitted as a 1221-page typescript in 1952 it was so substantial that initially a three-volume format was envisaged.[5] As published in two quarto-sized volumes, it had 496 black and white illustrations (none in colour), 358 pages of texts and another 150 pages of dense notes in two columns. The footnotes are in fact a study in themselves, as important, more so in some cases, as the main text. This seems particularly pointed given that Panofsky's previous book on Dürer, his other great study of northern Renaissance art, had no footnotes at all.[6] In *Early Netherlandish Painting* the notes are frequently like independent essays, often on iconographic themes, some tracing the development of a motif from Classical times to the present day, and could have been 'transferred straight into the columns of such compendia as the *Reallexikon zur Deutschen Kunstgeschichte*';[7] others contain extensive debates on the interpretation of documentary sources, on attribution, or even ground plans and reconstruction drawings.[8] Many of the notes include statements and ideas that are often so trenchant and sometimes so original or quotable ('only a personal communication from Hubert or Jan van Eyck will convince me that the Ghent Altarpiece was planned as it is now'; p.207, note 7) that they have spawned whole articles or set the terms of the debate for decades.[9] The index, compiled by Panofsky himself, is a further gauge of the encyclopaedic mind of the author and the tone and ambition of the book, with entries ranging from Athenaeus to Zola via St Augustine, Beethoven, Bramante, Descartes, Einstein, John Kane, Meleager, Michelangelo, Shakespeare, Steinbeck, Rabelais, Bertrand Russell, Oscar Wilde, Virgil and Watteau, and including one entry listing no less than six different types of perspective, one of Panofsky's favourite themes.[10]

The sheer size and scope of the book, with its vast and learned academic apparatus, have a tendency, however, to imply unimpeachable authority and a sense that the solutions had been found and the work had been done, a danger that Panofsky recognised and regretted. In 1957 he wrote to Léon M.J. Delaissé in response to his review of *Early Netherlandish Painting* that 'nothing could be more disappointing to me than if younger people should take my word as gospel truth. I have done my best to say this many a time; but you are quite right in feeling that the very volume of the darned thing and the artillery of footnotes may give an impression of finality which no reasonable person could

aim at in any field, and least of all a field still so beset with problems as that of Early Netherlandish painting and book illumination'.[11]

Some of the most striking and seductive aspects of Panofsky's book can be related to its genesis as a dazzling series of lectures, given in his role as Charles Eliot Norton Professor of Poetry at Harvard for 1947–48.[12] Panofsky's correspondence reveals how hugely honoured he was by this invitation, declared by Dora Panofsky to be 'the nearest to a Nobel Prize in our field in this country'.[13] The stakes were high: previous holders of the post had included Stravinsky, Robert Frost and T.S. Eliot; the sense of the text as a performance, spoken aloud for a highly educated, American upper-class audience, is probably more overt here than in anything else Panofsky wrote. Quotes from Shakespeare (unattributed), Latin texts (untranslated), allusions to poetry and to music pepper the text. There are frequent examples of rhythmic, crafted alliteration and casual cultural references, sometimes rolled into a single memorable sentence. Memling, for example, is compared to Mendelssohn and devastatingly characterised as 'the very model of a major minor master' (p.347), a formulation borrowed from Gilbert and Sullivan's *Pirates of Penzance*.[14] Artists and pictorial choices are set up in dramatic oppositions, their 'progress' often played out on a 'stage' ('the stage was set for Flemish painting to come into its own'; p.149) and the story is made more eventful by the frequent assertions of 'discoveries' and 'firsts' that rarely stand up to scrutiny but which certainly help the narrative excitement and momentum. Almost all Panofsky's protagonists do something for the first time, be it aerial perspective (the Boucicaut Master), signing their works (Jan van Eyck), single-point perspective (Petrus Christus), creating portraits with views through windows into a landscape (Dieric Bouts), or decisively 'leaving the middle ages behind' (the Master of Flémalle). Equally dramatic, and meaningful for a newly victorious, post-War American audience, are Panofsky's frequent metaphors of conquest, invasion, war and liberation: he talks of the 'emancipation' of figures (p.80), of the 'repatriation' of artists and styles (pp.67, 151), of artists having 'surrendered' to certain influences and 'freeing themselves from the domination' of others (p.351), or being released from 'the fetters of two-dimensionality' (p.16); Flanders and Italy are the 'Great Powers' in European painting (p.20); Jan van Eyck and Rogier van der Weyden have 'weapons' with which they 'achieved their victories' ('forged in Siena and Florence', pp.9, 20), with the metaphor peaking in one extended instance where he describes Germany and France as 'conquered by two or three successive waves of Flemish invasion. They were infiltrated by shock troops trained in the camps of the Flémalle Master and Jan van Eyck, swamped

by a massive army of Rogerians and held by a post-Rogerian occupation force' (p.308). A further appeal to his American audience lay in the nostalgic evocation of the spirit of Manifest Destiny: the Boucicaut Master is a 'pioneer' and 'explorer' (p.60); the de Limbourgs are 'settlers' (p.61), while Quentin Massys, Bernard van Orley and their followers made a 'declaration of independence' from their common past (p.356). Appropriately, in an atmosphere of post-War American positivism, the book closes with a chapter entitled 'The Founders' Heritage'. The narrative of this book, however densely argued and however littered with learned allusions from the full artillery of the humanist scholar, is undeniably rousing, and gives the sense of there being something of the utmost importance at stake.

While the distinctive rhetorical forms of *Early Netherlandish Painting* may derive from its conception as a lecture series, its content and method were the product of years of research and thought. These went back as far as Panofsky's student days in Freiburg where he engaged with the ideas of Heinrich Wölfflin and Alois Riegl under Wilhelm Vöge (to whom the book is dedicated) and Adolph Goldschmidt (who introduced him to the study of illuminated manuscripts).[15] At Hamburg in the 1920s, in a community that included Aby Warburg and the neo-Kantian philosopher Ernst Cassirer, Panofsky lectured on topics such as 'Die Anfänge neuzeitlicher Kunst um 1400' ('The Beginnings of Early Modern Art in 1400'), while developing his ideas on iconology and symbolic form, most notably expressed in his essay 'Die Perspektive als "symbolische Form"' ('Perspective as "Symbolic Form"').[16] This he would reuse almost thirty years later in a revised and edited version as the introductory chapter to *Early Netherlandish Painting*, where it sits rather strangely, an interloper from another moment in Panofsky's intellectual development.[17] Its purpose in part is to set up the conquest of space – what he calls 'the modern problem' – as the principal criterion for defining 'modern' (i.e. Early Netherlandish) painting (p.74). It was an idea that intriguingly mirrored Clement Greenberg's thinking about 'modern' (i.e. twentieth-century) painting, where flatness was an equally 'modern problem'. One wonders how this debate, and the rejection of subject-matter that accompanied it, may have influenced the formulations of Panofsky, the learned humanist and iconographer, who apparently did not appreciate contemporary art.[18]

Whatever his conscious or unconscious reaction to the debates on modern art, it was during Panofsky's years in America, where he settled in the 1930s, that he fully began to develop and explore his ideas about Netherlandish painting, teaching courses at the Institute of Fine Arts, New York University and at the Institute for Advanced Study, Princeton. The thirty-seven-page syllabus and

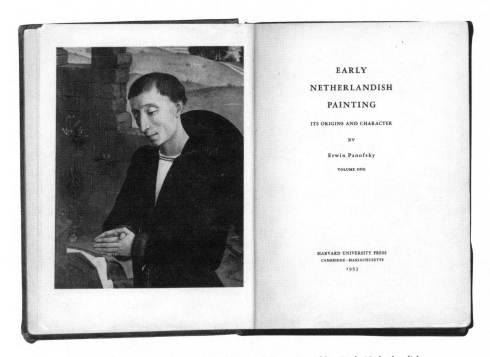

Frontispiece and title-page to Volume One of Erwin Panofsky, *Early Netherlandish Painting: Its Origins and Character*, 1953.

thirty-nine-page bibliography (almost entirely of works in German or French) that he gave out to students taking his 'Early Flemish Painting' course at the Institute of Fine Arts in 1935 follows a very similar structure to the book, and reads like a compressed version of its narrative, but without the chapters on disguised symbolism and the regional schools of the Netherlands.[19] The main research for the latter chapter was undertaken on a trip to Europe in 1936 when he visited The Hague, Leiden, Brussels, Paris and Haarlem, spending much of his time looking at manuscripts in the libraries there.[20] In Princeton in the 1930s and 1940s he had access to the newly developed Index of Christian Art, the brainchild of one of his friends, Henri de Waal, which must have added a new dimension to the way he undertook iconographical investigations. Just as important must have been the presence of Millard Meiss, Charles de Tolnay (who arrived at the Institute from Europe in 1939) and Meyer Schapiro, all of whom were publishing at that time on symbolism in Early Netherlandish painting. It was also in this decade that Panofsky wrote a series of articles that rehearsed his arguments on some key works that were reprised in the book: these included essays on the Ghent Altarpiece,

the Friedsam *Annunciation*, Van Eyck's *Timotheos* and, most famously, the *Arnolfini portrait* (published in 1934), his first publication in English and his first after leaving Adolf Hitler's Germany. Panofsky was still apparently grappling with some of the thorniest problems central to the book as he was about to start his Harvard lectures in October 1947. In that month he wrote to Fritz Saxl: 'I am still not sure as to the division of the hands in the Ghent Altarpiece and as to the authorship of the Turin–Milan – nowadays "Turin–Turin" – Hours', although, given that he also claims his lectures would be very dull and boring, this may have been exaggerated.[21] Nevertheless, his thoughts on the Ghent Altarpiece were to be thoroughly revised, if not completely overturned, by his trip to Belgium in 1952 when he spent many days looking at the original and discussing the recent technical investigation by Paul Coremans and his team. Although his manuscript had already been submitted before he left for Europe, he rewrote this chapter on his return: the 'Mouton [as he called the Ghent Altarpiece] appears to me a good deal more obscure than ever before', adding in a postscript 'Goddam the originals!'[22]

Panofsky's situation as a German émigré professor working in the American academy brought many benefits, exposing him to 'an art history without provincial limitations in time and space' and providing a certain distance, in his own view, from the nationalistic standpoints of his contemporaries in Europe.[23] However, he was also more distant physically than his European contemporaries from the 'originals'. This presented a particularly significant drawback in undertaking, in the immediate aftermath of the War, a project 'to describe a phenomenon as vast and intricate as Early Netherlandish painting' (p.vii). He had made only one journey to Europe between 1936 and the publication of his text, the 1952 trip to Belgium and Sweden made after the typescript had already been delivered.[24]

Panofsky had therefore not seen many of the works he was writing about for at least a decade, and some he had never seen at all: perhaps most startlingly he appears never to have been to the Museo del Prado, an omission that was hardly his fault, for he had been prevented from entering Spain by the outbreak of civil war when he was en route there in 1936.[25] That he had apparently not seen Van der Weyden's great *Descent from the Cross* or, presumably, his monumental Escorial *Crucifixion*, but was well acquainted with the *Crucifixion* diptych attributed to him in Philadelphia, is surely relevant when we read his accounts of these works.[26] That he had not seen the panels by the Master of Flémalle in London for many years, and the Seilern triptych at all, is equally telling,[27] and that the Ghent Altarpiece was fresh in his mind and eyes but the Turin–Milan Hours were far in his past[28] must be significant factors in how he dealt with these works.

The fact that Panofsky was largely working from memory or from black and white photographs inevitably posed problems, especially for a subject where detail and colour were such significant factors. These problems can be traced in his letters, and they emerge in the text: particularly revealing is one exchange with Colin Eisler in 1952. Panofsky asks of the Thyssen *Annunciation* by Van Eyck (then in Lugano): 'Can you by any chance remember the colors of the various kinds of simulated marble [. . .] I have not seen the thing, which is really beautiful, for many years, and am not quite sure as to the shades'. Eisler replied that he could not.[29] This did not stop Panofsky describing the colour and analysing its effects, with some assurance, in his book (p.192). A particularly unfortunate casualty of this necessary reliance on photographs and memory is his interpretation of Melchior Broederlam's *Annunciation* that opens the famous chapter on 'Reality and Symbol' (discussed below). Here, the purple wool held by the Virgin is used as the foundation for a whole series of arguments, one built on the other, about the meaning of the painting, defining its status as a major landmark on the road to the fully disguised symbolism of Van Eyck (pp.131–32). The 'wool' turns out, however, to be a light brown colour, not purple, and indeed not to be wool at all but a lit taper coiled into a clew by the light of which the Virgin is reading.[30] This itself does not invalidate Panofsky's method, of course, but it does show that if we want to build on Panofsky we have to return to the originals first: his book has to be used cautiously, bearing in mind the limited visual resources available at the time, the interpretive constructs of the author and the cultural milieu in which it was written.

As well as being distant from some of the major objects of his study, Panofsky was also distant from the archives. This, however, was as much by inclination and his philosophy as a historian as by circumstance. The humanist, as Panofsky himself defined it, 'respects tradition but rejects authority'.[31] In practice this meant that his history of Netherlandish painting was one that was built on other histories, even if he was developing a new art-historical approach. Friedrich Winkler shrewdly observed in his review of the book that 'Panofsky's strength is his unique, extended knowledge of the literature on art from antiquity to the Renaissance'.[32] The implication is that while Panofsky had a magnificent grasp of the literature, his knowledge of the source material, the documents on which the knowledge of the field had been based, was less apparent and less assured. Martin Davies recognised this too: 'it is probably true that his knowledge of the purely historical aspects of his subject, though formidable, is less formidable than his knowledge of iconography and critical interpretation.'[33] It is evident when one examines the

Interior spread showing the first page of Erwin Panofsky's famous discussion
of the Ghent Altarpiece and the Turin–Milan Hours. From Volume One of
Early Netherlandish Painting: Its Origins and Character, 1953.

Plates showing two versions of Jan van Eyck's portrait of Cardinal Nicolas
Albergati of 1431–32. From Volume Two of Erwin Panofsky, *Early Netherlandish
Painting: Its Origins and Character*, 1953.

sources of Panofsky's knowledge, as given in the footnotes and bibliography, that the documentary material he juggles and interprets with such virtuosity is garnered from those histories but rarely from the sources themselves, whether in published collections of documents of the nineteenth century or the actual archives. He was, then, using material that had already been transcribed, selected, sifted and edited, and while he often rejects the 'authority' of earlier interpretations, he relies on the traditions that presented it to him and had already decided what was relevant and what was not. For Panofsky this was a philosophical standpoint regarding historical process, and he defended it wittily, if somewhat disingenuously, in a letter of 1952 to the philosopher George Boas, in response to that writer's article 'Philosophy and Ritual'.[34] It is worth quoting in full. Panofsky states:

> If one should act on the premise that everybody should free himself from 'ritual' (that is to say, 'tradition'), the prospect would be somewhat appalling. Instead of approaching the sources from a vantage point determined by the traditions developed up to 1952, everyone should have to start at the very beginning, reading all the sources in the original, and thus forming his own opinion. This would be rather a job for the individual, all the more that he would have to act under the disheartening assumption that the next man would have to disregard all the results obtained by the first and begin all over again in his turn. There would also arise the question as to how we would obtain the necessary knowledge of Greek, Latin, Sanskrit, etc., without being influenced by tradition in the very process of learning these languages.

He concludes: 'In short, to be complete anarchists we should be obliged not only to free ourselves from the traditions established by purposeful interpretation but to write our own dictionaries.'[35] Boas replied: 'You are of course right that no one can start afresh. But all of us can become aware of how stale they are, of how much we are doing because of ritual, how little our problems are our own.'[36] This is good advice when considering the text of *Early Netherlandish Painting*.

The immediate impact of Panofsky's book when it was first published is an indication of the level of debate it was to instigate. It was reviewed by most of the eminent scholars in the field including Karel G. Boon, Martin Davies, Léon M.J. Delaissé, Julius Held, Millard Meiss, Otto Pächt and Friedrich Winkler.[37] They wrote learned, often lengthy, sometimes heated responses to and rebuttals of Panofsky's chronologies, method and attributions (the latter perhaps most heated in regard to the Turin–Milan Hours); some of these reviews, most notably

Pächt's, have become required reading in themselves. It is clear that there was nothing stale about Panofsky's scholarship. His choice to start his narrative in the fourteenth century, before Van Eyck (where all other authors since Karel van Mander had begun), and to investigate manuscript illuminators in France and Flanders as a way of penetrating the origins of Netherlandish painting, was seen as one of his most original achievements, although his attributions and the relevance of these works to what came later was challenged by some. The first four of his nine chapters are devoted to these antecedents, but it was the fifth, rather short chapter, placed (symbolically?) in the middle of the book and separating the forerunners from the founders, that would cause the most stir, both then and in subsequent decades. Entitled 'Reality and Symbol in Early Flemish Painting: "Spiritualia sub metaphoris Corporalium"',[38] it contained the now famous dictum that the imaginary reality created by Van Eyck 'was controlled to the smallest detail by a preconceived symbolical program' (p.137).

The many problems with Panofsky's theory have been well rehearsed.[39] Some of them he recognised himself, such as how to distinguish between what might be meaningful and what might be just a 'nice still life feature' (his solution to the dilemma: 'The use of historical methods tempered, if possible, by common sense', p.142). The objections Pächt put forward in 1955, and the problems he foresaw with the method (objections mostly ignored in America until the late 1970s and early 1980s), remain the most perceptive and cogently argued rebuttal of its suitability as a model of interpretation. He recognised the contradiction between Panofsky's disguised symbolism and his earlier definition in *Studies in Iconology* (1939) of 'symbolical values' as intrinsic and unintentional. Pächt predicted that if such preconceived programmes were assumed to be present, but were also supposedly hidden, interpretation would inevitably fall into 'a kind of decoding'. Even Held, who called the chapter 'required reading for all students of Flemish painting', acknowledged with some prescience the danger that it might 'become an invitation to trigger happy iconologists'. The story of the enthusiastic adoption of Panofsky's concept of disguised symbolism during the twenty years after publication, particularly in America, followed by its equally wholehearted and vocal rejection in subsequent decades, is well known. More recently there has been a cautious reassessment of its potential as a interpretative model. In 2001 Peter Parshall pointed out that the problems of Panofsky's concept of the relationship between text and images was largely semantic: 'It is ironic that in the present climate his forthright approach to defining a methodology [for Early Netherlandish painting] should provoke such bother.'[40]

Because the focus of much critical response to the book has centred on this concept of disguised symbolism and its application, and perhaps also because of Panofsky's impressive credentials and reputation as an iconographer, *Early Netherlandish Painting* is sometimes seen primarily as a work about the meaning of works of art, 'a tremendously extensive and detailed iconographic study'.[41] However, what Panofsky is chiefly concerned with is an overarching thesis about the nature and development of Early Netherlandish painting, of which its subject-matter and iconology are an integrated part. While Emile Mâle started the preface of *Religious Art in France* with the statement that his book 'is concerned with iconography and one should not expect to find here a history of our schools of art, of their struggles, their triumphs, their evolution',[42] Panofsky by contrast sets up his study in very different terms, as outlined in his preface: 'I have tried to clarify, as far as possible, the historical premises of their [the painters'] achievement; to assess what we know, or think we know, about their style; and to chart, however roughly, the course of those ensuing developments which may be said to constitute the main stream of the Early Netherlandish tradition' (p.vii). In this book, it could be argued, he comes closest to a fusion of Wölfflinian formal analysis with Warburgian iconography. This may be because of the nature of the task he had set himself: here, more than in anything else he wrote, he had to deal with the history of a whole region and period, with its many different artists and their works, as well as with its ideas.

Origins and character, style, knowledge and tradition: these are Panofsky's principal concerns in *Early Netherlandish Painting*. The narrative unfolds chronologically in a format familiar from the work of Max J. Friedländer, to whom Panofsky was deeply indebted for much of the sifting and ordering of the paintings.[43] Large parts of the text are devoted to characterising painters' styles, sometimes in the most eloquent and memorable of prose, and to setting out chronologies: indeed the chapter on Van Eyck is almost entirely a discussion of the order of his works in the 1430s.[44] Debates about attribution and the relocating of works from one regional school to another are often the primary topic at issue: this, for example, is the meat of chapter three, 'Sculpture and Painting around 1400: The Problem of Burgundy'. The content of images, and the differing extent to which a symbol was 'disguised', are brought to bear on arguments of attribution and date in chapter four, 'The Regional Schools', where it is the iconography of the manuscripts that is given in evidence for their status as precursors to the great 'founders', while in chapter six, on 'The Master of Flémalle', the nature of symbolism in the output of that painter is one of the main arguments for the early dating

of many of his works. The idea of development and progress and a firm belief in the possibility and importance of defining dates on the basis of style runs though the entire work. Indeed, in many ways the book is positively Vasarian: the narrative of increasing naturalism, of the 'conquering' of space, is told by a teleological progression of artists' biographies, and there is a tendency to link one artist to another, physically or spiritually. Thus Petrus Christus must have been present in Van Eyck's workshop, as he was 'the heir apparent' (p.308). Bouts in turn 'attaches himself to Petrus Christus' (p.315), the Master of the Aix *Annunciation* 'may be described as a twin brother of Jan van Eyck' (p.307), while Van der Weyden's 'very spirit was resurrected on German soil by Martin Schongauer' (p.308). Italian, and in particular Florentine, artists are the touchstone for artistic genius, and are used liberally to buttress Panofsky's claims for the significance of the Netherlanders: Claus Sluter 'contains potentially both Michelangelo and Bernini' (p.81); Petrus Christus is compared to Piero della Francesca (because of his use of perspective; p.310); Van der Weyden, 'having experienced the Florentine Rinascimento', meets Michelangelo in spirit at the end of their careers, 'halfway between two worlds' (p.289). It is worth recognising the narrative drive behind so much of what Panofsky constructs, since at times he bends the evidence to fit the need to tell a story.

Despite all this, *Early Netherlandish Painting* does still need to be read, since so much of the later literature is deeply rooted in its assumptions, theories and rhetoric. Moreover, Panofsky's descriptions of many works are lyrical and perceptive, and still have insights to impart, and his footnotes have yet to be fully mined. His chapter on the Ghent Altarpiece, in which he sets out his belief that the work was a composite of two separate altarpieces and not originally planned to be seen as it is today, is the most dense and tightly argued, written at the moment when the work was first being subjected to technical examination. It remains the most influential theory on the 'Mouton' yet written, and no one can work on that monument without addressing his ideas.[45]

The vast academic apparatus of *Early Netherlandish Painting*, its overwhelming demonstration of humanistic learning through extensive references to literature, poetry, music and Classical and patristic Latin sources in both the text and footnotes, and the wit and agility with which language is used, are some of the reasons the book has remained so revered. Its apparent authority is also one of its most dangerous qualities, not least because of its reliance, as discussed above, on 'tradition', and because, as Panofsky would have been the first to admit (and he did so fairly frequently in his correspondence following the book's publication), it was

very often 'wrong'. A large proportion of his judgments and interpretations have not stood the test of time or of scholarship, many falling to the axe of technical investigation and closer observation of the originals ('Goddam the originals!'), or shown to have been based on manipulation, even fabrication, of authoritative-sounding Latin sources. While this is important for unwary students and even for more experienced scholars to recognise, whether it matters in relation to the importance of his book is debatable. Panofsky being 'right' was not what made *Early Netherlandish Painting* so influential and stimulating; in fact, it was quite the opposite. In the 1957 letter to Delaissé quoted earlier he wrote: 'I am too old not to know that error is just as important a factor in history – and scholarship – as truth.'[46] For sixty years in error and in truth, *Early Netherlandish Painting* has made the field more studied and debated, more controversial and intriguing, more exciting and attractive, more intellectually respectable, and certainly more central to art-historical curricula in America and Europe.

Panofsky himself never really returned to the material he dealt with in *Early Netherlandish Painting*. Apart from an intense period in the summer of 1954 when he participated in a meeting of the Brussels Art Seminar, where he had enjoyable discussions 'in front of millions of x-ray photographs, infrared photographs and microsections' of the Ghent Altarpiece with a group that included Coremans, Davies and Pächt, he seems to have turned quickly to other things, most pressingly his 'little book' *Renaissance and Renascences* (1960).[47] He was never moved to revise the text in any manner or to publish further on his theories, altered as they necessarily were both by the reviews of his book and the findings of Coremans and others.[48] Part of Panofsky's greatness lay in his protean ability to move on, to range across a vast landscape of ideas and art-historical material. Indeed, in 1957 he wrote to Delaissé that tombs were his new hobby and that 'the whole field of Early Netherlandish painting, including book illumination, has so far receded into the background that for this reason alone I look upon the activities of younger scholars like one who has thrown a rubber bone to young lions and takes great pleasure in observing their worrying it from outside the cage'.[49] The worrying over the bone continues to this day.

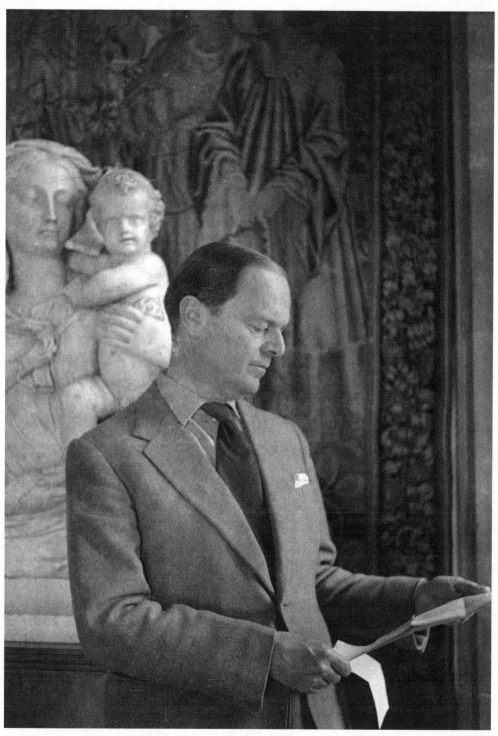

Kenneth Clark photographed by Cecil Beaton, May 1955.

Kenneth Clark

The Nude: A Study of Ideal Art, 1956

JOHN-PAUL STONARD

FEW ART HISTORIANS can claim to have defined the shape and direction of their subject as a specialist discipline yet also to have spoken to an audience number-ing millions. In his *The Nude: A Study of Ideal Art*, Kenneth Clark wrote the first book on a subject central to the history of art that was both accessible to a broad audience and made a serious contribution to scholarship.[1] Although it was not until the 1969 television series *Civilisation* that Clark could claim to have the same mass audience as his only rival in this respect, E.H. Gombrich, *The Nude* remains Clark's most important contribution to scholarship – and, so it happens, also his most controversial.

The traditional view that the nude was not strictly a 'picture category', that it was timeless, natural and above all God-given, was noted by Max J. Friedländer in 1942.[2] Although drawing and modelling from the nude were components of academic training, representations of the nude were not traditionally presented as a genre, or as the basis for a system of classification.[3] Clark could therefore right-fully claim that, with a couple of minor exceptions, his book was the first survey of a subject that was central to the history of art.[4] But in retrospect this hardly seems belated: it was only at a moment of transition, of the easing of distinctions between disciplines, that such a volume was possible. Soon, however, categories were being dissolved altogether, and Clark's breakthrough volume was itself being attacked as emblematic of an older way of seeing the world. It is not difficult to see how Clark appeared to the 1960s generation as the quintessence of an outdated, more restrictive order. Yet, in the case of *The Nude* the criticisms were aimed not at his humanism,

by which the perfected depiction of the human body was the highest achievement of Western art; nor at his interpretation of the bountiful nudes of Rubens as a form of Christian praise, or descriptions of 'Our Lord' on the Cross; nor at his 'undisguised admiration for the girls', as he put it in a letter to Bernard Berenson.[5] It was rather the well-known epithet with which the book opens, the famous distinction between the naked and the nude, which the new politicised art history latched on to. The 'huddled and defenceless' naked body is contrasted with the 'balanced, prosperous and confident' mien of the nude (p.1). If the nude is 'the body reformed', the naked body is by implication deformed, impoverished and subjugated.

Yet none of those who, to the present day, cite this distinction, note that Clark subsequently observes that it was 'forced' into the English language in the early eighteenth century by critics intent on proving the value of the beautiful human body as a subject of art. Nor do they note that Clark does not subsequently refer to the distinction, using the terms interchangeably, for example in his discussion of Manet's *Olympia* (p.153), and also freely deploys semi-robed figures as examples without feeling the need to question his basic premise. In fact the distinction between naked and nude is nothing more than a decoy: a device to focus the attention of his audience.[6]

The real story told in *The Nude* is that of the survival of the human body as the central subject for art since Classical Antiquity. Clark considers the history of art from Antiquity to Renoir as a diaspora of Classical prototypes, against which an 'alternative convention' swarmed like the barbarian cultures hemming in the old European empires. This theme was readily grasped by early reviewers. L.D. Ettlinger described in *The Burlington Magazine* the 'brilliantly revitalized account of the classical tradition' presented by Clark who, importantly, recognised 'no departmental boundary between classical archaeology and art history'.[7] Clark's mission was to show a general readership not only the continued relevance of the human figure as a form of artistic expression – at a time, it should be remembered, when figurative art was strongly identified with repressive political regimes – but also to revivify interest in Antiquity in the face of a modern attitude that had 'discarded the antique armour, forgotten the subjects of mythology and disputed the doctrine of imitation' (p.2).

The Nude was thus the first book for a general readership that dealt with the survival of pagan Antiquity in the motif of the human body, tracing the 'migrations of the image', and taking in 'the whole perspective of European art'.[8] It was also the first book to address this theme not from the perspective of dry scholarship, but on a level of human empathy that necessarily included erotic identification and

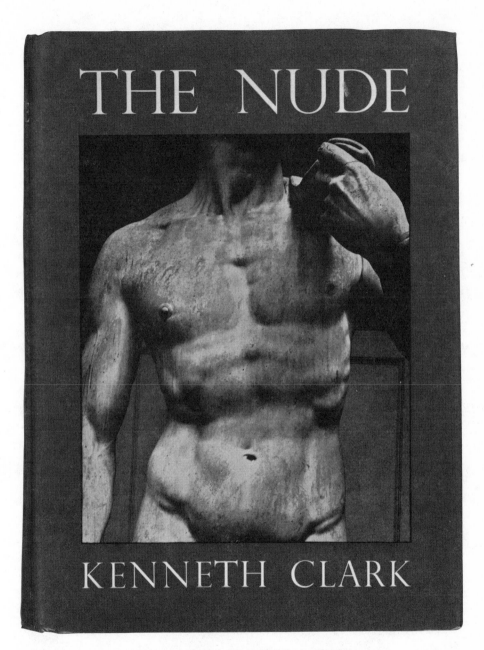

Front cover to Kenneth Clark, *The Nude: A Study of Ideal Art*, 1956.

sexual desire. The limits of Clark's ability to account for this, it must be said, have been set into relief by more recent academic work. His freely stated admiration for the unclothed female form, not untouched by gallantry, and expressed unguardedly in a later book on the subject,[9] is entirely unburdened by any notion of the politics of vision. But this is hardly surprising. Descriptions such as that of 'the small, full, manageable body, which has always appealed to the average sensualist', however accurate, are irredeemable, yet to criticise Clark for separating the nude 'from discourses about power and, ironically, the politics governing differences of class, gender and race',[10] is to be guilty of the 'immense condescension of posterity', as E.P. Thompson once put it.

Yet Clark was neither prurient nor puritan, and it is the idealism that features in the subtitle of his book that he deploys to trace the survival of the Classical prototype across the centuries. Not as an 'incentive to action',[11] but rather as an invitation to contemplation, unifying the sensual and the rational, can the nude incorporate 'real human needs and experiences' (p.22). It stands at the centre of aesthetic experience, as a result of our embodied experience of the world: our own physical proportions and the rhythm of our functioning are the basis for all judgments and systems of knowledge.

This idealism is exemplified by Clark's opening example: Apollo, the 'god of light', but also the 'vanquisher of darkness', (p.26) whose genealogy is traced from early Kouroi, through to the *Hermes* of Praxiteles, presented as the 'climax of [a] passion' that had first appeared in the 'schematic austerity' of Polyclitus, and achieved its zenith in 'Phidias's belief in the rectangular majesty of Apollo' (p.39). The tradition of Apollo is thus whittled down to a few moments of perfect achievement, from which latecomers such as the feeble Apollo Belvedere, with its 'weak structure and slack surfaces', is excluded (p.45). 'How pleasure in the human body once more became a permissible subject for art is the unexplained miracle of the Italian Renaissance', Clark writes, with direct reference to Donatello's *David*, who looks back over meagre Christian depictions of Adam to the beauty of the Classical Apollo. Yet the perfection of the nude in quattrocento painting (Pollaiuolo, Botticelli, Piero della Francesca and Perugino) was once again diluted by the rediscovery of the second-rate Apollo Belvedere. Whereas Dürer's response was his drawing of Apollo, a 'construction' of classicism showing his conviction 'that the body was a curious and rather alarming organism' (p.53), Raphael was able to detect the true Classical ethos of Apollo: 'Not only the grace of movement, but the sense of epiphany and the glance towards a more radiant world [. . .] reappear in the saints, poets and philosophers of the *Stanze*' (p.54). Clark's real concern,

however, is with the 'heroic humanism' that was first disinterred by Donatello, and it is thus in Michelangelo that the Apollonian ideal finds its 'greatest embodiment' in the marble *David*, 'a hero rather than a god' (p.58).

A more complex ideal is discerned in Apollo's counterpart, Venus, whose genealogy is traced in line with two types, the 'vegetable' and the 'crystalline' – the Venus of the flesh (*Naturalis*) and of the spirit (*Coelestis*). Clark elevates the latter, and traces her back to the Cnidian Venus of Praxiteles, the matrix of all beautiful nudes in art, known only, however, through second-rate copies, like less-fortunate family relations. Clark praises the 'heroic naturalness' of the Venus of Milo, who 'makes us think of an elm tree in a field of corn', witness to a vitality lost in Hellenistic and Roman depictions of Venus (p.83). Vitality returns in the paintings of Botticelli, 'one of the greatest poets of Venus', who could look 'beyond the Hellenistic replica to the impulse from which it derives' (pp.92–94). His *Primavera* is yet dissociated from Antiquity by her 'human quality' and quotient of pathos, most evident in her face, which 'reveals no thought beyond the present' and thus underlines her individuality. Raphael is of course the 'supreme master of Venus, the Praxiteles of the post-classical world' (p.103), but it was left to Giorgione to create a nude that would rival the Cnidian Venus as a model for centuries to come in the form of the *Sleeping Venus* at Dresden. Clark ends his account of *Venus Coelestis* with the most memorable paragraph of the book, in which he compares Giorgone's Venus, 'like a bud, wrapped in its sheath, each petal folded so firmly as to give us the feeling of inflexible purpose', with Titian's *Venus of Urbino*, where 'the bud has opened' (p.112).

From here it is a history of the flesh rather than the spirit. *Venus Naturalis* finds her first great embodiment in the crouching nude at the centre of Titian's *Diana and Actaeon*, 'one of the most seductive nudes in all painting' (p.124). Titian is 'one of the two supreme masters of Natural Venus' (p.119). The other is Rubens, who moves Clark to his most personal and, for the contemporary reader, most problematic writing. He suggests that we bring to mind the 'golden hair and swelling bosoms of his [Rubens's] Graces' as we sing harvest hymns 'on a bright Sunday in September'. After completing the passage on Rubens, he later recalled, Clark 'began to tremble, and had to leave my hotel bedroom and walk along the sea front'.[12] In the absence of the heroic ideal, or Cnidian virtue, the perils of the flesh are never far away. Of Boucher's *Miss Murphy*, lying sprawled and naked on a silken couch, Clark warns that 'Boucher has enabled us to enjoy her with as little shame as she is enjoying herself. One false note and we should be embarrassingly back in the world of sin' (p.140). The eighteenth century was thus to the female

nude what the post-Roman world was to the heroic male, and it was only with the arrival of Ingres, whose 'nuggets of obsessive form' (p.143) managed somehow to convey a feeling of idealised Classical beauty, that some sense of decorum returns. Courbet remains a 'heroic figure in the history of the nude', for the corporeality of his figures: 'his eye embraced the female body with the same enthusiasm that it stroked a deer, grasped an apple or slapped the side of an enormous trout' (p.151). The Cnidian Venus returns also with Renoir, whose picture of his wife, *La Baigneuse blonde* (1881), which Clark himself owned, 'gives us the illusion that we are looking through some magical glass at one of the last masterpieces extolled by Pliny' (p.156).

The three central chapters concerned with the expressive categories of energy, pathos and ecstasy were, for Ettlinger, 'the most original section of the book'.[13] The 'energetic' nude is traced from Antiquity through to Michelangelo, by way of a new protagonist, Hercules. Heroism as a theme unites the account of the energetic body with the pathetic body, 'defeated by pain'. Christian artists were obliged to search hard for antique models of bodily pathos, and in many cases had simply to invent, although the 'ideal character of the antique nude' is shown nowhere more decisively than in the fact that, 'in spite of the Christian horror of nakedness, it was the undraped figure of Christ which was finally accepted as canonical in representations of the Crucifixion' (p.221). The importance of the rediscovered Laocoön for Michelangelo's depictions of the body locked in spiritual struggle returns the narrative from a discussion of Christian pathos to antique heroism. Even with the pathetic nude of nineteenth-century art, it is the Classical tradition that wins through. Géricault studied antique reliefs for his famous raft; Delacroix employed '19th century daughters of Niobe' to add pathos to his historical set-pieces; and Rodin, whose overwrought figuration was saturated with 'man's tragic struggle with destiny', redeemed himself by looking at the Lapiths of Olympia and at Marsyas.

Ecstasy is the third category and leads the argument into the final part of the book, concerned with the 'alternative convention' of the Gothic nude, and of the fate of the human body in modern art. Clark examines the 'Dionysian motives' of the Thiasos, those ecstatic dancing figures, in particular the Maenads and the Nereids, carefree sea-nymphs, for which he had a particular fascination.[14] Yet ecstatic figures may also serve a deeper purpose and 'symbolise through the body some change or translation of the soul', which in the hands of an artist such as Bernini 'must be like one of those great ecstatic moments, love, levitation, or the sudden lift of a wave' (p.288). One might have thought that such an expressive

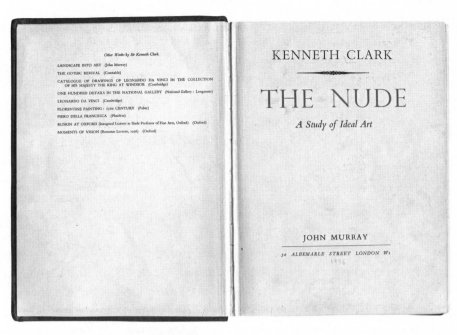

Title-page to Kenneth Clark, *The Nude: A Study of Ideal Art*, 1956.

Interior spread comparing Bernini and Raphael nudes.
From Kenneth Clark, *The Nude: A Study of Ideal Art*, 1956.

figure would have opened some discussion of twentieth-century representations of the unclothed human body, but only Matisse's *The dance* is briefly mentioned. Instead, Clark uses the corollary of ecstasy – rebirth – to return to Michelangelo's drawings of the Resurrection. Indeed, embedded in the pages of *The Nude* is a book about Michelangelo which suggests that Clark would have sacrificed every single work of art made after 1900 in favour of Michelangelo's drawing of the *Risen Christ* held in the Royal Library at Windsor.

'This most un-German of writers has absorbed German scholarship, and enriched his perceptions in the process', wrote Benedict Nicolson in his review of *The Nude*.[15] The comparative method used in the chapters on energy, pathos and ecstasy is clearly indebted to Wölfflinian formalism. Clark may also have been recalling Roger Fry's apperceptive category of 'vitality', the title of one of his *Last Lectures*, published in 1939 with an introduction by Clark – who also bemoaned Fry's rejection of Classical Greek art.[16] Yet a more intimate influence was the figure to whom the book is dedicated, Bernard Berenson. Much of the original writing was carried out at the Villa I Tatti, when Clark stayed there a number of times after 1950. The opportunity this provided to look at antique sculpture 'with an eye unprejudiced by the almost groundless traditions of anti-quarianism', as he put it, was an obvious precondition for the 'revitalising' aspect of his approach.[17] Clark wrote to his former mentor in November 1956: 'Before I see you again you will have received a copy of my book on the Nude which you kindly allowed me to dedicate to you. You will see how much of it is due to you on every page. It was conceived on walks on the hills behind I Tatti during one of those blissful periods when you let me stay there.'[18] Berenson replied that Clark had surpassed himself, illuminating the subject with 'precious epithets' and an admirably assimilated scholarship.[19]

The most startling of these epithets is that which introduces the chapter on the 'alternative convention': 'Roots and bulbs, pulled up into the light, give us for a moment a feeling of shame' (p.300). The 'alternative convention' is the anti-classical tradition of Gothic art, and the Christian art of northern Europe. Clark sketches a few moments when the 'alternative convention' appeared faintly to echo the glories of Antiquity, and the naked figure of Eve took on the same depth of feeling as the Classical nude. In the *Très Riches Heures* Eve is 'naked as a shrimp' (p.310) and unaware of her own shame, but later depictions by Van Eyck and by Hugo van der Goes show the underlying realism of the 'alternative convention', and, in the latter case, show 'the unfortunate condition to which the female body was reduced in the mediaeval mind' (p.313). For only when this

realism was synthesised into a new convention in the late paintings of Cranach, who 'evolved a decorative convention for the nude equal to that of 10th-century India' (p.321), was this northern eroticism comparable with the beauty of antique nudes. In one of the most dubious connections of the book, Clark moves from here directly to Rembrandt, whose defiance of classicism in the creation of often ugly, fleshy bodies was motivated, he writes, by 'Christian pity' (p.327). Pity becomes 'scrupulous honesty' in the case of his *Bathsheba*, 'a naked body permeated with thought' (p.330). The 'alternative convention' is traced cursorily through to German Expressionism, a movement dismissed, however, by Clark as an imaginative failure. Courbet is preferred to Cézanne for his ability to 'see the female body through memories of the antique'. Yet it is in Rouault's images of prostitutes, 'monsters of brutal depravity' (p.333), that the anti-classical tradition found its culmination, based on a religious attitude that found redemption in fear and degradation. One can only conjecture what Clark would have made of Willem de Kooning's *Women* paintings, the first exhibition of which opened at the Sidney Janis Gallery, New York, on 16th March 1953, the day after Clark gave his second Mellon lecture on the subject of the nude in Washington, DC.

Clark would certainly have made no bones about his opposition to such works and was clear, at least in public, about his attitude to most of the art of his own century. By 1900 the heroism of the Classical nude has disappeared. Venus vanishes after Renoir, just as the perfection of Apollo was superseded by the 'communal frenzy' of Dionysus; and with Rodin ended a tradition of the pathos and divinity of the body in art, thanks to the 'death wish' of modernity that the 'poets of Romanticism had foreseen, and the technicians of the present century have so brilliantly accomplished' (p.263). At best one can detect an academic tradition of 'the nude as an end in itself', as Clark titles his final chapter, which favours formal perfection over intuition, and considers the nude as a 'source of independent plastic construction'. Matisse's *Le nu bleu* is taken as the most recent manifestation of this tradition, which although anti-academic, was still concerned with 'significant form'. Picasso's *Les demoiselles d'Avignon*, by contrast, is a 'triumph of hate', and aimed entirely against the Classical tradition. The only twentieth-century artist who appears to have answered Antiquity in creating 'significant form' imbued with genuine emotion was, according to Clark, Henry Moore, who worked with a more intuitive relation to the female form. Clark's own reassessment of Classical art, and his realisation that something ought to be done about the dwindling appreciation of antique sculpture, was in part motivated by his own response to Henry Moore's work, Nicholas Penny has suggested.[20] Clark ends his book (without

Interior spread discussing prehistoric and Ancient Greek sculptures of Venus.
From Kenneth Clark, *The Nude: A Study of Ideal Art*, 1956.

being able to think of a final, pithy sentence, as he later confessed) by admitting his limited understanding of twentieth-century art, merely pointing to the 'far greater complexities' of the analogies on which were based the representations of modern man.

The Nude was met at first with unanimous praise, reflecting Clark's unassailable public standing. 'He more than any other single man during the last quarter of a century has been responsible for weaving visual art into the texture of English life. This he has achieved without any surrender of intellectual integrity', wrote Benedict Nicolson in the *New Statesman*.[21] It was, however, the great public success of *Civilisation* that precipitated the first wave of reaction. John Berger opened the fray with an assault on the 'privileged minority' of art historians and their appropriation of the past in *Ways of Seeing*, first shown on television and published as a book of the same title in 1972.[22] 'Men act and women appear' was Berger's formulation of the way women were made the objects of vision, and his implicit criticism of Clark is that he does not examine the political conventions of the 'way of seeing' – a phrase he in fact takes from Clark's book – implied by the nude in art.

The 'unrelenting moralism' of Berger's text and its simplistic reversal of the distinction between naked and nude, lauding the 'sexual image of the naked' as an emblem of commonality and solidarity, have been roundly criticised from a feminist perspective.[23] Discussions of 'the gaze' frame the senses in which 'ways of seeing' are never politically innocent, even when it comes to looking at Niobids and Kouroi.[24] Laura Mulvey in particular has provided a much more subtle basis on which a politically oriented psychoanalytic approach could be used to analyse the 'determining male gaze' within a patriarchal, phallocentric order – for which Clark was a prominent envoy.[25] His disavowal of any politics of vision or public, codified context in which representation is embedded is certainly the basis on which criticism can and has been mounted. Yet it is largely through a misreading, privileging the distinction between naked and nude as a key to *The Nude*, that this has occurred.[26]

In an article first published in 1980, and revised in a longer version that appeared ten years later, T.J. Clark addresses directly the social identity of Manet's *Olympia* as a prostitute, and thus offers a classic formulation of the way in which the unclothed body is politicised.[27] Without explicitly referring to *The Nude*, T.J. Clark uses the term 'naked' to suggest the way in which Manet was destabilising the concept of the courtesan in mid-nineteenth-century Paris, showing the real link to capital and the commodification of the body.[28] His discussion of the 'general theory of the nude', which emerged falteringly in art criticism in the 1860s, shows that the genre of the nude had at least been discussed, in the writing of Camille Lemonnier, for example, who juxtaposed the nude with the more common spectacle of the 'unclothed'.[29] The nakedness of Olympia reveals her social class origins, and leads T.J. Clark to a significant redefinition of nakedness and nudity: 'By nakedness I mean those signs – that broken, interminable circuit – which say that we are nowhere but in a body, constructed by it, by the way it incorporates the signs of other people. (Nudity, on the contrary, is a set of signs for the belief that the body is ours, a great generality which we make our own, or leave in art in the abstract.)'[30]

When the attempt is made to engage directly with *The Nude* on this issue, however, the target is generally missed. In 1992 Lynda Nead lamented the lack of any 'critical framework for discussing representations of the female body', and ascribed the 'astonishing' longevity of Clark's *The Nude* to this lack of resistance.[31] Nead argues that the goal of the female nude throughout history has been that of regulation and containment of the female body, and that all theories of the nude are implicated in such repressive aesthetics. She is doubtless right, and Clark's

movement from descriptions of female abundance to formal constraint occur throughout *The Nude*, in particular during his discussion of Rubens. Yet still her argument relies on a partisan reading of *The Nude* – she quotes Clark's description of the 'sheathed' Giorgione to signal his investment in the processes of repression, but not his comparison with the 'liberated' Titian. Her characterisation inevitably extends to framing Clark as a figurehead of the patriarchal establishment and repeats the most common error of putting him forward as an aloof conservative, which may be read in his manner but not in his politics, or his democratising approach to scholarship.

If there is a politics of vision at work in *The Nude*, it may be better situated in those aspects of the text that are internal, but not disclosed as guiding themes. Despite Clark's disavowal of the art of his own century, in fact his approach to the history of the nude as a heroic form, using the tools of connoisseurship, is thoroughly of its time. The struggle to define a heroic figurative art was central to the cultural politics of the twentieth century. For Fascism, the artist was a hero who would create perfect heroic bodies exemplary for national citizens. At the time Clark was writing, a similar attention to the exemplary role of the human figure was being demanded by Socialist Realism in the Soviet Bloc. Against this background one might think of Clark's revitalising of a popular understanding of Antiquity not just in the face of fashionable disregard, but also as a counter to extreme political appropriation of the heroic Classical body.

This raises furthermore the question of connoisseurship, and of the virtuosity of vision that is so much in evidence in *The Nude*. The importance of the heroic body for Fascism was its ability not to embody perfection but racial purity, and this message was one that should appear as a direct connection between viewer and work of art, like a flash of revelation based on bodily empathy. Boris Groys has defined heroism as the moment when the body manifests itself directly, when it is transformed by the heroic act from medium to message.[32] It may be said that a similar type of immediacy is at work in the 'virtuosity of vision' exercised by connoisseurship. Virtuoso vision is called on to see the lost original behind a poor Roman copy, discovering, for example, the Lysippic bronze of masterly complexity and condensation behind the replica of *The wrestlers* in the Uffizi (p.169). As a theory of vision, connoisseurship is a doctrine of the moment, the flash of intuition that reveals deep truth; and, by its virtuosity, is ranged against the mundane bourgeois experience of history. Groys has suggested that a belief in direct, unmediated contact with works of art must always be based on a faith in the body, and on a bodily identification between viewer and painted subject. The notion of an

immediate, corporeal response to a work of art, and the belief that questions of art ultimately come down to questions of the body is, therefore, a 'thoroughly modern faith.'[33]

By the time he came to write *Civilisation* Clark had realised that any account of heroism in the arts of the modern age must consider the question of technology, and of the changed relations between man and nature in the wake of industrialisation.[34] The heroic body of modern art cannot be considered aside from the impact of technology, from machine metaphors to prosthetics. At the time *The Nude* was first published, a new 'post-human' understanding of the body as a 'cybernetic organism' was emerging. From today's perspective, the absence of any account of technology is the most troublesome blind spot of *The Nude*. It might have figured in a discussion of anatomy, but the subject is dealt with only briefly, as if Clark was reluctant to go beneath beautiful surfaces – for inside was an ideal rather than a structure to be understood by science. Yet the faith that Clark kept in the human body, at a time when political appropriation and technological intervention appeared to have destroyed any vestige of Classical unity, has been answered by more recent art, wherein the body remains central.[35] Scholars today may take inspiration from the authority of expertise that Clark brings to his subject, and his tact in deploying this to create a vivid and compelling argument for the continued importance of the legacy of Antiquity. And, like the tradition of English criticism to which Clark belonged, that of Reynolds, Hazlitt, Ruskin, Pater and Fry, *The Nude* may be read simply for the pleasure of its sentences – however much of their innocence they may since have lost.

E.H. Gombrich photographed c.1962.

E.H. Gombrich

Art and Illusion: A Study in the Psychology of Pictorial Representation, 1960

CHRISTOPHER S. WOOD

'MAKING PRECEDES MATCHING': with this famous formula, the epitome of his *Art and Illusion* (1960),[1] E.H. Gombrich proposed that artists, before they ever dream of copying what they see before them, make pictures by manipulating inherited 'schemata' that designate reality by force of convention. At some point an artist compares a pictorial schema to direct observation of the world, and on that basis presumes to correct the schema. This then enters the stock of available formulae until some later artist holds it up to the world and ventures a further adjustment. In this way art may come to have a history. Beholders, in turn, make their own sense of pictures by collating what they see on the canvas with what they know about the world and with what they remember of other pictures.

Gombrich's account of the making of art as an experimental and even improvisational process impressed many readers beyond the academic discipline of art history. However, for two decades or more, many art historians have considered his name a byword for a rationalist, Eurocentric and naively naturalist approach to art with which they no longer would wish to be associated. A forceful blow to Gombrich's reputation was struck by Norman Bryson in his *Vision and Painting: The Logic of the Gaze* (1983), an intricately reasoned critique of the quest for an 'Essential Copy' that has supposedly driven Western art and art theory since Antiquity. Bryson argued that the picture, as a conventional sign, delivers not reality but only a coded message about reality, and that verisimilitude is nothing more than 'rhetoric' that persuades the unwary viewer that he or she is seeing things as they really are. Within the discipline of art history, for at least a decade,

Bryson's polemic was highly influential. His anti-naturalism was embraced by art historians who wished to modernise their discipline, bringing it into step with the development of critical theory and poststructuralism that by the 1980s had already profoundly reshaped literary studies.

The problem-solving model of the development of Western art that *Art and Illusion* proposed left Gombrich, in Bryson's view, aligned with an unacceptable classical theory of representation: 'so far from questioning the Whig optimism of that version, it in fact reinforces its evolutionary and teleological drive.'[2] After Bryson, one could almost be forgiven for thinking that the phrase 'Essential Copy', implying an endpoint to the process of experimentation, was Gombrich's, which it was not. Yet only a decade later Keith Moxey presented Gombrich as 'the most eloquent advocate' of the 'resemblance theory of representation', according to which 'representation has something to do with the imitation of nature'. Moxey then contrasted this view with that of the philosopher Nelson Goodman, numbering him among 'Gombrich's critics', who 'pointed out that [. . .] a picture never resembles anything so much as another picture'.[3] A reader who turns to Goodman's book *Languages of Art* for further elucidation, however, will be surprised to find that the author mentions Gombrich not as his intellectual antagonist, but rather as a principal witness in his own conventionalist cause: 'Gombrich, in particular, has amassed overwhelming evidence to show how the way we see and depict depends on and varies with experience, practice, interests, and attitudes.'[4]

In *Art and Illusion* Gombrich makes a powerful case against what Ruskin called the 'innocence of the eye' (p.296). Perception, in Gombrich's account, is not a given but a learned practice, involving an active construction of the world. Resemblance to reality is an effect generated by the interplay between the expected and the unexpected. Pictures are 'relational models' of reality (p.253). Pictorial realism was a historical and collective product, and hard-won. The artist is not free, but faces a limited array of choices (p.376). Cultures determine what is possible (p.86).

Such propositions inverted the conventional wisdom about representation. Like his near-exact contemporary, Claude Lévi-Strauss, Gombrich was a 'reverse thinker'. Lévi-Strauss argued that myths are made by combining bits and pieces of previous myths. Meaning does not precede, but rather follows, the myth-maker's *bricolage*. 'Mythical thought [. . .] is imprisoned in the events and experiences which it never tires of ordering and re-ordering in its search to find them a meaning.'[5] Gombrich too solved problems by turning them inside out. For

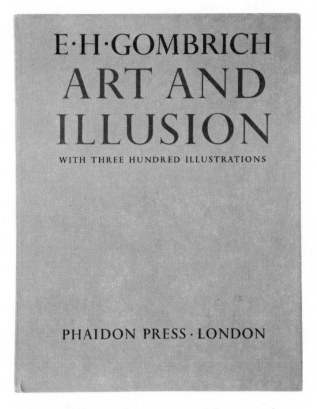

Front cover to E.H. Gombrich, *Art and Illusion: A Study in the Psychology of Pictorial Representation*, 1960.

example, he pointed out that astrological associations do not explain character traits but create them: human nature adjusts itself, as it were, to fit the signs.[6]

Gombrich's paradoxical argument is also homologous with that of Thomas S. Kuhn, who in his *The Structure of Scientific Revolutions* (1962) described the paradigmatic, essentially social basis of scientific knowledge. Just as Kuhn's demonstration of the collective and conventional nature of scientific knowledge was a revelation for non-scientists, so too were non-art historians greatly impressed by Gombrich's arguments. Kuhn stripped the scientific revolution of some of its aura by showing that scientists were driven by ambition and limited by force of habit. Gombrich, for his part, desanctified the contents of the great museums by showing how the painters, even as they were aiming at ideal form or expounding arguments, were also solving local, practical, technical problems. Yet art historians, already familiar with the conventions of pictorial representation,

were not taken by surprise, for this is the basic premise of the modern discipline of art history, especially as it was formulated by the pioneering theorists and historians Konrad Fiedler, Heinrich Wölfflin and Alois Riegl. 'People have at all times seen what they want to see', said Wölfflin.[7] *Art and Illusion* echoes and amplifies this dictum.

Further, Gombrich stands accused of reducing art to mere technology. Art, to an art historian, is self-evidently something *made*. The art historian is interested in the ways artists select and recombine, contrive and construct, perhaps even add to reality. To speak of artists striving to *match* their fabricated worlds to a real world is to render the making of art less a poetic activity and more a technology. Poesis or artistic creation, in many modern theories of art, is compromised if it submits to practical imperatives. Art making, an activity no doubt less free than it pretends to be, is nevertheless taken to symbolise the freedom of the imagination. Technology, by contrast, is a problem-solving process and does not claim autonomy.

To a certain extent Gombrich invited this reading of his work by distancing himself, in repeated comments throughout the 1960s and 1970s, from the radical constructionist reading of *Art and Illusion* – from Umberto Eco and Nelson Goodman, in effect. Gombrich felt that their positions were unreasonable. He also courted the naturalist reading of his work by appearing to say that European painters got better and better at representing the ways things looked between the fifteenth and the nineteenth centuries.

This raised the possibility that Gombrich might believe that European art was better than non-European art. Emerging in the early nineteenth century, at a moment when medieval art was recovered for scholarship and when academic prejudices in favour of ideal beauty and measured proportions were under attack, the discipline has deep roots in a relativist mindset. The eye of the modern academic art historian, whether in search of the underlying principles of form that reveal the shape of history itself, or in search of the concrete links that connect the artefact with historical life, is officially neutral. Riegl, whose pupil Julius von Schlosser was Gombrich's teacher, is alleged to have said that 'the best art historian is the one who has no personal taste'.[8]

Other art historians dismissed Gombrich as a reactionary who failed to grasp the power and significance of the dominant modes of the making of art in his own lifetime. Gombrich did not disguise his lack of sympathy for the twentieth-century avant-gardes and appeared to pander to the ill-informed opinion of the man on the street when he described works of modern art as 'bewildering',

as 'conundrums' or 'experiments', or as art that had 'lost its bearings'. Cubism in *Art and Illusion* is dismissed as a 'last desperate revolt against illusionism' (p.281).

But Gombrich's relation to modern art is more complicated than this. He was a contrarian by nature and could not abide the smug post-War consensus, among an educated elite, that abstraction had vanquished figuration once and for all. By the 1950s abstraction had lost its revolutionary edge and had become universally palatable. Critics across a wide ideological spectrum agreed that abstraction held out the promise of a new spiritualism, whether austere or romantic, in the face of the brutal literalisms and the delusionary mythologies that had together wrecked the century. The bourgeois amateur of art could congratulate him- or herself for apprehending a modern art which, according to André Malraux, writing in 1949, 'has liberated painting which is now triumphantly a law unto itself'.[9] Even the Thomist theologian Etienne Gilson, who delivered the A.W. Mellon Lectures in the Fine Arts in 1955, one year before Gombrich, proclaimed that painters could never again indulge in 'the easy pleasures of imitational or representational art'. Since Cézanne, Gilson affirmed with satisfaction, painting had been forced to submit to a 'cure of abstractionism'.[10] Gombrich did not like the complacent tone of this, any more than did Leo Steinberg, who in 1953 reminded readers that the ambitions of the major modern artists, including Manet, Van Gogh, Cézanne and Matisse, had been 'adequately summarized in Constable's dictum which defines the goal of painting as "the pure apprehension of natural fact"'.[11]

Unlike Steinberg, Gombrich in 1956 could not foresee the return to figuration, to iconography and to the plenitude of contemporary experience that was just on the horizon, the rejection of the dogma of abstraction. Gombrich's reaction to the crisis of art in a modern culture – the loss of confidence in any transcendental reference point – was simply to set aside the concept of art, at least provisionally. He mistrusted all the modern philosophical guides, metaphysicians and anti-metaphysicians alike, who might have offered him a glimpse of a new concept of art, suited to modern experience: Friedrich Nietzsche and Martin Heidegger, but also his own near-contemporaries, Theodor Adorno and Maurice Merleau-Ponty. Instead he envisioned a comprehensive 'science of the image'. Here he went far beyond Steinberg. After the War, Gombrich actually submitted to a publisher the project of an 'ambitious book of which actually *Art and Illusion* and the *Sense of Order* (1979) are only fragments: a general book on images and the different functions of images', for example, illustration, symbolism, emblems and decoration, to be called *The Realm and Range of the Image*. In his mistrust both of idealism (the hope that images might guide us to a truth beyond experience) and

Frontispiece and title-page to E.H. Gombrich, *Art and Illusion:
A Study in the Psychology of Pictorial Representation*, 1960.

of hermeneutics (the hope that the truth might be embedded somewhere deep inside the image), Gombrich is the ally of such disparate but influential figures as John Berger, Horst Bredekamp and Jonathan Crary. For *Art and Illusion*, with its many reproductions and analyses of posters, advertisements, popular prints, optical illusions and scientific illustrations, indisputably prophesied the field of study that would later be called *Bildwissenschaft* in Germany, and in Britain and America 'visual culture'. The student of visual culture, who may well harbour ambitions to liquidate the discipline of art history outright, believes that the study of images has been impeded by outmoded tastes for the fine arts, aesthetic experiences and the art of interpretation.

By identifying a problem-solving dynamic embedded within the history of the fine arts, Gombrich drew fire from two constituencies: on the one hand, those who believe that art historians should never tell the story of art as a story of progress, and on the other hand, those convinced that modern art does represent an advance on earlier art – not because it better renders how things appear, but because it proposes a new social order, captures the invisible structure of the cosmos or reflects on the nature of art itself.

Interior spread explaining the geometry of perspective, with an illustration from
Albrecht Dürer's *Unterweisung der Messung*, 1525. From E.H. Gombrich, *Art and Illusion:
A Study in the Psychology of Pictorial Representation*, 1960.

To the latter charge, Gombrich pleaded guilty: he was sceptical of all avant-gardisms. He reveals the sources of this view in his book-length interview with Didier Eribon, where he describes a long unpublished manuscript on the subject of caricature that he wrote together with Ernst Kris. The two authors saw carica-ture, which first appeared in European art only in the late sixteenth century, as a successor to the magical image, which in pre-modern times had been credited with the power to defame or even injure its subject. Caricature was only pos-sible once people stopped believing that the image could work real harm. When the interviewer asked Gombrich whether he still held this theory, the art histo-rian answered: 'No, certainly not.' For Kris, like so many other modern thinkers, including Freud as well as Riegl and Aby Warburg, was 'under the spell of an evolutionist interpretation of human history, imagined as a slow advance from primitive irrationality to the triumph of reason'. After the Second World War Gombrich felt it was simply no longer possible to believe optimistically in the inevitable refinement of the human spirit.[12]

Art historians, in Gombrich's view, were simply unable to resist telling the story of art as a progressive dominance of spirit over matter. He associated this

model with Hegel, but it has much older Christian roots. Gombrich was right that the dematerialisation of art is the basic plot structure of virtually all ambitious art history written since the nineteenth century, whether formalist, humanist, Marxist or poststructuralist in flavour; from Riegl, Wölfflin and Meyer Schapiro to T.J. Clark, Hubert Damisch and Rosalind Krauss. In this narrative, art begins by restaging a primal tactile or bodily relation to the world. At a later point art puts its trust in the sense of sight, offering the world as a picture. In this way the beholder is stabilised and put face to face with the work of art, preparing him or her either to enter into a virtual relation with the work, or to reflect on the work's reflections on the conditions of its own possibility, including the beholder's perceptual and cognitive participation; and so on *ad infinitum*. The story is retold with many nuanced variations. In Wölfflin's scheme, the linear or tactile mode is succeeded by the painterly or optical mode; but the sequence of linear to painterly can also be repeated, as a kind of sub-routine, inside an overall painterly regime. In the twentieth century of Krauss, the optical mode is shadowed by the threat of a collapse back into the corporeal; the power of the drives and the senses to confound the reflective ambitions of art becomes the very theme of modern art. But in the end it is always the asymmetry between body and mind that gives the narrative its shape. This is the account of the discipline, more or less, offered by Michael Podro's *Critical Historians of Art* (1982), a book that expressly excludes Gombrich.

Gombrich lost faith in reason as the basis for this narrative, and so turned to technology. Problem solving, as explicated in *Art and Illusion*, is a kind of externalised reason. Technology makes measurable progress and yet does not depend on human virtue, only competence. Gombrich was not saying that art, in the end, turns out to be nothing other than a technology. He was only saying that if you are interested in telling the story of art *as* a story, with a plot, and if you are interested in showing that art registers the progressive domination of mind over matter, then you had better narrow your field of vision and focus only on those episodes in the history of art when artists were trying to render the look of things.

Although he was averse to avant-garde art, Gombrich's theories of the production and reception of art developed in *Art and Illusion* can easily be extended beyond representational art to abstract art and indeed any art. Podro, in his book *Depiction* (1998), saw no barrier to extending Gombrich's account of the art of painting as a reflection on the conditions of perception – on the realisation of the subject through recognition, in Podro's terms – beyond the horizon of illusionistic painting. 'It would be hard to conceive of a practice of this kind [Mondrian's

abstractions] – this play of variations – without the cultivation of formal relations in earlier depiction, without familiarity with the consistencies of morphology that run through discrete objects and the re-vision of one feature through another.' The process is structured as a feedback loop: 'recognition sustained and developed itself through recruitment of its own material and psychological conditions to make itself more replete.'[13] The 'depiction' phase of art history, which has the merit of revealing clearly the structure of the game, now appears to have been a limited episode. Not only the 'look of things', but also the hidden essence of things, can be modelled, schematised, corrected. Some artists seem to do nothing but make and make, never bothering to match. In fact, they are comparing what they make to a conception of reality they find somewhere inside themselves.

We are not dealing with 'progress' here, but rather with an emergent process that seems, from the inside, to have a structure even if it is not at first clear where it is headed. It is like learning – not mastery of a skill, but learning as the growth of a deep familiarity with a subject or a problem. Learning is a convergent process that nevertheless has no endpoint. We may feel that we are learning more and more and yet, paradoxically, have no idea what it might be like to have learned everything, to have nothing more to learn. And this, I believe, is the nature of the process that Gombrich was describing. European art has at times appeared – even and especially to the artists themselves – to be a convergent process and yet no one has ever imagined that art would one day achieve its ends and cease to change.

In the last chapter of *Art and Illusion*, Gombrich wonders how art, if it is just a technology for simulating optical impressions, manages to amount to anything at all. In fact, he never once lost his sense of what art is and why it is significant, even as he denied himself any facile satisfaction in art. Like his teacher, Schlosser, who held an ineffable Crocean conception of art, Gombrich, in his scholarship, tends to evade the question. He gives us glimpses of his view of art only in gnomic comments, typically in the closing pages of his essays, for instance at the end of 'Raphael's "Stanza della Segnatura"', where the painter is credited with transforming humanistic commonplaces into a beautiful and complex composition that gives the impression of 'an inexhaustible plenitude'. Gombrich adds, and one wishes he had said just a little more on the topic: 'This plenitude is no illusion.'[14]

Such comments, which hint at a positive aesthetic, are rare. Gombrich understood that under the altered conditions of modernity, any theory of art has to be routed through a theory of the image, a *Bildwissenschaft*. Nevertheless his dramatic account of the dialectical honing of representational algorithms across time conjures up brief, mirage-like visions of an art that finally shows

us what life is like. The possibility of such an art had been explained away by a century of art-historical scholarship – a secular science. Gombrich, true to his Viennese training, demonstrated once more the paradoxical dependence of the image on formulae and improvised solutions. Yet in the end he cannot disguise his excitement about the image that manages somehow to seize the real. That image shines through *Art and Illusion*'s screen of explanations. Non-art historians did not perceive this shining through of reality, for they were more interested in the argument about the conventionality of pictorial representation, which was new to them. But some art historians *did*, and that is why they held Gombrich's book at arm's length. Bryson, when he called for a systematic semiotics of the image, was only telling art historians what they already wanted to hear: that the image of the true image is too threatening, that it must be exorcised, that it will drag us back to religion.

In the third chapter of *Art and Illusion*, 'Pygmalion's Power', Gombrich places his story within the long-term context of the myth of the image or artefact that comes to life. He assigned the dream of 'rivalling creation itself' (p.93) to an 'archaic' phase when images were thought by virtue of their lifelikeness to wield magical power. The impression of lifelikeness was created, not strictly by resemblance, but by efficacy within a 'context of action', a ritual or a game. But the threats to orthodox religion and to reason posed by magic and by ritual are worries that Gombrich inherited from 'Christianity' and the 'Enlightenment', respectively. In assigning the confusion of art and life to a primitive stage in human history, he accepted the very evolutionary model of human nature that he had reproached Freud and Warburg for holding. In fact, art's possessive relationship to life has by no means diminished in ardour. In modernity it simply takes different forms.

Techne, the Greek word for art, is what man adds to nature. The ultimate aim of *techne* – the challenge – is the generation of life out of non-life. At that point, art would come to an end because man becomes nature. Art never quite lost sight of that self-annihilating goal.[15] Sculpture and painting tried to capture and deliver life. When in the nineteenth century mechanical and electric technologies, immeasurably more powerful than the traditional media, took up the challenge of animation, the idea that one might still be able to fabricate living images by hand came to seem quaint. More lifelike than any oil painting were the images of photography and cinema. But not everyone believed that these marvels belonged to a history of art. When Gombrich delivered his Mellon Lectures at the National Gallery of Art in Washington, DC in 1956, many in his audience surely believed that the ambitions of serious art and the largely commercial motivations

of cinema, including animated films, had parted company forever. The caprices of Disney Hollywood Studios, it seemed, were a puerile, trivialised extension of the dream of a 'second life' that had once sustained the great tradition of the making of art.

Many artists in the late 1950s and early 1960s, impatient with the pieties surrounding painterly abstraction, were emboldened to turn to the illusion-generating technologies. These were the years of video art, multimedia performances, Fluxus, Structural film; the years of the introduction of photography into conceptual practice; not to mention photorealism in painting. Like the old masters, whose obsessions with perspective or light effects Gombrich chronicled, these artists found no contradiction between control over representational technologies and the project of delivering the world a second time in order to make it strange; to make art, in other words. *Art and Illusion* is more easily contextualised within a history of modern art than within a history of modern art history.

Today, half a century after the book's publication, the moving image, the animated image, the interactive image, the moving body, the machine and the flow of information itself have all become basic components of artistic production. The stagings and restagings that have structured art since the late 1950s, from Fluxus to Happenings, from performance and installation art to the art of relation and participation, might well be understood as reinsertions of creativity into 'contexts of action', rituals and games, with the aim of collapsing reflective distance and reinvesting the work of art with life. This project looms once again as the vanishing point of art. Illusion reaffirms the body as art's central preoccupation. The body generates perceptions and memories which it then imitates by fabricating images beyond its own boundaries, such as paintings or films. The illusion is nothing other than an external image that has come to resemble very closely an internal image, thus seemingly abolishing the boundary of the body. The body merges with its environment and so postpones annihilation.

The fusion of *techne* with life as envisaged by the artist is less sensational but no less real than the artificial life hypothesised today in the robotics or the biology laboratory. Gombrich seemed aware in 1956 that he was standing at the brink of a completely new era, in art as much as in science, but was unable to peer over the edge. In *Art and Illusion* he found nevertheless a way to remind us that art is most art-like when it imagines what it would be like not to be art.

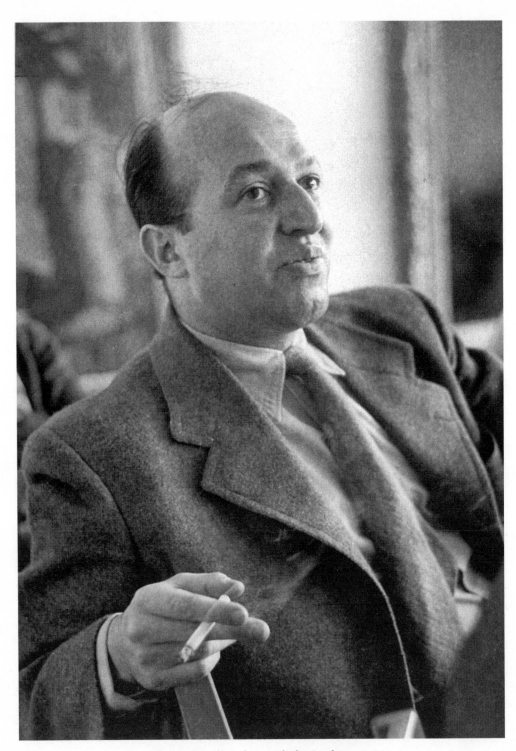

Clement Greenberg photographed in London, 1953.

Clement Greenberg

Art and Culture: Critical Essays, 1961

BORIS GROYS

THE ESSAY 'AVANT-GARDE AND KITSCH' (1939) that opens Clement Greenberg's *Art and Culture* (1961) remains the critic's most famous text, yet it is also his strangest.[1] It was obviously written with the intention of legitimising the avant-garde, of defending avant-garde art against its critics. However, it is difficult to imagine a text that would be less avant-garde in its main presuppositions and its rhetorical make-up. Texts from the epoch of the early avant-garde argue for the new and vital against the old and dead, for the future against the past. These texts preach a radical break with European art traditions – and in some cases even the physical destruction of traditional art. From Marinetti and Malevich, avant-garde artists and theoreticians expressed their unreserved admiration for a new technological era. They were impatient to abandon tradition and to create a zero point, a new beginning. They were only afraid that they lacked the will to break with tradition radically enough, to be new enough – to overlook something that should be rejected and destroyed but, instead, still connected their work to the art of the past. All works of art and texts of the historical avant-garde are dictated by this competition in radicalism, a will to find some traces of the past that others had overlooked, with the goal of completely erasing these traces.

Greenberg, however, starts his essay with the assertion that the avant-garde is a continuation of the great European artistic tradition, a way to 'keep culture moving in the midst of ideological confusion and violence' (p.5), and may even be described as a type of Alexandrianism. And he praises the avant-garde for being precisely such a continuation. For Greenberg the avant-garde is not an

attempt to create a new civilisation and a new mankind but an attempt at 'the imitation of imitating' (p.7) the masterpieces inherited by modernity from the great European past. If classical art was an imitation of nature, avant-garde art is an imitation of this imitation. According to Greenberg, successful avant-garde art reveals the techniques that traditional artists used to produce their works. In this respect an avant-garde artist is comparable to a well-trained connoisseur who is interested not so much in the subject of an individual work of art (because, as Greenberg states, this subject is mostly dictated to the artist from the outside, by the culture in which this artist lives), but in 'the disciplines and processes of art and literature themselves' (p.6). For Greenberg the avant-garde artist is indeed such a professional connoisseur, revealing the techniques that his or her predecessors used but ignoring their subjects. Thus, the avant-garde operates mainly by means of abstraction: it removes the 'what' of the work of art to reveal its 'how'. This shift in interpretation in the practice of avant-garde art, no longer understood as a radical, revolutionary new beginning, but as a thematisation of the techniques of traditional art – a 'superior consciousness of history' (p.4) – corresponds to a shift in the understanding of the politics of avant-garde art. Greenberg believes, namely, that the connoisseurship that makes the spectator attentive to the purely formal, technical, material aspects of the work of art is accessible only to those who 'could command leisure and comfort that always goes hand in hand with cultivation of some sort' (p.9). For Greenberg this means that avant-garde art can hope to get its financial and social support only from the same 'rich and cultivated' people who historically supported traditional art. Thus the avant-garde remains attached to the bourgeois ruling class 'by an umbilical cord of gold' (p.8).

To say to an avant-garde artist such as Marinetti or Malevich that he continues tradition instead of breaking with it is actually to insult him – and Greenberg knew this, of course. So why does he so obstinately insist on the avant-garde being a continuation of and not a break with traditional art? The reason, it seems to me, is more a political than an aesthetic one. Greenberg is not interested in avant-garde art per se, or even in avant-garde artists as producers of art – rather, he is interested in the consumer of art. The actual question that informs Greenberg's essay asks: who is supposed to be the consumer of avant-garde art? Or, in different terms: what constitutes the material, economic basis of avant-garde art, where that art is understood as a part of the societal super-structure? In fact, Greenberg is more concerned with establishing the socio-economic basis of avant-garde art than in analysing its utopian

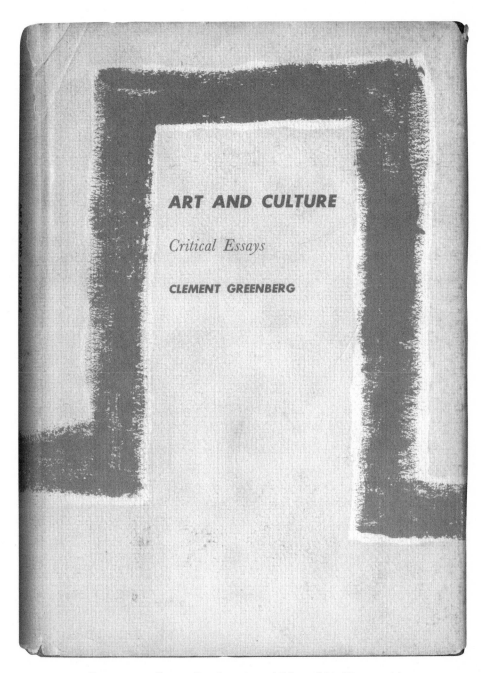

Front cover to Clement Greenberg, *Art and Culture: Critical Essays*, 1961.

dreams. This attitude reminds the reader of a question that tormented the Marxist revolutionary intelligentsia throughout the twentieth century: who is supposed to be the material, social recipient or, let us say, consumer of the revolutionary idea? It is well known that any initial hope that the proletariat could be such a driving material force bringing the Socialist revolution to realisation dwindled soon enough. Greenberg does not expect from the start that the half-educated masses could be consumers of avant-garde artistic revolutions. Rather, he finds it reasonable to expect that the cultivated bourgeoisie will support the new art. However, the historical reality of the 1930s brings Greenberg to the conclusion that the bourgeoisie is no longer able to fulfil the role of the economic and political supporter of high art. Time and again he states that the secured domination of high art can only be guaranteed by the secured domination of the ruling class. At the moment at which a ruling class begins to feel itself insecure, weakened and endangered by the rising power of the masses, the first thing that it sacrifices to these masses is art. To keep its real political and economic power the ruling class tries to erase any distinction of taste and to create an illusion of aesthetic solidarity with the masses – a solidarity that conceals real power structures and economic inequalities: 'the encouragement of kitsch is merely another of the inexpensive ways in which the totalitarian regimes seek to ingratiate themselves with their subjects' (p.19). Greenberg cites as examples the cultural politics of the Stalinist Soviet Union, Nazi Germany and Fascist Italy. But he also indirectly suggests that the American bourgeoisie follows the same strategy of aesthetic self-betrayal and false solidarity with mass-cultural kitsch in order to prevent the masses from the visual identification of their class enemy.

Ultimately, Greenberg sees no great difference between democratic and totalitarian regimes in their relationship to the avant-garde. Both regimes accept the taste of the masses to create an illusion of cultural unity between ruling elites and wider populations. Modern elites will not develop their own distinctive 'high' taste because they do not want to expose their cultural difference from the masses, nor to irritate them unnecessarily. This aesthetic self-betrayal of the modern ruling classes leads to a lack of support for any 'serious art'. In this respect Greenberg obviously follows conservative critics of modernity such as Oswald Spengler or T.S. Eliot – they and their writings figure throughout his criticism. According to these and similar writers, modernity leads to a cultural homogenisation of European societies. The ruling classes begin to think practically, pragmatically and technically. They become unwilling to lose their time

and energy through contemplation, self-cultivation and aesthetic experience. It is this cultural decline of old ruling elites that worries Greenberg in the first place – and thus, at the end of the essay, he expresses a more than vague hope for the coming victory of International Socialism (a codeword for Trotskyism) that would not so much create a new culture as secure 'the preservation of whatever living culture we have right now' (p.21). In an uncanny but very instructive way these final words of Greenberg's essay remind the reader of the main principle of Stalinist cultural politics reiterated innumerable times through all the Soviet publications of the same historical period: the role of the proletariat is not so much to create a new culture, but rather to appropriate and secure the best of what world culture has already created, because this heritage was betrayed by the bourgeoisie by its submission to Fascist rule – and by its support of the decadent, destructive, elitist avant-garde.[2] In fact, Greenberg's understanding of art was not very different from the famous Stalinist definition of writers and artists as 'engineers of the human soul'.

However, it should not be overlooked that in allying vanguard art with the high art of the past Greenberg found a new enemy for the avant-garde: kitsch. This he defines in a far more original way than the avant-garde: 'Kitsch is mechanical and operates by formulas. Kitsch is vicarious experience and faked sensations. Kitsch changes according to style, but remains always the same. Kitsch is the epitome of all that is spurious in the life of our times' (p.10). Greenberg radically displaced the avant-garde by dehistoricising the opposition between avant-garde and non-avant-garde. Instead of being understood as an opposition between the art of the past and that of the future, it became an opposition between high and low art inside the same modern, contemporary, present culture. According to the traditional, historicist scheme, the avant-garde was an artistic manifestation of modernity just as Renaissance, Baroque, Neo-classicism or Romanticism were artistic manifestations of earlier historical epochs. And there is no doubt that the artists of the historical European avant-garde shared this view. Greenberg himself speaks at the beginning of his essay of historical reflection as a precondition for the emergence of the avant-garde. But he also indicates that this succession within historical art ignores folk art and describes only the art history of the ruling class. Now, Greenberg believes that in modernity the art taste of the masses can no longer be ignored. Accordingly, the kitsch that is understood by Greenberg as an artistic manifestation of this mass taste also cannot be ignored. The conflict between different historical formations is substituted here by a class conflict inside the same

Capitalist modernity. The true achievement of 'Avant-Garde and Kitsch' is not Greenberg's theory of the avant-garde but his discovery of kitsch as a specific artistic formation. In the best Marxist tradition he turns his attention to the art of the oppressed classes and puts it at the centre of his cultural analysis – even if his own aesthetic attitude towards this art remains extremely negative. It is not accidental that 'Avant-Garde and Kitsch' served as a starting point for the analysis of the culture industry undertaken by Theodor Adorno and Max Horkheimer in their *Dialectic of Enlightenment* (1947). Even today our understanding of mass culture remains deeply indebted to 'Avant-Garde and Kitsch' because it is still informed by an opposition between mass culture and 'high' avant-garde art.

Of course, Greenberg was not the first writer who had reacted to the growth of modern mass culture. But this mass culture was mostly understood by avant-garde artists and writers simply as a sum of leftovers from previous cultural epochs that would disappear under the influence of the new avant-garde art, which would embrace the whole of society. European avant-gardes believed that the disappearance of these remnants of the past was inevitable because the laws of artistic progress are intimately connected to those of technological and social progress. On the contrary, Greenberg argues in his essay that kitsch is not simply a residue of previous epochs but a thoroughly modern phenomenon – in fact, as modern as the avant-garde itself. For Greenberg, kitsch reflects the sensibility of the modern masses who, precisely because of that, prefer kitsch to the art of the past. At the same time kitsch is a product of new technology and the new social order to an even greater extent than avant-garde art, because the avant-garde is still analysing the masterpieces of the past instead of simply using them as does kitsch, which borrows from a 'fully matured cultural tradition [. . .] its devices, tricks, stratagems, rules of thumb, themes, converts them into a system, and discards the rest' (p.10). In fact, Greenberg is very pessimistic about the historical prospects of the avant-garde, which he considers increasingly economically and politically abandoned, together with the high art of the past. But he is at the same time highly optimistic about the prospects of kitsch, which he sees as being a progressively more successful – if also extremely unpleasant and even hateful – competitor of the avant-garde. However, these two competitors are too heterogeneous in their goals and strategies to enter any genuine competition. Kitsch substitutes traditional art – the avant-garde simply analyses it. By discovering kitsch as a distinct phenomenon, Greenberg opens the way for the new avant-garde to analyse kitsch just as the historical avant-garde analysed

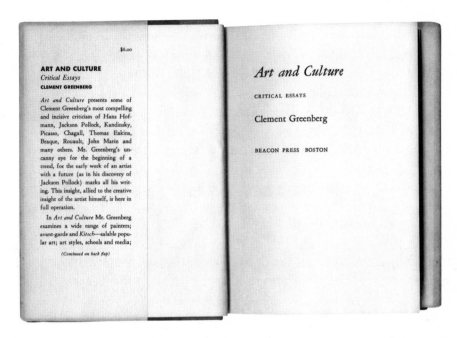

Title-page and front flap of the dustjacket to Clement Greenberg, *Art and Culture: Critical Essays*, 1961.

the art of the past. One can argue that without this Greenbergian discovery of kitsch as a specific aesthetic and artistic domain, Pop art and Conceptual art, as well as different practices of institutional critique, would be impossible, even if their representatives liked to criticise Greenberg, and notwithstanding the fact that these practices were not endorsed by Greenberg himself. In fact, he recast kitsch as the only true aesthetic manifestation of modernity, the true heir of the glorious art of the past. Greenberg redefined the avant-garde by reducing it to the role of analytical and critical interpreter of this art. The next step could only be to transfer this analytical approach from traditional art to its legitimate heir – namely, kitsch. Not accidentally, this critical attitude towards mass-cultural kitsch is time and again accused of being elitist and reflective of the arrogant, anti-democratic attitudes of the ruling bourgeoisie.

However, even if one is ready to agree with Greenberg that the avant-garde is not a truly innovative, creative and prophetic break with the past but merely a technical analysis of its art, it remains hard to believe that this techno-analytical attitude reflects the aesthetic taste of the bourgeoisie. Obviously, the ruling elites are not interested in the production of art but only in its consumption, even if their taste is more refined than that of the masses. De facto, Greenberg gives to

avant-garde art a definition that puts it beyond any possible evaluation by taste – be it popular or elitist. According to Greenberg, the ideal spectator of avant-garde art is less interested in it as a source of aesthetic delectation than as the source of knowledge, of information about art production, its devices, its media and its techniques. The art here ceases to be a matter of taste and becomes a matter of truth. In this sense one can say that avant-garde art is, indeed, autonomous – as modern science is autonomous, for example in being independent of any individual taste and political attitude. Here the famous Greenbergian 'autonomous art' ceases to be a synonym for 'elite taste' and 'ivory tower'. It becomes instead simply a manifestation of technical mastery and knowledge that is accessible and instructive for everybody who is interested in analysing and possibly acquiring such mastery and knowledge. Greenberg thus sounds more realistic when he says that avant-garde artists are artists' artists. But this insight seems to disappoint him because it does not provide avant-garde art with any solid social basis. It is like saying that revolution is only interesting for revolutionaries – which could also be true but remains somehow depressing. For Greenberg, artists are bohemians living without a secured position in a society in which they are working. That is why he assumes that a taste for truth is a minority concern, especially in the case of artistic truth understood as artistic technique. This answer seems to be correct if one has traditional or avant-garde art in mind. However, it ignores the fact that the popular spreading of art, be it also kitsch, presupposes a growing involvement of the masses not only in the consumption of art but also in its production. Already the work of Russian formalists, whose theory of the avant-garde was understood as an analysis of the purely formal, material 'made-ness' of the work of art, was used by Greenberg to refer to the fact that works of art are technically produced objects in the world and that they should therefore be analysed in the same terms as objects such as cars, trains or planes. From this perspective there is no longer any clear difference between art and design, between a work of art and a mere technical product. This constructivist, 'productivist' point of view opened the possibility of seeing art not in the context of leisure and informed contemplation, but in terms of production – in terms that refer more to the activities of scientists and workers than to a lifestyle of the leisure class. In fact, Greenberg follows the same line of reasoning when he praises the avant-garde for demonstrating techniques of art, instead of simply using its effects.

The second essay included in *Art and Culture*, titled 'The Plight of Culture', was written after the War, in 1953. Here, Greenberg insists even more radically

on the productivist view of culture, citing Marx as his most important witness. He states that modern industrialism devalued the concept of leisure – even the rich must work and are subject to the rule of efficiency as a measure of achievement, rather than being distinguished by their mastery of leisure activities: 'The rich themselves are no longer free from the domination of work; for just as they have lost their monopoly on physical comfort, so the poor have lost theirs on hard work' (p.31). That is why Greenberg agrees and disagrees at the same time with the diagnosis that T.S. Eliot gave to modern culture in his book *Notes Towards the Definition of Culture* (1948). Greenberg agrees with Eliot that traditional culture based on leisure and refinement had gone into a period of decline because modern industrialisation compels everyone to work. But at the same time Greenberg writes: 'The only solution for culture that I conceive of under these conditions is to shift its centre of gravity away from leisure and place it squarely in the middle of work' (p.32). Indeed, the abandonment of the traditional ideal of cultivation through leisure seems to be the only possible way out of innumerable paradoxes that were produced by Greenberg's attempt to connect this ideal with the concept of the avant-garde. He writes further about the proposed solution: 'I am suggesting something whose outcome I cannot imagine' (p.32). And again: 'Beyond this speculation, which is admittedly schematic and abstract, I cannot go [. . .] But at least it helps if we do not have to despair of the ultimate consequences for culture of industrialism. And it also helps if we do not have to stop thinking at the point where Spengler and Toynbee and Eliot do' (p.33).

The difficulty of imagining culture as situated 'in the middle of work' has its roots in the Romantic opposition between work of art and industrial product, an opposition that still informs Greenberg's writing even when he praises the avant-garde for shifting the attention of the spectator from the content of art to its technique. This is why Greenberg comes to the somewhat counter-intuitive assumption that only the ruling class, excluded from the production process, has enough leisure time to contemplate and aesthetically appreciate the technical in art. In fact, one would expect this kind of appreciation rather from the people who are immediately involved in the production of art. And, of course, the number of such people permanently grew over the course of modernity, and has grown exponentially in recent times. At the end of the twentieth and beginning of the twenty-first centuries art entered a new era – namely, an era of mass artistic production that followed the era of mass art consumption, as it was described by many influential theoreticians: as an era of kitsch (Greenberg), of 'cultural industry' (Adorno) or as a society of spectacle (Guy Debord). This was

Clement Greenberg and his wife Janice van Horne share a joke
at an event in New York, late 1950s or early 1960s.

the era of art that was made for the masses, of art that wanted to seduce and be consumed by the masses. Now, the situation has changed. There are primarily two developments that have led to this change. One is the emergence of new technical means of image production and distribution, the other is a shift in our understanding of art, a change of the rules used for the identification of what is and what is not art.

Contemporary design gives to the same populations the possibility of shaping and experiencing their own bodies, homes or workplaces as artistic objects and installations. Contemporary art has thus become a mass-cultural practice. Today's artist lives and operates primarily among producers of art, not among its consumers. For a long time this everyday level of shared artistic practice remained overlooked, even if many art theorists such as the Russian formalists, or artists such as Duchamp, tried time and again to attract our attention to modern everyday life as a field of art. In our own time everyday life has become even more artificial, theatricalised and designed. Today, the artist shares art with the public as earlier they shared with it religion or politics. To be an artist has ceased to be an exclusive fate – instead, it has become representative of society as a whole on its most intimate, everyday level.

Thus, one can say that in contemporary society the roles of the producer and the consumer of art have been combined, resulting in an ambiguous relationship between the individual and the work of art. On the one hand, as producers and, therefore, as consumers of art, we are attentive to the technical side of art with a goal to learn from, imitate, modify or reject. In this sense contemporary man looks at art necessarily by means of an avant-garde perspective, with an awareness of its technicality, its 'made-ness'. On the other hand, the same contemporary man is able simply to enjoy the effects of art without giving much attention to its technique, thus perceiving this art as kitsch. One can therefore argue that the distinction between avant-garde and kitsch, as introduced by Greenberg, does not describe two different areas, types or practices of art but, rather, two different attitudes towards art. Every work of art – and every object, for that matter – can be seen and appreciated from the avant-garde and from the kitsch perspectives. In the first case one is interested in its techniques, in the second case one is interested in its effects. Or, to put it in a different way, in the first case one looks at art as a producer and in the second case as a consumer. These two different attitudes cannot be rooted in the class structure of modern society because everybody has to work and everybody has time for leisure. Thus, our perception of art is permanently shifting between the avant-garde and kitsch. The opposition that Greenberg described as macro-cultural defines, in fact, the aesthetic sensibility of every individual member of contemporary society.

Francis Haskell photographed in Rome, c.1964.

Francis Haskell

Patrons and Painters: A Study in the Relations Between Italian Art and Society in the Age of the Baroque, 1963

LOUISE RICE

IN THE PREFACE to the third and (as he described it) final edition of *Patrons and Painters*, written shortly before his death in 2000, Francis Haskell reminisced about his earliest sojourns in Rome and the genesis of the book that, more than any other, established his reputation as one of the leading art historians of his generation.[1] It was the early 1950s. Haskell had come to Rome to write a dissertation on art and the Jesuits, but almost as soon as he arrived he began to expand the scope of his inquiry. As he immersed himself in the city's artistic riches, studying the works of the great Baroque painters in the churches and palaces for which they were made, he found that what most intrigued him were not the traditional questions of attribution and dating, style and iconography, but rather 'the character, social status, wealth, political ideas, and religious convictions of the men who commissioned the art'. And so he set out to see what he could discover about 'the goals and ambitions of those mysterious patrons who instilled such a powerful creativity in the artists who worked for them'. The resulting book, published in 1963, surveys the role of the patron–collector and his influence on the production of art in Italy over a period of nearly two centuries, from the glory days of the high Baroque in papal Rome to the beginnings of Neo-classicism in eighteenth-century Venice. A pioneering example of a new kind of social art history and still today, half a century after it was written, the single most comprehensive treatment of its subject in any language, *Patrons and Painters* offered a refreshingly different perspective on Italian Baroque art, one that has influenced scholarship in the field ever since.

At that time, the study of patronage was still regarded by many as ancillary to the core objectives of art history. Documentation pertaining to patrons and their collections was sought mainly to establish the authenticity, date and pedigree of works of art, rather than to shed light on the motivations and intentions of those who commissioned the works in the first place. Admittedly, attitudes were changing as contextual approaches to the study of art gained ground. In the field of Renaissance art, important contributions on individual patrons had long since paved the way, and more recently scholars like Martin Wackernagel had begun systematically to integrate patronage into the bigger picture, analysing the parameters of the patron–artist relationship and investigating the logistics of artistic production in quattrocento and early cinquecento Florence.[2] But no comparable overview existed for the later period. And what Haskell had in mind, in any case, was something rather different – a collective socio-cultural history of the men who, through their sponsorship and employment of painters, helped shape the character and determine the direction of Italian Baroque art. Haskell himself described his project as falling 'half way between History and Art History' (p.xix). He perhaps meant by this to acknowledge his debt to the great cultural historians of the past, in particular Jacob Burckhardt and Johan Huizinga, whose use of art in the analysis of history he much admired. But the phrase says more about how narrowly art history was defined fifty years ago than about the intrinsic interdisciplinarity of his approach. No one today would seriously question that the subject of his book falls squarely within the purview of art history. Indeed, the study of patronage in all its manifestations has become so central to the best current scholarship on Baroque art that it is hard to remember it was once considered peripheral.

The book is remarkable both for its geographical and chronological range and for its teeming cast of characters. It is divided into three parts. The first and most substantial treats seventeenth-century Rome, focusing on the decades before, during and after the Barberini pontificate (1623–44). An opening chapter looks at the relationship between patron and painter and the social and professional framework within which it operated. Subsequent chapters explore a diverse assortment of patrons and collectors, organised according to broad categories (the papal court, the church, the nobility, the professional classes, etc.). We are introduced, one by one, to the pope and his nephews; select members of their inner circle who helped shape Barberini taste and promote the family's cultural agenda; aristocratic collectors renowned for their discrimination; leaders of religious orders struggling to raise funds to pay for the decoration

of their churches; art-loving lawyers and doctors who financed their collecting habits by dealing on the side; and even the anonymous consumers at the bottom of the heap, who filled their modest quarters with cheap pictures of a kind that rarely survives. Not all painters had patrons, and Haskell also investigates how less well-established artists found customers either by relying on the services of professional dealers and middlemen, or, in rare cases, by exhibiting their works directly to the public at the annual church-run picture shows that were a curious feature of the Roman art scene. Even as conventional modes of aristocratic patronage continued unabated, a 'democratisation of art' (p.140) was afoot as the market evolved to accommodate a growing public.

In part two, attention shifts away from Rome to other parts of Italy and beyond. Royal patrons at the major courts of Europe were keen to acquire the works of Italian painters, as were Spanish viceroys and ambassadors, French ministers, the first wave of British Grand Tourists and assorted German prince-electors, whose penchant for pictures of nudes accounts in part for the success of artists such as Guido Cagnacci, churning out sexy Cleopatras, Bathshebas and Didos for a transalpine clientele. In Italy, too, patrons living in provincial towns far from the centres of power were able to buy from the best and to amass important collections of contemporary art. The collectors treated in part two often had no direct or personal acquaintance with the artists whose works they sought but dealt with them through agents or by correspondence.

In the third and final part, Haskell deals with painting in eighteenth-century Venice and the fortunes of Venetian painters both at home and abroad. As the city's economic and political power declined, so its importance as an international centre of the art trade grew. The patronage of the great patrician families, still decorating their palaces and villas with grandiose visions of their own past glory, is contrasted with that of dealer–collectors such as Consul Smith, who acted as Canaletto's agent and was a major player in the profitable business of selling pictures to Grand Tourists and collectors at home, or the urbane Francesco Algarotti, agent to Augustus of Saxony, who played a formative role in assembling the superb collection at Dresden. The disruption of traditional aristocratic life brought about by the French occupation of Italy and the fall of the Venetian Republic in 1797 led to a breakdown of existing systems of patronage and the dispersal onto the international art market of many of the great private collections of Italy.

Taking an inductive approach, Haskell tackles the general by focusing on the particular. Each chapter (apart from the first) is structured around a series of case

studies or profiles of individual patrons and collectors. The profiles are generally brief – rarely more than a few pages long and sometimes as short as a paragraph – but each gives a sense of the man, his place in society, his personality and taste, as well as his habits of commissioning and collecting art. The book thus has something of the character of a narrative prosopography, or group biography. The goal of the prosopographer is to reveal the constants and variables that characterise a given group by surveying the individuals who make up that group. The persons explored in *Patrons and Painters* had in common a keen interest in the pictorial arts and the means to commission or acquire them. Studying these men collectively enabled Haskell to uncover the general patterns and conventions that governed Baroque patronage. But it also gave him a structure within which to emphasise the uniqueness of each individual case and to demonstrate how differences of temperament, inclination, social status and personal and historical circumstance conditioned each patron's relations with the artists who worked for him and distinguished his patronage from that of anyone else. The reader comes away with the impression that, within the wider definition of the phenomenon, there were as many varieties and scenarios of patronage as there were patrons.

By subtitling the book 'Art and Society in the Age of the Baroque', Haskell was deliberately positioning it within the social history of art. It is worth remembering that in the 1950s, when he first conceived the study, social art history was a field largely defined and dominated by Marxist scholars such as Frederick Antal and Arnold Hauser.[3] Without explicitly alluding to these authors, Haskell offered a clear alternative to the deterministic, ideologically driven approaches embodied in their work. His is a social art history based not on any preconceived economic or class models but on a pragmatic assessment of the archival and other primary data. When he described his own method as 'severely empirical', he may have been trying to distinguish himself from this older generation of philosophically entrenched social art historians. 'I have been forced to think again and again about the relations between art and society', he wrote in the preface to the first edition, 'but nothing in my researches has convinced me of the existence of underlying laws which will be valid in all circumstances' (p.xviii). Connections there certainly are between art and the society that produces it, but they are infinitely complex, variable and contingent on human and historical factors.[4]

It should come as no surprise, then, that the book posits no general theory of patronage, no universal model applicable across different cultures and chronological periods. Haskell was manifestly uninterested in theory, and wary of generalisations and abstractions of any kind.[5] It is noteworthy that nowhere in

Front cover to Francis Haskell, *Patrons and Painters: A Study in the Relations
Between Italian Art and Society in the Age of the Baroque*, 1963.

this defining text on patronage is the term 'patronage' defined. Nor is it the only concept left, as it were, to speak for itself. Although the book is as much about collecting as commissioning works of art, the distinction between the two activities is never articulated. The author saw no need to belabour or complicate the point, trusting the reader to understand that, even though they were often one and the same, not all patrons collected and not all collectors were patrons. Terms like collector, connoisseur, amateur, agent, dealer, critic and customer are not synonymous, but nor are they mutually exclusive, and a patron could be any or all or none of these things.

Not long after the publication of *Patrons and Painters*, Haskell contributed the entry on patronage to the *Encyclopedia of World Art* and in it summarised what he considered to be the primary goal of all studies of patronage, namely 'an appraisal of the effect of patronage on the nature (type and content) and esthetic quality of the work of art'.[6] The pre-modern patron generally maintained a good deal of control over the pictures he commissioned, so much so that he might almost be considered in some ways a participant in the creative act. It was up to him, if he was so inclined, to dictate the dimensions, the medium, the number and length of the figures, the direction of the lighting, the subject-matter and (especially if unconventional) the iconography; he could even have a say in the design process by requiring the artist to submit a preparatory drawing or oil-sketch for his approval. But where his influence is much harder to detect is in that ineffable area of 'esthetic quality'. Could the patron, by imposing his own personal taste, influence the artist's style? Or was it inevitably the artist's style that shaped the patron's taste? At issue is one of those unresolvable chicken-and-egg dilemmas, fun to mull over but impossible to pin down. At times, Haskell gives the patron the upper hand, as when he attributes Pietro da Cortona's invention of a neo-Venetianising style to the influence of his patron Marcello Sacchetti,[7] or when he traces a certain strain of Baroque classicism to the antiquarian taste of Cassiano dal Pozzo.[8] But elsewhere it is the artist whom he acknowledges as the primary generating force in the partnership. When he speculates that Tiepolo's 'marvellous gifts and brilliance of execution created a need for his art fully as much as they satisfied it' (p.253), he puts his finger on the driving compulsion that binds painter and patron: the eternal dialectic between beauty and desire.

The book is not without its idiosyncrasies. Divided as it is mainly between Rome in the seventeenth century and Venice in the eighteenth, it reads in some ways more like two books than one. Haskell justified his decision to halt his survey of Roman patronage around the year 1680 by arguing that painting in Rome went

Interior spread discussing the relationship between Nicolas Poussin and his patron
Cassiano dal Pozzo, with plates showing works by Bernini, Claude Mellan and
Ottavio Maria Leoni. From Francis Haskell, *Patrons and Painters: A Study in the
Relations Between Italian Art and Society in the Age of the Baroque*, 1963.

into a steep decline after that date. In his view, the last couple of decades of the
seventeenth century and the beginning of the eighteenth marked 'an essentially
second-rate epoch' (p.164) characterised by a 'breakdown of taste' (p.158). Value
judgments of this kind are out of fashion these days and, in any case, the more we
have learned about Roman patronage of the later period, the less tenable seems
Haskell's dismissive view of it.[9] There is no doubt that art in Rome did undergo a
profound change towards the end of the century; Bellori's exclusion of Cortona,
Bernini and Borromini – the three artists whose names are virtually synonymous
with the Roman Baroque – from his *Lives of the Modern Painters, Sculptors and
Architects* (1672) marks a crucial turning point. But a change in the prevailing style
does not in itself imply either a quantitative or a qualitative decline in patronage,
and by omitting late seventeenth- and eighteenth-century Rome from the study,
he missed an opportunity to develop a meaningful comparison between Rome
and Venice, two centres of artistic activity with very different political conditions
and social structures.

Whatever its shortcomings, most would agree that *Patrons and Painters* ranks among the founding modern texts for the study of the Italian Baroque, on a par with works such as Emile Mâle's *L'art religieux après le Concile de Trente* (1932) and Rudolf Wittkower's *Art and Architecture in Italy 1600–1750* (1958). It brought a new level of intellectual rigour and excitement to a field still struggling to overcome the aesthetic prejudices that had clung to it for centuries. By emphasising the patron's perspective, it offered a socio-cultural framework for exploring the meaning and function of art. It vividly demonstrated the value of archival research, and the importance of primary sources generally, for advancing an understanding of seventeenth- and eighteenth-century art. And, in addition, it opened up new areas of investigation to serious scholarly study, including the history of collecting, the history of museums and exhibitions and, more generally, the history of taste and its permutations, subjects that came to the fore, particularly in British academic circles, in the decades following the book's publication. Indeed, Haskell himself went on to do fundamental work in all of these areas, even as his primary focus shifted from the Baroque to the nineteenth century.[10]

The book has generally enjoyed great critical acclaim. When it first appeared, its reviewers were unanimous in recognising not only the significance but also the outstanding originality of its contribution.[11] Later, as the discipline came increasingly under the sway of theory, the response was not always quite so positive. One scholar, commenting on Haskell's tendency to analyse works of art in terms of the 'describable historical conditions' of their production, intimated that he had not fully grasped or capitalised on the radical implications of his own approach;[12] others expressed dissatisfaction with his reliance on case studies and his reluctance to synthesise.[13] But *Patrons and Painters* is not what one would call a controversial book and the sheer virtuosity of its scholarship has tended to disarm those who might otherwise have argued with its methodological straightforwardness.

Of course today, almost fifty years after its publication, other questions arise. How well has it held up against the flood of scholarship that has succeeded it? Is it still essential reading now that patronage studies have so thoroughly entered into the art-historical mainstream and the art-in-context approach has become so very much the norm? Researchers following in Haskell's footsteps have not only turned up additional information about virtually every one of the individuals he explored; they have also uncovered whole areas and categories of patronage overlooked by him. For instance, recent scholarship on the role of women – on 'matrons as patrons' and nuns as patrons – has shown up a significant lacuna

in the book which, apart from scattered references to a few of the 'first ladies' of Europe (Marie de' Medici, Olimpia Maidalchini, Queen Christina of Sweden, etc.), takes no account of the phenomenon of female patronage nor considers the factors that distinguished it from the patronage of men. In short, new approaches and new interpretations have deepened and refined our understanding of almost every aspect of Baroque patronage, from its use in promoting political, diplomatic, dynastic, economic, religious and institutional agendas to its place in the complex intersecting networks of social obligation that underpinned communal life in pre-modern Italy.

Yet for all that there is hardly a page of Haskell's book that could not be updated, supplemented and, in some instances, significantly modified in the light of new research, its overarching narrative remains full of insights and profoundly stimulating.[14] When it was written, the book provided a kind of prolegomenon to a branch of art history that was still in its infancy. It introduced the dramatis personae whose commissioning and collecting activities helped determine the course of Italian art for the better part of two centuries, and laid down a road map for future research. Half a century later it is still read and still admired, less perhaps for the novelty of its content or its approach, than as a lucid and erudite introduction to its subject. Based almost exclusively on data drawn from primary sources, it remains a treasure trove of documentary information and is still a point of reference for most scholars active in the field today.

It is not a given that the most influential books are also the most entertaining to read, but it is so in this case. Haskell's approach to history is characterised by his focus on individuals: who they were, how they lived and what preoccupied, inspired or motivated them.[15] The first-time reader of *Patrons and Painters* experiences something rather like what the author himself experienced when, as a young man, he first started working in the archives and knew 'the unforgettable thrill of discovering a whole new world, whose inhabitants so resembled my own friends, colleagues, rivals, and enemies that I felt I could easily understand them, for all the aura of mystery surrounding them . . .'.[16] Haskell's vivid historical imagination, his fascination with personality and his keen interest in the human relationships that nourished and sustained artistic activity animate every page of the book and account, as much as anything else, for its enduring appeal.

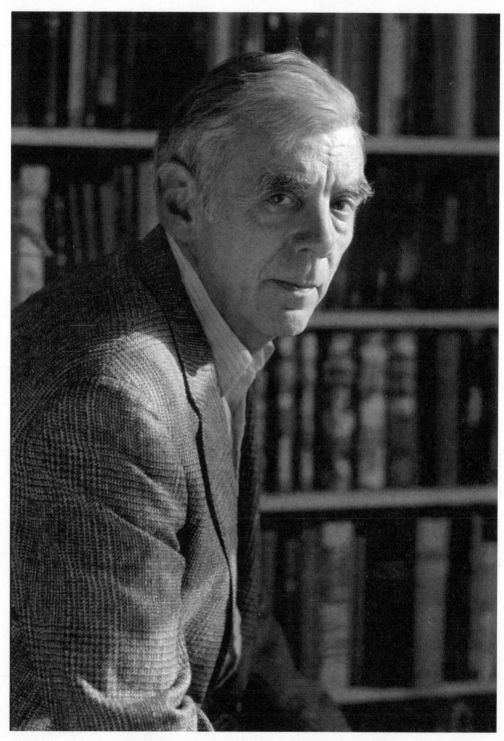

Michael Baxandall photographed at home in London, November 1989.

Michael Baxandall

Painting and Experience in Fifteenth Century Italy: A Primer in the Social History of Pictorial Style, 1972

PAUL HILLS

PAINTING AND EXPERIENCE IN FIFTEENTH CENTURY ITALY is one of the most celebrated and most misunderstood books of the past forty years. Its opening sentence, 'A fifteenth-century painting is the deposit of a social relationship', is so succinct and so programmatic that it is more often remembered than the book's subtitle, 'A Primer in the Social History of Pictorial Style'. In the preface Michael Baxandall underlined the message of the subtitle by declaring that the lectures that the book grew out of 'were meant to show how the *style* of pictures is the proper material of social history'. In two short paragraphs he used the word style four times, arguing that 'visual skills and habits become identifiable elements in the painter's style'. Those art historians in the later 1970s and 1980s who eagerly embraced the first sentence as a manifesto for the social history of art tended to overlook the fact that for Baxandall a new kind of social history, more nuanced and supple than that of Arnold Hauser or Frederick Antal, could only emerge by close engagement with – and reflection upon – pictorial style and the style and inflections of the language used to discuss and describe paintings.

It is easy to explain why this aspect of *Painting and Experience* was overlooked while the emphasis upon social history was embraced. As young scholars in the 1970s, my contemporaries and I were bored by the analysis of style as an aid to defining an artist's *œuvre*, or as a means of tracing genealogies of influence and narratives of stylistic change. The history of style as practised in some quarters seemed far too insulated from a broader understanding of history and culture. But the history of style as something generated and confined purely within the domain

of art was not Baxandall's concern. Rather, he was attempting to elucidate something more subtle that involves modes of living, the agency of working and using tools, and the communication of skills and experience in the medium of language.

The first edition of *Painting and Experience*, published by Oxford University Press, was distinctive in both appearance and content.[1] Although a hardback, its small format and modest production values suited its designation as a 'primer' and set it apart from the cloth-bound volumes on art of the middle decades of the century published by Phaidon. It was intended to be affordable for a wide readership and addressed, as the author writes in the preface, 'to people with a general historical curiosity about the Renaissance rather than to people just interested in Renaissance painting'. The presentation is marked by restraint. The acknowledgments are practical rather than intellectual; all relate to the provision of illustrations. There is no separate bibliography and, instead of footnotes, a section of 'References' is placed at the back guiding the reader to the publications in which the primary sources can be found. No modern authors or secondary sources are mentioned in the text and only a handful, other than those containing the primary texts, are mentioned in the 'References'. These include Rudolf Wittkower's *Architectural Principles in the Age of Humanism* and Sixten Ringbom's *Icon to Narrative*. Unlike the practice that has become dominant in subsequent decades, there is no proliferation of footnotes, no scholarly name-dropping, no parading of academic allegiances. Ulrich Middeldorf, in his review in the *Art Bulletin*, criticised the author for failing to acknowledge earlier publications, such as Julius von Schlosser's *Kunstliteratur* and Martin Wackernagel's *Lebensraum des Künstlers in der florentinischen Renaissance*.[2] Although in the second edition of 1988 Baxandall added a few references, including one to the recent English translation of Wackernagel, as well as inserting the texts in the original Latin or Italian, leanness in presentation was preserved.[3] This was intentional, and it was an enduring characteristic of Baxandall's scholarly style. In the preface to *Shadows and Enlightenment* (1995), for example, he declared that 'in the case of art history the referencing is deliberately minimal', pointing out that the field is 'choked with repetitious bibliographies'.[4]

This might seem a trivial aspect of *Painting and Experience* but it accords with the project of those Italian humanists who wished to strip away the accretion of scholastic commentary and to cut to the quick of the original text. Attention to the roles of text, author and reader, together with intensity of moral evaluation, was a crucial legacy of Baxandall's study of English at Cambridge under F.R. Leavis.[5] Direct engagement with primary sources, attending to the close grain of

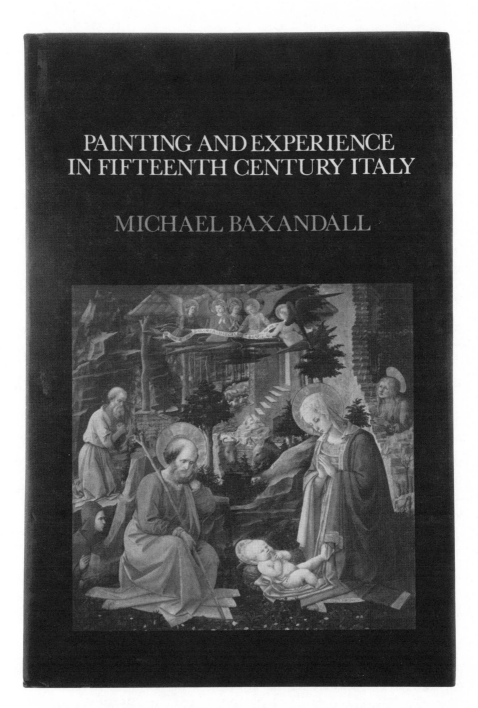

Front cover to Michael Baxandall, *Painting and Experience in Fifteenth Century Italy:
A Primer in the Social History of Pictorial Style*, 1972.

language and how it functioned, had underpinned the argument of Baxandall's first book, *Giotto and the Orators: Humanist Observers of Painting in Italy and the Discovery of Pictorial Composition 1350–1450* (1971).[6] It was his work on this, together with a series of groundbreaking articles in the *Journal of the Warburg and Courtauld Institutes*, that did the heavy lifting that cleared the way for him to write his 'primer' very quickly in the space of the summer of 1971.

The style of *Painting and Experience* is as distinctive as the presentation. The speed with which it was written is evident in the writing, which is as sprightly and precise as the steps of the *bassa danza* described by Lorenzo de' Medici and cited in the text (pp.78–80). In the preface Baxandall writes that it might be judged 'flighty', but in fact however daring the hypothesis, however high he leaps to draw an imaginative parallel, the argument is controlled and checked. This is exhilarating because we feel we are being taken on a quest rather than presented with a cut-and-dried body of facts, let alone a theory. Reading and looking with Baxandall is an invitation to engage with the unfamiliar and difficult, and to learn new skills of inferring and drawing analogies. We are prompted to reflect upon our own perceptions and judgments and to note how they differ from those, for instance, of a merchant in fifteenth-century Florence.

The title of the book deserves comment. The choice of the word 'experience' and its associations with anthropology in the mid-twentieth century have been noted, but the choice of 'painting' rather than the more inclusive 'art' is also worth pondering.[7] In the 1960s Penguin had launched a series, edited by Hugh Honour and John Fleming, under the rubric *Style and Civilization*. As an undergraduate at the time, I remember these paperbacks as affordable, highly readable and novel in the way they ranged across media and situated the art of a period or movement in a wider context than was usual in monographs or museum publications. In the series, Michael Levey's *Early Renaissance* and John Shearman's *Mannerism* were both published in 1967. *Mannerism*, in which Shearman drew parallels between characteristic forms in music and the visual arts, impressed Baxandall when he read it some years later.[8] Given his expertise in the field of Renaissance sculpture, acquired as Assistant Keeper at the Department of Architecture and Sculpture at the Victoria and Albert Museum between 1961 and 1965, when John Pope-Hennessy was Keeper, it is striking that he chose to write a book in which the visual matter consisted of paintings and prints, rather than one like those in the *Style and Civilization* series which encompass a range of arts.[9] This alerts us to the fact that, like his close friend Michael Podro and his future co-author Svetlana Alpers, Baxandall was essentially interested in how painters and their public constructed

and perceived pictorial depictions, how they exercised and developed pictorial intelligence, and how this related to the special nature of the painter's representational medium. Rather than treating painting and sculpture in a single volume and subsuming them in a discussion of the style and civilisation of a period, he attended to the special properties of each medium in turn: thus his next book, published in 1980, was *The Limewood Sculptors of Renaissance Germany.* But in the longer term it was the central place of the pictorial – of how the three-dimensional world can be rendered and perceived on a two-dimensional surface – in a distinctively European tradition that intrigued him. The subtitle of *Giotto and the Orators*, 'Humanist observers of painting in Italy and the discovery of pictorial composition 1350–1450', announced Baxandall's engagement with the pictorial in a key formative phase, and that continuing engagement underlies *Painting and Experience*. It is true that this is implicit rather than explicit in the book, and only obvious in the light of Baxandall's later pronouncements, but nevertheless the role of depiction, whether as mental exercise or physical act of delineating, is central to the argument. This has been neglected by those who regard the book as an exercise in contextual art history.

Although Baxandall is silent about intellectual debts in *Painting and Experience*, in his memoir and interviews in later years he acknowledged two books that in their different ways addressed the pictorial. The first was one of a select number of works of art history he read as an undergraduate, and which proved to be an enduring favourite, Heinrich Wölfflin's *Classic Art*. He valued the last section, entitled 'The New Pictorial Form', because it 'seemed to offer some basic critical categories', and it was a passage in Wölfflin which prompted the choice of the subject of 'Restraint' in Renaissance behaviour as a thesis topic, which he embarked upon under the tuition of E.H. Gombrich as Junior Research Fellow at the Warburg Institute.[10] The second book was Gombrich's own *Art and Illusion*, delivered as the Mellon lectures in 1956 but only published in 1960, the year after Baxandall arrived at the Warburg. Although Gombrich ranged over many media – including Greek sculpture – his overriding concern was with the pictorial, as the subtitle, 'A study in the psychology of pictorial representation', makes plain. As Baxandall later recalled, *Art and Illusion* was eagerly discussed chapter by chapter in a study group at the Warburg, and he was particularly impressed by Gombrich's account of projection.[11] Wölfflin's pictorial categories and Gombrich's emphasis on what the beholder brings to the viewing of painting both indirectly inform the account of painting and its public in *Painting and Experience*.

Before turning to the book's reception, let us consider its division into three parts. Each is in some sense provisional; each tries out a different argument. The first, entitled 'Conditions of Trade', examines contracts, letters and accounts 'to find an economic basis for the cult of pictorial skill'. The central thesis is that during the course of the fifteenth century there was a progressive shift among clients and the art-commissioning public from esteem for precious materials, such as gold leaf and blue pigment made from lapis lazuli, towards esteem for skill. 'It would be futile', he writes, 'to account for this sort of development simply within the history of art' (p.14). Instead this shift is explained in broadly Marxian terms by exploring how both parties, the painter and the client, 'worked within institutions and conventions – commercial, religious, perceptual, in the widest sense social – that were different from ours and influenced the forms of what they together made' (p.1). Notice that Baxandall does not set up a crude opposition here between the paymaster-client calling the shots and the painter bending to his will, but rather posits something being 'made together', something shaped by the common ground of institutions and conventions, as well as more elusive moral values.

We may get closer to Baxandall's nuanced concept of the agency of the patron, or what he prefers to call the client, by comparing it with that put forward by Francis Haskell in his seminal book, published in 1963, *Patrons and Painters: A Study in the Relations Between Italian Art and Society in the Age of the Baroque*.[12] Both scholars acknowledge the importance of the patron and of the institutions that governed the relationships between artists, patrons and critics, but Baxandall – unlike Haskell – is not especially interested in patrons or collectors as personalities and eccentrics. He does not present them as case studies or as figures that might be interesting in themselves, but rather as witnesses to something larger and more difficult to apprehend. It is a matter of shared perceptions, and it concerns the question of how a work of art comes to take a particular form within a given society. Baxandall's notion of how the perceptual processes of artist and client were both mutually inflected by the institutions and conventions in which they operate is not foreshadowed in *Patrons and Painters*. In an interview of 1994 he paid tribute to Haskell's work on Tiepolo but confessed that Haskell's approach was 'not something I'm particularly interested in pursuing'.[13] *Painting and Experience* is about skills in the vernacular world of work and how they are exercised in depiction, rather than the history of taste or institutions.

Baxandall was his own most severe critic. Never entirely satisfied by his account of the conditions of trade in Part I of *Painting and Experience*, he refined

it in Chapter IV of *The Limewood Sculptors of Renaissance Germany* and again in his discussion of 'the brief' which is a recurring topic of *Patterns of Intention*.[14] He wrote to me in 1993 that 'a direct and penetrating address to the pictures' was what he missed 'in current art history writing'; and in an interview five years later he confessed his unease at 'being lumped with the social history of art'. One senses his dismay that his account of the conditions of trade in *Painting and Experience* appeared to have given rise to studies of Renaissance art that paid little heed either to the specifics of artistic style or to questions of perception. It led him to dismiss the first part of his book as inadequate.[15]

By contrast, it was Part II, 'The Period Eye', in which Baxandall articulated his most influential ideas about perception and 'the cognitive style', which he regarded as most productive. His term 'the period eye' has entered the language of art history. To reread the pages in which he first launches the idea, then tests it and refines it, is to be reminded of what a flexible, multifaceted concept he formulated compared with the often rather reductive version of it invoked by later art historians. Opening with a section entitled 'Relative Perception', Baxandall lays out the optical basis of vision before proceeding to show how the configuration of lines in a printed plan of the Holy Sepulchre were seen differently according to 'the habits of inference and analogy' of the viewer. These habits of inference, meshing with the complex processes of perception, form the basis of the cognitive style shared by painters and their public. As the argument proceeds it is clear that Baxandall's focus is on a cultivated public, one that might exercise skills that were analogous to those they used in their business and daily life, such as the gauging of barrels or learning the steps of a dance, when looking at paintings.

This much has become well known: what deserves note in the light of later trends in art history is how Baxandall envisages the relationship between religion, civic life and painting. In the late 1960s Florentine studies were still dominated by a heroic conception of liberty and enlightenment fostered by the great mid-twentieth century scholar of civic humanism, and refugee from Nazi Germany, Hans Baron.[16] Following Baron's lead, art historians – including Gombrich – had exalted the civic humanists as standard bearers of freedom and of progressive tendencies in fifteenth-century Florentine art while they neglected the pervasive role of religion. Baxandall, who knew his humanists well, declared – only half in jest – that 'church-going and dancing business men', including Lorenzo de' Medici, are a more 'representative type of the Quattrocento man than some that are current – "civic humanist", for example' (p.109). In his discussion entitled

'The function of images', he led the way in restoring the centrality of religious images and their use in daily life to the understanding of fifteenth-century painting. The distinction between 'progressive' and by implication humanist art on the one hand, and traditional religious art on the other, was discarded.

One might see this as part of a religious turn in Renaissance studies which gathered force in the 1980s and was to lead in time to detailed accounts of how friar-painters were shaped by the context of their religious orders and fifteenth-century movements of reform, including William Hood's *Fra Angelico at San Marco* and Megan Holmes's *Fra Filippo Lippi: The Carmelite Painter*.[17] But we should distinguish this phase from the later emphasis upon the role of cult images, attributable in some measure to the influence of Hans Belting's *Bild und Kult*, which was published in German in 1990 and in an English translation as *Likeness and Presence: A History of the Image Before the Era of Art* in 1994.[18] As Jeffrey Hamburger points out in Chapter 16 of this book, Belting's overwhelming emphasis on cult images in the later Middle Ages undervalues the enduring importance of other types and genres, notably narrative.[19] Indeed, the current fascination with the agency of such objects as relics or miracle-working images, often of little artistic distinction, is very different from Baxandall's. After an incisive discussion of the Church's view of the function of images, he reformulates the question by asking 'What sort of painting would the religious public for pictures have found lucid, vividly memorable, and emotionally moving?' (pp.43–45).

Once again we are brought back to perception and redirected to the specific qualities of fifteenth-century depiction. The pages that follow are among the most searching and perhaps the most unresolved in the book. They reveal a peculiar tension that exists between Baxandall the art critic – who in an interview with Allan Langdale said that 'I still think of myself of doing Roger Fry, you know, in a different way' – and Baxandall the broadly Marxian historian.[20] Looking at the *Transfiguration* by Giovanni Bellini, a painter to whom Fry had devoted a monograph, Baxandall remarks on 'its hypertrophy of the weightily concrete and eloquently patterned at the permissible expense of the particular' (p.48). This is an acute observation of an art-critical nature. Reading the paragraph in which this insight is offered, one notes how the author twists and turns to incorporate it into his conceptual schema. Tellingly, the programmatic opening sentence of *Painting and Experience*, 'A fifteenth-century painting is the deposit of a social relationship', is now reconfigured as something looser: 'The painting is the relic of a cooperation between Bellini and his public.' Baxandall the critic describes something very illuminating about Bellini's style, but in this

Interior spread showing drawings by Pisanello and after Leonardo da Vinci. From Michael Baxandall, *Painting and Experience in Fifteenth Century Italy: A Primer in the Social History of Pictorial Style*, 1972.

instance the explanation – that Bellini could count on the missing particular 'being contributed by the other side' – seems forced.

It is in the pages that follow, in which Baxandall discusses fifteenth-century paintings of the Annunciation in the light of contemporary sermons, that he achieves a more precise and successful way of thinking about the contribution the public might bring to reading and empathising with an image. By following the phases of the 'mystery' of the Annunciation and the gamut of emotions experienced by the Virgin Mary, as clearly laid out by the preacher, we apprehend what the fifteenth-century beholder might have brought to paintings of this subject.

Many scholars in their books and countless students in their essays have used these pages to sharpen their own accounts of what is happening in a fifteenth-century religious painting. Baxandall's preference for drawing upon sermons to gauge what a relatively literate public might find vividly memorable and emotionally moving in a painting is rather different from the emphasis of later scholars on liturgy and cult. He restores religious images to a central place

in any discussion of fifteenth-century art, but he does not separate them from the skills and perceptions that informed daily life.

At the end of Part I, after acknowledging the limitations of contractual documents in affording any sense of the hallmarks of a painter's style, Baxandall turned to a description of the qualities of contemporary painters written by an agent of the Duke of Milan (pp.23–27). In his commentary on this memorandum he brings into play the kind of linguistic analysis of texts that he had deployed in *Giotto and the Orators*. He concludes on a typically candid note of caution, observing that 'when we look at the paintings (by Botticelli, Filippino, Ghirlandaio) we can give a sense, our sense, to the Milanese agent's remarks, but it is unlikely that this sense is his' (p.27).

This introduces an abiding interest in how different languages and their syntax inflect or channel perceptual priorities. Deploying his own agile command of language Baxandall teased out these distinctions, savouring the strangeness and particularity of words, from *Giotto and the Orators* to his final collection of articles, *Words for Pictures* (2003), and his posthumously published novel, *A Grasp of Kaspar* (2010).[21] And it was language which was the principal focus of Part III of *Painting and Experience*, entitled 'Pictures and Categories'.

In *Giotto and the Orators* he had explored how the different syntax and sentence structure of Classical Latin and vernacular Italian constrained or enabled critical discrimination, and it is this that he takes up again. But alerted by Baxandall's tributes to Wölfflin we may now recognise that the idea of structuring his discussion around sixteen terms drawn from Cristoforo Landino's description of the painters of his time – including 'ease, grace, ornateness, variety, foreshortening and blitheness' – echoes the last section of *Classic Art* where Wölfflin described 'the new pictorial form' under four heads or groups of qualities: repose, spaciousness, mass and size; simplification and lucidity; complexity; unity and inevitability. Focusing on the distinctions drawn by an art critic, Landino, and inspired by a critical procedure of Wölfflin's, Baxandall directs the reader to reflect upon the value and limitations of art criticism. Unlike much art-historical writing its primary intent is not to convey a body of knowledge, and it frustrates us if we look for a conclusion. Indeed the exposition arouses some perplexity, for on the one hand we are shown that many of the terms employed by Landino are derived from Classical rhetoric and are rather arbitrarily imposed upon the art he describes, while on the other hand Baxandall's exposition lends a certain authority to the terms as if they had become the basis for the classification of styles. But if we recognise the procedure as an exercise in criticism, we may view it as heuristic, provisional and

open rather than proscriptive. In a discipline dominated by regard for empirical research, excessively reliant upon contextual information, this is a procedure that has become unfamiliar.

Painting and Experience was not an overnight success. It received comparatively few reviews. Middeldorf in the *Art Bulletin* was highly critical. John Shapley, in an enthusiastic review that appeared in the *Art Journal* as late as 1976, observed that *Painting and Experience* had received less attention than *Giotto and the Orators*. Giles Robertson in a brief notice in *The Burlington Magazine* wrote that 'it would be hard to think of a more valuable book to put into the hands of students of Renaissance painting'.[22] In interviews in the 1990s Baxandall admitted that 'one writes to irritate partly', and was taken aback that it was not the art historians he associated with the Courtauld Institute of Art whom he ended up irritating but rather senior scholars at the Warburg, including Gombrich, who felt that the period eye was simply a new version of the tainted notion of *Zeitgeist*. The author voiced disappointment that the book did not reach its intended audience of historians, although in the longer term it undoubtedly reached a wider audience of cultural historians and anthropologists, including Pierre Bourdieu and Clifford Geertz, and already in the later 1970s it attracted the attention of Marxist art historians, notably T.J. Clark. Clark admired aspects of the book, but criticised *Painting and Experience* for its failure to address the question of ideology. As Langdale has discussed this broader intellectual reception in some detail, I will not cover the same ground here but rather focus upon its reception within the field of Renaissance studies.[23]

The influence of *Painting and Experience* has been enormous and fragmented. The discussion of the conditions of trade has prompted many publications on 'the business of art'.[24] The most significant books on Italian Renaissance art published in English since 1972 pay homage to the period eye.[25] But few of them engage in any detailed manner with what Baxandall calls 'relative perception' and its habits of inference and analogy. Baxandall's attention to language has drawn renewed attention to the role of critical terms, memorably in David Summers's *Michelangelo and the Language of Art*.[26] But at the same time many surveys of Renaissance art include excerpts from primary sources in translation alongside the text in separate boxes entitled 'The Contemporary Voice', 'The Patron Speaks' or the 'The Artist Speaks' as though their language was transparent or neutral. Baxandall's lesson that syntax and sentence structure constrain thought is overlooked.

The most common criticism of *Painting and Experience* is that it conceives of audience too narrowly. Evelyn Welch, for example, in her widely used volume

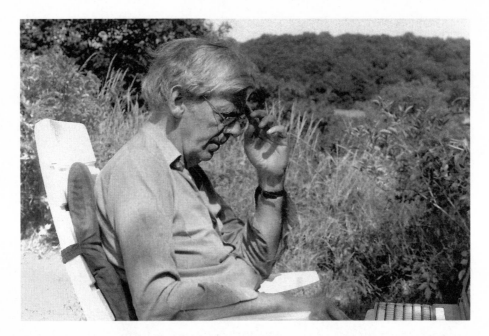

Michael Baxandall at his computer in the garden of his home, 1990s or early 2000s.

in the Oxford History of Art, published in 1997 and originally entitled *Art and Society in Italy 1350–1500*, writes:

> This book is very indebted to the idea of the period eye, but I would suggest we need to multiply our vision, sensitizing our understanding of the many different ways and possibilities of seeing and observing objects which existed in the past. [27]

On the face of it this is odd because Baxandall's account of the period eye already offered multiple ways of understanding how paintings were seen and observed, but the real target here, reflecting the lessons of gender studies and feminist art history, is that Baxandall's typical viewer of art is an educated male. More recently, Patricia Rubin in her book *Images and Identity in Fifteenth-Century Florence* (2007) has made the most wide ranging and powerful use of Baxandall's method by any scholar to date. In the section entitled 'The Eye and the Beholder', she offers an extended argument that 'the reading of pictorial style or social experience as envisioned and as viewed need not be restricted to the notional Renaissance man of the picture-buying class'.[28] Whereas Baxandall claimed that 'peasants and the urban poor play a very small part in the Renaissance culture

that interests us now', Rubin points out, with some reason, that they were nevertheless witnesses to sacred ritual and public spectacle and by implication responsive to its imagery.

This mix of admiration for the concept of the period eye with criticism that Baxandall's fifteenth-century beholder was too narrowly defined, both in terms of gender and social standing, is broadly representative of where current published scholarship stands. One might add that the trend towards 'de-civilising' the Renaissance is also largely at variance with Baxandall's focus on depictions that put a cultivated audience on their intellectual mettle, and which in turn may put us on our intellectual mettle. The evaluation of artistic quality has become deeply unfashionable. A few years ago I overheard an eminent scholar lecturing to students on a study abroad programme in the choir of S. Francesco at Arezzo. They were told much about the patrons and even more about the stories of the True Cross in the Golden Legend but not a word was said about Piero della Francesca's mastery of design and colour. Critical evaluation was avoided. It may be that, as John Paoletti and Gary Radke put it in the introduction to their survey *Art in Renaissance Italy*, published in 1997, that 'aesthetics were not the driving force behind the commission and creation of works of art', but order and clarity of design, beauty in short, *were* a priority.[29] Baxandall teaches us that style permeates every aspect of behaviour and that it has a moral dimension. To neglect qualities of style, and how choices between styles were made in quattrocento society, is to miss something essential. The danger today is that a generation of art historians is being trained without much ability to read the *style* of pictures – rather than their content – as proper material of social history. It is too sophisticated to be a 'primer', but returning to *Painting and Experience in Fifteenth Century Italy* is now more salutary than ever.

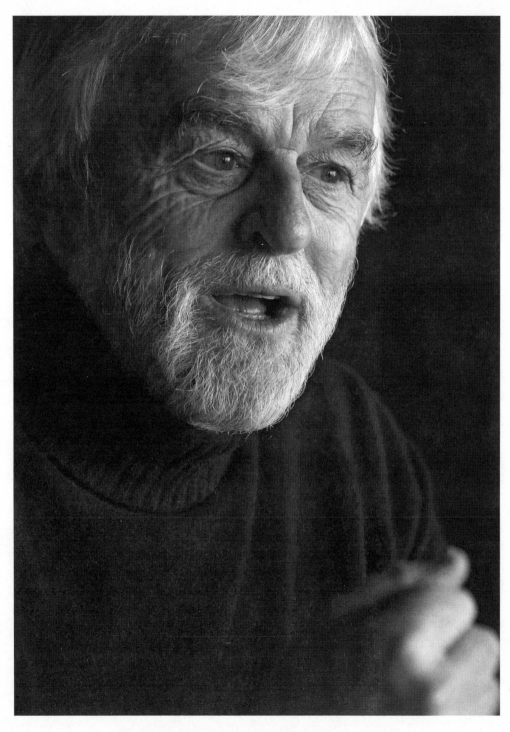

T.J. Clark talks with journalists in Madrid during the presentation
of a new book on Picasso, 24th November 2011.

T.J. Clark

Image of the People: Gustave Courbet and the 1848 Revolution, 1973

ALASTAIR WRIGHT

TOGETHER WITH ITS COMPANION volume, *The Absolute Bourgeois: Artists and Politics in France, 1848–1851*, T.J. Clark's *Image of the People* is rightly seen as one of the founding texts for what has perhaps been the dominant art-historical approach of the last three decades or so: the social history of art. Thus the statement of purpose with which Clark begins – 'This book sets out [...] to discover the actual, complex links which bind together art and politics in this period' – sounds more familiar today than it did at a time when, he suggests, writing on modernism was dominated by 'the history of an heroic *avant-garde*' and by formalist celebrations of 'an art of pure sensation'.[1] There is a danger for us in the apparent familiarity of Clark's argument: art history – perhaps the social history of art most of all – has not always learned the lessons offered by the book (a subject to which we will return later). But for some of the book's first readers a rather different danger seemed to present itself, as Alan Bowness, reviewing *Image of the People* for *The Burlington Magazine*, made clear: 'The tone is strident, even hectoring at times [...] Baudelaire or Champfleury or Courbet [...] become actors on a stage, playing roles assigned to them for reasons of historical inevitability.'[2] For Bowness the problem was that the book seemed partisan, fitting the facts to a predetermined political schema and thus lacking the allegedly neutral objectivity of mainstream art history. Such objectivity was, of course, a myth, but Bowness was right to spy partisanship: *Image of the People* wears its allegiances firmly on its sleeve.

The discipline-reshaping first chapter, 'On the Social History of Art', treats general questions of method from an avowedly Marxist – or, more accurately,

neo-Marxist – perspective. Indeed Clark's first move is to dismissively summarise orthodox Marxism's mechanical view of art as the reflection of the dominant ideology of an age: 'Courbet is influenced by Realism which is influenced by Positivism which is the product of Capitalist Materialism. One can sprinkle as much detail on the nouns in that sentence as one likes; it is the verbs which are the matter.'[3] Why the verbs? Because they imply a one-way street, with the economic organisation of society (the 'base') determining everything else – all the other legal, cultural and artistic forms (the 'superstructure') that passively follow wherever the 'base' leads. In the preface to the 1981 edition of *Image of the People*, Clark was to make explicit what the chapter's title had merely implied: that Arnold Hauser's *Social History of Art* (1951) was the prime example of this mistaken approach.[4] In its stead Clark proposes that art be credited with a more active role: 'The making of a work of art [. . .] is a series of actions in but also on history [. . .] A work of art may have ideology (in other words, those ideas, images, and values which are generally accepted, dominant) as its material, but it *works* that material; it gives it a new form and at certain moments that new form is in itself a subversion of ideology.'[5]

Such subversion is necessary, Clark suggests, because ideology blinkers our view of the world. The art historian 'studies blindness as much as vision'.[6] Clark takes aim here at E.H. Gombrich: 'the problem of schema and pictorial tradition is rather altered. The question becomes: in order to see certain things, what should we believe about them?'[7] That is to say, it is ideologies and not apolitical pictorial schemata – as Gombrich had proposed in *Art and Illusion* (1960) – that limit an artist's vision. Clark reminds us of the Prince in Henry James's *The Golden Bowl*, a man who simply does not *see* 'below a certain social plane' (a shopkeeper stands before him, but the Prince registers nothing of him beyond his brute presence). Such blindness, Clark suggests, 'is a nineteenth-century disease', and art was for the most part infected.[8] *Image of the People* has at its heart the question of how Courbet nevertheless found visual forms adequate to the task of bringing an image of the people into view, and what that view looked like.

In 1973 Clark was not alone in expressing reservations about the 'base-superstructure' model. Nicos Hadjinicolaou, whose Marxist *Art History and Class Struggle* appeared in the same year, entertained similar doubts.[9] But in Hadjinicolaou's analysis of specific works of art those doubts evaporated as he offered highly generalised readings of the visual ideology of an age – almost always, for him, the reflection of the ruling class's ideology (in the nineteenth century, that of the middle class in full ascendancy). Clark explicitly avoids such

Front cover to T.J. Clark, *Image of the People: Gustave Courbet and the 1848 Revolution*, 1973.

epochal history, focusing on the narrow span of the Second Republic (1848–51), and is far more precise about class: there was, he notes, 'more than one middle class and more than one class struggle'.[10] Indeed, Clark is more precise about everything. The methodological positioning of the opening chapter is followed by five chapters whose combination of fine-grained historical and visual analysis with an explicitly articulated theoretical framework sets *Image of the People* apart both from mainstream Western art history in the early 1970s and from the usual practice of Marxist art history from which Clark was, if anything, even more keen to distinguish his own approach.

The second and third chapters, which examine the Courbet myth and the artist's canny production of his own image in his self-portraits of the 1840s, treat the historical material – the writings of Courbet and his supporters; the critics' grumbles or nods of approval; and the assorted connotations of artistic bohemia in mid-century Paris – with a subtlety and a precision of critical source

analysis (no document is taken at face value as straight historical evidence) that undoubtedly owes much to Clark's years as an undergraduate historian at Cambridge. (The meticulous treatment of historical examples probably explains why academic historians took to the book rather more quickly and fully than would some art historians; from the start, *Image of the People* was well reviewed in history journals.)[11] Clark's Courtauld training (*Image of the People* and *The Absolute Bourgeois* appeared – quite remarkably – in the same year that Clark completed the Ph.D. from which they are drawn) is equally apparent in the compelling accounts of individual works of art that punctuate the text and very often do the work of carrying the argument forward. If this is Marxism, it is a variety that takes very seriously the visual qualities of the image. The fourth chapter continues in the same vein, scrutinising Courbet's ambivalent involvement – and that of his friends (Baudelaire and Champfleury, most notably) – in the events of 1848 and 1849.

The fifth and sixth chapters, in many ways the real meat of the book, treat at length the reception of Courbet's major paintings of 1849–50, detailing how viewers in different locations – Besançon, Dijon and Paris – responded in specific ways to the paintings. Here Clark is most clearly distinct from writers like Hadjinicolaou: pictures are not seen as representing a fixed ideology but rather as intervening in ideology in different ways in different situations (the meaning of a painting will change, that is to say, according to where, when and by whom it is seen). Clark is also in these chapters at his most concrete both about the wider historical context – in particular the rapidly shifting political allegiances of the countryside, considered not as a unity but as an endlessly differentiated array of classes, regions, towns and villages, each with their own particular history – and about the pictures and their own histories. He examines how they work their source material (most importantly the conventions and ideological implications of popular imagery); by whom they were seen (the question of the public – real or imagined – is central to Clark's investigation of the paintings as 'actions in but also on history'); and what the critics had to say (or found themselves unable to say) about them. This attention to how a specific historical conjuncture – *these* paintings in *this* exhibition in front of *these* viewers – generated ideological significance could not be further removed from Hadjinicolaou's schematic account of Courbet's Realism as the product of a rising middle class and Capitalist materialism. Clark's central claim, again, is that the art historian must attend to the 'actual, complex links which bind together art and politics' if anything at all is to be understood of how the wider historical context makes its way into the work of art.

If Cambridge and the Courtauld played their part in the formation of the book, Clark's critical engagement with Marxism suggests that Bowness was close to the mark when he objected to the book having been 'conditioned by the intellectual climate and political conditions of Paris in [the] late 1960s'.[12] As so often, the hostile critic gets it at least partly right, although Clark would not have had to cross the Channel to acquaint himself with recent developments in Western Marxism: witness the bibliography's citation of articles from the London-based *New Left Review*. Nevertheless, a year in Paris at the Centre National de la Recherche Scientifique (1966–67) was undoubtedly crucial in offering first-hand exposure to the heady mix of Marxism and psychoanalysis (Sigmund Freud and Jacques Lacan also figure in the bibliography) that characterised Continental thought in the 1960s. Certainly that mix left its mark on the text. Listen, for example, to the 'analogy with Freudian theory' that Clark proposes in the first chapter to explain his approach to period criticism: 'Like the analyst listening to his patient, what interests us, if we want to discover the meaning of this mass of criticism, are the points at which the rational monotone of the critic breaks, fails, falters [. . .] [T]he points where the criticism is incomprehensible are the keys to its comprehension.'[13] More important than the nod to the authority figure here is the work Clark makes the analogy do. The approach – and this will be true in looking at paintings as well as listening to critics – is to identify those places where the discourse does not add up, where what is being said (or painted) shows itself to be riven by only-ever-partially masked disjunctions.

What this means in practice will be clearer if we look at Clark's analyses of one or two of Courbet's works. Consider the account in the third chapter of the famous self-portrait *Man with a pipe* (1846): 'for the first time in Courbet's art an image holds contradictory meanings. The picture is built of two parts, which work for the most part against each other: the fragile, provocative face in the centre, and round it the ragged frame of hair and beard. Inside the oval, evenly lit but with shadowed lids, the smoker's features are vulnerable and delicate [. . .] But the head as a whole is stronger, different, deliberately unkempt and aggressive.'[14] After scanning the image for contradictions, Clark interprets these as a sign that the subject is divided against himself: 'It is the first time Courbet is equivocal about himself, which in this case is a sign of progress.'[15] Why progress? Because, in good Freudian fashion, the subject is revealed to be composed of divergent and not necessarily compatible fragments. Of course, this is not quite Freudianism: Clark has little interest in psychobiography. Rather, what the picture's disjunctions reveal are the contradictions in the construction of artistic

bohemia and in Courbet's imagining of himself in relation to it. Was bohemia tied to the *classes dangereuses* and to working-class Paris, or was the bohemian 'the bourgeois playing at being a bourgeois'?[16] Was the bohemian merely a late Romantic, absorbed in his own dreams (Clark compares the smoker's features to Courbet's arch-Romantic *Despairing man* of 1842), or was he a political radical, aggressive, provocative and challenging the bourgeoisie? Less Freud, then, than Marx: the disjunctions that threaten the unity of any discourse – of the self or of society – find their origin in tensions between and within classes.

For Clark, such equivocation and indeterminacy are what politics is made of. Hence the central place given to the *Burial at Ornans*. Before Clark, the standard account held that the picture was rather straightforwardly Socialist in its orientation. This was evident, it was argued, in its promotion of ordinary folk to the size of painted monarchs; in its materialist concentration on the here-and-now (and associated denial of the spiritual); and in its putatively democratic composition (the sort of 'intuitive analog[y] between form and ideological content', as Clark disdainfully puts it, that interprets 'the lack of firm compositional focus [as] an expression of the painter's egalitarianism').[17] Clark reads the evidence very differently. Starting from the observation that what most disturbed the painting's first viewers was their uncertainty as to its meaning,[18] he argues that the threat posed by the picture lay in its indeterminate depiction of class – an indeterminacy deriving from its portrayal in a rural setting of a mass of figures wearing the modern bourgeois uniform of the black frock-coat. One critic saw 'rustic men and women, some of whom are bourgeois'; another saw the 'deplorable and vulgar peasant'.[19] None could quite name what they saw, their efforts to do so leaving only 'the traces of a radical uncertainty; almost, one might say, the remnants of something the critics preferred to repress'.[20] Again the Freudian inflection of the argument is clear. And again, its Marxist orientation is equally to the fore: the Parisian middle class was shocked because one of its founding myths (here Clark cites Lévi-Strauss on myth),[21] namely that city and country were absolutely distinct – the former modern and structured by class hierarchies, the latter a unified and timeless idyll – was punctured by the *Burial*'s blurring of the line between peasant and bourgeois and between the habits of town and country. Courbet's image of the people is one that refuses its subject any coherence. This, in turn, rendered less secure the urban bourgeoisie's own identity, for it was upon the myth of a stable urban–rural divide that the Parisian bourgeoisie secured their position: not upon the economic base, but upon the structures of thought that allowed them to forget how fragile their status was, how thin the line between them and what lay below.

VII GUSTAVE COURBET *The Meeting* 1854

Interior spread discussing the political situation in France c.1850, with
an illustration of Courbet's 1854 painting *The meeting*. From T.J. Clark,
Image of the People: Gustave Courbet and the 1848 Revolution, 1973.

The thrust of the argument, then, is that stable structures were called into question by Courbet's painting, and that this was more challenging to its audience than any open declaration of Leftist dogma would have been (the latter, although potentially threatening in 1848 or 1850, would ultimately have reinforced middle-class identity, securing it in its opposition to the baying mob). For Clark, art resists power most effectively not by direct opposition but by undoing the structures of thought upon which power's operation rests. Thus (at least in part) his faith in the value of art. Hauser and Hadjinicolaou tended to see art as a tool of the ruling class and were resigned to the fact that efforts at oppositional art under Capitalism always ended in failure (recuperation ever the fate of even the most radical art). They saw Courbet in precisely these terms: one must not, Hauser cautioned, make 'a prophet out of a confusedly chattering painter and a historical event out of the exhibition of an unsaleable picture [the *Burial*]'.[22] For Clark, 'confusedly' is the key: the *Burial* was ultimately more subversive – more effective – than Socialist banner-waving precisely because it introduced confusion into the urban bourgeoisie's sense of the world and of their place within it.

It may well be that the Right found this more troubling than straightfor-ward opposition. Those on the Left were for the most part equally unimpressed: 'nobody wanted the massive, ironic presentation of a rural bourgeoisie. The Left – or rather, its artistic spokesmen in Paris – wanted a glorification of the simple rural life, or perhaps a straightforward portrayal of its hardships [. . .] The Right and Centre wanted a preservation of the rural myth.'[23] Thus, although Clark some-times suggests a broader, more popular audience lurking just off-stage,[24] he for the most part does not push the claim that Courbet's art spoke to the values of this public. Indeed this 'public' was as much the educated critics' nightmare fantasy as it was a fact on the ground. The artist's famous reliance on compositions drawn from popular imagery is only secondarily seen as signalling an allegiance to the art and – by extension – to the values of the people. Clark is more interested in two questions: first, how the forms of popular imagery allowed the painter to see 'below a certain social plane', to offer an image – however confused – of the people; second, how Courbet made strategic use of popular art's habitual mixing of tone, translated in the *Burial* into 'the collision of religious and secular, the abrupt movement within the same canvas from gravity to grotesque', in order to undo stable meaning (which is to say, to undo the very image of the people that popular art had itself made possible in the first place; we sense here something of the densely intertwined nature of Clark's argument).[25]

Two observations suggest themselves at this point. The first has to do with the credit given to the work of art – and not to any work of art, but to the rare (very rare) examples that are seen as having rendered less secure the structures of thought upon which power rests. Indeed it is a work of literature – Balzac's *Les Paysans* – that stands as about the only work, besides the paintings of Courbet, said to pass muster (Clark quotes approvingly from Pierre Macherey's Marxist analysis of Balzac's text).[26] Clark might be accused of reinstating – albeit in a radically altered form – the old story of great art's (or literature's) greatness resid-ing in its rich complexity (a story that by and large leaves the canon intact). There may be a grain of truth in such carping, but Clark makes no claim to be writing any other sort of history (this is not visual culture *avant la lettre*); and he would claim – rightly so, the historical evidence suggests – that Courbet's work *did* baffle the critics more than any other, implying that some pictures just may be more complex and more intractable than others, or were experienced as such in their day.

The second, related observation is that a more complex image of the artist emerges from Clark's account. Courbet becomes a rather different kind of Leftist

hero: not a run-of-the-mill Socialist, glorifying the worker or documenting the ills of Capitalist society (this is why the *Stonebreakers* cannot be Clark's key example: it looks too obviously engaged). Instead we have a much more ambivalent figure. At times the suggestion seems to be that the contradictions end up in the *Burial* unwittingly: 'It does not concern us whether the ambiguities I have pointed out were consciously or unconsciously devised: they are nonetheless *there*.'[27] Again the Freudian inflection of Clark's Marxism is clear: the disjunctions that promise to dismantle ideology's representations are something of which the painter himself might not be aware. Like the critics, Courbet – or his painting – is put on the couch. At other times, Clark intimates that the ambiguities on view in Courbet's work are the result of a deliberate strategy on the painter's part: 'to adopt the procedures and even the values of popular art [as Courbet did in the *Burial*] – that was profoundly subversive.'[28] The language in the first chapter is even more suggestive of an active subject: there Courbet is said to 'juggle with meanings, switch codes, lay false trails'.[29]

All this suggests that there are two models at work in Clark's book. Alongside the Freudian-Marxist (the label, of course, vastly oversimplifies), which has the artist as unwitting subject, is another – not unrelated – model that finds its roots in a more activist strain of 1960s Parisian thought. Clark, as we have noted, had been reading the *New Left Review*, but he would later voice reservations about what he saw as the journal's willed silence on the subject of the Situationist International (SI), a loose grouping of Marxist anti-Capitalists best known for its prominence during May 1968 and for an influential text, *The Society of the Spectacle*, written the year before by its founder, Guy Debord.[30] Clark himself had joined the SI in 1966, although relationships were not always cordial: along with the other English members, he was officially excluded a year or so later. But he remained (and remains) attached to the group's ideas, and his account of Courbet juggling with meanings parallels in suggestive ways one of the SI's key models of political activity: *détournement*. The strategy was simple, and often took art as its object: an already existing painting was altered – painted over, slogans inscribed into its surface, and so forth – in such a way that its previous meaning was undone, overturned or shown to be contestable.[31] The resonance with Clark's account of Courbet seems clear.

It would be a mistake, however, to tie Clark's account too closely to a single strand of SI thought – or indeed to any particular camp. The richly varied lines of argument in *Image of the People* cannot be pinned down with any such dogmatic certainty to this or that aspect of the intellectual context of the 1960s. But that

context as a whole is clearly determining. *Image of the People* draws in general terms from what Leftist politics – certain strains of it, at least – was becoming in the later 1960s. It also draws in the most concrete way on the particular situation in which Clark found himself as he wrote the book. As he notes in the 1981 preface, *Image of the People* and *The Absolute Bourgeois* were 'written for the most part in the winter of 1969–70 [in the library of St Anne's College, Oxford], in what seemed then (and still seems) ignominious but unavoidable retreat from the political events of the previous six years. Those events haunt the books' best and worst pages'.[32] Haunt, but do not mar. The book may be grounded in 1968, in Paris, London and (a year or so later) an Oxford library: how could it not be? So, too, Clark's pessimism – 'After Courbet, is there any more "revolutionary" art?'[33] – may reflect the bitter aftermath of May 1968 as much as that of February 1848. But I would wager that it was his sense of the contradictions of his own time that allowed Clark to think as deeply as he did about the contradictions both in Courbet's own life and in the society around him.

We have noted Bowness's reservations about Clark's approach. Clark returned fire in the 1981 preface: 'reviews in such places were unfailingly – nay hypnotically – daft.'[34] But to give Bowness his due he was not entirely unsympathetic, noting in the book 'an awareness of the need for new approaches to history (in particular neo-Marxist and structuralist) which is wholly admirable'.[35] Surprising words, perhaps, but not entirely out of step with the general reception of the book. Historians, as noted earlier, were rather more wholehearted in their praise, but quite early on a number of mainstream art-historical journals reviewed the book in mostly positive terms.[36] The impact of Clark's approach was felt most directly in Leeds, where in 1976 he founded the MA in the Social History of Art, but the influence of his brand of social art history quickly spread much further afield.

I wrote at the outset that there was a danger in the apparent familiarity of *Image of the People*. This was that the book became a template for a social history of art whose practitioners at times fail to grasp what gave the model its value. As the influence of Clark's approach spread, art historians all too often fell back into precisely the failing he had identified in earlier Marxist accounts: the assumption that works of art can be understood as reflections of a broadly sketched historical context. More troublingly, a tendency emerged within certain practices of the social history of art to reject 'theory', seen as idle game-playing or – worse – as an updated formalism blind to pressing issues of class, race and gender. As we have seen, however, an openness to Continental theory was present in Clark's work

from the start. He may be widely recognised as one of the progenitors of the social history of art, with its central injunction to locate the work of art in a historical context understood to have to do with power. But he could equally be seen as a point of origin for an approach with which he is less often associated, and which might in the most general sense be labelled poststructuralist. (This is clearest in his account of myth in relation to the *Burial*: the Parisian middle class has an interest in seeing the world as divided neatly into two camps, the urban and the rural; this dyadic structure is undone – shown to be unstable – by Courbet's painting.) This approach became the norm for radical politics in the 1980s, when a generation of scholars examined the dominant discourse for its fault-lines instead of appealing to the grand narratives previously favoured by the Left, and celebrated those artists whose work could be seen as having likewise identified the fault-lines (Clark's reading of Manet in *The Painting of Modern Life* (1984) cemented this stance: it was what allowed the slightly unlikely figure of the dandyish boulevardier to be loved by Left-leaning academics). Contemporary artists followed suit, inserting themselves into the dominant discourse, but ironically, in such a way as to destabilise its structures: the tactic was already run-of-the-mill (which is not to say ineffective) by the late 1970s – just think of Cindy Sherman and Barbara Kruger.

The attention to context promoted by the social history of art and the lessons in close reading offered by more theoretically inclined approaches have together produced some of the best art history of the last twenty or more years. But 'together' is the key: each needs the other. Parsing paintings for their internal inconsistencies risks remaining a purely academic exercise without a sense of the historical context within which those inconsistencies had real – political – meanings and consequences. Equally one-sided is the dry charting of historical context without a sense of how, in complex and often indeterminate ways, 'the available systems of visual representation, the current theories of art, other ideologies, social classes, and more general historical structures and processes' coalesce in a single work of art.[37] In its attention to Courbet's particular relation to mid-century ideologies, to the specific nature of his (divided) class status, to the concrete situations in which his art was seen by the public, and to the way in which the paintings worked these materials to produce new and often unsettling meanings, *Image of the People* stands as an almost unrivalled example of what is possible when theoretical sophistication and historical precision come together.

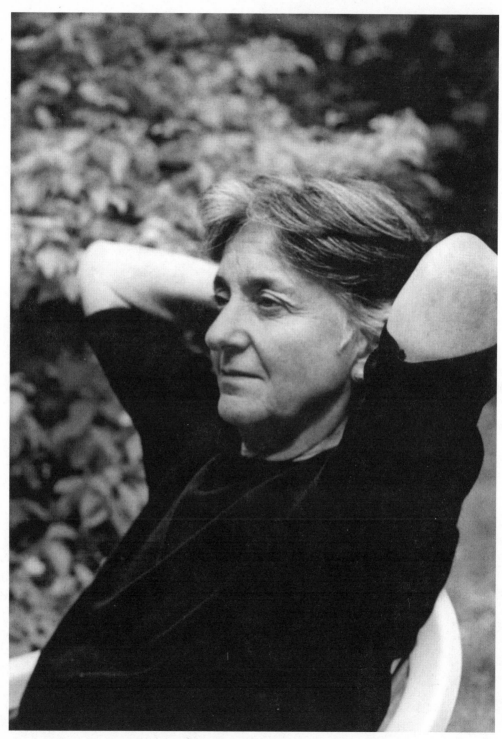

Svetlana Alpers photographed by Michael Baxandall, 2004.

Svetlana Alpers

The Art of Describing: Dutch Art in the Seventeenth Century, 1983

MARIËT WESTERMANN

'UNTIL RECENTLY IT was the descriptive aspects of Dutch art that held the attention of viewers. For better or worse, it was as a description of Holland and Dutch life that writers before the twentieth century saw and judged seventeenth-century Dutch art.'[1] With that shot across the bow, Svetlana Alpers announced the intention of *The Art of Describing* (1983) to restore this historiographic legacy to the study of Dutch painting. From their different aesthetic positions, Joshua Reynolds, who disparaged the subjectlessness of this art, and Eugène Fromentin, who championed its unmotivated character, agreed on its quiddity: 'namely, that the relationship of this art to the world is like that of the eye itself' (p.xix). This view of Dutch art creates problems for its art-historical understanding and critical valuation:

> Dutch pictures are rich and various in their observation of the world, dazzling in their display of craft, domestic and domesticating in their concerns. The portraits, still lifes, landscapes, and the presentation of daily life represent pleasures taken in a world full of pleasures: the pleasures of familial bonds, pleasures in possessions, pleasure in the towns, the churches, the land. In these images the seventeenth century appears to be one long Sunday, as a recent Dutch writer has put it [following Hegel], after the troubled times of the previous century. Dutch art offers a delight to the eyes and as such seems perhaps to place fewer demands on us than does the art of Italy [. . .] The problem faced by a modern viewer is how to make this art strange, how to see what is special about an art with which we feel so at home, whose pleasures seem so obvious (p.xxii).

The book's first goal, then, was to help us understand that this seemingly transcriptional art is anything but self-evident and to indicate how it came about. That project took fundamental issue with the then recent ascendance of iconography as the correct investigative protocol for the kinds of painting identified in Alpers's statement: portraiture, still life, landscape and genre. On this level, the book positioned itself squarely in the historiography of a flourishing art-historical subfield: the 'Dutch Art in the Seventeenth Century' of the book's subtitle.

The introductory references to Reynolds and to the more rigorous character of Italian art, however, immediately placed the text on a higher plane of contestation, that of the methodological apparatus of art history and the privileged role of Italian art in its formation. In widely cited passages, Alpers declared the inadequacy of methods of inquiry designed for the understanding of Italian Renaissance painting to the ocular appeal of Dutch painting. Her efficient summation of the humanist theory of painting certainly made it sound irrelevant to Fromentin's conception of Dutch painting as 'the portrait of Holland':

> I have in mind the Albertian definition of the picture: a framed surface or pane situated at a certain distance from a viewer who looks through it at a second or substitute world. In the Renaissance this world was a stage on which human figures performed significant actions based on the texts of the poets. It is a narrative art. And the ubiquitous doctrine *ut pictura poesis* was invoked in order to explain and legitimize images through their relationship to prior and hallowed texts (p.xix).

While Alpers acknowledged that few Italian paintings observed Alberti's one-point perspective formula, she claimed a comprehensive reach for it as 'a general and lasting model' that was internalised by artists and art critics and eventually enshrined in the historiography of art, beginning with Vasari and operative to our day. Having published a compelling article early in her career on the humanist aesthetics coursing through Vasari's *Lives*, Alpers saw that a strict interpretation of humanist art theory would virtually preclude the recognition of any aesthetic or intellectual ambition for the Dutch pictures that gave her pleasure.[2] On just such terms, Vasari's paragon, Michelangelo, reportedly had dismissed the Flemish artists who could be seen as precursors to the Dutch masters of the Golden Age:

> In Flanders they paint with a view to external exactness or such things as might cheer you and of which you cannot speak ill, as for example saints and prophets.

They paint stuffs and masonry, the green grass of the fields, the shadow of trees, and rivers and bridges, which they call landscapes [. . .] And all this, though it pleases some persons, is done without reason or art, without symmetry or proportion, without skilful choice or boldness and, finally, without substance or vigour (p.xxiii).[3]

The higher stake planted in *The Art of Describing* is the defence of art that does not conform to the Italo-humanist line. The Dutch pictures of interest to Alpers form but a small subset of a vast array of world art produced without any knowledge of that humanist theory, with no discernible interest in it, or even in deliberate opposition to it. Within the European tradition alone, all sorts of art have generated alternative modes of interpretation that help us see them as forceful agents in their cultural moments as well as in ours; Alpers cites several instances of such productive resistance – sometimes on the part of the art, more often on the part of the art historian – from Alois Riegl (p.xx). To Alpers, the non-narrative Dutch art of the seventeenth century presented itself as a similar case that could decentre art history from a model developed out of Italian perspectival and narrative art precisely for the history of that art:

Though they differ in many respects, each of these writers felt the need to find a new way to look at a group of images, at least partly in acknowledgment of their difference from the norms provided by Italian art. It is in this tradition, if I can call it that, that I would like to place my own work on Dutch art [. . .] A major theme of this book is that central aspects of seventeenth-century Dutch art – and indeed of the northern tradition of which it is part – can best be understood as being an art of describing as distinguished from the narrative art of Italy (p.xx).

The relation of the case study on Dutch painting to the larger intervention was embodied in the book's main title, *The Art of Describing*. If the most innovative Dutch painting in the seventeenth century might be understood as quintessentially descriptive, so might other kinds of art that could be among its direct local sources (Jan van Eyck), contemporaries in other places including Italy (Caravaggio and Velázquez), or descendants in multiple technologies and modes (Manet, photography, Mondrian). The rapidly expanding geographic, technological and visual remit of descriptive art suggested by this list, culled from Alpers's own examples, posed obvious challenges for the case study addressed to historians of Dutch art; yet for the broader art-historical community, the intervention's

excitement depended on the potential for such drift. At the time, art history in the United States, France and Britain had developed an impatience with iconography as developed by Panofsky or pictorial analysis based on Wölfflin's spatial and compositional binaries, both of which had origins in their authors' knowledge and valuation of Italian Renaissance art. The concern was not so much with the techniques of research and description in the iconographic and analytical toolkit as with their institutionalisation of a distinction between 'content' and 'form' or 'style' that looked increasingly untenable as deconstructionist and semiotic analysis began to inform the history of art.

The study of Dutch painting, long centred in the empirical analysis of collections, archives and literature in the Netherlands, had remained largely impervious to these concerns; in the later 1960s, leading scholars in the field such as Hessel Miedema and Eddy de Jongh had established a new model of iconographic investigation that linked pictorial motifs to a discourse of sexual, economic and political morality. In an approximate inversion of the 'disguised symbolism' that Panofsky had discerned in many early Netherlandish paintings (which would presumably not have been hidden for most viewers), de Jongh had coined the term *schijnrealisme* ('apparent realism') for the realistic guise of symbols for genitalia, intercourse or corruption. The value of this iconographic work was its grounding of the famously subjectless Dutch pictures in their local culture, by reference to external modes of cultural expression. All of a sudden, it was possible to situate Dutch genre pictures, portraits, landscapes and still-life paintings in relation to texts, even if they did not necessarily have narrative. The voluminous theological, theatrical, poetic and emblematic literature of the Dutch Republic offered ample evidence of the moral preoccupations of Dutch culture, and it was a fount of readily available verbal explanations for the presence of endlessly repeated motifs. The emblem, with its integration of pictures and texts, from captioning to ironic glosses, was such a rich resource that the search for *schijnrealisme* in all things could easily be caricatured as mirthless footnote-hunting. The most sensitive work in this vein undoubtedly brought out one aspect – often in comic register – of the pleasure or interest that artists or their publics took in the pictures. And eventually the awareness of allusive potentials encouraged the recognition of patterns of conventionality in the realist feints themselves. But just as Otto Pächt had wondered about the presumed erudition of the painters whom Panofsky credited with elaborate symbolic programmes – or rather the priority of that activity for them – so Alpers questioned the single-minded and pervasive didacticism assumed by the new iconography of Dutch art,

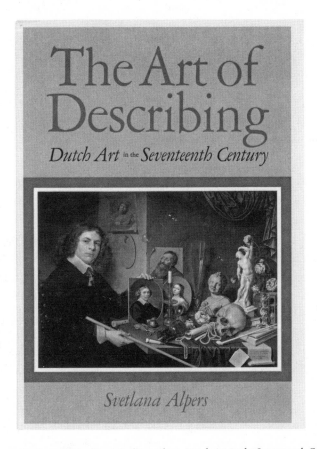

Front cover to Svetlana Alpers, *The Art of Describing: Dutch Art in the Seventeenth Century*, 1983.

which lacked a coherent theory of why all this allegorising should take such care to look as if it were the unvarnished record of what the eye could see.[4] This particular manifestation of the Italo-humanist bias became the subject of a pointed polemic in Alpers's 'Appendix: On the Emblematic Interpretation of Dutch Art' (pp.229–33). Three decades on, this essay reads as a topical afterthought to a book that had many more interesting and generative points to make.

For Alpers's model to offer a way forward, either for the history of Dutch painting or for the discipline at large, the Dutch case study would have to hold up under the weight of its twinned ambitions. To make the case, she cast a wide net to place Dutch seventeenth-century painting in what she called its visual culture, borrowing Michael Baxandall's term but reframing it more broadly as an alternative to the history of Dutch art (p.xxv). The Dutch visual culture of *The Art*

of Describing is a capacious matrix of seeing and picturing that includes optical magnification, camera obscura projection, educational drawing, map making, inscriptions in or as images, and theoretical models of images projected onto the human retina. While Alpers has maintained that a circumstantial approach to visual and other cultural information has always been integral to art history, it would be more precise to say that she extended that possibility into realms that were then not usually considered in relation to painting, Dutch or otherwise.[5] *The Art of Describing* was an early model for scholars in and outside art history who were attracted to the interdisciplinary study of visual culture. To Alpers, who cited Clifford Geertz as a methodological authority, a roughly anthropological method was necessitated by what was then thought to be the virtual absence of any theoretical and critical writing from the period that could give purchase on the mimetic drive of the pictures that were central to her arguments. That impression has been partially corrected by the work of Eric Jan Sluijter and others,[6] but the field stands forever in Alpers's debt for her alternative framework for recovering the conditions that made possible an art so preoccupied with resembling the world.

And an exhilarating multimedia theatre it is: even if one questioned, as many did, the direct relationship to Dutch paintings of the disparate texts, images, anecdotes and artefacts across the seventeenth-century cultural, social and intellectual field, one could not but delight in the range of reference and the creativity of suggested connections. Proceeding for the most part by analogy between painting and its cultural cognates and by masterly verbal echoes, amplifying rather than softening across chapters, Alpers proposed five pictorial impulses in Dutch culture under which the most distinctive aspects of Dutch seventeenth-century art manifested themselves as descriptive rather than narrative. In shorthand, these pictorialising drives may be termed 'natural knowledge', 'Keplerian', 'representational craft', 'mapping' and 'inscriptional'. Each received a chapter's worth of dense and well-illustrated attention, and their originality warrants a brief review.

In the first chapter, Constantijn Huygens, the influential diplomat, connoisseur and Latinist, appears as a student of natural history and promoter of the new optical instruments applied with special energy in Holland. Having witnessed the wonders of the microscopic world, Huygens wishes his late friend Jacques de Gheyn were still alive to draw them for publication in a book to be called 'New World'. Improvements to the camera obscura, developed by Cornelis Drebbel, an eccentric inventor at the English court, make Huygens exult over the lively images as the rival to painting. In religious reflections, Huygens devises optical and perspectival metaphors for our position within Creation.

The material creates a suggestive context for Huygens's possible connection of these visual interests to what he saw in paintings by his contemporaries, and as an arbiter of taste he may have transmitted such ideas more widely. It may well be that the strength of the mimetic tradition of oil painting since Van Eyck had prepared him to yearn for de Gheyn's art in picturing microscopic vision, or to see the camera obscura image as 'reflection painting', or to express a delight in that image similar to his pleasure in paintings. The inevitable indeterminacy of such claims, however, is a challenge for the reader. At the end of this chapter, as of the others, we have been plugged into a network of data, references, echoes and connections, usually pulsating with energy but sometimes short-circuiting with overload. Typically, as Alpers honestly admits, the information flow generates more questions than answers:

> The fact that the country that first used microscopes and telescopes had Van Eyck and other works like his in its past is not just an amusing coincidence, as Panofsky once claimed. Didn't northern viewers find it easier to trust what was presented to their eyes in the lens, because they were accustomed to pictures being a detailed record of the world seen? Given the extraordinary articulateness and persistence of the pictorial tradition in the north [. . .] one is hard put to assign precedence in these matters. The cultural space that images can be said to occupy in Huygens's world and writing raises but does not answer such questions (p.25).

In the following chapter, the optical framework is widened. Johannes Kepler's theory of vision as the passive registration of the world imaged on the retina is offered as the model or analogue for all central aspects of Dutch – or is it Northern? – painting. Kepler certainly referred to the image on the concave retina as *pictura*, and Alpers considers this equivalence symptomatic of an implicit Dutch theory of the painted image. She argues that the Keplerian theory of vision is commensurate with the camera obscura's picturing of a given world, and therefore stands in opposition to the Albertian picture window with its dependence for image coherence on the fixed position of a viewing eye. In the Albertian mode, man is the measure and maker of the visible world; in the Keplerian, man receives without prejudice an aggregate view of what the surface of the world gives up to vision. Alpers finds another pictorial parallel for Keplerian vision in the distance-point perspective construction evident in a number of Dutch pictures. This studio practice, well recorded in the Netherlands (although not unknown in Italy), determines the location and the seen shape of objects and figures within a pictorial space using

two distance points placed at the edges of the picture surface, rather than conceiving them in relation to the Albertian viewer in a fixed position external to the picture's scene, who views the space receding to a single vanishing point.

Pieter Saenredam's seemingly self-effacing manipulation of distance-point perspective to convey an image of the world is the star witness in this account. The descriptive intentions Alpers implies for Saenredam's choice and adjustments of distance-point construction are questionable; for many artists, this method was simply an easier way to handle complex architectural elements in pictorial space – Saenredam's specialty. It had the effect of positioning the purported viewer very close to the picture surface, generating odd wide-angle views and unexpected novelties of vision. Whether Saenredam liked this condition of the technique because it forced him to be clever in finding ways to convey information about the pictorial environment, or whether he liked the still-life quality of those highly visible near surfaces is a moot question. In describing his *Interior of the St Laurens Church at Alkmaar*, Alpers economically captures the dependence of these effects on Saenredam's mastery of the system – and in the process helps make it strange:

> The eye passes low through two doors and through free space to the left, and is stopped by a high, lean slice of space behind the pillar at the right [. . .] The small figures at the right are markers, at their eye level, of the horizon line. There is a certainty displayed in what the surface can contain. There are the few decorations of the white-washed church: the painted organ case, the hanging that ends with the truncated image of a man's head (p.64).

Saenredam's craft sets up a transition to a long account of the tradition of illusion that makes Dutch seventeenth-century painters not only the heirs of Van Eyck, but more spectacularly the visualisers of an experimental mode of research and learning espoused by such different and non-Dutch scientists and educators as Robert Hooke, Francis Bacon and Johann Comenius. Alpers notes a parallel between the emphasis of these thinkers on the use of images in the transmission of new knowledge and their call for the development of pictorial skill. The chapter juxtaposes riveting descriptions of the illusionistic and representational feats of Dutch painters and pays fresh attention to stunning images that are often dismissed as informational or instructive. Art here appears as *techne* in the strongest sense of the term. With provocative finesse, Alpers turns prime exemplars of the vanitas interpretation of Dutch still life and genre (scintillating skulls, soap bubbles

Comparative illustrations of the interior of the Church of St Bavo in Haarlem.
From Svetlana Alpers, *The Art of Describing: Dutch Art in the Seventeenth Century*, 1983.

and hourglasses abound) into novel taxonomies of the visual world, presenting them as hyper-crafted allegories of the relationship between manual picturing and knowledge.[7] Other than well-travelled scholar–artists such as Samuel van Hoogstraten, few artists may have kept up with the members of the Royal Society, but the demonstrable relationship between his pictorial interests and their concerns, and the connections between his pictures and those of painters in Holland without such academic access, opened up new avenues of research into the conceptual aspects of studio craft, and the language that might be recovered for them.[8]

Alpers's essay on 'The Mapping Impulse in Dutch Art' has entered the art-historical discourse most fully, and remains a staple of footnotes and course syllabi in many fields. It has a venerable pedigree in the perceptual investigations of mapping by E.H. Gombrich, whom Alpers acknowledged as the teacher most critical to her formation. But whereas Gombrich's interest in maps concerned their utility in establishing the motivated, rather than completely arbitrary conventionality of pictures of all kinds, Alpers saw in Dutch mapping the clearest historical link yet between Dutch art and a generalised Dutch commitment to

the pictorial diagramming of worldly knowledge. Maps are pictures, after all, and Alpers was surely right that 'there was perhaps at no other time or place such a coincidence between mapping and picturing' (p.119). The coincidence manifests itself in the decorative presence of maps on walls, in the ubiquity of cartography in portraiture, genre painting and still life, and in the complex business relations between print publishers, engravers, draughtsmen and other makers of pictures.

Alpers acknowledges these facts, but is more interested in the epistemological overlaps between the map and the picture, in the aesthetic enhancements that maps borrow from pictures, and in the panoramic presentation of spatial knowledge that maps may have suggested to landscape painters such as Philips Koninck. The argument leads with the picture Alpers holds responsible for her insight into the descriptive character of Dutch art: Vermeer's *The Art of Painting*.[9] In a tour de force of description, she makes us see why the famously comprehensive map with its crackled varnish is 'in size, scope, and graphic ambition [. . .] a summa of the mapping art of the day, represented in paint by Vermeer' (p.122). Alpers credits Vermeer with claiming the intellectual prestige and pictorial accomplishments of cartography for painting, placing his signature (one of only three in his *œuvre*) on the map, and composing the picture so that the last word in the map's title, DESCRIPTIO, is in clear view. These observations attracted strong criticism from scholars of Dutch art – curiously so. Given what we know of Vermeer's exceedingly deliberate, innovative and thoughtful working methods, the signature as well as the prominence of the map and its title seem unlikely to be accidental. Vermeer's commitment to this painting seems to have been personal; he apparently gave it the title it still bears – a highly idiosyncratic act for the period – and his widow protected it from creditors after his death.[10] Neither the signature nor the inscription are 'keys' to the painting, and nor does Alpers claim that. The methodological question is whether that one DESCRIPTIO, a standard title for maps of the day, can productively generate a catch-all for what matters about Dutch art, and by extension the other non-narrative, non-window pictures that might qualify as descriptive.

Within Dutch culture, the word had significant standing as a term of encyclopaedic remit. For map making and for taxonomising accounts of voyages, the Dutch word for description, *beschryvinghe*, was the term of choice. In the promotional titles beloved of publishers, then as now, the noun would be embellished with *nieuwe* (new), *wonderlicke* (wondrous), *curieuse* (curious) or *waere* (true) – words that signalled the up-to-date, modern, fascinating and reliable quality of the report or picture. Many of these accounts were richly

illustrated with both the most conventional as well as unique engravings, which were described as enhancers of the novelty, curiousness and truth of the written descriptions. These adjectival amplifiers of 'description' have undeniable resonance in the period's writings on art, and if one were to rewrite 'The Mapping Impulse in Dutch Art' today one could well tease out these correspondences. But in reference to a perspective system, retinal image, camera obscura projection or oil painting, 'describing' may not carry the universal sweep suggested by the *beschryvinghe* in maps. Does a retinal image describe, or is it just simply there? 'Picture' seems to cover the range of image types in that sentence more closely, and it is a term Alpers uses often – but *pittura* is of course Alberti's term for painting and would not do to articulate the defining difference of Netherlandish or northern modes of pictorial representation.

The account of mapping as picturing, painting as participating in a cartographic moment, stands at the apex of *The Art of Describing*. The ensuing chapter 'Looking at Words' struggles with an apparent difficulty for the *ut pictura visio* theory of Dutch art: the prominence of inscribed texts all over Dutch paintings, from signatures, dates, locations, and names and ages of portrait sitters to – more distinctively for Dutch art – proverbs and narrative hints on letters, musical instruments, pieces of furniture and grave markers. Alpers offers marvellous insights into the pernickety tags in Saenredam or the illegible letters in Vermeer, but seems to undervalue the ambitions and achievements of many Dutch painters – and not just history painters – with her broad claims that inscriptions in Dutch painting are offered up as one more thing to look at or as a caption of equal weight to the image. Jan Steen, who invented incomparable ways of being a comic painter, displayed both knowledge of the narrative structure and staging of comic genres and a deliberate independence from them; this ambivalent relationship to texts made his art entertaining, biting and pictorially new. Things in Steen are fun to look at, but as in all good comedy, his unvarnished representation of the world is about recognisable social foibles, not about feigning optical veracity for its own sake. In his art, as in the still lifes, landscapes and interiors illustrated by Alpers, the means by which pictures address us as if they are the world also organise that world for us: they help persuade us of the naturalness of the cultural knowledge embedded in these representations, from the aesthetic and scientific assumptions of interest to Alpers to the social and moral propositions favoured by De Jongh and a generation of social historians of Dutch painting.

The Art of Describing was recognised immediately as a major intervention in the historiography of Dutch art and a challenge to the discipline. The book was

reviewed in all major journals for the history of art and many other publications of record, by senior historians of culture in and outside Dutch studies. Its ambition was recognised, lauded, picked apart and criticised. Historians of Dutch art, especially those in the Netherlands, were highly sceptical of the apparent return to a subjectless art and defensive about the achievements of iconography as a more inclusive and sensitive method than its caricature as 'emblematic' would suggest. In the initial reception, the epilogue's provocative challenge to iconography drowned out the book's claims for the seriousness of Dutch painting on terms derived from its pictorial qualities rather than an appeal to texts.[11]

Historians of art and culture with wider interests, such as Gombrich, Anthony Grafton and Thomas DaCosta Kaufmann, recognised the account's attempt to revalue the thoughtfulness in this impressive art.[12] Most reviews, however, shared concerns about the historicity of the relationship between the exciting phenomena of a broadly cast northern European visual culture and the work of Dutch artists making pictures. Many noted the exclusion of some of the most significant painters of the period, by the standards of their day and by those of their later critical fortunes, as well as the neglect of Dutch history painting and its humanist sources. The appearance of similar interests and phenomena in seventeenth-century Italy also cast doubt on the sharpness of the distinctions drawn by Alpers.[13]

As I reread the book, so many years later, the critiques appeared to overplay the book's sleight of hand, probably provoked by its purported rescue of the intellectual and artistic rigour of Dutch art from iconographers, narrativists and humanist snobs. Even if Alpers's argument strains the boundaries of her field of observation, and the book's title promises more than it could possibly deliver, no claim is made that *all* Dutch art describes according to her model. And her aim was never to freeze and isolate a set of Dutch pictorial concerns in time or place. Louis Marin, in the most sustained engagement with the work's argument for parity between Dutch painting and Kepler's model of vision as a picture on the surface of the retina, not a window into depth, noted its forward lean to modernist preoccupations with surface as painting's figure for its relation to the visible world.[14] Alpers, citing painters from Picasso to Mondrian to Johns throughout the book, implicitly acknowledged that this forward continuity internal to painting is the flipside of her disavowal of a complete break between the religiously grounded painting of Van Eyck and the art of Protestant Holland. Late in the book, she approvingly cites Lawrence Gowing's recognition that Vermeer's pellucid facture, for all its proto-photographic illusionism, eventually acknowledges its ultimate incommensurability with the life of the world. Upon close approach,

what had cohered optically as this object made of that material dissolves into the seemingly arbitrary marks of the artist, made whole again only by the viewer's step back and the eye's complicity in the fantasy. Alpers's engagements with the artists of her own time (and her intellectual debts to Gombrich) meant that she would never advocate a simplistic view of Dutch paintings as truly unmediated records of visual experience. The relationship between artifice and nature in this art, and its material character, are restated by example time and again:

> We might then consider Vermeer's *View of Delft* not as a copy done after a camera obscura or as a photograph (both of which claims have been made in the past), but as a display of this notion of artifice. A claim is made on us that this picture is at the meeting-place of the world seen and the world pictured. That border line between nature and artifice that Kepler defined mathematically, the Dutch made a matter of paint (p.35).

In the rhetorical drive of an argument intended to shake a great Dutch art free of the shackles of humanist art theory in its most recent iconographic incarnation, such subtleties were often lost on readers confronted with a book ranging, in fewer than three hundred pages, across dozens of artists and places, image types and studio practices, historical periods and cultural formations.

Art history has caught up with *The Art of Describing* in its heightened allowance for speculative thought, comprehensive inclusion of evidence of visual and pictorial culture, and close attendance to the epistemological claims that paintings make. No scholar of Dutch art has been able to work seriously in the field without engaging with the book's problems. Alpers's exclusion of the classicising and Italianate Dutch artists who were popular in their time made us recognise that the pictures Alpers cares about may be Holland's most distinctive contribution to the history of painting. Pictures by Vermeer and Kalf, Saenredam and ter Borch make us aware of the process of seeing, and just how much of the visible world we edit out when we see. These painters did so by updating the innovations of Van Eyck and Bruegel, and they thereby created a space for the invention and reception of other 'realist' art, from Chardin to photography. Dutch paintings assumed a new centrality in art history and other disciplines as works to look at and think about, and fine new researches took off from pictures briefly mentioned, insights made in passing. Alpers helped us understand how it could be that in these pictures there could be both reason and art, skilful choice and boldness, and, certainly, substance or vigour.

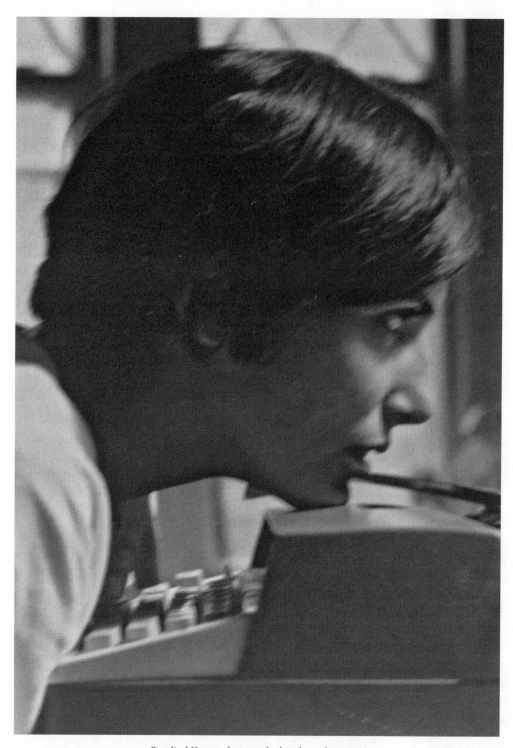

Rosalind Krauss photographed in the early 1980s.

Rosalind Krauss

The Originality of the Avant-Garde and Other Modernist Myths, 1985

ANNA LOVATT

IN 1998, THE ARTIST SAM DURANT produced a diagram that humorously indicates the extent to which the work of Rosalind Krauss has contributed towards and been appropriated by the discourses of art criticism, art history and, to a lesser extent, art practice. *Quaternary Field/Associative Diagram* is a semiotic square that purports to map a system of relationships between Robert Smithson, the Rolling Stones, Neil Young and Kurt Cobain, along axes marked 'Song Lyric', 'Entropy', 'Pop Star' and 'Scatological Structures'.[1] Associating the celebrated land artist with pop cultural icons of the 1960s and later, the diagram is an adaptation of the one published in Krauss's now-canonical essay 'Sculpture in the Expanded Field' (1978), reprinted in her influential anthology *The Originality of the Avant-Garde and Other Modernist Myths* (1985).[2] That book was among the first to bring structuralist and poststructuralist theory to bear on the study of the visual arts, counteracting what Krauss perceived to be the 'increasingly positivist' ethos of art history as an academic discipline (p.90). Now a reading list staple, *The Originality of the Avant-Garde* contributed to the radical upheaval of that discipline during the 1970s and 1980s. And, as Durant's parodic homage demonstrates, Krauss's provocative methodological approach has ensured the book's enduring appeal and continuing contestation.

The Originality of the Avant-Garde was Krauss's fourth book. After completing her Ph.D. at Harvard in 1969, she published the resulting monograph, *Terminal Iron Works: The Sculpture of David Smith*, in 1971.[3] A catalogue raisonné of Smith's work followed in 1977, the same year as her next book, *Passages in Modern*

Sculpture.[4] During the late 1970s, Krauss was promoted to Professor of Art History at Hunter College and appointed Professor of Art History at the Graduate Center, CUNY. But she continued to regard herself primarily as a critic, gaining international recognition while writing for *Artforum* during the late 1960s and early 1970s.[5] Along with Michael Fried, Krauss was one of a group of younger writers who aligned themselves with the systematic 'formalist' criticism of Clement Greenberg, in opposition to the poetic, 'existentialist' art-writing popularised by Harold Rosenberg during the 1950s.[6] Greenberg had been writing for the *Partisan Review* and the *Nation* for over two decades when Krauss and others first encountered his work in the anthology of his writings, *Art and Culture: Critical Essays* (1961).[7] As Daniel Siedell has pointed out, this collection of articles, excised from their original journalistic and polemical contexts, revised and collated in a scholarly publication, cemented Greenberg's reputation with an academic audience.[8] *Art and Culture* thus provided a formal model for *The Originality of the Avant-Garde* which, nevertheless, was radically different in intent.

Throughout the late 1960s, Krauss devoted herself to mastering the Greenbergian methodology, which was predicated upon close formal analysis, lucidity of expression and the construction of developmental narratives. Towards the end of the decade, however, she began to question the restrictions imposed by this approach, doubts publicly aired in her article 'A View of Modernism' (1972). The concluding paragraph of that essay explained: 'I began as a modernist critic and am still a modernist critic, but only as part of a larger sensibility and not the narrower kind.'[9] But by the late 1970s Krauss perceived a rupture in cultural production that could not be accounted for within the modernist lexicon. Searching for a term with which to describe this shift, she observed: 'the one already in use in other areas of criticism is postmodernism. There seems no reason not to use it' (p.287). Although the critical currency of the term 'postmodernism' is now severely depleted, *The Originality of the Avant-Garde* captures its potency and potential at a particular moment in recent history. It is within the discourses surrounding an emergent 'postmodernism' that the book can now be most productively located.

Leo Steinberg was one of the first to use the term 'postmodernism' with reference to the visual arts in his 1968 lecture 'Other Criteria', later developed into an article for *Artforum*, and a book of the same name.[10] Against Greenberg's insistence on the developmental logic of modernist art, Steinberg proposed that the characteristic surface of the 1960s – exemplified in the work of Robert Rauschenberg – marked a distinctive break with painterly tradition. Krauss took

The Originality
of the Avant-Garde
and Other
Modernist Myths

Rosalind E. Krauss

Front cover to Rosalind Krauss, *The Originality of the Avant-Garde and Other Modernist Myths*, 1985.

up this argument in the introduction to *The Originality of the Avant-Garde*, explicitly distancing herself from Greenberg's insistence on the 'unbreachable, seamless continuity' of modernism (p.1). But while Steinberg's account of the 'flatbed picture plane' centred on the reconfiguration of an essentially painterly surface, by the late 1970s the term 'postmodernism' had come to designate a broader set of cultural practices. In the book, Krauss extended her previous commitment to sculpture, while pointing to photography as the 'operative model' for much of the new work (p.210). Photography's role in the demise of modernism was concurrently explored by Douglas Crimp, who shared Krauss's interest in structuralist and poststructuralist theory. Crimp suggested that Steinberg's account of 'postmodern' painting had unconsciously paralleled the 'archaeological' enterprise of Michel Foucault, with its emphasis on rupture, limit, discontinuity and transformation, as opposed to tradition, influence, development and evolution.[11] Like Crimp, Krauss looked to poststructuralism for the tools with which to excavate the unfamiliar terrain of postmodern culture.

One model for this methodological approach was the work of Annette Michelson, to whom *The Originality of the Avant-Garde* was dedicated. Michelson lived in Paris for an extended period during the 1950s and 1960s and was fully conversant in Continental philosophy at a time when most of her *Artforum* colleagues were still unreconstructed 'Greenbergers'.[12] In a 1969 essay on Robert Morris, Michelson suggested that the reflexive spectatorial encounter engendered by Minimalism might be understood with reference to the philosophy of Maurice Merleau-Ponty, a proposition that was to become a central tenet of *Passages in Modern Sculpture*. Michelson's lecture 'Art and the Structuralist Perspective' introduced structuralist diagrams to the New York art world in 1970, before the associated French texts had been translated.[13] Michelson subsequently planned to translate Michel Foucault's essay 'Ceci n'est pas une pipe' (1968) for a proposed special issue of *Artforum* on performance art.[14] The proposal was rejected and – as relations at the magazine became increasingly fractious – she and Krauss resigned in 1976 to found a new journal, *October*.

Nine of the fourteen essays in *The Originality of the Avant-Garde* were first published in *October* between 1976 and 1983, while two appeared in other journals, two were commissioned by museums and one by a commercial gallery. Besides these commissions, the essays often responded to current events (a lecture on Picasso, an exhibition of works by Rodin, a trio of publications on Sol LeWitt) and deployed an array of methodologies often incompatible with, if not directly opposed to, one another (linguistic philosophy, structuralism, poststructuralism,

psychoanalysis, phenomenology and logic, to name a few). When Siedell asks: 'How do these texts, written on different occasions for different purposes, now function in a single critical narrative?' the answer is that they do not, although various micro-narratives (such as the cultural turn from modernism to post-modernism, the poststructuralist critique of structuralism, or Krauss's own development as a critic) can be traced through them.[15] Krauss has recently suggested that the job of the critic 'entails a perpetual reassessment of the field she surveys and the demand that it be articulated in her writing'.[16] Perhaps the most striking example of this 'reassessment' was Krauss's subsequent abandonment of the term 'postmodernism', the validity of which was insisted upon throughout *The Originality of the Avant-Garde*.

The book begins with the proposition that the real interest of critical writing lies not in its judgments but in its method. With this statement Krauss distinguishes her own critical project from that of Greenberg, whose teleological view of modernism was predicated upon pronouncements of aesthetic value. Krauss had previously questioned Greenberg's judgment but not his approach, championing artists he dismissed (such as Jasper Johns and Donald Judd) within a conceptual framework that remained indebted to him. But *The Originality of the Avant-Garde* announced her renunciation of that approach in favour of an alternative set of methodologies that had been revolutionising other areas of American intellectual life. Drawing on the work of Ferdinand de Saussure, Roland Barthes, Foucault and Jacques Derrida, Krauss proposed that a work of art might be best understood not as the organic outcome of past traditions but as a structural object. According to this model, meaning is produced not by the act of picturing or labelling, but via a system of substitutions, whose terms are irreducible to any single referent. Throughout the book, Krauss is concerned with *how* meaning is generated (or, in the case of Georges Bataille, how it degenerates), rather than *what* things mean – insistently berating 'positivist' art history for its slavish pursuit of the definitive interpretation.[17]

Part I of the book, 'Modernist Myths', deals primarily with European art of the late nineteenth and early twentieth centuries (the modernist grid, Picasso, Giacometti, Surrealism, Julio González, nineteenth-century photography, Rodin), while Part II, 'Toward Postmodernism', begins with Duchamp but concentrates primarily on contemporary American art (lens-based media, Jackson Pollock, LeWitt, Richard Serra, site-specific art). Despite Krauss's enthusiasm for French theory, postmodernist practice is thus located firmly within the American context, and centred around a small group of (predominantly male) practitioners working

in New York. One essay written for a French audience concerns itself explicitly with how to 'translate' the 'culturally rooted' sculpture of Serra into terms that that audience will be able to understand, and proceeds to position Serra's sculpture in a relationship of 'mutual repulsion and antagonism' with that of the European modernist Giacometti (pp.260–74). Krauss thus retains Greenberg's emphasis on New York as the epicentre of advanced art, a striking stance given the increasing internationalism of the art world in the 1970s. The earliest essays appear in the second part of the book, indicating that Krauss's demythologisation of European modernism was prompted in part by her direct engagement with contemporary American art. While the proximity of this engagement proved extremely productive, the suggestion that the practices under discussion were representative of a 'truly postmodernist art' was more problematic. The heterogeneity of 'postmodernist' art – which included feminist art, performance, institutional critique and Neo-expressionist painting – was not conveyed by Krauss's book which, in its content and its method, evinced a certain 'intolerance for incoherence'.[18] Krauss has recently acknowledged as much, explaining that she 'fled' *Artforum* 'because the commitment of that magazine to art as social statement was increasingly hostile to the aesthetic concerns necessary to formulate the basis of formal coherence'.[19] The spectre of formalism, apparently vanquished in the introduction to *The Originality of the Avant-Garde*, thus continued to haunt her subsequent criticism.[20]

The book's title essay responded to a vast Rodin retrospective at the National Gallery of Art in Washington, the centrepiece of which was a new cast of *The gates of hell*, taken in 1978. Since the first cast of the *Gates* was made three years after Rodin's death in 1918, Krauss took this opportunity to explore the tension between Rodin's 'ethos of reproduction' and the rhetoric of originality that had characterised the work's critical reception (p.153). While attempting to deconstruct the binary opposition 'original/reproduction' with reference to the avant-garde, Krauss envisaged a series of scenarios in which a viewer watching a film of the cast being made might perceive the new *Gates* to be a 'fake' or 'fraud'. Her article prompted a furious response from the exhibition's organiser, Albert Elsen, who insisted that Rodin's bronze editions were traditionally considered 'originals'. Noting that the film scheduled for the exhibition was not ultimately shown, Elsen demanded: 'Just what do we call out when a critic invents issues, makes up contradictions, promotes a double standard, and reviews an event that has not yet happened?'[21] A meticulous demolition of Elsen's response by Krauss swiftly followed, published in *The Originality of the Avant-Garde* under the title 'Sincerely Yours' (pp.174–94).

Opening pages to Rosalind Krauss's response to Albert Elsen's critique of her essay on Rodin's casts of *The gates of hell*. From *The Originality of the Avant-Garde and Other Modernist Myths*, 1985.

Interior spread exploring the work of Julio González. From Rosalind Krauss, *The Originality of the Avant-Garde and Other Modernist Myths*, 1985.

This acrimonious exchange demonstrates the 'flatly incomprehensible' nature of the questions raised by Krauss's book for many more traditional art historians (p.5). Elsen failed to recognise that rather than using the words 'original' and 'reproduction' pejoratively, Krauss sought to explore the structural relationship between these terms. Yet the dramatic impact of her essay was due in part to her evocation of imaginary speakers, who make precisely those judgments she strategically circumvents. In the book's last essay, 'Poststructuralism and the Paraliterary', Krauss observes in the work of Barthes and Derrida a 'dramatic interplay of levels and styles and speakers', more familiar in literature than in critical discourse (p.292). A related stratification occurs throughout *The Originality of the Avant-Garde*, in which Krauss virtuosically performs the role of the formalist critic deploying the comparative method, then the lawyer presenting a case ('Exhibit A: . . .'), then the sceptic in the audience as the Rodin film unfolds. These divergent voices infinitely enliven the book, but their multiplicity works against the unilateral thrust of polemic, making Krauss's exact position difficult to determine.[22]

The second essay in the book, 'In the Name of Picasso', responded to the new body of scholarship generated by the Museum of Modern Art's 1980 Picasso retrospective, which placed emphasis on the artist's biography as a tool for interpreting his work. Krauss identified in the work of a number of prominent art historians – William Rubin, Linda Nochlin and Robert Rosenblum among them – an urge to limit the play of meaning in Picasso's paintings and collages by anchoring that meaning to the proper name. This fixing of signification was deemed to be 'highly objectionable' when applied to Picasso and 'grotesque' when attached to collage, which Krauss conceived as a system of relationships predicated upon indeterminacy and absence, through which meaning is generated but never fixed (p.39). Collage was thus understood to thematise the 'impersonal' operations of language, in the de Saussurian sense of *langue*: a differential system to which the individual must submit in order to communicate (p.39).

Krauss's structuralist approach to questions of originality and authorship had a substantial impact on art-historical discourse which – as she pointed out in her introduction – was 'still pursuing such issues as though no critique had ever been advanced about the methodological status of these concepts' (p.5). Yet her abstraction of the art object (and the linguistic sign) from the social and historical conditions of its production was deeply troubling for Marxist and feminist critics. Drawing on the work of Jean Baudrillard, Craig Owens likened de Saussure's differential hypothesis to the ideological process in bourgeois society, 'which

systematically strips both objects and subjects of their materiality and their history by submitting them to a differential logic so that their *value* can be determined'.[23] Angela Partington highlighted the loss of specificity this approach engendered in Krauss's book, resulting in 'a total lack of consideration of class, race, or gender differences in delineating the discursive spaces of aesthetic objects'.[24] Partington also expressed her surprise at the omission of feminist art, given its stylistic heterogeneity and the feminist engagement with structuralist theory. Krauss was not alone in this 'remarkable oversight': in 1983 Owens pointed out that feminism had been something of a blind-spot in writing on postmodernism.[25] Yet it is still striking that, surrounded by feminist art critics and art historians such as Lucy Lippard and Nochlin, Krauss made no reference to the politics of gender and mentioned female artists only briefly in the book. Anna Chave has subsequently argued that the 'all-white, male' version of the Minimalist canon was reinforced not only by the depersonalisation of Minimal art but by the concomitant 'objectivity' of contemporary criticism.[26] Although this is undoubtedly true, Chave's attempt to redress the balance by interpreting Krauss's criticism biographically (via her relationship with Robert Morris),[27] is a retrogressive step, threatening to reinstitute what Krauss had condemned twenty years earlier as an 'art history of the proper name' (p.28).

Krauss's ambivalent relationship with art history during the late 1970s and early 1980s is a consistent subtext of her book. In the introduction, she explains that her project was motivated in part by the recent 'capture' of art-critical writing by art history (p.5). 'Reading Jackson Pollock, Abstractly' is a polemic against 'this presumably new breed, the historian/critic, who is correcting taste *by* filling in the historical record' (p.221). Yet Krauss was herself a product of the convergence of criticism and art history, having been allowed to write her Ph.D. on a contemporary sculptor, David Smith, following his untimely death.[28] *The Originality of the Avant-Garde* coincided with the acceleration of her academic career and institutional recognition in the form of two professorships in art history. And throughout the book, Krauss implies that her attack on contemporary art history acts to defend the fundamental tenets of the discipline. 'In the Name of Picasso' points to the work of Alois Riegl and Erwin Panofsky, insisting that 'from its very beginning art history called upon a theory of representation that would not stop with mere extension (or denotation) but would allow for intension (or connotation)' (p.27). Elsewhere, Krauss likened her own structuralist approach to the use of oppositional categories in Heinrich Wölfflin's *Principles of Art History*, which she described as exemplary of an 'art history without names'.[29] Rather than

breaking with art history's methods, Krauss thus implied that her book marked a return to the founding principles of the discipline.[30]

As David Carrier has pointed out, Krauss's goals were really quite different from Wölfflin's.[31] Although Wölfflin formulated five oppositional categories in order to describe a periodic shift, he did not regard these pairings as abstract structures, but as the descriptors of alternative modes of illusionistic representation.[32] In an extended study of Krauss's career published in 2002, Carrier characterised her as a 'philosophical art critic' in the tradition of Vasari, Hegel, Ruskin, Panofsky, Gombrich and Greenberg.[33] Remarking on the heterogeneity of this list, Daniel Siedell has suggested that Krauss embodies a more specific and recent phenomenon, that of the 'academic art critic', 'whose entire career has been defined by and against the art-historical establishment'.[34] In the concluding paragraph of *The Originality of the Avant-Garde*, Krauss pointed out that poststructuralist theory was being most enthusiastically embraced by graduate students, within the university context (p.295). And it was within academia that the mode of criticism pioneered by Krauss and associated with the journal *October* ultimately thrived.

Reviewing *The Originality of the Avant-Garde* in 1985, Yve-Alain Bois suggested that the book's import lay precisely in the 'articulation or juncture between criticism and history'.[35] While acknowledging the Marxist critique of structuralism and poststructuralism as 'ahistorical', Bois argued that Krauss's attack on humanism and positivisim, 'the ideological crutches on which traditional art history rests', exposed the inherent 'ahistoricity' of the discipline in the academy.[36] By resisting art historians' attempts to assimilate nineteenth-century photography into the pictorial tradition ('Photography's Discursive Spaces'), insisting that Pollock's black and white paintings were not an attempt to deal with iconography ('Reading Jackson Pollock, Abstractly') and arguing for a definitive rupture between postmodern practice and the art of the past ('Sculpture in the Expanded Field'), Krauss defended the historical specificity of the practices concerned. Her understanding that 'no historical object exists as such without having first been constituted and evaluated through a system of thought and interpretation' was what made Krauss's approach so convincing for Bois, and so influential for subsequent generations of art historians.[37] If a critical awareness of 'methodology' now features prominently in the writing and teaching of art history, it is thanks in part to Krauss's book, and the related set of critical projects once termed 'the new art history'.

This 'new' art history now lies firmly in the historical past, as does that which was once called 'a postmodernism of resistance'.[38] In recent years, Krauss has

sought to retrieve some of the modernist concepts jettisoned in *The Originality of the Avant-Garde*, particularly the idea of medium-specificity. Observing the current ubiquity of installation art and the unashamedly affirmative relationship much of this work has with the art institution, she has argued that what was once a critical dismemberment of the modernist medium has become an 'official position'. Three decades after 'Sculpture in the Expanded Field' was published, Krauss dissociated herself from the postmodernist attack on the medium, arguing for its importance and, ultimately, for the continuation of the modernist project.[39] *Perpetual Inventory*, her recent 'sequel' to *The Originality of the Avant-Garde*, contends that – far from offering a radical critique of modernism – the 'post-medium condition' is today's 'monstrous myth'.[40]

Hans Belting photographed by Felix Gruenschloss shortly before a lecture
at the Karlsruhe Institute of Technology, 20th January 2009.

Hans Belting

Bild und Kult: Eine Geschichte des Bildes vor dem Zeitalter der Kunst, 1990

JEFFREY HAMBURGER

HANS BELTING'S *Bild und Kult* has had an enormous impact since its publication in German in 1990 and its translation into English under the title *Likeness and Presence: A History of the Image before the Era of Art* (1994). This essay will give some account of its influence and, in particular, will discuss its connection to Belting's subsequent work, much of it on modern and contemporary art. At first glance, this might seem to represent an abrupt departure from the history of the cult image that is *Bild und Kult*'s focus. The book's scope, however, is far broader than even its vast chronological span – from Late Antiquity through the Reformation – initially implies.

After an introduction that makes an effective argument for an interdisciplinary approach adequate to 'the deeper levels of experience that images probe', Belting systematically sets about his task of 'adopt[ing] a historical mode of argumentation that traces them back to the context in which they historically played their part' (p.3). Drawing on the testimony of legends of supernatural origins, visions and miracles, Belting succinctly defines what he regards as his central challenge: 'if we remain within the millennium with which this book is concerned, we are everywhere obstructed by written texts, for Christianity is a religion of the word. If we step outside this millennium into the modern period, we find art in our way, a new function that fundamentally transformed the old image [. . .] Art history therefore simply declared everything to be art in order to bring everything within its domain, thereby effacing the very difference that might have thrown light on our subject' (p.9). Seeking to overcome the barriers

represented by Art with a capital A, Belting tells the story of the image from the earliest icons that survive at Sinai and Rome through to the development of the altarpiece in late medieval Italy.

Today, twenty years after its publication, it is difficult to convey the refreshing shock Belting's book conveyed to a young art historian eager to think in terms of the function, not simply the attribution, dating and iconography, of medieval images. More compelling, however, than the book's grandiose historical panorama and its sheer range of reference is its wealth of ideas, governed by a clear storyline, namely the origins and transformation of the cult image in its passage from East to West across one-and-a-half millennia, and a still clearer – perhaps too clean-cut – conceptual structure, neatly summarised by the work's subtitle. Art, image, cult: all three terms demand definition and invite disputation, especially when deployed across such a broad canvas, all the more so given that the German word *Bild* is rich in connotations in ways that its English equivalent is not. In Belting's later work, the difference, in German, between 'image' and 'picture' has permitted him to emphasise the notion that a picture is a medium that permits the image to acquire a presence tantamount to that of the body. Art history thus becomes a history of media as well as of the body, aspects that come into sharper focus in Belting's more recent book, not yet translated into English, *Das Echte Bild* (2005).[1]

Bild und Kult's more immediate aim was to recast the relationship between the art of Byzantium and the West, a touchstone topic for early modern as well as medieval art. Indeed, one of the accomplishments of Belting's book, for which all medievalists ought to be grateful, is that it came as a clarion call to modernists that modernity, however defined, can only be understood against the foil, not just of Antiquity, but also of all that intervened. Focusing on the interrelationship of function and pictorial rhetoric, Belting helped tip the balance in discussions of medieval art (and beyond) from issues of production to conditions of reception. As part of this process, Belting, with others, redrew the art-historical topography of the Mediterranean, charting cross-currents stirred up by cultural exchange, colonisation and the Crusades. Still more important, he recast the origins of the independent easel painting, the canonical vehicle of modern art.

Belting's book crystallises a turning point, for himself and for the history of art. Before considering its impact, however, one must consider its genealogy, adumbrated by Belting himself in his review of Otto Demus's *Byzantine Art and the West* (1970).[2] Remarking that 'new methods, other than those analyzing stylistic forms, are needed to clarify these manifold connections', Belting nonetheless observed that Demus was 'devising a kind of program for future

Front cover to Hans Belting, *Bild und Kult: Eine Geschichte des Bildes vor dem Zeitalter der Kunst*, 1990.

research'. Belting then quoted his fellow Byzantinist: "'Had it not been for the transformation of Hellenistic panel painting into Byzantine icon painting and the transfer of this art form to the West, the chief vehicle of Western pictorial development would not have existed or would have come into existence a good deal later [. . .] Of course, the Byzantine models were, from the very beginning, not only subjected to a thorough transformation, but also adapted to serve the specifically Italian requirements for altar panels and a new kind of devotional image". As if defining his plan, first for *Das Bild und sein Publikum: Form und Funktion früher Bildtafeln der Passion* (1981), which focused on the reception and transformation of the image of the Man of Sorrows in the late medieval West, then for *Bild und Kult*, Belting added: 'It is precisely this process of adapting and transforming Byzantine models on which research will have to concentrate'.

Were medievalists to come cold to Belting's most recent work, which has focused on modern and contemporary art, they might, in addition to being impressed by the extraordinary scope and reach of his scholarship, be amazed to learn that the first half of his career was spent as one of the most distinguished Byzantinists of his or any other generation. Just as *Bild und Kult* divides the history of European art into two distinct phases, so too, Belting's career can be viewed as falling into two parts. In each case, however, the second phase is inextricably linked to the first. Far more than a synthesis of his own contributions to the study of Byzantine art and its reception in the Latin West, Belting's book also stands as his envoi to art history itself. It is as if in finishing with the subject for himself, Belting invited his colleagues to join him in saying goodbye to it. *Das Ende der Kunstgeschichte?* (1983) questioned precisely the kind of grand narrative that he would present in *Bild und Kult*, even as that book provided the cornerstone of a series of subsequent publications that, taken as a whole, chart an arc that is Hegelian in its dimensions. With the revised republication of *Das Ende der Kunstgeschichte* (1995), the removal of the question mark converted Belting's query into statement of fact. Belting's attention turned subsequently to a more amorphous yet labile quantity, the image, not so much in the Middle Ages as in contemporary media. This tack in Belting's work, which insists on paired oppositions between, on the one hand, word and sign and, on the other hand, image and body, coincides with and has in part propelled the so-called 'iconic turn'.

To re-review *Bild und Kult*, therefore, is to re-examine the trajectory of the history of art, in at least one of its arcs, over the past generation. The book set the stage for a still more ambitious, if problematic, recasting of the concept of

the image, one that in Belting's self-proclaimed 'anthropology of the image' (*Bild-Anthropologie*) – itself part of a broader turn towards anthropology in the Humanities, above all in Germany – aspires to a level of generality that transcends time, place and, in many respects, the particularities of culture.[3] In its insistence on the image as a substitute for the body and on both the body and the physical image as entities onto which imagined images can be impressed or projected, Belting's anthropology of the image finds notable analogies in the historical anthropology of Jean-Claude Schmitt. Schmitt's landmark article, 'La Culture de l'imago' (1996), like Belting's more recent work, insists on a continuum among material and immaterial images, extending from concrete embodiments to the imagination and, ultimately, the *imago dei* as the governing concept in medieval characteri-sations of what it means to be human.[4] In their philosophical bent, French and German historical anthropology differ quite strongly from their Anglo-American counterpart, which tends in turn to be more sociological in character.

If *Bild und Kult* focused on the image before art, Belting's subsequent work has come to rest on what he sees as avatars of the medieval image in the present. In this scheme of things, medieval 'art' (cast by Vasari as an egregious excep-tion to the right rules of representation that governed in Antiquity and that were laboriously recovered, then surpassed, in the Renaissance), proves instead to rep-resent a more universal ontology of the image. In this view, the image, striving for reunification with the body for which it stands, remains free to act unen-cumbered by theology or, in Belting's view, its modern equivalent, art-historical theory. The Middle Ages, rather than representing the great exception to the rule, instead defines a norm that itself undergoes a renaissance of sorts in the present. To this extent, Belting's understanding of the exceptional character of Western art shares a great deal with the views of E.H. Gombrich, although by contrast the value that Belting places on the art of the Renaissance until the fall of the *ancien régime* is almost entirely negative.

Belting's conjunction of what traditionally were art-historical opposites – the medieval and the modern – goes a long way to explaining a trend, especially in Germany, that began in the 1990s, namely, the mixing of contemporary and medieval art in exhibitions and museum installations that for better (or worse) instrumentalise medieval art to explore purported intersections between pre-modern and post-modern modes of image making, from body and performance art to installation art and beyond.[5] Always provocative, such comparisons also have their limits, no less than the analogies drawn by literary critics between deconstruction and negative theology.[6] Not that moderns working on medieval

Christian art need give it any credence, but in the Middle Ages there existed a ground of meaning that in the meantime has fallen away.

Belting's re-evaluation of modernity in the light of the Middle Ages thus becomes part of a larger set of historical narratives attempting to cope with secularisation and, in particular, Weber's concept of disenchantment, which looms larger than Belting acknowledges in his interpretive framework.[7] The same could be said of Walter Benjamin, in particular his classic essay 'The Work of Art in the Age of Mechanical Reproduction', first published in French in 1936.[8] Mentioned only once in *Bild und Kult* (p.99), Benjamin's essay defines many of the terms of Belting's argument. Benjamin's 'aura' is not the same as Belting's 'cult', above all in that Benjamin's concept extended to include much of what Belting designates as art. Nonetheless, Benjamin identifies 'two polar types' of the work of art, just as Belting defines two ages, one before and one after the work of art. 'With one', states Benjamin, 'the accent is on the cult value (*Kultwert*); with the other, on the exhibition value (*Austellungswert*) of the work'.[9] The 'ritualistic basis, however remote, is still recognizable as secularized ritual even in the most profane forms of the cult of beauty [. . .] developed during the Renaissance and prevailing for three centuries'.[10] Benjamin's understanding of medieval art, his romanticisation of the concept of aura (rooted in Alois Riegl and, earlier still, in '*Einfühlungsästhetik*'), and his distinction between '*Kultwert*' and '*Austellungswert*', all have come in for criticism, in particular, because the mass reproduction of works of art in the late Middle Ages, even if it eventually contributed to the unravelling of 'aura' in the Reformation, had, at least at first, no impact on their efficacy whatsoever.[11] Belting's book and, even more so, his subsequent work participate in a nostalgia for immediacy and presence that has most clearly been enunciated in Hans-Ulrich Gumbrecht's *Production of Presence* (2004), which appeals to (problematic) notions of Eucharistic presence as defined in the Middle Ages.[12] Medieval art was hardly as free of mediation and effects of representation as some of its champions would apparently like to believe.[13] Religious convictions are hardly incompatible with – dare one use the word? – the aesthetic cunning of much medieval art; witness its renewed appreciation in the modernity from which Belting too stringently divorces it.[14]

The survival and study of medieval art have always been inflected by the art of the time in which it was appreciated or depreciated in turn. Moreover, medieval art played a seminal role in shaping the courses both of modern art and modern art history, both of which in turn constantly informed one another. Whatever one thinks of the results, Belting's work provides eloquent and effective

testimony to this ongoing dialogue.[15] The massive dislocation (and destruction) of monuments following the French Revolution and subsequent secularisations coincided with the embodiments of nostalgia represented by artistic movements such as the Pre-Raphaelite Brotherhood, the Nazarenes and, more generally, the Gothic Revival.[16] Medieval art in turn had a profound impact on the development of modernism, not only in the work of writers such as William Morris and John Ruskin, but, closer to the time of art history's emergence in Germany, in the work of authors such as Riegl and Wilhelm Worringer, both of whom looked to the art of Late Antiquity and the Middle Ages for embodiments of a non-classical aesthetic.[17] Many of the 'founding fathers' of art history in the late nineteenth and early twentieth century were, not coincidentally, medievalists.

One can hardly hope for medieval art to assume similar prominence in the artistic developments of our own day. Nonetheless, similar interactions can be observed, a dialogue in which Belting, in the light of his position at the Staatliche Hochschule für Gestaltung in Karlsruhe, has played an influential role. Matthew Barney's exhibition *Prayer Sheet with the Wound and the Nail* (Schaulager, Basel, 12th June to 3rd October 2010) represented only the most recent manifestation of this phenomenon.[18] The title alone evokes medieval devotional imagery, no less than did Chris Burden's performance piece *Trans-Fixed* (1974), in which he (in)famously had himself nailed to a Volkswagen Beetle that emerged from a garage with its engine roaring to imitate shrieks of pain.[19] The nails that had pierced Burden's hands later were installed in a reliquary-like container made out of Plexiglas, an uncanny anticipation of the Schaulager's presentation of the 'relics' of Barney's artistic athleticism. In both works, the body of the artist becomes a Christ-like incarnation of virtue, an inimitable 'true image' that can only be exhibited through a series of simulacra that are then collected like relics. What the pilgrims who flock to galleries to view traces of these performances truly believe or expect is another matter. It is by no means clear that the contemporary artist makes a convincing or charismatic hermit saint.

Despite such experiments, it is difficult to imagine the study of medieval art once again assuming a seminal role in the discourse on contemporary art. Given, moreover, the encrustations of criticism that surround and condition both the production and reception of art today, one can hardly accept at face value Belting's repeated approximation of art history to theology – both, as he construes them, after-the-fact attempts to constrain the power of the image. In *Bild und Kult*, the textual sources on which Belting draws are sent packing to a useful appended anthology, almost as if to keep the images pure of their baleful

influence. At a distance, Belting's philippics against theology (and, to a lesser extent, theory) participate in a larger oscillation in the valuation of discursive versus visual experience, of which the story of the image that he tells itself forms a part. Belting tells this story in such a way as to discount or downplay the discursive character of what has come to be called visuality.[20] Whether word and image, however, remained so separate, especially in the monastic experience of what we commonly call works of art, is very doubtful. Moreover, in the medieval West, theologians had remarkably little to say that is of direct relevance to medieval imagery and seldom extended their remarks beyond a small set of stereotypes. In other contexts, their writings, far from suggesting the hostility Belting suggests, are more indicative of a certain sovereign indifference. In contrast, on theological matters they suggest remarkable sophistication regarding issues of representation – for example, on the relationship of the visible to the invisible, which was central to debates over the Incarnation and, hence, of images. In the light of the sums of money poured into patronage, their relative reticence could in most contexts be construed as either toleration or tacit approval, as opposed to the Byzantine East, where image theory remained central to definitions of orthodoxy.

Despite the barriers, and in no small measure due to Belting's influence, medieval art is enjoying something of a renaissance, not least in the study of the Renaissance itself. The partition between the medieval and early modern suddenly seems quite porous, a breaking down of boundaries that was initiated by historians before it was taken up in literary studies, again in the 1990s.[21] In response to Belting's definition of the Middle Ages as the era of the image before that of art, scholars of the Italian Renaissance have begun to explore the extent to which cult images and the attitudes associated with them persisted into the modern era.[22] Medievalists, in turn, have looked with a fresh eye at the ways in which medieval images could be construed as aspiring to the condition of art, if by that word is meant, at least in part, images that cultivate and recognise their artifice, suggest self-awareness on the part of their patrons and makers, and, in specifically Christian contexts, develop various visual strategies to mark the limitations of the image when it comes to representing the invisible.[23] Whereas a book such as Klaus Krüger's *Das Bild als Schleier des Unsichtbaren: Ästhetische Illusion in der Kunst der frühen Neuzeit* (2001) traces the origins of self-reflexive strategies deep into the Middle Ages, others, such as Christopher S. Wood's *Forgery, Replica, Fiction: Temporalities of German Renaissance Art* (2008) and *Anachronic Renaissance* (2010, co-authored with Alexander Nagel), although deeply indebted to Belting, challenge standard accounts of secularisation by insisting on referentiality and

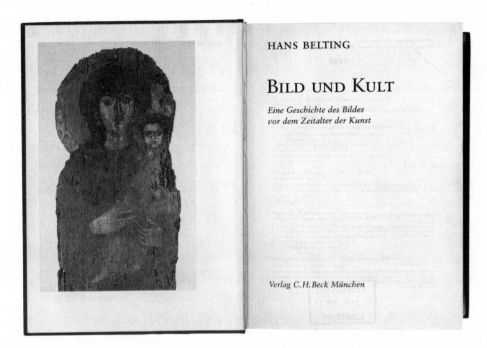

Frontispiece and title-page to Hans Belting, *Bild und Kult:*
Eine Geschichte des Bildes vor dem Zeitalter der Kunst, 1990.

what they call 'substitutionality' – in essence, iconic modes of participation – as opposed to representation. Such complications and qualifications undercut the simplicity of Belting's clear separation of epochs, but testify to the attraction and persuasiveness of the questions that structured his inquiry.

Revisiting Belting's monumental book further provides an opportunity to reflect on the profound and persistent differences between art-historical scholarship in the English-speaking and German-speaking worlds. These differences stem in part from a *dialogue des sourds*, not least because ever fewer Anglo-American scholars, let alone their students, read German with ease (to which it might be added that some German scholars, if not Belting, cultivate a prose style, including English neologisms and barbarisms, that defies easy reading).[24] The differences in approach, however, cannot be attributed to linguistic barriers alone, above all because several of Belting's books (if not, unfortunately, his monumental *Die Erfindung des Gemäldes: Das erste Jahrhundert der niederländischen Malerei*, co-authored with Christiane Kruse, 1994) have been translated into English. Moreover, a programmatic statement of Belting's method, 'Image,

Medium, Body: A New Approach to Iconology', appeared, late but in earnest, in 2005 in *Critical Inquiry*.[25]

Despite these translations, it must be said that Belting's impact on English-language scholarship has been limited. The differences between Belting's self-proclaimed *Bild-Anthropologie* and the most relevant strands in Anglo-American scholarship can best be summed up if one compares Belting's book to, on the one hand, David Freedberg's *Power of Images* (1989), virtually contemporaneous with *Bild und Kult*, and, on the other hand, W.J.T. Mitchell's *Picture Theory* (1994).[26] These books participate in what has variously been called the 'pictorial' or the 'iconic turn', but in different ways. Whatever it represents, the 'iconic turn' points in diametrically different directions. Belting sees art history as akin to theology in so far as it quashes or resists the age-old identification of images with living bodies. In contrast, Freedberg distinguishes between the two, assigning theology a constructive role: 'It is not just psychology that is at stake, but also the relations between theology and psychology', he argues, adding that Belting 'fails to see that the general psychological theory is already present in the Byzantine theory of images'.[27] Rather than characterising theologians as censors, Freedberg casts them as agents provocateurs.[28] Freedberg claims that what he considers typical for the Middle Ages proves normative for all of human history, not just in the West. In Freedberg's forceful formulation 'the ontology of holy images is exemplary for all images'.[29] If anything, Belting's work subsequent to *Bild und Kult*, above all his recent study of optics and perspective (*Florenz und Bagdad: Eine westöstliche Geschichte des Blicks*, 2008), has, in focusing on questions of perception, drawn closer to Freedberg's position.[30] Nonetheless, it remains telling that whereas in America advocates of the 'pictorial turn', in particular Mitchell, focus on pictures, the mass media and refer to Panofsky, by contrast, in Germany, the 'iconic turn' focuses on the body as medium and takes Aby Warburg as its obsessive point of reference. By insisting on various forms of cultural embeddedness, American image theory, whether presented under the rubric 'visual culture' or 'visual studies', presents a very different picture. In Mitchell's words: 'Whatever the pictorial turn is, then, it should be clear that it is not a return to naive mimesis, copy or correspondence theories of representation, or a renewed metaphysics of pictorial "presence". It is rather a post-linguistic, post-semiotic rediscovery of the picture as a complex interplay between visuality, apparatus, institutions, discourse, bodies and figurality.'[31] Amidst this range of theoretical options, for anyone who still believes in the conditioning effects of culture, society, class and gender, let alone other factors, there is reason to be sceptical about all general claims

regarding the nature of images. Such claims can be taken to underwrite a globalisation of art history at the price of an unattractive homogeneity. Belting himself has contributed to this trend, partly by virtue of his laudable efforts to expand the sometimes parochial purview of German art history, which, in a further contrast to American art history, remains – with notable exceptions – myopically focused on the art of Europe.[32]

It is too early to predict whether, as an outgrowth of Belting's book on the 'history of the image before the age of art', the history of art will give way in turn to an all-inclusive history of images. Although widely admired, Belting's *Bild-Anthropologie* has less often been imitated, above all in the United States, but also in Germany. Belting focuses almost obsessively on images of the body, whereas the cosmos of images embraces many other subjects, not all of which can be simply subsumed under the category of dreams or projections of the human imagination. Moreover, there are competing visions of what, in Germany, following Gottfried Boehm, is called the 'iconic turn',[33] not to mention the question of whether more empirically minded scholars working in other traditions – whether in the United States or elsewhere – will follow the Germans' characteristically philosophical lead.[34] Whereas Boehm champions a hermeneutic of the image independent of texts, Horst Bredekamp's *Bildwissenschaft*, in ways different from Belting's, seeks to subsume all images, including scientific imaging and mass media, to an expanded art-historical domain that, as always, established itself in art and social practice long before it did in academia.[35] Such debates have serious stakes, not simply for anything so narrow as the 'discipline', however defined, as for the understanding of something as important as what Belting himself called 'the most interesting question of all: why images?'[36]

An essay such as this cannot pass in review the extraordinary number of specialised topics that Belting's synthesis brought together by, again in his own words, 'overcoming the narrow treatment of the topic that is prevalent today'.[37] Some of his suggestions have garnered assent, others not. In its focus on the cult image, however defined, and its impact, Belting's book, despite its vast coverage, provides a foreshortened vision of medieval art that excludes many other genres and media that do not fit comfortably with his framework. By his own admission, narrative imagery plays no role.[38] Neither, by and large, does sculpture or metalwork, both of which for much of the Middle Ages were valued more highly than painting and played critical roles in cult contexts. So powerful is Belting's storyline that the cult image has sometimes come to stand for medieval art *tout court*. The Western monastic tradition, which had a decisive impact on attitudes towards

images in the medieval West, gets short shrift. The book too often falls back on appeals to popular culture when, in the Middle Ages, as Peter Brown was among the first to insist, divisions between high and low were hardly as well-defined as in modernity.[39] Belting's definition of just what constitutes a cult image has itself been called part of a '*kunstwissenschaftliche Ikonenmystik*'.[40] Whereas Belting succinctly, yet broadly, defines the sphere of the cult image as that which 'deals with people and with their beliefs, superstitions, hopes and fears in handling images', historians of liturgy would counter that the concept of cult more narrowly represents a corporate paradigm. Not all images representing persons were regarded as miraculous 'living' images, a privilege that could on occasion also be extended to other types and genres, narrative imagery included. In his recent re-evaluation of the origins of apsidal decoration in the medieval West (*The Apse, the Image and the Icon: An Historical Perspective of the Apse as a Space for Images*, 2010), Beat Brenk (perhaps unfairly) does not mention Belting's book or even his landmark article on S. Maria Antiqua, arguing that cult imagery and the practices associated with it, far from an inheritance from Antiquity, by and large represent inventions of later Late Antiquity.[41] In contrast, Belting, seeking to sustain the onset of modernity c.1500 as his great divide, presents a relatively seamless transition between ancient and Christian cult practices, with reservations regarding power and presence given as expressions of textual (and theological) anxiety. Rather than representing a substratum of popular belief on which Christian tradition would eventually build, however, ancient religious practices and the attitudes towards art that accompanied them were both complex and contradictory.[42] In the words of Peter Stewart:

> [...] it would be somewhat harder to construct a modern 'era of art' if his [Belting's] attention to the Roman world extended back beyond late antiquity. For while Roman responses to images were pre-modern – they may have been 'irrational' in many ways and they certainly do not correspond precisely to the modern Western concept of art – they nevertheless have too much in common with that perspective to be confined in a kind of anthropological crucible.[43]

Ancient attitudes towards cult statues ranged from scepticism to veneration, but contemporaries seem to have had little trouble reconciling cult and culture.[44] It may seem petulant to ask more of a book that already provides so much, but in tracing the story of the Christian cult image, too much is taken for granted at the outset. At stake in these debates, beyond perennial problems of periodisation,

are the originality and character not simply of the Renaissance, should one still care to use that term, but also, more critically, of early Christian art.

Scholars working in the early modern period who take Belting's book as the last word on the Middle Ages would do well to pay close attention to these debates, since they have important implications for the broader applicability of some of its bolder hypotheses, especially as they have been developed and extended in his subsequent work. At issue is how the Middle Ages are framed, and the degree to which the period is seen as the crucible of modernity or its antithesis. These debates are not new, and Belting's work constitutes part of a continuous re-evaluation. His book participates in a return to a vision of the Middle Ages that is more instinctual or at least pre-discursive, but without the pejorative judgment that previously attached to condemnations of its alterity. More important, however, and perhaps ultimately more fruitful, has been Belting's willingness, with a similar anthropological bent, to ignore what his adventuresome predecessor Warburg characterised as the '*Grenzpolizei*', the disciplinary border guards. Even if, contra Belting, both the concept of art in the Middle Ages and art history as a whole appear to have a future, there can be no doubt that Belting's book will have played a transformative role in shaping their course.

Notes

INTRODUCTION, PP.7–19

JOHN-PAUL STONARD

1 R. Fry: 'The Baroque', *The Burlington Magazine* 39 (1921), p.146.
2 A.H. Barr, Jr.: *Matisse: His Art and His Public*, New York 1951, p.95. Barr also clears up the confusion over *Luxe, calme et volupté* with two paintings from 1907, *Luxe I* and *Luxe II*.
3 A.H. Barr, Jr.: 'Modern Art Makes History, Too', in *Art Journal* 1 (1941), p.5.
4 K. Clark: *The Other Half: A Self-Portrait*, London 1977, p.7.
5 E. Sears: 'Kenneth Clark and Gertrude Bing: Letters on "The Nude"', *The Burlington Magazine* 153 (2011), pp.530–31. I am grateful to Sears for drawing my attention to this important aspect of Clark's intellectual background, not mentioned in my own essay in this book.
6 S. Alpers: 'Is Art History?', *Daedalus* 106 (1977), pp.1–13.
7 R. Krauss: 'In the Name of Picasso', in *idem: The Originality of the Avant-Garde and Other Modernist Myths*, Cambridge MA 1985, p.25.

CHAPTER 1, PP.20–29

Emile Mâle: *L'art religieux du XIIIe siècle en France: Etude sur l'iconographie du Moyen Age et sur ses sources d'inspiration*, 1898
ALEXANDRA GAJEWSKI

1 Unless otherwise indicated, references in this essay are to E. Mâle: *The Gothic Image: Religious Art in France of the Thirteenth Century*, New York, Evanston, San Francisco and London 1972 (hereafter cited as Mâle), which is a reprint of Dora Nussey's translation of the third French edition published as E. Mâle:

Religious Art in France of the Thirteenth Century: A Study in Medieval Iconography and its Sources of Inspiration, London 1913. More recently, Princeton published a new edition: E. Mâle: *Religious Art in France, the Thirteenth Century: A Study of Medieval Iconography and Its sources* (Bollinger Series, 90.2), transl. by M. Mathews, Princeton 1985.
2 A. Adam: 'Les années de jeunesse et de formation d'après la correspondance et les souvenirs', in *Emile Mâle (1862–1954): La construction de l'œuvre: Rome et l'Italie*, Rome 2005, pp.7–20.
3 'Bibliographie des travaux d'Emile Mâle', in *ibid.*, pp.317–39.
4 '. . . we feel that there is something in [thirteenth-century art] akin to a soul'; Mâle, p.viii.
5 For Mâle's later publications, see the bibliography cited at note 3 above.
6 For Didron, see C. Brissac and J.-M. Léniaud: 'Adolphe-Napoléon Didron ou les media au service de l'art chrétien', *Revue de l'Art* 77 (1987), pp.33–42. Mâle also mentions C. Cahiers and A. Martin; for those two and for Crosnier, see J. Neyrolles: 'Deux approches de l'iconographie médiévale dans les années 1840', *Gazette des Beaux-Arts* 128/1534 (1996), pp.201–22.
7 E. Emery: *Romancing the Cathedral: Gothic Architecture in Fin-de-Siècle French Culture*, New York 2001, pp.11–22; and J.-M. Léniaud: *Viollet-le-Duc ou les délires du système*, Paris 1994, pp.27–34.
8 See E. Vergnolle: 'La Société Française d'Archéologie, de sa fondation en 1834 à nos jours', presentation given at the Society of Antiquaries of London, 2008. On SFA website: http://www.sf-archeologie.net/La-Societe-Francaise-d-Archeologie,81.html, accessed 8th October 2012.
9 For the impact of Chateaubriand's views on nineteenth-century

France, see W. Sauerländer: 'La cathédrale et la Révolution', in *idem: Cathedrals and Sculpture*, London 2000, II, pp.841–43; on Chateaubriand's philosophy of nature, see A. Adam: 'La genèse d'une cathédrale romantique: le Génie du Christianisme de Chateaubriand', in J. Prungnaud, ed.: *La Cathédrale*, Villeneuve d'Ascq 2001, pp.51–57.
10 In addition to the authors mentioned, see J. Michelet: *Histoire de France – Moyen Age*, Paris (2nd ed.), II, p.661; '*Elle est veuve, elle est vide l'église. Son profond symbolisme, qui parlait alors si haut, il est devenu muet*'; and J.-K. Huysmans, letter to Arij Prin of 2nd February 1897: 'I am redoing all of medieval symbolism, something that no longer exists . . .'; quoted in Emery, *op. cit.* (note 7), p.116; and E. Mâle: *Art et artistes du Moyen Age*, Paris 1939 (3rd ed.), p.v.
11 A.-J. Crosnier: *Iconographie Chrétienne: ou, Etude des sculptes, peintures, etc., qu'on recontre sur les monuments religieux du Moyen-Age*, Paris 1848, pp.4 (with reference to Apocalypse 21) and 8.
12 Emery, *op. cit.* (note 7), pp.20–21.
13 A.-N. Didron: *Iconographie Chrétienne: Histoire de Dieu*, Paris 1843, pp.xx–xxi.
14 Mâle, pp.viii–xi.
15 *Ibid.*, p.viii. For art history in France, see L. Therrien: *L'histoire de l'art en France: Genèse d'une discipline universitaire*, Paris 1998, pp.221–344; R. Recht: 'Emile Mâle, Henri Focillon et l'histoire de l'art du Moyen Age', *Académie des Inscriptions & Belles-Lettres* (November–December 2004), pp.1653–55.
16 In his memoirs, Mâle recalled that the defeat of 1870 awoke in him the wish to do something for a humiliated France, and that while travelling in France he first had the idea of devoting himself to a French subject of research;

see E. Mâle: *Souvenirs et correspondances de jeunesse*, Nonette 2001, pp.86 and 133. For the effect of 1870 on France, see E. Emery and L. Morowitz: *Consuming the Past: The Medieval Revival in Fin-de-Siècle France*, Aldershot 2003, pp.19–24.

17 Emery, *op. cit.* (note 7), pp.29–35; of course, Mâle himself contributed to that vision of the cathedral. For the cathedral in nineteenth-century France, see also Sauerländer, *op. cit.* (note 9), pp.830–64.

18 Mâle, p.x.

19 Emery, *op. cit.* (note 7), p.5; Emery points out that Zola, Huysmans and Proust were the only authors of this period whose writings described real cathedrals.

20 Mâle, p.399.

21 For Didron's and Mâle's appreciation of Vincent of Beauvais, see J. Schneider: 'Vincent de Beauvais à l'épreuve des siècles', in S. Lusignan and M. Paulmier-Foucart, eds.: *Lector et Compilator: Vincent de Beauvais, frère prêcheur: Un intellectuel et son milieu au XIIIe siècle*, Grâne 1997, pp.31–32 and 36–37. Mâle used the printed edition *Speculum majus*, IV, Douai 1624.

22 *Idem*: 'Vincent de Beauvais et l'histoire du "Speculum Maius"', *Journal des Savants* (January–June 1990), pp.97–124.

23 *Ibid.*, p.107, note 29; the idea goes back to Hugh of St Victor.

24 Modern scholarship supports this view; see *ibid.*, p.99, note 6.

25 Mâle, p.389.

26 Didron, *op. cit.* (note 13), pp.vi–vii and xiii–xvii; and Mâle, pp.vii–xv and 58–63. See P. Kurmann, "Die gotische Kathedrale – Ordnungskonfiguration par excellence?" In B. Schneidmüller and S. Weinfurter, eds.: *Ordnungskonfigurationen im hohen Mittelalter*, Ostfildern 2006, pp.279–302.

27 V. Hugo: *Notre-Dame de Paris*, Paris 1831, V, II: '*Ceci tuera cela*'; see also Emery, *op. cit.* (note 7), pp.15–16.

28 Mâle, p.390.

29 Sauerländer, *op. cit.* (note 9), pp.845–48; and Emery, *op. cit.* (note 7).

30 D. Russo: 'Emile Mâle, l'art dans l'histoire', in *op. cit.* (note 2), pp.257–59; and J. Baschet: 'L'iconographie médiévale', in *ibid.*, p.277.

31 Mâle, p.23.

32 *Ibid.*, pp.viii, ix and 26; he also calls it '*l'esprit*' (p.20).

33 *Ibid.*, p.184.

34 *Ibid.*, p.22; perhaps a reference to Hugo, who called Notre-Dame a '*vaste symphonie en pierre*', in Hugo, *op. cit.* (note 27), III, I.

35 Mâle, pp.169–70.

36 Mâle's understanding of 'thought' becomes very clear when, in the French edition, he asserts that those images that had no ulterior meaning were '*exemptes de pensée*'; E. Mâle: *L'art religieux du XIIIe siècle en France*, Paris 1948 (8th ed.), p.124.

37 According to Mâle's memoirs, he rediscovered Catholicism in the course of his work on the Middle Ages; see Mâle, *op. cit.* (note 16), p.152: '*l'étude du Moyen Age me fit sentir la grandeur et la bienfaisance de cette religion, qui n'a pas de commune mesure avec les autres*'.

38 E. Mâle: 'Cours d'iconographie chrétienne, première leçon', in *op. cit.* (note 2), pp.67–70.

39 In the French edition; Mâle, *op. cit.* (note 36), e.g. pp.55, 58, 63 and 121; see also A. Grabar: 'Notice sur la vie et les travaux de M. Emile Mâle', *Académie des Inscriptions & Belles-Lettres* (January–March 1962), pp.328–44.

40 Mâle, *passim*, esp. pp.20 (for quotation), 52–53 and 283.

41 *Ibid.*, e.g. p.22.

42 *Ibid.*, p.397.

43 Emery and Morowitz, *op. cit.* (note 16), pp.92–108; and Recht, *op. cit.* (note 15), p.1656.

44 Mâle, pp.396–99; Mâle, like many of his contemporaries, was unhappy with his times; see also pp.129 and 284. For Zola's *Les Trois Villes* and Huysmans's Durtal cycle, see Emery, *op. cit.* (note 7); for Huysmans, see also O.G. Oexle and M.A. Bojcov, eds.: *Bilder der Macht in Mittelalter und Neuzeit: Byzanz – Okzident – Russland*, Göttingen 2007, p.633.

45 K. Künstle: 'Symbolik und Ikonographie der christlichen Kunst. Zur Methodologie der christlichen Ikonographie', in E. Kaemmerling, ed.: *Ikonographie und Ikonologie: Theorien, Entwicklung, Probleme*, Cologne 1979, pp.72–73.

46 G. Kopp-Schmidt: *Ikonographie und Ikonologie: Eine Einführung*, Cologne 2004, pp.47–48.

47 K. Michels: *Aby Warburg: Im Bannkreis der Ideen*, Munich 2007, pp.61–105.

48 See X. Barral I Altet: *L'art médiéval*, Paris 1991 (13th ed.), pp.111–13; and Russo, *op. cit.* (note 30); see also note 52 below.

49 For iconography around 1900, see H. Dilly: 'Emile Mâle (1862–1954)', in *idem*, ed.: *Altmeister moderner Kunstgeschichte*, Berlin 1999, pp.132–48; and Recht, *op. cit.* (note 15), pp.1657–59.

50 Therrien, *op. cit.* (note 15), pp.293–97. Mâle had been teaching art history at the Sorbonne since 1906 to support Henry Lemonnier who held the first chair in art history, established in 1899, and who retired in 1912.

51 For the impressions of one of his former students, see G. Bazin: *Histoire de l'histoire de l'art: De Vasari à nos jours*, Paris 1986, pp.208–14.

52 See Grabar, *op. cit.* (note 39); L. Neagley's review of Mâle's *Religious Art in France*, Princeton 1986, in *Speculum* 65 (1990), pp.192–94; M. Camille: *The Gothic Idol: Ideology and Image-Making in Medieval Art*, Cambridge 1989, p.xxvii; A. Corbellari: 'Emile Mâle et Joseph Bédier: de la gloire de la France à l'apologie des clercs', *Gazette des Beaux-Arts* 132 (1998), pp.235–44; R. Recht: *Le croire et le voire: L'art des cathédrales (XIIe–XVe siècle)*, Paris 1999, pp.290–307; and Baschet, *op. cit.* (note 30).

53 Neagley, *op. cit.* (note 53).

54 See R. Bradley: 'Backgrounds of the title "Speculum" in mediaeval literature', *Speculum* 29 (1954), pp.100–15.

CHAPTER 2, PP.30–41

Bernard Berenson: *The Drawings of the Florentine Painters Classified, Criticised and Studied as Documents in the History and Appreciation of Tuscan Art, with a Copious Catalogue Raisonné*, 1903
CARMEN C. BAMBACH

The research on Berenson presented in this essay was refined during a three-month Craig Hugh Smyth

Visiting Fellowship at Harvard University's Villa I Tatti in Florence in spring 2009. References to plates in Berenson's original text are given as 'BB' followed by the plate number and, where they are not taken from the 1903 edition, the year of the relevant edition.

1 B. Berenson: *The Drawings of the Florentine Painters Classified, Criticised and Studied as Documents in the History and Appreciation of Tuscan Art, with a Copious Catalogue Raisonné*, 2 vols., London 1903 (hereafter cited as Berenson 1903).

2 *Idem*: *The Drawings of the Florentine Painters: Amplified Edition*, Chicago 1938 (hereafter cited as Berenson 1938); and *idem*: *I disegni dei pittori fiorentini*, transl. by L. Vertova Nicolson, Milan 1961 (hereafter cited as Berenson 1961).

3 Editorial [Benedict Nicolson]: 'In Honour of Berenson', *The Burlington Magazine* 97 (1955), p.195, in the special issue celebrating Berenson's ninetieth birthday.

4 K. Clark: 'Bernard Berenson', *The Burlington Magazine* 102 (1960), p.383.

5 Berenson 1961, I, p.7; the translation is my own. See also P. Pouncey: 'Bernard Berenson, "I disegni dei pittori fiorentini", Milan 1961', *Master Drawings* 3 (1964), pp.278–93.

6 B. Berenson: 'The Rudiments of Connoisseurship', in *idem*: *The Study and Criticism of Italian Art*, London 1910, p.147 ('the Sense of Quality is indubitably the most essential equipment of a would-be connoisseur').

7 Berenson 1961, I, pp.7–8; the translation is my own. These statements are absent in the 1903 and 1938 editions.

8 *Idem*, *op. cit.* (note 6), pp.vi and 111–48.

9 See, among others, D.A. Brown: exh. cat. *Berenson and the Connoisseurship of Italian Painting: A Handbook to the Exhibition*, Washington, DC (National Gallery of Art) 1979.

10 Berenson, *op. cit.* (note 6), p.113.

11 See G. Morelli: *Italian Painters: Critical Studies of their Works* (*The Galleries of Munich and Dresden; The Borghese and Doria Pamfilj Galleries in Rome*), London

1900, I, pp.1–63; Berenson, *op. cit.* (note 6), pp.119–26 (p.122: 'It is now time to elaborate the definition, and to discuss the methods of the science'). The exception mentioned is A. Perrig: *Michelangelo's Drawings: The Science of Attribution*, New Haven and London 1991.

12 Berenson 1938, I, p.xi.

13 Compare K. Clark, *op. cit.* (note 4), pp.382–83; and S.J. Freedberg: 'Some Thoughts on Berenson, Connoisseurship, and the History of Art', *I Tatti Studies: Essays in the Renaissance* 3 (1989), pp.22–23.

14 *Ibid.*, pp.21–22.

15 See the mention of Clark in Berenson 1938, I, p.9; and Clark, *op. cit.* (note 4), p.382.

16 See the version of the story told in *ibid.*, p.383.

17 Berenson, *op. cit.* (note 6), pp.116–19.

18 The literature on this subject has grown enormously; see C. Baker, C. Elam and G. Warwick, eds.: *Collecting Prints and Drawings in Europe, c.1500–1750*, Aldershot 2003.

19 This aspect was brilliantly explored by Francis Haskell in his *Patrons and Painters: A Study in the Relations Between Italian Art and Society in the Age of the Baroque*, New York 1963. On 'the period eye', see M. Baxandall: *Painting and Experience in Fifteenth Century Italy: A Primer in the Social History of Pictorial Style*, Oxford 1972.

20 This can be especially followed from the correspondence maintained by Berenson with his contemporaries of which the main repository is at Villa I Tatti. See also, for instance, N. Mariano: *The Berenson Archive: An Inventory of Correspondence*, Cambridge MA 1965; C. Garboli, C. Montagnani and G. Agosti: *Bernard Berenson–Roberto Longhi: Lettere e Scartafacci, 1912–1957*, Milan 1993.

21 J.P. Richter: *Leonardo*, London 1880; and *idem*: *The Literary Works of Leonardo da Vinci Compiled and Edited from the Original Manuscripts*, London 1883; 2nd ed. 1939; 3rd ed. 1970.

22 H.P. Horne: *Botticelli: Painter of Florence*, London 1908; repr. Princeton 1980.

23 P.N. Ferri: *Catalogo riassuntivo dalla raccolta di disegni antichi e moderni posseduta dalla R. Galleria degli Uffizi di Firenze*, Rome 1890.

24 A. Venturi: *Storia dell'arte italiana*, Milan 1901–40; *idem*: 'Raccolta di disegni delle Gallerie dell'Accademia di Venezia', *Le Gallerie nazionali italiane: Notizie e documenti* 2 (1896); and *idem*: 'L'uso della mano sinistra nella scrittura e nei disegni di Leonardo da Vinci', *L'arte* 42 (1939), pp.165–73.

25 See esp. Morelli, *op. cit.* (note 11); and the listings for Morelli's publications in the bibliography of Berenson 1938, p.ix.

26 Berenson, *op. cit.* (note 6), p.115.

27 See F. Viatte, R. Bacou and C.M. Goguel: exh. cat. *L'œil du connaisseur: Hommage à Philip Pouncey: Dessins italiens du Louvre*, Paris (Musée du Louvre) 1992; N. Turner and J.A. Gere: exh. cat. *The Study of Italian Drawings: The Contribution of Philip Pouncey*, London (British Museum) 1994; and sale, Sotheby's, New York, *The Philip Pouncey Collection*, 21st and 23rd January 2003.

28 See note 5 above; and P. Pouncey: 'Drawings by Garofalo' and 'A Drawing of a Prophet by Signorelli', *The Burlington Magazine* 97 (1955), pp.196–200 and 221, respectively. Compare H. Zerner: 'What Gave Connoisseurship its Bad Name', and J.A. Gere: 'Some Observations on the Practical Utility of Connoisseurship', in K. Oberhuber et al., eds.: *Drawings Defined*, New York 1987, pp.289–90 and 291–305, respectively.

29 B. Degenhart: 'Zur Graphologie der Handzeichnung: Die Strichbildung als stetige Erscheinung innerhalb der italienischen Kunstkreise', *Kunstgeschichtliches Jahrbuch der Bibliotheca Hertziana* 1 (1937), pp.225–340. See also *idem*: 'Die Schüler des Lorenzo di Credi', *Münchner Jahrbuch der bildenden Kunst* 9 (1932), pp.95–161. But Degenhart did not even make it into the list in Berenson's abbreviated bibliography of vol.2; B. Degenhart: 'Di alcuni problemi di sviluppo della pittura nella bottega del Verrocchio, di Leonardo e di Lorenzo di Credi', *Rivista d'arte* 14, ser.II–4, nos.3–4 (1932), pp.263–300 and 403–44; and *idem*: 'Eine Gruppe von Gewandstudien des jungen Fra Bartolommeo', *Münchner*

Jahrbuch der bildenden Kunst
NS 11 (1934), pp.222–31.

30 B. Degenhart and A. Schmitt:
'Methoden Vasaris bei der
Gestaltung seines "Libro"', in W. Lotz
and L. L. Möller, eds.: *Studien zur
toskanischen Kunst: Festschrift für
Ludwig Heinrich Heydenreich* [1963],
Munich 1964, pp.45–64; *idem*: exh.
cat. *Italienische Zeichnungen, 15.–18.
Jahrhundert*, Munich (Staatliche
Graphische Sammlung) 1967;
*idem: Corpus der italienischen
Zeichnungen, 1300–1450. Teil I:
Süd- und Mittelitalien*, Berlin 1968;
*idem: Corpus der italienischen
Zeichnungen, 1300–1450. Teil II:
Venedig; Addenda zu Süd- und
Mittelitalien*, Berlin 1980; and
*idem: Corpus der italienischen
Zeichnungen, 1300–1450. Teil II:
Venedig; Addenda zu Süd- und
Mittelitalien: Mariano Taccola*,
Berlin 1982.

31 Berenson 1938, I, p.xii ('add that the
difficulties of studying drawings are
greatly increased by the absence of
proper reproductions').

32 On these points, compare Berenson
1938, I, p.xii (quoted); Berenson
1961, I, p.12; and Freedberg, *op. cit.*
(note 13), p.17.

33 R. Oertel: 'Wandmalerei und
Zeichnung in Italien: Die Anfänge
der Entwurfszeichnung und
ihre monumentale Vorstufen',
*Mitteilungen des Kunsthistorischen
Institutes in Florenz* 5 (1940),
pp.217–314.

34 On these aspects, see also C.C.
Bambach: *Drawing and Painting
in the Italian Renaissance Workshop:
Theory and Practice, 1300–1600*,
Cambridge and New York 1999.

35 H. Tietze and E. Tietze-Conrat:
*The Drawings of the Venetian
Painters in the Fifteenth and
Sixteenth Centuries*, New York 1944.

36 See footnote 1 in Berenson 1938, II,
p.167, with regard to Michelangelo.

37 Berenson 1938, I, p.xi.

38 *Idem* 1961, I, p.107.

39 *Idem* 1903, I, pp.148–49.

40 *Ibid.*, p.149.

41 *Ibid.*

42 See *ibid.*; and C.C. Bambach:
'Leonardo, Left-Handed
Draftsman and Writer', in *idem*:
exh. cat. *Leonardo da Vinci Master
Draftsman*, New York (Metropolitan
Museum of Art) 2003, pp.31–57.

43 See C. Pedretti and G. Nepi Sciré:
*I Disegni di Leonardo da Vinci
e della sua cerchia nel Gabinetto
dei disegni e stampe delle Gallerie
dell'Accademia di Venezia*, Florence
2003, pp.104–06, no.8.

44 See also Pouncey, *op. cit.* (note 5),
p.287.

45 *Ibid.*, p.283.

46 Clark, *op. cit.* (note 4), p.382; and
P. Zambrano: *Bernard Berenson:
Amico di Sandro*, Milan 2006,
with previous literature.

47 One can strike works from the
Signorelli corpus (BB 2509B,
2509D–7, 2509E–9 and 2509C);
see also Pouncey, *op. cit.* (note 5),
pp.291–92.

48 Finiguerra's substantial corpus of
drawings was reconstructed by
Bernhard Degenhart and Annegrit
Schmitt in 1968, and was the subject
of a monograph by L. Melli: *Maso
Finiguerra: I disegni*, Florence 1995.

49 The greatly restored portrait
drawing at the Corcoran Gallery,
Washington, DC (BB 892A in the
1961 ed., fig.294), is accepted by
the present author as an autograph
but retouched cartoon fragment by
Domenico himself (here largely in
agreement with Berenson), rather
than as a copy of somewhat later
date, as believed by Pouncey,
op. cit. (note 5), p.285.

50 Berenson 1938, I, p.252.

51 Pouncey, *op. cit.* (note 5), p.287; and
C. van Tuyll van Serooskerken: exh.
cat. *Baccio Bandinelli*, Paris (Musée
du Louvre) 2008, p.71, no.11.

52 J.A. Gere: *Taddeo Zuccaro:
His Development Studied in His
Drawings*, Chicago 1969, p.183,
no.156.

53 Inexplicably, Berenson's correct
attribution to Aristotile da Sangallo
was rejected in P. Joannides: *Musée
du Louvre: Inventaire général des
dessins italiens, VI: Michel-Ange:
Elève et copistes*, Paris 2003,
pp.278–79, no.157.

54 Berenson 1961, II, p.546, no.2488,
fig.695.

55 *Ibid.*, I, p.363.

56 J. Wilde: *Italian Drawings in the
Department of Prints and Drawings
in the British Museum: Michelangelo
and his Studio*, London 1953.

57 Compare Ferri, *op. cit.* (note
23), pp.36–37; Berenson 1961, I,
pp.467–68; Pouncey, *op. cit.* (note 5),

p.284; and M. Faietti: 'The Critical
Fortunes of Bronzino's Drawings
from Vasari to Berenson', in C.C.
Bambach, J. Cox-Rearick and
G.R. Goldner, eds.: exh. cat.
The Drawings of Bronzino, New
York (Metropolitan Museum
of Art) 2010.

58 Berenson, *op. cit.* (note 6),
pp.111–19 and 120.

CHAPTER 3, PP.42–53

Heinrich Wölfflin:
*Kunstgeschichtliche Grundbegriffe:
Das Problem der Stilentwicklung
in der neueren Kunst*, 1915
DAVID SUMMERS

1 H. Wölfflin: *Kunstgeschichtliche
Grundbegriffe: Das Problem der
Stilentwicklung in der neueren Kunst*,
Munich 1915; this essay uses the
10th ed., Basel 1948; and *Principles
of Art History: The Problem of the
Development of Style in Later Art*,
transl. M.D. Hottinger, New York
1950, first published in 1932 from
the 7th German ed. of 1929; also M.
Lurz: *Heinrich Wölfflin: Biographie
einer Kunsttheorie*, Worms 1981; and
J. Hart: 'Heinrich Wölfflin', in M.
Kelly, ed.: *Encyclopedia of Aesthetics*,
New York and Oxford 1998, IV,
pp.472–76.

2 M. Warnke: 'On Heinrich Wölfflin',
Representations 27 (1989), pp.172–87.

3 H. Wölfflin: *Renaissance und Barock:
eine Untersuchung über Wesen
und Entstehung des Barockstils in
Italien*, Munich 1888; English ed.:
Renaissance and Baroque, transl.
K. Simon, Ithaca 1967, pp.15 and 23.

4 D. Summers: 'E.H. Gombrich and
the Tradition of Hegel', in P. Smith
and C. Wilde, eds.: *A Companion
to Art Theory*, Oxford and Malden
2002, pp.139–49; and D. Adler:
'Painterly Politics: Wölfflin,
Formalism and German Academic
Culture, 1885–1915', *Art History* 27
(2004), pp.431–77.

5 E. Panofsky: 'Das Problem des
Stils in der bildenden Kunst', in
H. Oberer and E. Verheyen, eds.:
*Aufsätze zu Grundfragen der
Kunstwissenschaft*, Berlin 1980,
pp.19–27; and M.A. Holly: *Panofsky
and the Foundations of Art History*,
Ithaca 1984, pp.46–68.

6 W. Benjamin: 'Strenge
 Kunstwissenschaft: Zum ersten
 Bande der "Kunstwissenschaftliche
 Forschungen"', *Literaturblatt
 der Frankfurter Zeitung* (30th
 July 1933); English translation
 published as 'The Rigorous Study
 of Art: On the First Volume of
 the "Kunstwissenschaftliche
 Forschungen"', in C.S. Wood, ed.:
 *The Vienna School Reader: Politics
 and Art Historical Method in the
 1930s*, New York 2000, pp.439–51;
 and E.H. Gombrich: 'In Search
 of Cultural History', in *idem:
 Ideals and Idols: Essays on Values
 in History and in Art*, London 1979,
 pp.24–59.
7 A. Hauser: *The Philosophy of Art
 History*, Cleveland 1958, p.124.
8 Introduction to H. Wölfflin:
 Classic Art, London 1959, p.vi.
9 R. Fry: 'Baroque Art', *The Burlington
 Magazine* 39 (1921), pp.145–48;
 repr. in *idem: Transformations*,
 London 1926.
10 A. Hildebrand: *The Problem of
 Form in the Fine Arts*, repr. in
 H.F. Malgrave and E. Ikonomou,
 eds.: *Empathy, Form, and Space:
 Problems in German Aesthetics,
 1873–1893*, Santa Monica 1994,
 pp.227–79; see also S. Anderson-
 Riedel: 'Heinrich Wölfflin, Hans
 von Marées and the Principles
 of Art', *Pantheon* 57 (1999),
 pp.152–60.
11 See M. Podro: *The Critical
 Historians of Art*, New Haven
 and London 1982, pp.57–58.
12 H. Wölfflin: *Prolegomena zu
 einer Psychologie der Architektur*,
 Munich 1886; English translation
 in Malgrave and Ikonomou,
 op. cit. (note 10), p.183.
13 First published posthumously
 in 1966 in Graz; English
 translation: *Historical Grammar
 of the Visual Arts*, transl. J.E. Jung,
 ed. B. Binstock, New York 2004,
 pp.123–25.
14 In *Vorträge der Bibliothek Warburg
 (1924–25)* [published in Leipzig and
 Berlin 1927], pp.258–330; English
 translation: *Perspective as Symbolic
 Form*, transl. C.S. Wood, New York
 1991.
15 C.J. Farago: '"Vision Itself has
 a History": "Race", Nation, and
 Renaissance Art History', in *idem*,
 ed.: *Reframing the Renaissance:
 Visual Culture in Europe and
 Latin America, 1450–1650*, New
 Haven and London 1995, pp.67–88.
16 F.J. Schwartz: 'Cathedrals and Shoes:
 Concepts of Style in Wölfflin and
 Adorno', *New German Critique* 76
 (1999), pp.3–48.

CHAPTER 4, PP.54–65

Roger Fry: *Cézanne: A Study
of His Development*, 1927
RICHARD VERDI

1 '"Paul Cézanne", by Ambroise
 Vollard: Paris, 1915, A Review by
 Roger Fry', *The Burlington Magazine*
 31 (1917), p.53.
2 R. Fry: *Cézanne: A Study of His
 Development*, 2nd ed., London 1927,
 p.51 (cited hereafter as RFC).
3 RFC, p.28.
4 V. Woolf: *Roger Fry: A Biography*,
 Oxford 1995, pp.235–36.
5 RFC, p.38.
6 D. MacCarthy: 'Roger Fry and the
 Post-Impression Exhibition of 1910',
 in *idem: Memories*, London 1953,
 p.181.
7 D. Sutton, ed.: *Letters of Roger Fry*,
 London 1972, I, pp.298–301, no.242.
8 M. Denis: 'Cézanne', *The Burlington
 Magazine* 16 (1910), pp.207–19; and
 ibid., pp.275–80.
9 Sutton, *op. cit.* (note 7), I, p.338,
 no.296.
10 *Ibid.*, pp.473–74, no.469.
11 R. Fry: *Vision and Design*, London
 1920, p.191.
12 R. Fry: 'An Exhibition of French
 Painting', *The Burlington Magazine*
 65 (1934), p.35.
13 RFC, p.13.
14 Sutton, *op. cit.* (note 7), II, p.408,
 no.397.
15 RFC, pp.31–40 (for the discussion
 which follows).
16 *Ibid.*, pp.42–51.
17 *Ibid.*, p.57.
18 *Ibid.*, pp.58–59. Here and elsewhere
 'R' refers to J. Rewald: *The Paintings
 of Paul Cézanne: A Catalogue
 Raisonné*, London 1996.
19 RFC, pp.63–66.
20 *Ibid.*, pp.68–71.
21 Fry, *op. cit.* (note 12), p.30.

CHAPTER 5, PP.66–75

Nikolaus Pevsner: *Pioneers of the
Modern Movement from William
Morris to Walter Gropius*, 1936
COLIN AMERY

1 The biographical and bibliographical
 information used here and
 elsewhere in this essay has been
 drawn from the following: J.R. Barr:
 Sir Nikolaus Pevsner: A Bibliography,
 Charlottesville VA 1970; S. Bradley
 and B. Cherry, eds.: *The Buildings
 of England: A Celebration*, London
 2001; S. Games, ed.: *Pevsner on Art
 and Architecture: The Radio Talks*,
 London 2002; P. Draper: *Reassessing
 Nikolaus Pevsner*, Farnham 2004;
 and J. Newman: 'An Appreciation
 of Nikolaus Pevsner', in *idem* and
 B. Cherry, eds.: *Nikolaus Pevsner:
 The Best Buildings of England*,
 Harmondsworth 1986.
2 N. Pevsner: *Academies of Art,
 Past and Present*, Cambridge 1940.
3 *Idem: An Enquiry into Industrial
 Art in England*, Cambridge 1937.
4 *Idem*: Review of 'Le Corbusier und
 Pierre Jeanneret (1930), Ihr gesamtes
 Werk von 1910 bis 1929', *Göttingische
 Gelehrte Anzeigen* 193 (1930),
 pp.303–12.
5 R. Middleton: Obituary, Sir
 Nikolaus Pevsner, *The Burlington
 Magazine* 126 (1984), p.234.
6 The four editions are: N. Pevsner:
 *Pioneers of the Modern Movement
 from William Morris to Walter
 Gropius*, London 1936; *idem:
 Pioneers of Modern Design*, New
 York 1949; Harmondsworth 1960;
 and New Haven and London 2005.
 All quotations in this essay are
 from the first edition.
7 Faber & Faber had published Walter
 Gropius's *The New Architecture
 and the Bauhaus* in 1935, the year
 before it issued Pevsner's book.
8 W. Pinder: *Das Problem der
 Generationen in der Kunstgeschichte
 Europas*, Berlin 1926.
9 Pevsner's reluctance was evident
 in discussions held at the offices
 of *Architectural Review* between
 Pevsner, the present writer and the
 late Kenneth Browne on the subject
 of 'townscape' in the late 1970s.

CHAPTER 6, PP.76–87

Alfred H. Barr, Jr.: *Matisse: His Art and His Public*, 1951
JOHN ELDERFIELD

Matisse: His Art and His Public, 1951, and other books by Alfred H. Barr, Jr. mentioned in the text were published by the Museum of Modern Art, New York. The references to Barr's place within US art history draw upon J. Elderfield: 'The Adventures of the Optic Nerve', in J. Morrill, ed.: *The Promotion of Knowledge: Lectures to Mark the Centenary of the British Academy, 1902–2002*, Oxford 2004, pp.53–85, and this essay refers in places to the author's review of Pierre Schneider's 1984 and J. Flam's 1986 monographs; J. Elderfield: 'Matisse: Myth vs. Man', *Art in America* 11/2 (1987), pp.297–302.

1 B. Nicolson: 'Alfred H. Barr Jr., "Matisse: His Art and His Public" (New York: The Museum of Modern Art, 1951)', *Art Bulletin* 34 (1952), pp.246–49.

2 A.H. Barr: *Matisse: His Art and His Public*, New York 1951, p.9.

3 [J. Richardson]: 'Henri Matisse: A Twentieth-Century Master', *Times Literary Supplement* (25th March 1955), pp.173–75, esp. p.175.

4 C. Bock-Weiss: *Henri Matisse: A Guide to Research*, New York 1996.

5 J. Flam: *Matisse: A Retrospective*, New York 1988.

6 Matisse: 'Notes d'un peintre', *La Grande Revue* (1908), in J. Flam: *Matisse on Art*, Berkeley and Los Angeles 1995, pp.30–43, esp. p.42.

7 Barr, *op. cit.* (note 2), p.201.

8 The article was reprinted in book form as R. Fry: *Henri-Matisse*, London 1935, pp.24–25.

9 N. Bryson: 'Signs of the Good Life', *Times Literary Supplement* (27th March 1987), p.328.

10 [Richardson], *op. cit.* (note 3), p.174.

11 E. Panofsky: 'Three Decades of Art History in the United States: Impressions of a Transplanted European', in *idem*: *Meaning in the Visual Arts. Papers in and on Art History*, New York 1955, pp.321–46, esp. p.329.

12 F. Trapp: 'The Paintings of Henri Matisse: Origins and Early Development, 1890–1917',

Ph.D. diss. (Harvard University 1952).

13 Nicolson, *op. cit.* (note 1), pp.247 and 249.

14 A.H. Barr, Jr.: 'Modern Art Makes History, Too', *Art Journal* 1 (1941), pp.3–6.

15 F.J. Mather, Jr.: 'Old Art or New', *ibid.* 1/2 (January 1942), pp.31–33; and L. Schmeckebier: Modern Art First, Not Last', *ibid.* 1/3 (March 1942), pp.60–63.

16 P. Schneider: *Matisse*, New York 1984, p.9.

17 A. Blunt: 'Matisse's life and work', *The Burlington Magazine* 95 (1953), pp.399–400.

CHAPTER 7, PP.88–101

Erwin Panofsky: *Early Netherlandish Painting: Its Origins and Character*, 1953
SUSIE NASH

1 E. Panofsky: *Early Netherlandish Painting: Its Origins and Character*, Cambridge MA 1953. It was published in two volumes, the first containing the text, the second the plates.

2 E. Panofsky: *Die altniederländische Malerei: Ihr Ursprung und Wesen*, transl. J. Sander and S. Kemperdick, Cologne 2001; and *idem*: *Les primitifs flamands*, transl. D. Le Bourg, Paris 1992.

3 D. Wuttke, ed.: *Erwin Panofsky Korrespondenz, 1910 bis 1968: Eine kommentierte Auswahl in fünf Bänden*, Wiesbaden 2006 (in five volumes; hereafter cited as *Korrespondenz* followed by volume number, letter number and page reference).

4 For example in a letter to Gregor Paulson of May 1953; *Korrespondenz*, IV, 1063, p.425.

5 Report on the typescript from Wallace Brockway to the Bollingen Foundation, c.December 1951; *Korrespondenz*, IV, 1514, pp.254–56.

6 E. Panofsky: *The Life and Art of Albrecht Dürer*, Princeton 1943.

7 O. Pächt: 'Panofsky's "Early Netherlandish Painting"–I', *The Burlington Magazine* 98 (1956), pp.110–16, esp. p.110.

8 Among many shining examples are note 1 to p.327, where the

iconography of the Holy Kinship is outlined; note 2 to p.194, which includes a ground plan of the fictive church in Jan van Eyck's Berlin painting, compared with that of Notre Dame at Dijon; and note 5 to p.327, where a reconstruction of Geertgen tot Sint Jans's Vienna Triptych is set out at great length.

9 One of the most influential of all Panofsky's 'rules', on the principles of heraldry as applied to the position of men and women in devotional portraits, is found in note 16, to p.294, a rule that has been reformulated recently by H. van der Velden: 'Diptych Altarpieces and the Principle of Dextrality', in J. Hand and R. Spronk, eds.: *Essays in Context: Unfolding the Netherlandish Diptych*, New Haven and London 2006, pp.124–55; an example of how a tradition of (mis)interpretation can be traced back to the authority of a footnote by Panofsky is an article by the same author, H. van der Velden: 'Petrus Christus's Our Lady of the Dry Tree', *Journal of the Warburg and Courtauld Institutes* 60 (1997), pp.89–110.

10 According to a letter from Panofsky to Leo Steinberg in May 1953 he was devoting that summer to this task alongside proofreading the text; *Korrespondenz*, III, 1605, p.427. The bibliography is probably less useful: as noted by L.M.J. Delaissé: 'Enlumineur et peinture en Pays-Bas. A propos du livre d'E. Panofsky "Early Netherlandish Painting"', *Scriptorium* 11 (1957), pp.109–18, esp. p.109, it was perhaps too generous, citing both *'le meilleur et l'inutile ou presque'*.

11 Letter of September 1957; *Korrespondenz*, IV, 2125, pp.154–55. Panofsky emphasised this point again in a letter to Karel G. Boon, another reviewer: 'the purpose of my book was not to solve all unsolved problems but to give a kind of general view of the subject and point out the fact that the majority of the questions still await a final answer'; *Korrespondenz*, IV, 2138, pp.173–74.

12 See the comments on the lectures made by the Committee for the Charles Eliot Norton Chair of Poetry to Robert J. Oppenheimer,

then Director of the Institute for Advanced Study, Princeton; *Korrespondenz*, II, 1230, p.953.

13 *Korrespondenz*, II, 1132, p.797.

14 This type of formulation is untranslatable and, for example, is lost entirely in the French version where it becomes '*ce type exemplaire de grand maître mineur*', Panofsky, *op. cit.* (note 2), p.629. The difficulty of translating Panofsky is discussed by Kemperdick and Sander, *op. cit.* (note 2), p.553.

15 Panofsky's intellectual formation in his years at Freiburg and Hamburg and his reactions to the work of Wölfflin, Riegl and Cassirer have been explored in detail by M.A. Holly: *Panofsky and the Foundations of Art History*, Ithaca and London 1984; Panofsky's debt to the great medievalist Vöge was acknowledged by him in E. Panofsky and E.C. Hassold: 'Wilhelm Vöge: A Biographical Memoir', *Art Journal* 28 (1968), pp.27–37.

16 Published in *Vorträge der Bibliothek Warburg (1924–25)*, pp.258–330.

17 K. Moxey: *The Practice of Persuasion: Paradox and Power in Art History*, Ithaca and New York 2001, pp.90–102.

18 See C. Schoell-Glass: 'A Symposium on Erwin Panofsky. Hamburg', *The Burlington Magazine* 134 (1992), pp.547–48; and the obituary of Panofsky by H.W. Jansen: 'Erwin Panofsky (1892–1968)', *American Philosophical Society Yearbook* (1969), pp.151–60, esp. p.160.

19 I would like to thank Patricia Rubin and Sarah Johnson of the Institute of Fine Arts, New York, for making their documents on the courses that Panofsky taught available to me.

20 *Korrespondenz*, I, 584, pp.915 and 917.

21 Letter to Saxl of October 1947; *Korrespondenz*, II, 78, p.878.

22 Letter to William Heckscher from Stockholm in September 1952, *Korrespondenz*, III, 1550, pp.335–36.

23 E. Panofsky: 'Three decades of art history in the United States. Impressions of a transplanted European', *Art Journal* 14 (1954), pp.7–27, esp. p.13; in a letter of 1949 to George Kubler he had already formulated the differences between the discipline in Europe and America as 'differences which may all be summed up under the heading of "distance"'; *Korrespondenz*, II, 1277, p.1027.

24 See the report on the typescript by Wallace Brockway of December 1951, *Korrespondenz*, III, 1514, pp.254–55.

25 On 4th August that year he wrote: 'I am very sorry indeed that my ignorance of the Prado still remains, and possibly will remain, a blot on the escutcheon of the Institute', *Korrespondenz*, I, 586, p.917.

26 *The Descent from the Cross* was exhibited in Paris in 1923, so it is conceivable that he saw it at that point; the Escorial *Crucifixion* has never been lent.

27 In 1967 Panofsky wrote to Jan van Gelder to recant what he had said about the work in his book: '[I must] apologize for having written about a picture I had never seen. On the whole, I have been lucky that it wasn't worse'; letter in painting file, Courtauld Gallery, London.

28 It has not yet been established whether Panofsky ever saw the Turin–Milan Hours.

29 *Korrespondenz*, III, 1563, pp.356–57, November 1952.

30 M. Comblen-Sonkes: *Le Musée des Beaux-Arts de Dijon: Les primitifs flamands. I. Corpus de la peinture des anciens Pays-Bas méridonaux au quinzième siècle* 14, Brussels 1986, pp.73–79 and 152–58.

31 H. van de Waal: 'In Memoriam Erwin Panofsky, March 30, 1892– March 14, 1968', *Mededelingen der Koninklijke Nederlandse Akademie van Wettenschappen* 35 (1972), p.231.

32 F. Winkler: 'Panofskys Stärke ist seine einzigartige, ausgebreitete Kenntnis des Schrifttums über Kunst von der Antike bis zur Renaissance', *Kunstchronik* 8 (1955), pp.9–12 and 21–26, esp. p.9.

33 M. Davies: 'Flemish founding fathers', *Art News Review* 53 (1954), p.58.

34 Both Panofsky and Boas refer to the article as 'A Defense of Anarchy'; G. Boas: 'Philosophy and Ritual', *Proceedings and Addresses of The American Philosophical Association* (1951–52), pp.5–17.

35 *Korrespondenz*, III, 1554, pp.339–40.

36 *Ibid.*

37 K.G. Boon: 'Erwin Panofsky's *Early Netherlandish Painting* en de sindsdien verschenen literatuur over dit onderwerp', *Oud Holland* 72 (1957), pp.169–90; Davies, *op. cit.* (note 33), pp.58, 23 and 57–58; Delaissé, *op. cit.* (note 10); J. Held, in *Art Bulletin* 53 (1955), pp.203–34; M. Meiss, in *New York Times Book Review* (7th March 1954), p.5; Pächt, *op. cit.* (note 7); *idem*: 'Panofsky's "Early Netherlandish Painting"–II', *The Burlington Magazine* 98 (1956), pp.267–79; and Winkler, *op. cit.* (note 32).

38 The subtitle is from Thomas Aquinas's *Summa Theologiae*: '*Unde convenientes in sacra Scriptura traduntus nobis spiritualia sub metaphoris corporalium*' (Ia I, 9). Panofsky, characteristically, does not identify its source in his text.

39 Notably in L. Benjamin: 'Disguised Symbolism Exposed and the History of Early Netherlandish Painting', *Studies in Iconography* 2 (1976), pp.11–24; J. Marrow: 'Symbol and Meaning in Northern European Art of the Late Middle Ages and Early Renaissance', *Simiolus* 16 (1986), pp.150–69; J.B. Bedaux: *The Reality of Symbols: Studies in the Iconology of Netherlandish Art, 1400–1800*, The Hague 1990; E. Hall: *The Arnolfini Betrothal: Medieval Marriage and the Enigma of Van Eyck's Double Portrait*, Berkeley 1994, pp.95–129; C. Harbison: 'Realism and Symbolism in Early Flemish Painting', *Art Bulletin* 66 (1984), pp.588–602; R. Falkenburg: 'The Household of the Soul: Conformity in the Mérode Triptych', and P. Parshall: 'Commentary: Conformity or Contrast', both in M. Ainsworth, ed.: *Early Netherlandish Painting at the Crossroads: A Critical Look at Current Methodologies*, New York 2001, pp.1–17 and 18–25.

40 Parshall, *op. cit.* (note 39), p.18.

41 M. Podro: 'Panofsky, Erwin', in J. Turner, ed.: *The Grove Dictionary of Art*, London 1996, vol. 24, p.17; Kemperdick and Sander, *op. cit.* (note 2), p.555.

42 E. Mâle: *Religious Art in France: The Late Middle Ages: A Study of Medieval Iconography and its Sources*, Princeton 1986, p.v.

43 M.J. Friedländer: *Die altniederländische Malerei*, Berlin 1924–37.

44 The discovery in 1959 of the date 1437 on the Dresden triptych overturned this chronology, in which the triptych plays an important part in defining Jan's 'early' style.

45 Panofsky's theories on the Ghent Altarpiece have been returned to more recently and given new support in a study of the quatrain painted on the frame. See H. van der Velden: 'The Quatrain of the Ghent Altarpiece', *Simiolus* 35 (2011), pp.5–39.

46 *Korrespondenz*, III, 2103, p.119, May 1957.

47 *Korrespondenz*, III, 1704, pp.589–60.

48 'Several of my cherished theories about the van Eycks have been exploded; but on the whole my hypothesis seems to be a little more right – or at least a little less wrong – than everybody else's'; *Korrespondenz*, III, 1704, p.589, letter to Oswald Veblen of July 1954.

49 *Korrespondenz*, IV, 2103, p.120.

CHAPTER 8, PP.102–15

Kenneth Clark: *The Nude: A Study of Ideal Art*, 1956
JOHN-PAUL STONARD

1 K. Clark: *The Nude: A Study of Ideal Art*, London 1956. The first chapter was published in the October 1954 issue of *Art News*. It was developed from Clark's Mellon lectures given at the National Gallery, Washington, DC, in 1953, to which were appended three extra chapters and a series of endnotes. An eighth edition was published by Princeton University Press in 1990. Page references in this essay refer to the Pelican Books edition first published in 1960.

2 M.J. Friedländer: *On Art and Connoisseurship*, London 1942, pp.104–07.

3 M. Pointon: *Naked Authority: The Body in Western Painting 1830–1908*, Cambridge 1990, p.12.

4 Clark cites two previous attempts to treat the subject, both published in German before 1914, but neither can have influenced his own volume, nor are they read today. J. Lange: *Die menschliche Gestalt in der Geschichte der Kunst*, Strasbourg 1903; and W.

Hausenstein: *Der nackte Mensch*, Munich 1913.

5 Clark wrote to Berenson on 19th June 1957: '. . . the Catholics have written to me that the Greeks were not nasty homosexuals, and the homosexuals to say that I was not sufficiently conscious of the beauty of the male body – which I think is true. My undisguised admiration for the girls has given some mild offence'. Berenson Archive, Villa I Tatti. The author thanks William Mostyn-Owen for drawing his attention to Clark's unpublished correspondence with Berenson.

6 The distinction also makes clear, on a more practical level that it was acceptable to contemplate unclothed bodies as long as they were considered as art, a point that in 1953 was important to emphasise. When Clark gave his lectures in Washington, DC the word 'Nude' was removed from the title for fear of provoking censorship from Congress. See K. Clark: *The Other Half*, London 1977, p.87.

7 L.D. Ettlinger: 'The Nude in Art', *The Burlington Magazine* 99 (1957), pp.348–49.

8 *Ibid.*, p.348.

9 K. Clark: *Feminine Beauty*, London 1980.

10 R. Leppert: *The Nude: The Cultural Rhetoric of the Body in the Art of Western Modernity*, Cambridge MA 2007, p.9.

11 The phrase is taken from Clark's report to the Longford Committee on pornography: 'The moment art becomes an incentive to action it loses its true character. This is my objection to painting with a communist programme, and it would also apply to pornography'; *Pornography: The Longford Report*, London 1972, p.100.

12 Clark, *op. cit.* (note 6), p.187.

13 Ettlinger, *op. cit.* (note 7), p.349.

14 See K. Clark: 'Transformations of Nereids in the Renaissance', *The Burlington Magazine* 97 (1955), pp.214–19.

15 B. Nicolson: 'The Body Into Art', *The New Statesman and Nation* (29th December 1956), pp.844–45, esp. p.844.

16 K. Clark, ed.: *Last Lectures by Roger Fry*, London 1939.

17 Clark, *op. cit.* (note 6), p.106.

18 Clark to Berenson, 2nd November 1956, Berenson Archive, Villa I Tatti.

19 Berenson to Clark, 9th December 1956, Berenson Archive, Villa I Tatti.

20 N. Penny: 'Kenneth Clark, 1903–1983. The Nude: A Study of Ideal Art 1953', in E. Cropper, ed.: *The A.W. Mellon Lectures in the Fine Arts: Fifty Years*, Washington, DC 2002, pp.31–34, esp. p.31.

21 Nicolson, *op. cit.* (note 15), p.844.

22 J. Berger: *Ways of Seeing*, London 1972.

23 In particular, Pointon, *op. cit.* (note 3), pp.15–16.

24 See S. Brown: '"Ways of Seeing" Women in Antiquity: An Introduction to Feminism in Classical Archaeology and Ancient Art History', in A.O. Koloski-Ostrow and C.L. Lyons, eds.: *Naked Truths: Women, Sexuality and Gender in Classical Art and Archaeology*, London and New York 1997, pp.12–42, esp. note 30.

25 See L. Mulvey: *Visual and Other Pleasures*, Basingstoke 1989, pp.14–26.

26 See M. Postle: 'Pygmalion, Painted Flesh, and the Female Body', in C. Saunders, U. Maude and J. Macnaughton, eds.: *The Body and the Arts*, Basingstoke 2009, pp.165–85, esp. p.175.

27 T.J. Clark: 'Preliminaries to a Possible Treatment of *Olympia* in 1865', *Screen* 21/1 (Spring 1980). A longer version of this article constitutes chapter two, 'Olympia's Choice', in *idem: The Painting of Modern Life: Paris in the Art of Manet and his Followers*, London 1990, rev. ed. [1984], pp.79–146.

28 *Ibid.*, esp. p.117.

29 *Ibid.*, pp.128–29.

30 *Ibid.*, p.146.

31 L. Nead: *The Female Nude: Art Obscenity and Sexuality*, London 1992, p.2.

32 See B. Groys: 'The Hero's Body: Adolf Hitler's Art Theory', in *idem: Art Power*, Cambridge and London 2008, pp.131–40, esp. p.131. For an account of the transformation of Classical prototypes into the 'heroic masculinity of modern society', see M. Myrone: *Bodybuilding: Reforming Masculinities in British Art, 1750–1810*, New Haven and London 2005.

33 Groys, *op. cit.* (note 32).

34 See chapter thirteen, 'Heroic Materialism', in K. Clark: *Civilisation*, London 1969.

35 For example, from the paintings of Lucian Freud and John Currin (who has identified *The Nude* as required reading) to the direct, unsettling presentation of nude bodies by Vanessa Beecroft; yet also to the unsettling cult of mass-nudity in the photographs of Spencer Tunick. 'A mass of naked figures does not move us to empathy, but to disillusion and dismay', wrote Clark with some prescience (p.4). For Currin, see J. Saltz, ed.: *An Ideal Syllabus: Artists, Critics and Curators Choose the Books We Need to Read*, London 1998.

CHAPTER 9, PP.116–27

E.H. Gombrich: *Art and Illusion: A Study in the Psychology of Pictorial Representation*, 1960
CHRISTOPHER S. WOOD

1 E.H. Gombrich: *Art and Illusion: A Study in the Psychology of Pictorial Representation*, New York 1960. Originally delivered in 1956 as the A.W. Mellon Lectures in the Fine Arts at the National Gallery of Art, Washington, DC.

2 N. Bryson: *Vision and Painting: The Logic of the Gaze*, Cambridge 1983, p.21.

3 K. Moxey: *The Practice of Theory: Poststructuralism, Cultural Politics, and Art History*, Ithaca 1994, pp.30–31.

4 N. Goodman: *Languages of Art*, Indianapolis and Cambridge 1976, p.10. Gombrich played a similar role in Umberto Eco's *Theory of Semiotics*, Bloomington 1976, pp.204–05, a classic treatise that makes the most extreme case possible for the conventionality of signs. Even iconic signs, or pictures, which would seem to be related to what they signify in more than conventional ways, figure in Eco's analysis as the products of cultural convention. In making his case, Eco enlisted none other than Gombrich, citing his analysis of Constable's recoding of the light effects in the English landscape in *Wivenhoe Park* (National Gallery

of Art, Washington, DC; 1816).

5 C. Lévi-Strauss: *The Savage Mind*, Chicago 1966, p.22.

6 R. Woodfield: 'Warburg's "Method"', in *idem*, ed.: *Art History as Cultural History: Warburg's Projects*, Amsterdam 2001, p.285, citing a little-read essay by Gombrich published in a Belgian journal in 1954.

7 H. Wölfflin: *Principles of Art History* (1915), New York 1950, p.17. Gombrich even began his second chapter with the very anecdote from Ludwig Richter – involving four draughtsmen who strive to render a natural motif with perfect objectivity and end up producing four quite different-looking works – that Wölfflin had retold on the first page of his *Principles*.

8 Cited by O. Pächt in *idem*: *The Practice of Art History*, London 1999, p.29.

9 Cited by L. Steinberg: 'The Eye is a Part of the Mind', in *idem*: *Other Criteria*, New York 1972, p.290.

10 E. Gilson: *Painting and Reality*, New York 1957, pp.259 and 265, note 25.

11 Steinberg, *op. cit.* (note 9), p.292.

12 *Ibid.*, pp.51–53.

13 M. Podro: *Depiction*, New Haven 1998, p.26. Bryson, *op. cit.* (note 2), p.30, allowed as much. W. Iser: *How to Do Theory*, Oxford 2006, pp.52–55, makes a similar argument. See the more extended discussion of Gombrich in W. Iser: *The Fictive and the Imaginary: Charting Literary Anthropology*, Baltimore and London 1993, pp.284–89.

14 E.H. Gombrich: 'Raphael's "Stanza della Segnatura"', in *idem*: *Symbolic Images*, London 1972, p.101. See also the final words of 'Meditations on a Hobby Horse', in the volume of the same name (London 1963); or *Art and Illusion*, p.396, the penultimate sentence of the book, on our habitual reluctance 'to recognize ambiguity behind the veil of illusion'.

15 Compare the reference by Bryson to a 'generally held, vague, common-sense conception of the image as the resurrection of Life'; Bryson: *op. cit.* (note 2), p.3. I am not sure that common sense does conceive of the image in this way, but if it does, then this is the most interesting remark Bryson makes in *Vision and Painting*.

CHAPTER 10, PP.128–39

Clement Greenberg: *Art and Culture: Critical Essays*, 1961
BORIS GROYS

1 All page references in this essay are to the first paperback edition of *Art and Culture: Critical Essays*, Boston 1965. 'Avant-Garde and Kitsch' was originally published in the *Partisan Review* (Autumn 1939), and appeared in revised form in *Art and Culture*. This collection also contains Greenberg's post-War essays on art in Paris, eight essays on American art from Thomas Eakins to David Smith and a 'general' section including 'The crisis of the easel picture'. The volume ends with four essays of literary criticism on T.S. Eliot, Brecht, Kafka and the Victorian novel.

2 See B. Groys: *The Total Art of Stalinism: Avant-Garde, Aesthetic Dictatorship, and Beyond*, Princeton 1992, p.37ff.

CHAPTER 11, PP.140–49

Francis Haskell: *Patrons and Painters: A Study in the Relations Between Italian Art and Society in the Age of the Baroque*, 1963
LOUISE RICE

1 F. Haskell: *Mecenati e pittori: L'arte e la società italiane nell'età barocca*, Turin 2000, pp.7–11. Subsequent references are to the first edition (London 1963) unless otherwise specified. On Haskell's contributions to the history of art, see Werner Busch's postscript to the German translation of *Patrons and Painters* (*Maler und Auftraggeber: Kunst und Gesellschaft im italienischen Barock*), Cologne 1996, pp.581–90; P. Griener: *Francis James Herbert Haskell (April 7, 1928–January 18, 2000)', *Zeitschrift für Kunstgeschichte* 64 (2001), pp.299–303; 'Scritti in ricordo di Francis Haskell: Giornata di studio alla Fondazione Giorgio Cini . . . 4–5 Novembre 2000', *Saggi e memorie di storia dell'arte* 25 (2001), pp.287–363; W. Hardtwig: 'Der Historiker und die Bilder. Überlegungen zu Francis Haskell', in H. Berding, ed.: *Hochkultur des*

bürgerlichen Zeitalters, Göttingen 2005, pp.136–53; B. Toscano: 'Wittkower, Longhi, Haskell e la fortuna storico-artistica del papato Borghese', in *idem*, ed.: *Arte e immagine del papato Borghese (1605–1621)*, San Casciano 2005, pp.11–16; and G. Wimböck: 'Francis Haskell (1928–2000)', in U. Pfisterer, ed.: *Klassiker der Kunstgeschichte*, Munich 2008, pp.226–38.

2 M. Wackernagel: *Der Lebensraum des Künstlers in der florentinischen Renaissance: Aufgaben und Auftraggeber, Werkstatt und Kunstmarkt*, Leipzig 1938. For additional bibliography reflecting the state of patronage studies at the time, see D.S. Chambers: *Patrons and Artists in the Italian Renaissance*, London 1970, pp.209–11. The entertaining chapter on patronage in Rudolf and Margot Wittkower's *Born Under Saturn*, published in the same year as *Patrons and Painters*, is broader in its geographical scope but also mainly focused on the fifteenth and sixteenth centuries.

3 F. Antal: *Florentine Painting and its Social Background: The Bourgeois Republic before Cosimo de' Medici's Advent to Power: Fourteenth and Early Fifteenth Centuries*, London 1948; and A. Hauser: *The Social History of Art*, New York 1951.

4 On the tangled and sometimes fraught concept of a social history of art, see Craig Clunas's entry in R. Nelson and R. Shiff, eds.: *Critical Terms for Art History*, Chicago and London 2003, pp.465–77. Clunas points out that Haskell, like Michael Baxandall after him, addressed 'some of the prime issues of a social history of art' (p.469) while avoiding the controversies that often accompanied it.

5 N. Penny: 'Francis Haskell (1928–2000)', *The Burlington Magazine* 142 (2000), p.308.

6 F. Haskell: 'Patronage', *Encyclopedia of World Art*, IX, New York and London 1966, cols.118–31.

7 '[Sacchetti's] encouragement of Pietro to copy Raphael and Titian marks a focal point in the history of seventeenth-century art: that combination of Raphael's freest, most imaginative design [the *Galatea*] with Titian's warmth

of colour was the foundation stone on which Baroque painting was established'; Haskell 1963, *op. cit.* (note 1), p.39.

8 *Ibid.*, pp.101–02, 114, 137, 204 and 206.

9 Ellis Waterhouse in his 'Painting in Rome in the Eighteenth Century', *Art Institute of Chicago Museum Studies* 6 (1971), pp.7–8 and 21, took issue with Haskell's position on this matter, pointing out that the notion of Rome's decline in the settecento is 'almost wholly an invention of the present century'. See also M. Levey: 'Francis Haskell and Eighteenth-century Venice', in 'Scritti in ricordo di Francis Haskell', *op. cit.* (note 1), pp.329–30.

10 F. Haskell: *Rediscoveries in Art: Some Aspects of Taste, Fashion and Collecting in England and France*, Ithaca 1976; *idem* and N. Penny: *Taste and the Antique: the Lure of Classical Sculpture, 1500–1900*, New Haven and London 1981; F. Haskell: *Past and Present in Art and Taste*, New Haven and London 1987; and *idem*: *The Ephemeral Museum: Old Master Paintings and the Rise of the Art Exhibition*, New Haven and London 2000.

11 E.H. Gombrich: *Observer* (23rd June 1963); M. Levey: *New Statesman* (28th June 1963); F. Watson: *Times Literary Supplement* (16th August 1963), p.617; H. Honour: *Apollo* 78 (December 1963), pp.521–22; J. Lees-Milne: *Connoisseur* 155 (1963), p.49; L. Fröhlich-Bume: *Pantheon* 22 (1964), pp.187–88; W. Vitzthum: *L'œil* 117 (1964), pp.44–45; R.L. Colie: *Renaissance News* 17 (1964), pp.116–18; and A. Pallucchini: *Arte Veneta* 18 (1965), pp.209–10. Surprisingly, it was not reviewed in *The Burlington Magazine*.

12 S. Alpers: 'Is Art History?', *Daedalus* 106 (1977), pp.2 and 12, note 6.

13 E. Cropper and C. Dempsey: 'The State of Research in Italian Painting of the Seventeenth Century', *Art Bulletin* 69 (1987), pp.502–04.

14 Whenever the book was reissued, Haskell took the opportunity to correct minor errors, supplement the bibliography and highlight those works of recent scholarship that had a particular bearing on his text. But the idea of significantly reworking the book in order to bring it

properly up to date appalled him and he refused to entertain it.

15 T. Montanari: 'Ultimi incontri alla Scuola Normale di Pisa', in 'Scritti in ricordo di Francis Haskell', *op. cit.* (note 1), pp.346–47; and L. Puppi: 'Nel segno di Haskell', in *ibid.*, p.360.

16 Haskell 2000, *op. cit.* (note 1), p.8.

CHAPTER 12, PP.150–163

Michael Baxandall: *Painting and Experience in Fifteenth Century Italy: A Primer in the Social History of Pictorial Style*, 1972
PAUL HILLS

1 All references are to the first edition: M. Baxandall: *Painting and Experience in Fifteenth Century Italy: A Primer in the Social History of Pictorial Style*, Oxford 1972.

2 U. Middeldorf in *Art Bulletin* 57 (1975), pp.284–85.

3 M. Wackernagel: *The World of the Florentine Renaissance Artist*, transl. A. Luchs, Princeton 1981.

4 M. Baxandall: *Shadows and Enlightenment*, New Haven and London 1995, p.vii.

5 For Leavis, see Baxandall's memoir: *Episodes: A Memory Book*, London 2010, pp.63–72, where he notes 'that "close reading" was not what was specific to Leavis, though he did it or something like it' (p.63), and emphasises 'the intensity of his moral response to literature' (p.69).

6 *Idem*: *Giotto and the Orators: Humanist Observers of Painting in Italy and the Discovery of Pictorial Composition, 1350–1450*, Oxford 1971.

7 See A. Langdale: 'Art History and Intellectual History: Michael Baxandall's Work between 1963 and 1985', Ph.D. diss. (University of California, 1995); and *idem*: 'Aspects of the Critical Reception and Intellectual History of Baxandall's Concept of the Period Eye', *Art History* 21 (1998), pp.479–97, esp. pp.480–82. There are many references to anthropology and anthropological linguistics in an extended interview of 1996. The interviews were conducted by Richard Candida Smith at the J. Paul Getty Research Institute, Los Angeles. The transcript, entitled *Substance, Sensation and Perception*,

is available online at the Getty website. Since pagination varies between electronic versions and the printed version that I consulted in the Warburg Institute library, it is most convenient to refer to the numbering of the tapes, which is used to divide the summary of contents that precedes the transcript of the interview; references to anthropological linguistics, tape III, side 2; hereafter cited as the Getty interview.

8 I suggest he may not have read *Mannerism* until some years later since in the Getty interview he mistakenly states that it was published after *Painting and Experience* rather than five years earlier (tape V, side 2).

9 For Baxandall at the V. & A., see Baxandall, *op. cit.* (note 5), pp.125–40.

10 *Ibid.*, pp.72 and 118. Wölfflin's *Classic Art* is also mentioned as an early preference in the Getty interview, tape I, side 2. *Die klassische Kunst* was first published in 1899 and translated into English in 1903; it became more widely known in the translation by Peter and Linda Murray published by Phaidon in 1952.

11 Getty interview, tape III, side 1. In an interview conducted by Allan Langdale on 3rd February 1994, and transcribed as Appendix II to Langdale 1995, *op. cit.* (note 7), Baxandall acknowledges Gombrich's account of how the beholder projects, but denies that his own concept of 'the period eye' is 'a fleshing out' of Gombrich's 'beholder's share' (pp.345–46).

12 See Chapter 11 of the present book: L. Rice: 'Francis Haskell: *Patrons and Painters: A Study in the Relations Between Art and Society in the Age of the Baroque*, 1963', pp.140–49.

13 Langdale 1995, *op. cit.* (note 7), pp.369–70.

14 M. Baxandall: *The Limewood Sculptors of Renaissance Germany*, New Haven and London 1980, esp. chapter IV, 'The Market', pp.95–122; and *idem: Patterns of Intention: On the Historical Explanation of Pictures*, New Haven and London 1985.

15 Unease about being lumped with the social history of art is expressed in the Getty interview, tape V, side

2; for the dismissive comment about Part I of *Painting and Experience*, see tape VII, side 1; Baxandall's letter to the present writer is dated 2nd October 1993.

16 Hans Baron's most influential work was *The Crisis of the Early Italian Renaissance*, Princeton 1955.

17 W. Hood: *Fra Angelico at San Marco*, New Haven and London 1993; and M. Holmes: *Fra Filippo Lippi, The Carmelite Painter*, New Haven and London 1999.

18 See Chapter 16 of the present book: J. Hamburger: 'Hans Belting: *Bild und Kult: Eine Geschichte des Bildes vor dem Zeitalter der Kunst*, 1990', pp.202–15.

19 *Ibid.*, p.213–15.

20 Langdale 1995, *op. cit.* (note 7), p.364. In Baxandall, *op. cit.* (note 5), p.72, he is more guarded when commenting on what he read at Cambridge: 'Roger Fry I respected but did not warm to'.

21 *Idem: Words for Pictures*, New Haven and London 2003; and *idem: A Grasp of Kaspar*, London 2010.

22 Middeldorf, *op. cit.* (note 2); J. Shapley: *Art Journal* 35 (1976), pp.294–96; and G. Robertson: *The Burlington Magazine* 117 (1975), p.619.

23 Langdale 1995, *op. cit.* (note 7); this paragraph is indebted to the account in Langdale.

24 For example, M. O'Malley: *The Business of Art*, New Haven and London 2005.

25 P. Fortini Brown's formulation of 'an eyewitness style' in *Venetian Narrative Painting in the Age of Carpaccio*, New Haven and London 1988, for example, is avowedly indebted to Baxandall; see esp. p.131.

26 D. Summers: *Michelangelo and the Language of Art*, Princeton 1981.

27 E. Welch: *Art and Society in Italy 1350–1500*, Oxford 1997, p.22.

28 P.L. Rubin: *Images and Identity in Fifteenth-Century Florence*, New Haven and London 2007, p.98. The invaluable bibliographic notes in Rubin's book acknowledge Baxandall's continuing relevance, dealing at length with such topics as 'Seeing and Being Seen', 'The Period Eye', and 'Sight and Social Practice', pp.328–33.

29 J. Paoletti and G. Radke: *Art in Renaissance Italy*, London 1997, p.14.

CHAPTER 13, PP.164–75

T.J. Clark: *Image of the People: Gustave Courbet and the 1848 Revolution*, 1973
ALASTAIR WRIGHT

1 T.J. Clark: *Image of the People: Gustave Courbet and the 1848 Revolution*, 2nd ed., Princeton 1982, pp.10 and 18 (cited hereafter as Clark).

2 A. Bowness: 'The New Courbet Literature', *The Burlington Magazine* 119 (1977), p.291.

3 Clark, p.10.

4 A. Hauser: *The Social History of Art*, London 1951; see Clark, p.6.

5 *Ibid.*, p.13 (original emphasis).

6 *Ibid.*, p.15.

7 *Ibid.*, p.16.

8 *Ibid.*

9 N. Hadjinicolaou: *Art History and Class Struggle*, Paris 1973, transl. L. Asmal, London 1976, pp.77–78.

10 Clark, p.142.

11 See *inter alia* M.D. Biddiss: untitled review, *The Historical Journal* 18/2 (1975), pp.434–36; and H.D. Weston: untitled review, *History* 60/199 (1975), pp.321–22.

12 Bowness, *op. cit.* (note 2), p.291.

13 Clark, p.12.

14 *Ibid.*, pp.44–45.

15 *Ibid.*, p.45.

16 *Ibid.*, p.34.

17 *Ibid.*, pp.10–11. Clark (p.178, note 70) cites as an example L. Nochlin: 'The Development and Nature of Realism in the Work of Gustave Courbet: A Study of the Style and its Social and Artistic Background', unpublished Ph.D. diss. (New York University, 1963); Nochlin repeated the claim in her *Realism*, London 1971, p.48.

18 'It was precisely its lack of open, declared *significance* which offended most of all; it was the way the *Burial* seemed to hide its attitudes, seemed to contain within itself too many contraries'; Clark, p.83 (original emphasis).

19 *Ibid.*, pp.141 and 142.

20 *Ibid.*, p.142.

21 *Ibid.*, p.151.

22 Hauser, *op. cit.* (note 4), p.62.

23 Clark, p.142.

24 'What the critics feared was precisely the irruption of a new public, not amenable to their own civilised and responsible instructions. It was this

public which made Courbet's art political'; *ibid.*, p.135.

25 *Ibid.*, p.139.

26 *Ibid.*, p.120.

27 *Ibid.*, p.115 (original emphasis).

28 *Ibid.*, p.140.

29 *Ibid.*, p.18.

30 For Clark's comments on the *New Left Review*'s 'eloquent silence' regarding the SI, see T.J. Clark and D. Nicholson-Smith: 'Why Art Can't Kill the Situationist International', *October* 79 (Winter 1997), p.17.

31 See A. Jorn: 'Détourned Painting [1959]', cited in E. Sussman *et al.*: exh. cat. *On the Passage of a Few People Through a Rather Brief Moment in Time: The Situationist International, 1957–1972*, Paris (Centre Georges Pompidou), London (Institute of Contemporary Arts) and Boston (Institute of Contemporary Arts) 1989–90, pp.140–42.

32 Clark, p.6.

33 *Ibid.*, p.154.

34 *Ibid.*, p.7.

35 Bowness, *op. cit.* (note 2), p.291.

36 See *inter alia* A. de Leiris: 'The Recent Courbet Literature', *Art Quarterly* 1/1 (1977), pp.134–38. Neo-Marxist journals were also, predictably enough, well disposed; see F. Jameson: 'Political Painting: New Perspectives on the Realism Controversy', *Praxis* 1/2 (1976), pp.225–30.

37 Clark, p.12.

CHAPTER 14, PP.176–89

Svetlana Alpers: *The Art of Describing: Dutch Art in the Seventeenth Century*, 1983
MARIËT WESTERMANN

1 S. Alpers: *The Art of Describing: Dutch Art in the Seventeenth Century*, Chicago 1983, p.xvii.

2 *Idem*: '"Ekphrasis" and Aesthetic Attitudes in Vasari's "Lives"', *Journal of the Warburg and Courtauld Institutes* 23 (1960), pp.190–215.

3 Alpers here quotes Francisco de Hollanda's account of Michelangelo's views; F. de Hollanda: *Four Dialogues on Painting*, transl. A.F.G. Bell, London 1928, pp.15–16.

4 Alpers's arguments against De Jongh's method may be compared

with Otto Pächt's review of Panofsky's *Early Netherlandish Painting* (1953), at the time a rare instance of criticism of that work; O. Pächt: 'Panofsky's "Early Netherlandish Painting": part I', *The Burlington Magazine* 98 (April 1956), pp.110–16; and part II (August 1956), pp.267–79.

5 S. Alpers and M. Westermann: 'Taking Dutch Art Seriously: Discussion', in E. Cropper, ed.: *Dialogues in Art History, from Mesopotamian to Modern: Readings for a New Century*, Washington, DC 2009, p.274.

6 E.J. Sluijter: *Seductress of Sight: Studies in Dutch Art of the Golden Age*, Zwolle 2000; and P. Taylor: 'The Concept of "Houding" in Dutch Art Theory', *Journal of the Warburg and Courtauld Institutes* 55 (1992), pp.210–32.

7 The interpretation of Dutch still life as collection-like in its categorisations and juxtapositions was extended by E. Honig: 'Making Sense of Things', *RES: Anthropology and Aesthetics* 34 (1998), pp.166–83.

8 The *Art of Describing* stimulated excellent researches of this kind, including C. Brusati: *Artifice and Illusion: The Art and Writing of Samuel van Hoogstraten*, Chicago 1995; *idem*: 'Stilled Lives: Self-Portraiture and Self-Reflection in Seventeenth-Century Netherlandish Still-Life Painting', *Simiolus* 20 (1990–91), pp.168–82; and C.S. Wood: '"Curious Pictures" and the Art of Description', *Word and Image* 11 (October–December 1995), pp.332–52.

9 S. Alpers: 'Taking Dutch Art Seriously: Now and Then', in Cropper *op. cit.* (note 5), pp.255–56.

10 J.M. Montias: *Vermeer and His Milieu: A Web of Social History*, Princeton 1989, pp.189–230 and 338–39; and A.K. Wheelock, Jr.: *Vermeer and the Art of Painting*, New Haven and London 1995.

11 See esp. the reviews by E. de Jongh: *Simiolus* 14 (1984), pp.51–59; J. Stumpel: *The Burlington Magazine* 126 (1984), pp.580–81; and J. Bruyn: *Oud Holland* 99 (1985), pp.155–60.

12 Deeply engaged reviews, although not without sceptical notes, include E.H. Gombrich: 'Mysteries of Dutch Painting', *New York Review of Books*

(10th November 1983); A. Grafton and T. DaCosta Kaufmann: 'Holland without Huizinga: Dutch Visual Culture in the Seventeenth Century', *Journal of Interdisciplinary History* 16 (1985), pp.255–65; J. Białostocki: *Art Bulletin* 67 (1985), pp.520–26; and I. Gaskell: *Oxford Art Journal* 7 (1984), pp.57–60.

13 Concerns about the geographic range of Alpers's evidence were raised in the reviews by Stumpel, *op. cit.* (note 11), and by Grafton and DaCosta Kaufmann, *op. cit.* (note 12). Rome in the first decade of the seventeenth century was home to a rich observational and experimental culture of scientists and artists; see D. Freedberg: *The Eye of the Lynx: Galileo, His Friends, and the Beginnings of Modern Natural History*, Chicago 2003.

14 L. Marin: 'In Praise of Appearance', *October* 37 (Summer 1986), pp.98–112.

CHAPTER 15, PP.190–201

Rosalind Krauss: *The Originality of the Avant-Garde and Other Modernist Myths*, 1985
ANNA LOVATT

1 On Durant, see K. Young, M. Darling and R. Kersting: *Sam Durant*, Los Angeles 2002.

2 R. Krauss: 'Sculpture in the Expanded Field', in *idem*: *The Originality of the Avant-Garde and Other Modernist Myths*, Cambridge MA 1985, pp.276–90. Unless otherwise stated, all references and page numbers in this essay are to the paperback edition, Cambridge MA 1986.

3 *Idem*: *Terminal Iron Works: The Sculpture of David Smith*, Boston 1971.

4 *Idem*: *The Sculpture of David Smith: A Catalogue Raisonné*, New York 1977; and *idem*: *Passages in Modern Sculpture*, New York 1977.

5 For a history of *Artforum*, see A. Newman, ed.: *Challenging Art: Artforum 1962–1974*, New York 2000.

6 Described in R. Krauss: 'A View of Modernism' (1972), in *idem*: *Perpetual Inventory*, Cambridge MA 2010, p.121.

7 C. Greenberg: *Art and Culture: Critical Essays*, Boston 1961.
8 D. Siedell: 'Rosalind Krauss, David Carrier, and Philosophical Art Criticism', *Journal of Aesthetic Education* (Summer 2004), p.102.
9 Krauss, *op. cit.* (note 6), p.128.
10 Steinberg's 1968 lecture was given at the Museum of Modern Art, New York, and developed into the article 'Reflections on the State of Criticism', *Artforum* (March 1972), and the book *Other Criteria: Confrontations with Twentieth-Century Art*, New York 1972.
11 D. Crimp: 'On the Museum's Ruins', revised version in H. Foster, ed.: *The Anti-Aesthetic: Essays on Postmodern Culture*, New York 1983, p.45.
12 Donald Judd referred to Fried and Krauss as 'Greenbergers' in 'Complaints: part I' (1969), in D. Judd: *Complete Writings 1959–1975: Gallery Reviews, Book Reviews, Articles, Letters to the Editor, Reports, Statements, Complaints*, Halifax 1975, p.198. For more on the often antagonistic dialogue between Judd and Krauss, see D. Raskin: 'The Shiny Illusionism of Krauss and Judd', *Art Journal* (Spring 2006), pp.6–21.
13 Recounted in Newman, *op. cit.* (note 5), p.144.
14 R. Krauss: preface to R. Allen and M. Turvey, eds.: *Camera Obscura, Camera Lucida: Essays in Honour of Annette Michelson*, Amsterdam 2003, pp.9–11.
15 Siedell, *op. cit.* (note 8), p.99.
16 Krauss 2010, *op. cit.* (note 6), p.xi.
17 On Bataille, see 'No More Play', in Krauss, *op. cit.* (note 2), p.64: '*Informe* denotes what alteration produces, the reduction of meaning or value, not by contradiction – which would be dialectical – but by putrefaction: the puncturing of the limits around the term, the reduction to the sameness of the cadaver – which is transgressive'. The work of Bataille was to be explored more extensively in R. Krauss and Y.-A. Bois: *Formless: A User's Guide*, New York 1997.
18 C. Owens: 'Analysis Logical and Ideological' (1985), repr. in *idem*: *Beyond Recognition: Representation, Power and Culture*, Berkley 1994, p.276.
19 Krauss 2010, *op. cit.* (note 6), p.1.

20 In a review of Krauss's book and a subsequent introduction to *Art Since 1900: Modernism, Antimodernism, Postmodernism*, Yve-Alain Bois has differentiated between a 'morphological' conception of formalism and a 'structuralist' one, identifying Krauss with the latter; see Y.-A. Bois: review of *The Originality of the Avant-Garde*, *Art Journal* 45/4 (1985), pp.369–73; and *idem*, B.H.D. Buchloh, R. Krauss and H. Foster: *Art Since 1900: Modernism, Antimodernism, Postmodernism*, London 2004.
21 A.E. Elsen and W.A. Haas: 'On the Question of Originality: A Letter', *October* 22 (Spring 1982), p.109.
22 For a critique of Krauss's notion of the 'Paraliterary', see J. Margolis: 'Reinterpreting Interpretation', *Journal of Aesthetics and Criticism* (Summer 1989), pp.237–51.
23 Owens 1994, *op. cit.* (note 18), p.281.
24 A. Partington: Review of *The Originality of the Avant-Garde and Other Modernist Myths*, *Oxford Art Journal* 9/2 (1986), p.65.
25 C. Owens: 'The Discourse of Others: Feminists and Postmodernism' (1983), repr. in *idem* 1994, *op. cit.* (note 18), pp.166–90.
26 A. Chave: 'Minimalism and Biography', *Art Bulletin* 82 (2000), p.149.
27 *Ibid.*, pp.153–54.
28 Recounted in Newman, *op. cit.* (note 5), p.78.
29 R. Krauss: 'Re-Presenting Picasso', *Art in America* (December 1980), pp.90–96.
30 Apart from 'In the Name of Picasso', this theme is taken up most explicitly in the book's introduction and the essays 'Photography's Discursive Spaces' and 'Reading Jackson Pollock, Abstractly'.
31 D. Carrier: *Rosalind Krauss and American Philosophical Art Criticism: From Formalism to Beyond Postmodernism*, Westport CT 2002, p.43.
32 H. Wölfflin: *Principles of Art History: The Problem of the Development of Style in Later Art*, transl. M.D. Hottinger, New York 1950.
33 Carrier, *op. cit.* (note 31), p.3.
34 Siedell, *op. cit.* (note 8), p.100.
35 Bois, *op. cit.* (note 20), p.369.
36 *Ibid.*
37 *Ibid.*

38 Introduction to Foster, *op. cit.* (note 11), p.xii.
39 R. Krauss, Y.-A. Bois, H. Foster and B.H.D. Buchloh: 'Roundtable: The Predicament of Contemporary Art', in *idem*, *op. cit.* (note 20), p.674.
40 Krauss 2010, *op. cit.* (note 6), p.xiv.

CHAPTER 16, PP.202–15

Hans Belting: *Bild und Kult: Eine Geschichte des Bildes vor dem Zeitalter der Kunst*, 1990
JEFFREY HAMBURGER

The author would like to thank Ruth Bielfeldt, Caroline Bynum, Frank Fehrenbach, Hildegard Elisabeth Keller and Peter Probst for commenting on previous versions of this essay. Quotations in the text are taken from the English translation by Edmund Jephcott: *Likeness and Presence: A History of the Image Before the Era of Art*, Chicago 1994.

1 H. Belting: *Das Echte Bild: Bildfragen als Glaubensfragen*, Munich 2005.
2 *Idem*: review of O. Demus's *Byzantine Art and the West*, *Art Bulletin* 54 (1972), pp.542–44.
3 For some context, see U. Peters: 'Historische Anthropologie und mittelalterliche Literatur: Schwerpünkte einer interdisziplinären Forschungsdiskussion', in *Festschrift Walter Haug und Burghart Wachinger*, Tübingen 1992, I, pp.63–86; and C. Kiening: 'Anthropologische Zugänge zur mittelalterlichen Literatur: Konzepte, Ansätze, Perspektiven', in H.-J. Schiewer, ed.: *Forschungsberichte zur Germanistischen Mediävistik*, Bern 1996, pp.11–129. Belting's work surprisingly makes no reference to A. Gell: *Art and Agency: An Anthropological Theory*, Oxford 1998.
4 J.-C. Schmitt: 'La culture de l'imago', *Annales HSS* (January–February 1996), pp.3–36. See also *idem*: 'Imago: Entre image et imaginaire', in A. Dutu and N. Dodille, eds.: *Culture et politique*, Paris 1995, pp.83–96; *idem*: 'Image: De l'image à l'imaginaire', in J. Baschet and J.-C. Schmitt, eds.: *L'image: Fonctions et*

usages des images dans l'Occident
médiéval, Paris 1996, pp.29–37; *idem*:
'Plädoyer für eine komparative
Geschichte der religiösen Bilder',
*Zeitsprünge: Forschungen zur Frühen
Neuzeit* 1 (1997), pp.244–68; and
idem: 'La permanence des images
et les changements de temporalité',
in T. Dufrêne and A.-C. Taylor, eds.:
*Cannibalismes disciplinaires: Quand
l'histoire de l'art et l'anthropologie se
rencontrent*, Paris 2009, pp.179–87.

5 J. Gerchow, ed.: *Ebenbilder:
Kopien von Körpern – Modelle
des Menschen*, Ostfildern 2002;
and B. Latour and P. Weibel, eds.:
*Iconoclash: Beyond the Image
Wars in Science, Religion and
Art*, Karlsruhe 2002, both with
contributions by Belting. See also
I. Bartl-Fliedl and C. Geissmar,
eds.: *Die Beredsamkeit des Leibes:
Zur Körpersprache in der Kunst*,
Salzburg 1992.

6 I. Almond: 'How Not to Deconstruct
a Dominican: Derrida on God
and "Hypertruth"', *Journal of the
American Academy of Religion*
68 (2000), pp.329–44.

7 Although it does not discuss Belting,
see J. Elkins and D. Morgan, eds.:
Re-Enchantment, London 2008,
for the broader context in which
Belting's book participates and,
to a certain extent, helped create.

8 Among the few to note the
connections is K.-O. Werckmeister:
'Jutta Helds "Monument und
Volk" und Hans Beltings "Bild und
Kult"', *Georges-Bloch-Jahrbuch des
Kunstgeschichtlichen Seminars der
Universität Zürich* 2 (1995), pp.7–11.

9 D. Schöttker, ed.: *Walter Benjamin:
Das Kunstwerk im Zeitalter seiner
technischen Reproduzierbarkeit
und weitere Dokumente*, Frankfurt
am Main 2007, pp.20–21.

10 *Ibid.*, p.18.

11 H. Beck and H. Bredekamp: exh.
cat. *Kunst um 1400 am Mittelrhein:
Ein Teil der Wirklichkeit*, Frankfurt
am Main (Liebieghaus) 1975–76;
W. Kemp: 'Fernbilder: Benjamin
und die Kunstwissenschaft', in
B. Lindner, ed.: *Walter Benjamin
im Kontext*, 2nd enlarged ed.,
Königstein im Taunus 1985, pp.224–
57, esp. pp.250–54; H. Bredekamp:
'Der simulierte Benjamin:
Mittelalterliche Anmerkungen
zu seiner Aktualität', in A. Berndt

et al., eds.: *Frankfurter Schule und
Kunstgeschichte*, Berlin 1992, pp.117–
40, translated as: 'The Simulated
Benjamin: Medieval Remarks on
its Actuality', *Art in Translation*
1/2 (2009), pp.285–301.

12 H.-U. Gumbrecht: *Production
of Presence: What Meaning Cannot
Convey*, Stanford 2004.

13 For strategies of mediation in
medieval art, see, for example, C.
Walker Bynum: 'Seeing and Seeing
Beyond: The Mass of St. Gregory
in the Fifteenth Century', in A.-M.
Bouché and J. Hamburger, eds.: *The
Mind's Eye: Art and Theology in the
Middle Ages*, Princeton 2005,
pp.208–40; and H.L. Kessler: 'Real
Absence: Early Medieval Art and
the Metamorphosis of Vision', in
*Morfologie sociali e culturali in
Europa fra tarda antichità e alto
Medioevo* (*Settimana internazionale
di studi 45*), Spoleto 1998, pp.1157–211.

14 H. Schlie: 'Ein "Kunststück" Jan
van Eycks in der Nachfolge der
mittelalterlichen Artefakt- und
Kunsttheorie', in C. Laude and G.
Hess, eds.: *Konzepte von Produk-
tivität im Wandel vom Mittelalter
in die Frühe Neuzeit*, Berlin 2008,
pp.243–86.

15 M. Caviness: 'Erweiterung des
"Kunst"-Begriffs: Die Rezeption
mittelalterlicher Werke im
Kontext nachimpressionistischer
Bewegungen', *Oesterreichische
Zeitschrift für Kunst und
Denkmalpflege* 40 (1986), pp.204–15,
translated as 'Broadening the
Definitions of Art: The Reception
of Medieval Works in the Context
of Post-Impressionist Movements',
in P.J. Gallacher and H. Damico,
eds.: *Hermeneutics and Medieval
Culture*, Albany 1989, pp.259–82.
See, most recently, T. Buddensieg:
'Die karolingischen Maler in Tours
und die Bauhausmaler in Weimar:
Wilhelm Koehler und Paul Klee',
Zeitschrift für Kunstgeschichte 73
(2010), pp.1–18.

16 J. Nayrolles: *L'invention de l'art
roman à l'époque moderne (XVIIIe–
XIXe siècles)*, Rennes 2005; and C.
Grewe: *Painting the Sacred in the
Age of Romanticism*, Farnham
and Burlington VT 2009.

17 M.R. Olin: *Forms of Representation
in Alois Riegl's Theory of Art*,
University Park PA 1992; M. Gubser:

*Time's Visible Surface: Alois Riegl
and the Discourse on History
and Temporality in Fin-de-Siècle
Vienna*, Detroit 2006; N.H.
Donahue, ed.: *Invisible Cathedrals:
The Expressionist Art History of
Wilhelm Worringer*, University Park
PA 1995; J. Trilling: 'Medieval Art
without Style? Plato's Loophole and
a Modern Detour', *Gesta* 34 (1995),
pp.57–62; and C. Öhlschläger:
*Abstraktionsdrang: Wilhelm
Worringer und der Geist der
Moderne*, Paderborn 2005.

18 http://www.schaulager.org/en/index.
php?pfad=archiv/matthew_barney/
katalog, accessed 8th October 2012.

19 F. Hoffman *et al.*, eds.: *Chris Burden*,
Newcastle upon Tyne 2007.

20 See, for example, D. Kuspit:
'Traditional Art History's Complaint
against the Linguistic Analysis of
Visual Art', *Journal of Aesthetics
and Art Criticism* 45 (1987), pp.345–
49. For Late Antiquity, see P. Brown:
'Images as a Substitute for Writing',
in E. Chrysos and I. Wood,
eds.: *East and West: Modes
of Communication: Proceedings
of the First Plenary Conference at
Merida*, Leiden 1999, pp.15–34.

21 See, for example, H.A. Oberman:
*The Dawn of the Reformation:
Essays in Late Medieval and Early
Reformation Thought*, Grand Rapids
1992; and J. Simpson: 'Diachronic
History and the Shortcomings of
Medieval Studies', in G. McMullan
and D. Matthews, eds.: *Reading the
Medieval in Early Modern England*,
Cambridge 2007, pp.17–30.

22 F. Jacobs: 'Rethinking the Divide:
Cult Images and the Cult of Images',
in J. Elkins and R. Williams, eds.:
Renaissance Theory, New York 2008,
pp.95–114.

23 For one example, see A. Speer:
'Kunst ohne Kunst? Interartifizialität
in Sugers Schriften zur Abteikirche
von Saint-Denis', in S. Bürkle and
U. Peters, eds.: *Interartifizialität:
Die Diskussion der Künste in
der mittelalterlichen Literatur
(Zeitschrift für deutsche Philologie:
Sonderheft zum Band 128)*,
Berlin 2009, pp.203–20.

24 To note but one example, the
concept of a 'visualistic turn',
employed in K. Sachs-Hombach,
ed.: *Bildtheorien: Anthropologische
und kulturelle Grundlagen des*

Visualistic Turn, Frankfurt am Main 2009. 'Mediality' is another such term that lacks any clear meaning in English.

25 H. Belting: 'Image, Medium, Body: A New Approach to Iconology', *Critical Inquiry* 31 (2005), pp.302–19.

26 For the first instance of the term, see W.J.T Mitchell: 'The Pictorial Turn', *Artforum* 30/7 (March 1992), pp.89–94.

27 D. Freedberg: 'Holy Images and Other Images', in S.C. Scott, ed.: *The Art of Interpreting*, University Park PA 1995, p.71. Freedberg continues: 'I find the Byzantine theory of images to be both *massangebend* and paradigmatic, in the historical as well as in the psychological sense'.

28 *Idem: The Power of Images: Studies in the History and Theory of Response*, Chicago 1989, pp.161–91.

29 *Idem, op. cit.* (note 27), pp.69–89, esp. p.69.

30 H. Belting: *Florenz und Bagdad: Eine westöstliche Geschichte des Blicks*, Munich 2008.

31 W.J.T. Mitchell: *Picture Theory: Essays on Visual and Verbal Representation*, Chicago 1994, p.16.

32 H. Belting: *Szenarien der Moderne: Kunst und ihre offenen Grenzen*, ed. P. Weibel, Berlin 2005; *idem* and A. Buddensieg, eds.: *The Global Art World: Audiences, Markets, and Museums*, Ostfildern 2009.

33 G. Boehm: 'Die Wiederkehr der Bilder', in *idem*, ed.: *Was ist ein Bild?*, Munich 1994, pp.11–38.

34 W. Sauerländer: 'Iconic Turn? Eine Bitte um Ikonoklasmus', in C. Maar and H. Burda, eds.: *Iconic Turn: Die neue Macht der Bilder*, Cologne 2004, pp.407–26; *idem*: 'Kunstgeschichte und Bildwissenschaft', in J. Früchtl and M. Moog-Grünewald, eds.: *Asthetik in metaphysikkritischen Zeiten: 100 Jahre: Zeitschrift für Asthetik und Allgemeine Kunstwissenschaft (Sonderheft der Zeitschrift für Asthetik und Allgemeine Kunstwissenschaft 8)*, Tübingen 2007, pp.93–108.

35 H. Bredekamp: 'A Neglected Tradition? Art History as "Bildwissenschaft"', *Critical Inquiry* 29 (2003), pp.418–28.

36 H. Belting: *Likeness and Presence: A History of the Image Before the Era of Art*, transl. E. Jephcott, Chicago 1994, p.xxii.

37 *Ibid.*

38 H. Belting and D. Blume, eds.: *Malerei und Stadtkultur in der Dantezeit: Die Argumentation der Bilder*, Munich 1989, does not deal with narrative imagery from the early Christian period to the High Middle Ages.

39 P. Brown: *The Cult of the Saints: Its Rise and Function in Latin Christianity*, Chicago 1981.

40 See Peter Schmidt's report on the conference at the Kunstgeschichtliches Institut der Universität Frankfurt am Main, in collaboration with the Liebieghaus, Frankfurt, 22nd to 24th June 2007: 'Sinn und Un-Sinn des Kultbildes: Die Intellektualisierung und die Mystifizierung mittelalterlicher Kunst', *Kunstchronik* 61/9–10 (2008), pp.457–61.

41 B. Brenk: *The Apse, the Image and the Icon: An Historical Perspective of the Apse as a Space for Images*, Wiesbaden 2010; and H. Belting: 'Eine Privatkapelle im frühmittelalterlichen Rom', *Dumbarton Oaks Papers* 41 (1987), pp.55–69.

42 T.S. Scheer: *Die Gottheit und ihr Bild: Untersuchungen zur Funktion griechischer Kultbilder in Religion und Politik*, Munich 2000.

43 P. Stewart: 'Gell's Idols and Roman Cult', in R. Osborne and J. Tanner, eds.: *Art's Agency and Art History*, Oxford 2007, pp.158–78, esp. pp.161–62.

44 G. Didi-Huberman: '"Imaginum pictura . . . in totum exoleuit": Début de l'histoire de l'art et fin de l'époque de l'image', *Critique* 586 (1996), pp.138–50; D. Steiner: *Images in Mind: Statues in Archaic and Classical Greek Literature and Thought*, Princeton 2001; P. Stewart: *Statues in Roman Society: Representation and Response*, Oxford 2003, pp.184–222; and J. Mylonopoulos, ed.: *Divine Images and Human Imaginations in Ancient Greece and Rome*, Leiden 2010.

Bibliographical Essays

In this section, the term 'edition' refers to the first publication and any subsequent version of the book that incorporates substantial modifications or additions to the original. In most cases these are signalled by the publisher, although there is no agreed definition between publishers as to what constitutes a new edition. Reprinted or reissued volumes are not considered new editions here.

EMILE MALE (1862–1954)

BIOGRAPHY

Emile Mâle was a medievalist specialising in French Gothic art and architecture. He was a pioneering figure in the iconographic approach to art history – the study of the sources and meaning of pictorial elements, as opposed to pictorial form – and he coined the term 'iconography' in 1927. From 1886 he taught literature at secondary schools, but began lecturing on art-historical subjects in 1892. His doctoral thesis was finished in 1898 and published as *L'art religieux du XIIIe siècle en France* in the same year. He began teaching Christian medieval archaeology at the Sorbonne in Paris in 1906 and was appointed to a new chair in medieval art there in 1912. Mâle continued to research and publish on the subject of French medieval art, and was appointed the honorary director of the Ecole française de Rome in 1923, where he stayed until 1937. Following the War he took up the position of curator at the Musée Jacquemart-André, Paris.

PUBLICATION HISTORY

L'art religieux du XIIIe siècle en France: Etude sur l'iconographie du Moyen Age et sur ses sources d'inspiration

First published: 1898
Original language: French

Editions to date in original language: Ten
First translation: German, 1907
Other languages: English, Spanish

L'art religieux du XIIIe siècle en France: Etude sur l'iconographie du Moyen Age et sur ses sources d'inspiration was first published in Paris by Ernest Leroux in 1898. The second 'revised and corrected' edition was published by Armand Colin in Paris in 1902, and a third in 1910, 'revised and augmented'. It was eventually to form one of the volumes of a series of four works covering French medieval art, all published by Armand Colin, comprising *L'art religieux de la fin du Moyen Age en France* (1908); *L'art religieux du XIIe siècle en France* (1922); and *L'art religieux après le Concile de Trente: Etude sur l'iconographie de la fin du XVIe siècle, du XVIIe et du XVIIIe siècles: Italie, France, Espagne, Flandres* (1932). Further French editions of *L'art religieux du XIIIe siècle en France* were published in 1919 (fourth edition), 1923 (fifth edition), 1925 (sixth edition), 1931 (seventh edition), 1948 (eighth edition) and 1958 (ninth edition). All subsequent printings reproduce the text of the ninth edition, the first to appear after Mâle's death. It was reprinted by Armand Colin in 1968, 1969, 1986, 1987, 1988, 1990 and 1993. A new edition appeared in 1986, again reproducing the text of the ninth edition.

The first English translation was made by Dora Nussey from the third French edition, and published simultaneously in London and New York in 1913 as *Religious Art in France in the XIII Century: A Study in Mediaeval Iconography and its Sources of Inspiration* (J.M. Dent & Sons, London; E.P. Dutton & Co., New York). Nussey's English translation was republished in New York in 1958 by Harper & Row as *The Gothic Image: Religious Art in France of the Thirteenth Century*, a version which ran to three editions (1961, 1972). It was reissued in 2000 as *Religious Art in France of the Thirteenth Century* (Dover Publications, New York). In 1985 a new translation by Marthiel Mathews of the ninth revised and corrected French edition (1958) was published by Princeton University Press as *Religious Art in France, the Thirteenth Century: A Study of Medieval Iconography and Its Sources* (as of 2012 out of print).

The very first translation, into German, was made by the wealthy banker Lorenz Zuckermandel of the second French edition, published in 1907 as *Die kirchliche Kunst des XIII. Jahrhunderts in Frankreich: Studie über die Ikonographie des Mittelalters und ihre Quellen* (Strasbourg, J.H.E. Heitz). A new German translation by Gerd Betz was published in 1986 (reissued in 1994) as *Die Gotik: Die französische Kathedrale als Gesamtkunstwerk* (Stuttgart and Zürich, Belser). It first appeared in Spanish in a translation by Abundio Rodríguez as *El Gótico: La iconografía de la Edad Media y sus fuentes* published by Ediciones Encuentro, Madrid, in 1986. It was reissued in 2001 by the same publisher, as *El arte religioso del siglo XIII en Francia: El gótico*.

FURTHER BOOKS BY EMILE MALE

Quomodo Sybillas recentiores artifices representaverint, Paris (Ernest Leroux), 1899.
La cathédrale de Reims, Paris (Bloud & Gay), 1915.
L'art allemand et l'art français du Moyen Age, Paris (Armand Colin), 1917.
Art et artistes du Moyen Age, Paris (Armand Colin), 1927.
Rome et ses vieilles églises, Paris (Flammarion), 1942.
La fin du paganisme en Gaule et les plus anciennes basiliques chrétiennes, Paris (Flammarion), 1950.
Souvenirs et correspondances de jeunesse, Nonette (Editions Créer), 2001.

BOOKS AND ARTICLES ON EMILE MALE

E. Lambert: 'Bibliographie des travaux du Emile Mâle', in: *Cahiers de Civilisation Médiévale* 2, Poitiers (CESCM), 1959.
A. Grabar: 'Notice sur la vie et les travaux de M. Emile Mâle', in: *Académie des Inscriptions & Belles-Lettres* (January–March 1962), pp.328–44.
E. Kaemmerling, ed.: *Ikonographie und Ikonologie: Theorien, Entwicklung, Probleme*, Cologne (DuMont), 1979.
Emile Mâle: Le symbolisme chrétien. Exposition organisée par la bibliothèque municipale de Vichy au Centre Culturel et au Grand Casino de Vichy, 28 mai–20 juin 1983, exh. cat., Vichy (Centre Culturel), 1983.
G. Bazin: *Histoire de l'histoire de l'art: De Vasari à nos jours*, Paris (Michel), 1986.
M. Camille: *The Gothic Idol: Ideology and Image-Making in Medieval Art*, Cambridge (Cambridge University Press), 1989.
L. Therrien: *L'histoire de l'art en France: Genèse d'une discipline universitaire*, Paris (Editions du Comité des travaux historiques et scientifiques), 1998.
H. Dilly, ed.: *Altmeister moderner Kunstgeschichte*, Berlin (Reimer), 1999.
J.M. Luxford: 'Emile Mâle', in C. Murray, ed.: *Key Writers on Art: The Twentieth Century*, London and New York (Routledge), 2002.
E. Emery and L. Morowitz: *Consuming the Past: The Medieval Revival in Fin-de-Siècle France*, Aldershot (Ashgate), 2003.

G. Kopp-Schmidt: *Ikonographie und Ikonologie: Eine Einführung*, Cologne (Deubner), 2004.

Emile Mâle (1862–1954): *La construction de l'œuvre: Rome et l'Italie*, Rome (Ecole française de Rome), 2005.

BERNARD BERENSON (1865–1959)

BIOGRAPHY

Bernard (Bernhard) Berenson was born in Lithuania in 1865 and raised in Boston. He studied literature under Charles Eliot Norton at Harvard University, graduating in 1887. Following a visit to Europe in 1885 as a student, Berenson made the decision to settle in Italy and devote himself to studying Italian art, eventually establishing a home at the Villa I Tatti at Settignano, near Florence. Over the following two decades he published a series of books (often assisted by Mary Logan, who became his wife) that were to define the study of Italian art by the application of connoisseurship as a method. The core principle of his approach – the primacy of the eye over the document in determining the authorship of a painting – is stated in his essay 'The Rudiments of Connoisseurship (A Fragment)', written in 1894 and published in 1902. This approach was reflected in his groundbreaking study *Lorenzo Lotto* (1895; 1955; 1956), and also in his four studies of regional schools, *Venetian Painters* (1894), *Florentine Painters* (1896), *Central Italian Painters* (1897) and *North Italian Painters* (1907), which were brought together as *The Italian Painters of the Renaissance* in 1930 (Oxford, Clarendon Press) and subsequently reprinted several times. However it was in his study of the drawings of the Florentine painters, published in 1903, that his connoisseurship was given its most brilliant and lasting expression. His early work as a

connoisseur and attributionist led to an often controversial involvement with the art market. He remained living and working at the Villa I Tatti, and in later life wrote on questions of aesthetics and prepared his memoirs and diaries for publication. On his death in 1959, Berenson bequeathed the Villa I Tatti, its gardens and surrounding property, along with his art collection, library, papers and photographic archive, to Harvard University. Since 1961, Villa I Tatti has operated as a leading research institution, The Harvard University Center for Italian Renaissance Studies.

PUBLICATION HISTORY

The Drawings of the Florentine Painters Classified, Criticised and Studied as Documents in the History and Appreciation of Tuscan Art, with a Copious Catalogue Raisonné

First published: 1903
Original language: English
Editions to date in original language: Four (one British, three American)
First translation: Italian, 1961
Other languages: —

Berenson's *The Drawings of the Florentine Painters* was first published by John Murray, London, in two volumes in 1903. An American

limited edition of 355 copies was released in the same year by E.P. Dutton and Co., New York. It was published in greatly revised and expanded form with an extra volume of illustrated plates (I. Text; II. Catalogue; III. Illustrations) by the University of Chicago Press in 1938; this version was also printed in Italy by Leo S. Olschki, Florence. A second, 'collector's' edition with 'essential changes, additions, and new appendices' was published by the University of Chicago Press in 1970. A further 'amplified' edition was published by Greenwood Press, New York, in 1969, and reprinted the following year. An Italian translation, by Luisa Vertova Nicolson, appeared in 1961 as *I disegni dei pittori fiorentini*, with revisions and a new preface by the author (Milan, Electa), reprinted in 1968. A print-on-demand paperback of all three volumes was available in 2011 from the Literary Licensing LLC, Montana.

FURTHER BOOKS BY BERNARD BERENSON

The Venetian Painters of the Renaissance, New York (G.P. Putnam's Sons), 1894.
Lorenzo Lotto: An Essay in Constructive Art Criticism, New York (G.P. Putnam's Sons), 1895.
The Florentine Painters of the Renaissance, New York (G.P. Putnam's Sons), 1896.
The Central Italian Painters of the Renaissance, New York; London (G.P. Putnam's Sons), 1897.
The Study and Criticism of Italian Art, London (George Bell & Sons), 1901.
The North Italian Painters of the Renaissance, New York (G.P. Putnam's Sons), 1907.
A Sienese Painter of the Franciscan Legend, London (J. M. Dent & Sons), 1909.
Three Essays in Method, Oxford (Clarendon Press), 1927.
Studies in Medieval Painting, New Haven (Yale University Press), 1930.
The Italian Painters of the Renaissance, Oxford (Clarendon Press), 1930.
The Italian Pictures of the Renaissance: A List of the Principal Artists and their Works with an Index of Places, Oxford (Clarendon Press), 1932.
Aesthetics and History, New York (Pantheon), 1948.
Sketch for a Self-Portrait, London (Constable), 1949.
Rumor and Reflection, New York (Simon & Schuster), 1952.
Caravaggio: His Incongruity and His Fame, London (Chapman & Hall), 1953.
The Arch of Constantine; or, The Decline of Form, London (Chapman & Hall); New York (Macmillan), 1954.
Piero della Francesca; or, The Ineloquent in Art, London (Chapman & Hall); New York (Macmillan), 1954.
One Year's Reading for Fun (1942), New York (Knopf); London (Weidenfeld & Nicolson), 1960.
The Passionate Sightseer: From the Diaries, 1947 to 1956 (pref. by Raymond Mortimer), New York (Simon & Schuster); London (Thames & Hudson), 1960.
H. Kiel, ed.: *The Bernard Berenson Treasury: A Selection from the Works, Unpublished Writings, Letters, Diaries, and Journals of the Most Celebrated Humanist and Art Historian of Our Times, 1887–1958*, New York (Simon & Schuster), 1962.
N. Mariano, ed.: *Sunset and Twilight: From the Diaries of 1947–1958*, New York (Harcourt, Brace & World), 1963.
D. Biocca, ed.: *A Matter of Passion: Letters of Bernard Berenson and Clotilde Marghieri*, Berkeley (University of California Press), 1989.

BOOKS ON BERNARD BERENSON

W. Mostyn-Owen: *Bibliografia di Bernard Berenson*, Milan (Electa), 1955.
S.S. Sprigge: *Berenson: A Biography*, London (Allen & Unwin), 1960.
N. Mariano: *The Berenson Archive: An Inventory of Correspondence*, Cambridge MA (Harvard University Press), 1965.

U. Morra: *Conversations with Berenson*,
Boston (Houghton Mifflin), 1965.

N. Mariano: *Forty Years with Berenson*,
New York (Knopf), 1966.

D. A. Brown: exh. cat. *Berenson and the
Connoisseurship of Italian Painting:
A Handbook to the Exhibition*, Washington,
DC (National Gallery of Art), 1979.

E. Samuels: *Bernard Berenson: The Making
of a Connoisseur*, Cambridge MA (Belknap
Press), 1979.

C. Simpson: *Artful Partners: Bernard Berenson
and Joseph Duveen*, New York (Macmillan),
1986.

E. Samuels: *Bernard Berenson: The Making of a
Legend*, Cambridge MA (Belknap Press), 1987.

C. Garboli, C. Montagnani and G. Agosti, eds.:
*Bernard Berenson–Roberto Longhi: Lettere e
Scartafacci, 1912–1957*, Milan (Adelphi), 1993.

M.A. Calo: *Bernard Berenson and the Twentieth
Century*, Philadelphia (Temple University
Press), 1994.

P. Zambrano: *Bernard Berenson: Amico
di Sandro*, Milan (Electa), 2006.

HEINRICH WÖLFFLIN (1864–1945)

BIOGRAPHY

The Swiss art historian Heinrich Wölfflin established an approach to the study of art termed 'formalist', examining questions of artistic style rather than content. Although he began his studies in the field of philosophy in Basel, Wölfflin changed to art history under the influence of his teacher, the cultural historian Jacob Burckhardt. Following a period studying with the philosopher Wilhelm Dilthey in Berlin, he completed his studies in Munich, where he wrote a dissertation on psychological interpretations of architecture, published in 1886 as *Prolegomena zu einer Psychologie der Architektur*. His concern with overarching abstract notions of interpretation was to inform much of his subsequent writing, including *Renaissance und Barock* (1888), completed after some time spent living in Italy. Following this he taught in Munich, returning to the University of Basel in 1893 to succeed Burckhardt as Professor of Art History. His 1898 *Die klassische Kunst* describes the transformation from early to high Renaissance art in terms of generalised social and psychological categories. He was appointed Ordinarius Professor at the University of Berlin in 1901, where his lectures received wide critical acclaim. Here he completed a monograph on the work of Albrecht Dürer, published in 1905. Repressive cultural policies of the Prussian State compelled him to resign his position, and he returned to the more liberal city of Munich to take up a position at the University in 1912. His *Kunstgeschichtliche Grundbegriffe* was published during the First World War, in 1915, and remains the most complete expression of his philosophical approach to the history of art, and the book that brought him international recognition. At the age of sixty, and at the height of his academic powers, Wölfflin surprised many of his colleagues by deciding to return to Switzerland and take up a position at the University of Zürich in 1924. Here he was to write his last books, including *Italien und das deutsche Formgefühl*, which focused on the relationship between German and Italian art.

PUBLICATION HISTORY

Kunstgeschichtliche Grundbegriffe: Das Problem der Stilentwicklung in der neueren Kunst

First published: 1915
Original language: German
Editions to date in original language: Nineteen
First translation: Spanish, 1924
Other languages: Chinese, Croatian, Dutch, English, French, Hebrew, Hungarian, Italian, Japanese, Korean, Polish, Russian, Slovenian, Swedish, Turkish

Heinrich Wölfflin's *Kunstgeschichtliche Grundbegriffe* was published in Munich by F. Bruckmann in 1915. The first nine editions were published by Bruckmann from 1917 to 1948. The eighth edition, published in 1943, was the last to be personally revised by the author. Simultaneously with the ninth Munich edition in 1948, a tenth edition was published by Benno Schwabe & Co in Basel, the location for all subsequent German editions and printings, with the exception of the eleventh, published in Darmstadt, and an East German version published in Dresden by VEB Verlag der Kunst in 1983. Wölfflin published an important revision of the entire volume in 1933, first in the journal *Logos* (vol.22, no.2, 1933), and then in book form as *Kunstgeschichtliche Grundbegriffe: Eine Revision* (Tübingen, J.C.B. Mohr [P. Siebeck]), 1933.

The first translation was into Spanish, by José Moreno Villa, as *Conceptos fundamentals de la historia del arte* (Madrid, Calpe, 1924). The seventh German edition (1929) was translated into English by Marie Donald Mackie Hottinger as *Principles of Art History: The Problem of the Development of Style in Later Art* and published simultaneously in 1932 by Holt, New York, and George Bell & Sons, London. A Russian translation by A.A. Frankovskij was published in Leningrad in 1930 as *Osnovnye ponjatija istorii iskusstv*. In 1936 a Japanese translation by Moriya Kenji was published in Tokyo by Iwanami Shoten.

A French translation appeared in 1952 as *Principes fondamentaux de l'histoire de l'art: Le problème de l'évolution du style dans l'art moderne,* translated by Claire and Marcel Raymond, Paris, Gallimard, 1952 (further editions in 1961, 1966, 1992, 1997). It was translated into Swedish by Bengt G. Söderberg as *Konsthistoriska grundbegrepp: stilutvecklingsproblem i nyare tidens konst* and published in Stockholm, Oslo, Copenhagen and Helsingfors in 1957. Further translations were made into Croatian (1958); Dutch (1960); Hebrew (1962); Polish (1962); Hungarian (1969); Turkish (1985); Chinese (1987); Italian (1994); Korean (2009) and Slovenian (2009).

FURTHER BOOKS AND ARTICLES BY HEINRICH WÖLFFLIN

Prolegomena zu einer Psychologie der Architektur, Munich (Kgl. Hof- und Universitätsbuchdruckerei von Dr. C. Wolf & Sohn), 1886.
Renaissance und Barock: Eine Untersuchen über Wesen und Entstehung der Barockstil in Italien, Munich (Ackermann), 1888.
Die klassische Kunst, Munich (F. Bruckmann), 1889.
Die Kunst Albrecht Dürers, Munich (F. Bruckmann), 1905.
Italien und das deutsche Formgefühl, Munich (F. Bruckmann), 1931.
'*Kunstgeschichtliche Grundbegriffe*: Eine Revision', *Logos: Internationale Zeitschrift für Philosophie der Kultur* 22 (1933), pp.210–18.
Gedanken zur Kunstgeschichte: Gedrucktes und Ungedrucktes, Basel (Schwabe), 1941.
Kleine Schriften (1886–1933), ed. J. Ganter, Basel (Schwabe), 1946.

BOOKS AND ARTICLES ON HEINRICH WÖLFFLIN

'Heinrich Wölfflin', *The Burlington Magazine* 84 (1944), pp.133–34.
J. Gantner, ed.: *Jacob Burckhardt und Heinrich*

Wölfflin: Briefwechsel und andere Dokumente ihrer Begegnung, 1882–1897, Basel (Schwabe), 1948.

J.G. Hart: 'Heinrich Wölfflin. An Intellectual Biography', Ph.D. diss. (University of California, Berkeley, 1981).

M. Lurz: *Heinrich Wölfflin: Biographie einer Kunsttheorie*, Worms (Werner'sche Verlagsgesellschaft), 1981.

J. Gantner, ed.: *Heinrich Wölfflin, 1864–1945: Autobiographie, Tagebücher und Briefe*, Basel (Schwabe), 1984.

M. Podro: *The Critical Historians of Art*, New Haven; London (Yale University Press), 1982.

M. Warnke: 'On Heinrich Wölfflin', *Representations* 27 (1989), pp.172–87.

J. Hart: 'Heinrich Wölfflin', in M. Kelly, ed.: *Encyclopedia of Aesthetics*, New York; Oxford (Oxford University Press), 1998, IV, pp.472–76

F.J. Schwartz: 'Cathedrals and Shoes: Concepts of Style in Wölfflin and Adorno', *New German Critique* 76 (1999), pp.3–48.

D. Adler: 'Painterly Politics: Wölfflin, Formalism and German Academic Culture, 1885–1915', *Art History* 27 (2004), pp.431–77.

ROGER FRY (1866–1934)

BIOGRAPHY

Roger Eliot Fry was the pre-eminent writer on art in Britain in the early twentieth century. He trained as a scientist and later as a painter before becoming a recognised authority on Italian Renaissance art. In 1899 he published a study of Bellini and in 1903 was co-founder of *The Burlington Magazine* in London. In 1905–10 Fry was Curator of European Painting at the Metropolitan Museum of Art, New York. During this time his enthusiasm grew for recent and contemporary art. He was responsible for the first and second Post-Impressionist exhibitions in London in 1910 and 1912, with their notable displays of work by Cézanne, Gauguin, Van Gogh, Matisse and Picasso. He founded and directed the Omega Workshops for interior design and decoration (1913–19). Substantial critical essays on art and aesthetics were published in *Vision and Design* (1920) and *Transformations* (1926), and his acclaimed study of Cézanne followed in 1927. He was Slade Professor of Art at Cambridge in 1933–34.

He is chiefly known for his formalist theory of art which emphasises the physical properties of a work rather than its subject-matter or emotive content. In his last years a reassessment of the role of subject-matter informed his rigorous formal analysis; this fruitful new direction was curtailed by his sudden death in 1934. Kenneth Clark edited Fry's *Last Lectures* (1939) and the following year his friend Virginia Woolf published *Roger Fry: A Biography*.

PUBLICATION HISTORY

Cézanne: A Study of His Development

First published: 1927
Original language: English
Editions to date in original language: Four (two British, two American)
First translation: Spanish, 2008
Other languages: Chinese, French, Italian

Originally written in French as an article for the December 1926 issue of the magazine *L'Amour de l'Art*, Roger Fry's work on Cézanne was expanded for publication in English the following year by Leonard and Virginia Woolf at the Hogarth Press, London. A second edition appeared in 1932 and was reprinted twice (1952, 1962). An American edition appeared simultaneously with the first British edition, published by Macmillan, New York, with a second edition appearing in 1952. Later American printings were issued by Noonday Press, New York, in 1958 (with an introduction by Alfred Werner, reprinted 1960, 1963, 1968 and 1970) and the University of Chicago Press in 1989, a reprint of the 1960 American edition, with a new introduction by Richard Schiff. A print-on-demand edition was made available by Kessinger Publishing in 2004.

The first translation was into Spanish by Paula Lizarraga Gutiérrez in 2008 as *Cézanne: Un estudio de su evolución* (Pamplona, Ediciones Universidad de Navarra). The following year translations appeared in Italian, by N. Salomon (Turin, Ananke), and by Yubing Shen into Chinese as *Saishang ji qi hua feng de fa zhan* (Guilin, Guangxi, Normal University Press).

Further books by Roger Fry

Giovanni Bellini, London (At the Sign of the Unicorn), 1899.
Vision and Design, London (Chatto & Windus), 1920.
Transformations: Critical and Speculative Essays on Art, London (Chatto & Windus), 1926.
Flemish Art: A Critical Survey, London (Chatto & Windus); New York (Brentano's), 1927.
Characteristics of French Art, London (Chatto & Windus), 1932.
The Arts of Painting and Sculpture, London (Victor Gollancz), 1932.
Reflections on British Painting, London (Faber & Faber); New York (Macmillan), 1934.

Last Lectures, with an Introduction by Kenneth Clark, Cambridge (Cambridge University Press); New York (Macmillan), 1939.
D. Sutton, ed.: *Letters of Roger Fry*, London (Chatto & Windus), 1972.

Books and articles on Roger Fry

V. Woolf: *Roger Fry: A Biography*, London (Hogarth Press), 1940.
B. Nicolson: 'Post-Impressionism and Roger Fry', *The Burlington Magazine* 93 (January 1951), pp.11–15.
B. Lang: 'Significance or Form: The Dilemma of Roger Fry's Aesthetic', *Journal of Aesthetics and Art Criticism* 21 (1962) pp.167–76.
D. Taylor: 'The Aesthetic Theories of Roger Fry Reconsidered', *Journal of Aesthetics and Art Criticism* 36 (1977), pp.63–72.
D.A. Laing: *Roger Fry: An Annotated Bibliography of the Published Writings*, New York (Garland), 1979.
J.V. Falkenheim: *Roger Fry and the Beginnings of Formalist Art Criticism*, Ann Arbor (UMI Research Press), 1980.
F. Spalding: *Roger Fry: Art and Life*, Berkeley (University of California Press), 1980.
P. Jutras: 'Roger Fry et Clive Bell: divergences fondamentales autour de la notion de "Significant Form"', *Revue d'Art Canadienne / Canadian Art Review* 20 (1993), pp.98–115.
C.D. Goodwin, ed.: *Art and the Market: Roger Fry on Commerce in Art: Selected Writings, Edited and with an Interpretation*, Ann Arbor (UMI Research Press), 1998.
C. Green, ed.: exh. cat. *Art Made Modern: Roger Fry's Vision of Art*, London (Courtauld Institute of Art), 1999.
C. Elam: *Roger Fry's Journey: From the Primitives to the Post-Impressionists*, Watson Gordon Lecture 2006, Edinburgh (National Galleries of Scotland and University of Edinburgh), 2008.

NIKOLAUS PEVSNER (1902–83)

BIOGRAPHY

Nikolaus Pevsner was an English architectural historian of German birth who achieved fame with his extensive series of guides, *The Buildings of England*. Born in Leipzig, he studied in various cities in Germany before completing a thesis on the Baroque architecture of his native city. Following a period lecturing at the University of Göttingen, Pevsner settled permanently in Britain in 1935 as a result of anti-Jewish Nazi employment law. He had travelled in Britain in the early 1930s and had a strong affinity with British art and architecture. His *Pioneers of the Modern Movement* was published in 1936. From 1942 to 1945 he edited *Architectural Review*, began lecturing at Birkbeck College, University of London, and also began a long association with Penguin Books, for whom he wrote *An Outline of European Architecture* (1942). From 1945 he worked on the famous *Buildings of England* series, and also edited the *Pelican History of Art* volumes. He gained British citizenship in 1946. After the War he became involved in broadcasting, and gave talks on BBC radio on diverse topics in the arts, including the Reith Lectures in 1955.

PUBLICATION HISTORY

Pioneers of the Modern Movement from William Morris to Walter Gropius

First published: 1936
Original language: English
Editions to date in original language: Six (three British, three American)
First translation: German, 1957
Other languages: Hungarian, Italian, Portuguese, Russian, Spanish

Nikolaus Pevsner's *Pioneers of the Modern Movement from William Morris to Walter Gropius* was first published in 1936 in London by Faber & Faber. The first American edition was published under the same title the next year by Frederick A. Stokes, New York. In 1949, a second, revised American edition appeared under the new title *Pioneers of Modern Design* published by the Museum of Modern Art, New York. In 1960, a British edition, further revised and rewritten, was published as *Pioneers of Modern Design: From William Morris to Walter Gropius* by Penguin Books, Harmondsworth (reissued in 1970 and 1991 as part of the Pelican paperback series). In 2005 Yale University Press, New Haven, issued a fourth revised and expanded edition with colour illustrations and an introduction and commentaries by Richard Weston. A 75th anniversary edition was published by Palazzo Editions, Bath, in 2011, based on the 2005 edition.

The first translation appeared in 1957 in German, by Elisabeth Knauth, as *Wegbereiter moderner Formgebung: Von Morris bis Gropius* (Hamburg, Rowohlt). A new edition of this translation was published by DuMont, Cologne, in 1983 (reprinted in 1996), with a foreword by the architectural historian Wolfgang Pehnt. *Pioneers* was translated into Italian by Enrica Labo as *I pionieri dell'architettura moderna: Da William Morris a Walter Gropius* (Bologna, Calderini, 1960, 1962). A further translation by Antonello Negri was published under the same title in Milan by Garzanti Libri (1968, 1983, 1999). A Portuguese translation by João Paulo Monteiro was released by Editora Ulisseia in 1962 as *Os pioneiros do desenho moderno: De William Morris a Walter Gropius*. A Spanish version by Odilia Suárez and Emma Gregores was published in 1977 by Ediciones Infinito in Buenos Aires, as *Pioneros del diseño moderno: De William Morris a Walter*

Gropius. The same year a Hungarian translation by Mihály Falvay was published by Gondolat, Budapest, as *A modern formatervezés úttoroi.*

FURTHER BOOKS BY NIKOLAUS PEVSNER

Leipziger Barock: Die Baukunst der Barockzeit in Leipzig, Dresden (Wolfgang Jess), 1928.
An Enquiry into Industrial Art in England, Cambridge (Cambridge University Press), 1937.
Academies of Art, Past and Present, Cambridge (Cambridge University Press), 1940.
An Outline of European Architecture, Harmondsworth (Penguin), 1942.
The Leaves of Southwell, Harmondsworth (Penguin), 1945.
The Buildings of England, 46 vols., Harmondsworth (Penguin), 1951–74.
The Englishness of English Art, London (The Architectural Press); New York (Praeger), 1956.
Studies in Art, Architecture and Design, 2 vols., New York (Walker), 1956; London (Thames & Hudson), 1968.
Ruskin and Viollet-le-Duc: Englishness and

Frenchness in the Appreciation of Gothic Architecture, London (Thames & Hudson), 1969.
Some Architectural Writers of the Nineteenth Century, Oxford (Clarendon Press), 1972.
A History of Building Types, London (Thames & Hudson); Princeton (Bollingen Series, Princeton University Press), 1976.

BOOKS ON NIKOLAUS PEVSNER

J.R. Barr: *Sir Nikolaus Pevsner: A Bibliography,* Charlottesville (University of Virginia), 1970.
B. Cherry and J. Newman, eds.: *Nikolaus Pevsner: The Best Buildings of England,* Harmondsworth (Penguin), 1986.
S. Bradley and B. Cherry, eds.: *The Buildings of England: A Celebration,* London (Penguin Collectors Society), 2001.
S. Games, ed.: *Pevsner on Art and Architecture: The Radio Talks,* London (Methuen), 2002.
P. Draper, ed.: *Reassessing Nikolaus Pevsner,* Farnham (Ashgate), 2004.
S. Harries: *Nikolaus Pevsner: The Life,* London (Chatto & Windus), 2011.

ALFRED H. BARR, JR. (1902–81)

BIOGRAPHY

Alfred Hamilton Barr, Jr., was born in Detroit in 1902 and raised in Baltimore. He studied art history at Princeton University before pursuing doctoral research at Harvard University, where he studied with Paul J. Sachs. After a period travelling in Europe in 1923, Barr returned to teach art history at Vassar College, Harvard, Princeton and Wellesley College. He directed his teaching towards modern art and design, and continued work on his doctoral thesis on the topic of 'The Machine in Modern Art', which eventually became 'Cubism and Modern Art', although this research was never completed. In 1929 he became the first director of the newly created Museum of Modern Art, New York. Influenced by his experiences in Europe, he was responsible for building up the collection and the organisation of the Museum, and mounted, among other exhibitions, major retrospectives of Matisse (1931) and Picasso (1939). He continued working at the Museum of Modern Art until his retirement in 1967.

PUBLICATION HISTORY

Matisse: His Art and His Public

First published: 1951
Original language: English
Editions to date in original language: One
(American)
First translation: —
Other languages: —

Matisse: His Art and His Public was first
published in 1951 in New York by the Museum
of Modern Art, illustrated in black and white
with a small selection of colour plates. It included
two pages of additions and corrections listed
at the front of the volume. In 1966 and again in
1974 it was reissued by Arno Press in New York,
which had taken over the reprinting of all out-
of-print Museum of Modern Art publications.
A version of *Matisse* was published in New York
by Beaufort Books in 1967, which subsequently
appeared as an illustrated paperback edition
in 1974 distributed by the New York Graphic
Society in the United States, and by Little,
Brown & Company in London. A version was
published in Britain by Secker & Warburg in 1975

that reproduced exactly the text of the original
clothbound edition, including the list of additions
and corrections, but with a different selection
of colour plates. It has not been translated.

FURTHER BOOKS BY ALFRED H. BARR, JR.

Cubism and Abstract Art, New York
 (Museum of Modern Art), 1936.
What is Modern Painting?, New York
 (Museum of Modern Art), 1943.
Picasso: Fifty Years of His Art, New York,
 (Museum of Modern Art), 1946.

BOOKS ON ALFRED H. BARR, JR.

A.G. Marquis: *Alfred H. Barr, Jr.: Missionary
 for the Modern*, Chicago (Contemporary
 Books), 1989.
S.G. Kantor: *Alfred H. Barr, Jr., and the
 Intellectual Origins of the Museum of Modern
 Art*, Cambridge MA (MIT Press), 2002.
K. Kuh: *My Love Affair with Modern Art:
 Behind the Scenes with a Legendary Curator*,
 New York (Arcade), 2006.

ERWIN PANOFSKY (1892–1968)

BIOGRAPHY

Erwin Panofsky, or 'Pan', was the founder of
the modern iconographical approach to
the study of art history. While a student in Jura,
Berlin and Munich he took classes in philosophy,
philology and art history before graduating
from Freiburg University, where he wrote his
dissertation on Dürer under the medievalist
Wilhem Vöge. Exempted from military service

following a horse riding accident, he spent
the War years attending seminars on medieval
art given by Adolph Goldschmidt. In 1920,
after submitting independent research on
Michelangelo to the newly established University
of Hamburg, he was invited to become the first
professor and chair of its art history department.
A brilliant period of intellectual development

and writing followed, as Panofsky formed close associations with the Warburg Institute and became part of an intimate circle of intellectuals that included Fritz Saxl (with whom he co-wrote a monograph on Dürer's *Melancholia I* in 1923), Aby Warburg and the philosopher Ernst Cassirer. Panofsky was greatly influenced by the neo-Kantian thinking of Cassirer as well as the pioneering cross-disciplinary approach of Warburg, and it was during this time that he built his reputation through the publication of several works that laid out the foundations of his unique approach, such as 'Die Perspektive als "symbolische Form"' (1927) and *Hercules am Scheidewege* (1930). In 1934, he was one of many Jewish intellectuals forced out of academic positions in Germany by the Nazi party and he emigrated to the United States. He spent his first year at New York University before going to Princeton to fulfil the positions both of visiting lecturer and member of the recently created Institute for Advanced Study. His American years saw the substantial development of his methodology and the publication of his greatest works: *Early Netherlandish Painting* (1953), *Meaning in the Visual Arts* (1955) and *Pandora's Box: The Changing Aspects of a Mythical Symbol* (1956). He became Charles Eliot Norton Lecturer at Harvard in 1947 and gave regular international lectures. After retiring Emeritus from the Institute of Advanced Study, he became the Samuel Morse Professor of Fine Arts at New York University in 1963. He was married first to art historian Dora Mosse and later to Gerda Sörgel. He died in Princeton, an American citizen.

PUBLICATION HISTORY

Early Netherlandish Painting: Its Origins and Character

First published: 1953
Original language: English
Editions to date in original language: Two (American)

First translation: French, 1992
Other languages: German, Japanese, Spanish

Erwin Panofsky's Charles Eliot Norton lectures of 1947–48 were first published in two volumes by Harvard University Press (Cambridge MA) in 1953 as *Early Netherlandish Painting: Its Origins and Character*. The university publishing house produced regular hardback reprints in 1958 (second), 1964 (third) and 1966 (fourth), at which time Harper & Row took over the printing as part of their Icon editions series in New York, issuing the first illustrated paperback volume of the work in 1971. A new (thus second) edition appeared in 1977 and was subsequently reprinted. An ebook was published in 2002 by the Digital Library Federation, based on the later Harvard edition.

Successful translations have appeared, the first in French in 1992 by Dominique Le Bourg as *Les primitifs flamands* with Editions Hazan in Paris. A new edition of this translation was published in 2010. A Spanish edition was released in 1998 with the Madrid publisher Cátedra under the title *Los primitivos flamencos*, translated by Carmen Martínez Gimeno. A German translation by Jochen Sander and Stephan Kemperdick, *Altniederländische Malerei: Ihr Ursprung und Wesen*, appeared from DuMont, Cologne, in 2001. Each of these translations has enjoyed regular reprintings and subsequent paperback editions. In 2001, a Japanese-language edition was printed in Tokyo by Chuo-Koron Bijitsu Shuppan.

FURTHER BOOKS AND ARTICLES BY
ERWIN PANOFSKY

Dürers Kunsttheorie: Vornehmlich in ihrem Verhältnis zur Kunsttheorie der Italiener, Berlin (Reimer), 1915.
Dürers Stellung zur Antike, Vienna (Österreichische Verlagsgesellschaft Eduard Hölzel), 1922.
with F. Saxl: *Dürers 'Melencolia 1': Eine quellen- und typengeschichtliche Untersuchung*, Leipzig (B.G. Teubner), 1923.

Idea: Ein Beitrag zur Begriffsgeschichte der älteren Kunsttheorie, Leipzig (B.G. Teubner), 1924.

'Die Perspektive als "symbolische Form"', in: *Vorträge der Bibliothek Warburg (1924–25)*, Leipzig (B.G. Teubner), 1927.

Hercules am Scheidewege und andere antike Bildstoffe in der neueren Kunst, Leipzig (B.G. Teubner), 1930.

Studies in Iconology: Humanist Themes in the Art of the Renaissance, New York (Oxford University Press), 1939.

The Life and Art of Albrecht Dürer, Princeton (Princeton University Press), 1943.

Gothic Architecture and Scholasticism, Latrobe (Archabbey Press), 1951.

Meaning in the Visual Arts, New York (Doubleday Anchor Books), 1955.

Pandora's Box: The Changing Aspects of a Mythical Symbol, New York (Pantheon) 1956.

Renaissance and Renascences in Western Art, Stockholm (Almqvist & Wiksell), 1960.

Aufsätze zu Grundfragen der Kunstwissenschaft, Berlin (B. Hessling), 1964.

D. Wuttke, ed.: *Erwin Panofsky Korrespondenz, 1910 bis 1968: Eine kommentierte Auswahl in fünf Bänden*, 5 vols., Wiesbaden (Harrassowitz), 2001–11.

BOOKS ON ERWIN PANOFSKY

M. Meiss, ed.: *De Artibus Opuscula XL: Essays in Honour of Panofsky*, New York (New York University Press), 1961.

R. Heidt: *Erwin Panofsky: Kunsttheorie und Einzelwerke*, Cologne (Böhlau), 1977.

M. Podro: *The Critical Historians of Art*, New Haven (Yale University Press), 1982.

M.A. Holly: *Panofsky and the Foundations of Art History*, Ithaca; London (Cornell University Press), 1984.

B. Reudenbach, ed.: *Erwin Panofsky: Beiträge des Symposions, Hamburg 1992*, Berlin (Akademie Verlag), 1994.

I. Lavin, ed.: *Meaning in the Visual Arts: Views from the Outside; A Centennial Commemoration of Erwin Panofsky (1892–1968)*, Princeton (Institute for Advanced Study), 1995.

M. Waschek and R. Recht, eds.: *Relire Panofsky: Cycle de conférences organisé au Musée du Louvre par le Service culturel du 19 novembre au 17 décembre 2001*, Paris (Musée du Louvre; Beaux-Arts de Paris), 2008.

KENNETH CLARK (1903–83)

BIOGRAPHY

Kenneth Clark was an art historian and pioneer of arts broadcasting in addition to being a major public figure in the arts during the middle years of the twentieth century. He studied at Winchester College and then at the University of Oxford, where he abandoned his earlier aspirations to become an artist and changed to art history. Through the intercession of Charles Bell, the Keeper of the Ashmolean Museum, Oxford, Clark met Bernard Berenson in 1925, and shortly after took up a position with Berenson revising his 1903 publication *The Drawings of the Florentine Painters*. He was subsequently engaged to catalogue the collection of drawings by Leonardo da Vinci at the Royal Library, Windsor, and went on to write a highly

respected monograph on the artist (published 1939). After a brief period working as Keeper of the Ashmolean Museum, in 1933, at the age of thirty-one, Clark was appointed Director of the National Gallery, London, and the next year as surveyor of the King's Pictures. He was responsible for many major acquisitions, and ensured the preservation of the Gallery's paintings during wartime, moving them to safety in a disused Welsh quarry cavern. He resigned from the National Gallery in 1945 to concentrate on writing and lecturing. A book on Piero della Francesca appeared in 1951. He was made Chairman of the Arts Council in 1953, the same year that *The Nude* was first delivered as a lecture series, and the next year was involved in establishing the first commercial television company in Britain, the ITA. He made numerous documentaries about the arts, many of them directed by his son, the film-maker Colin Clark. It was for the BBC that he made his most popular series, *Civilisation*, first broadcast in 1969, which earned him widespread fame, particularly after its success in America.

PUBLICATION HISTORY

The Nude: A Study of Ideal Art

First published: 1956
Original language: English
Editions to date in original language: Two
(one British, one American)
First translation: German, 1958
Other languages: French, Japanese, Spanish

The result of Kenneth Clark's 1953 A.W. Mellon Lectures at the National Gallery, Washington, DC, *The Nude: A Study of Ideal Art* was first published by John Murray, London, in 1956. It was reprinted the following year, and a new version appeared in 1960. The same year it was published in the Pelican paperback series by Penguin Books, London, with new printings appearing in 1964, 1970, 1976, 1985 and 1993.

An American edition was published in 1956 as *The Nude: A Study in Ideal Form*, as part of the Pantheon Books Bollingen Series of the A.W. Mellon lectures (reprinted in 1957 and 1964). Trade paperback printings appeared with Doubleday Anchor Books, New York (1956, 1959 and 1983). Other versions were issued by the Reprint Society, London (1958), the University Press Group, Bognor Regis (1972), Harper & Row and Book Club Associates (both London, 1973), Rizzoli, New York (1980), and Fine Communications / MJF Books, New York (1996, 1997).

Princeton University Press took over the Bollingen edition, reprinting it with the Bollingen Foundation in 1971, 1972, 1984, 1990 and 1992. The most recent version, in hardback format and based on the Princeton University Press 1990 edition, appeared with the Folio Society, London, in 2010, with a new introduction by Charles Saumarez Smith. None of the versions in English subsequent to the first edition 1956 were substantially modified or revised by Clark, and none are therefore considered a second edition.

The first translation was made by Hanna Keil into German as *Das Nackte in der Kunst*, and was published by Phaidon, Cologne, in 1958. It appeared in French as *Le nu*, translated by Martine Laroche and published by Le Livre de Poche, Paris, in 1969. A two-volume edition of this translation was published by Hachette, Paris, in 1987, with reprintings in 1998 and 2008. A Spanish translation by Francisco Torres Oliver was published in 1981 by Alianza, Madrid, as *El desnudo: Un estudio de la forma ideal*, with numerous subsequent reprintings. An Italian translation by Doletta Oxilia Caprin was published as *Il nudo: Uno studio della forma ideale* by Aldo Martello, Milan, in 1959, and reissued by Neri Pozza, Vicenza, in 1995. Translations have also been made into Japanese by Chikuma Shobo, Tokyo, and Chinese by the Prophet Press in Taipei City and in simplified form by the Hainan Publishing House, Haikou.

FURTHER BOOKS BY KENNETH CLARK

The Gothic Revival, London (Constable), 1928.
A Catalogue of the Drawings of Leonardo da Vinci in the Collection of His Majesty the King at Windsor Castle, Cambridge (Cambridge University Press); New York (Macmillan), 1935.
One Hundred Details from Pictures in the National Gallery, London, London (National Gallery), 1938.
Last Lectures, with an Introduction by Kenneth Clark, Cambridge (Cambridge University Press), 1939.
Leonardo da Vinci: An Account of his Development as an Artist, Cambridge (Cambridge University Press), 1939.
Landscape Into Art, London (John Murray), 1949.
Piero della Francesca, London (Phaidon), 1951.
Rembrandt and the Italian Renaissance, London (John Murray); New York

(New York University Press), 1966.
Moments of Vision, London (John Murray), 1973.
Civilisation, London (British Broadcasting Corporation and John Murray), 1971.
Another Part of the Wood: A Self-Portrait, London (John Murray), 1974.
The Other Half, London (John Murray); New York (Harper & Row), 1977.
What is a Masterpiece?, London (Thames & Hudson), 1979.
The Art of Humanism, New York (Harper & Row), 1981; London (John Murray), 1983.

BOOKS ON KENNETH CLARK

M. Secrest: *Kenneth Clark: A Biography*, London (Weidenfeld & Nicholson), 1984.
D. Cannadine: *Kenneth Clark: From National Gallery to National Icon*, Linbury Lecture, London (National Gallery), 2002.

E.H. GOMBRICH (1909–2001)

BIOGRAPHY

Ernst Hans Josef Gombrich was born and raised in Vienna in a cultured, musical family. He demonstrated an early affinity for art history, and in 1928 went to study the subject at the University of Vienna, eventually writing his thesis on the architecture of Giulio Romano under the supervision of Julius von Schlosser. After writing a short book on caricature with the curator and psychoanalyst Ernst Kris, Gombrich was awarded a two-year fellowship at the Warburg Institute in Hamburg to edit and publish the papers of Aby Warburg. He emigrated with his parents to London in 1938, working first at the recently migrated Warburg Institute and then at the Courtauld Institute

of Art, London, where he lectured on Giorgio Vasari. During the War he worked for the BBC intercepting and translating German radio broadcasts, and was based at Evesham. He returned to the Warburg Institute in 1946 and continued his work publishing Warburg's papers, a project that resulted in his intellectual biography on the subject published in 1970. His survey volume *The Story of Art* was published in 1950 to great acclaim and firmly established his public profile and popular reputation, which were consolidated by the appearance ten years later of *Art and Illusion*. He lectured at the universities of Oxford and London before becoming Director of the Warburg Institute

in 1959, a post he held until 1976. He lectured widely and published prolifically on diverse areas of art history, and held numerous prestigious academic positions, including Slade Professor of Fine Arts at Oxford (1950–53), at Harvard (1959) and at Cambridge (1961–6).

PUBLICATION HISTORY

Art and Illusion: A Study in the Psychology of Pictorial Representation

First published: 1960
Original language: English
Editions to date in original language: Seven (six British, one American)
First translation: Dutch, 1960
Other languages: Bulgarian, Chinese, Czech, French, Hebrew, Hungarian, Italian, Japanese, Polish, Portuguese, Romanian, Serbo-Croat, Spanish, Turkish

First published by Phaidon in 1960, Gombrich's *Art and Illusion: A Study in the Psychology of Pictorial Representation* was the product of the author's A.W. Mellon lectures given at the National Gallery of Art in Washington, DC, in 1956. An American edition was also published in 1960 by the Bollingen Foundation, New York, and distributed by Pantheon Books. A second edition, with a new preface by Gombrich, was published the next year by Phaidon and Pantheon Books. A third new preface by Gombrich was included with the 'Millennium Edition', published in 2000. The sixth Phaidon edition appeared in 2002, and in 2010 it was digitised for online access. Since 1969 the American edition has been published by Princeton University Press.

It was first translated into Dutch by Hendrik van Teylingen and W.A.C. Whitlau as *Kunst en illusie: De psychologie van het beeldend weergeven* (Zeist, 1960). An Italian translation by Renzo Federici appeared as *Arte e illusione: Studio sulla psicologia della rappresentazione*

pittorica (Turin, Einaudi, 1965). It was translated into German by Gombrich's sister, Lisbeth Gombrich, and published by Phaidon in Cologne in 1967 as *Kunst und Illusion: zur Psychologie der bildlichen Darstellung*; further editions were published by Belser in Stuttgart. A translation into French by Guy Durand was published by Gallimard in Paris as *L'art et l'illusion: Psychologie de la représentation picturale* (1971).

A Spanish translation by Gabriel Ferrater appeared as *Arte e Ilusión: Estudio sobre la psicología de la representacion pictórica* (Barcelona, Gustavo Gili, 1972) and a version in Swedish, by Kerstin Karling, as *Konst och illusion: en studie i bildframställningens psykologi* (Stockholm, Rabén & Sjögren, 1968). It was also translated into Chinese in 1986 by Fan Jinzhong for the magazine *Compilations of Translations in Art*, published by the Chinese Academy of Fine Arts in Beijing. Further translations include: Hungarian (1972); Romanian (1973); Japanese (1979); Polish (1981); Serbo-Croat (1984); Czech (1985); Portuguese (1986); Bulgarian (1988); Hebrew (1988; also in Braille) and Turkish (1993).

FURTHER BOOKS BY E.H. GOMBRICH

'Giulio Romano als Architekt', Ph.D. diss. (University of Vienna, 1933).
with E. Kris: *Caricature*, Harmondsworth (Penguin), 1940.
The Story of Art, New York; London (Phaidon), 1950.
Meditations on a Hobby Horse, and Other Essays on the Theory of Art, London (Phaidon), 1963.
Norm and Form, London (Phaidon), 1966.
In Search of Cultural History, Oxford (Clarendon Press), 1969.
Aby Warburg: An Intellectual Biography, London (Warburg Institute), 1970.
Symbolic Images, London (Phaidon), 1972.
Means and Ends: Reflections on the History of Fresco Painting, London (Thames & Hudson), 1976.

The Heritage of Apelles: Studies in the Art of the Renaissance, London (Phaidon), 1976.

Ideals and Idols: Essays on Values in History and in Art, Oxford (Phaidon), 1979.

The Sense of Order: A Study in the Psychology of Decorative Art, Oxford (Phaidon); Ithaca (Cornell University Press), 1979.

The Image and the Eye: Further Studies in the Psychology of Pictorial Representation, Oxford (Phaidon); Ithaca (Cornell University Press), 1982.

Tributes: Interpreters of Our Cultural Tradition, Oxford (Phaidon); Ithaca (Cornell University Press), 1984.

Topics of our Time: Twentieth-Century Issues in Learning and in Art, London (Phaidon), 1991.

A Lifelong Interest: Conversations on Art and Science with Didier Eribon, London (Thames & Hudson), 1993.

Shadows: The Depiction of Cast Shadows in Western Art, London (National Gallery), 1995.

The Preference for the Primitive: Episodes in the History of Western Taste and Art, New York; London (Phaidon), 2002.

A Little History of the World, New Haven (Yale University Press), 2005.

BOOKS AND ARTICLES ON E.H. GOMBRICH

W.J.T. Mitchell: 'Nature and Convention: Gombrich's Illusions', in: *Iconology: Image, Text, Ideology*, Chicago (University of Chicago Press), 1986, pp.75–94.

J. Onians, ed.: *Sight and Insight: Essays on Art and Culture in Honour of E.H. Gombrich at 85*, London (Phaidon), 1994.

J.B. Trapp: *E.H. Gombrich: A Bibliography*, London (Phaidon), 2000.

L'arte e i linguaggi della percezione: L'eredità di Sir Ernst H. Gombrich, Milan (Electa), 2004.

E.H. Gombrich: In Memoriam: Actas del I Congreso Internacional "E.H. Gombrich (Viena 1909–Londres 2001): Teoría e Historia del Arte", Pamplona (Ediciones Universidad de Navarra), 2003.

CLEMENT GREENBERG (1909–94)

BIOGRAPHY

Clement Greenberg was one of the outstanding art critics of the twentieth century, a leading supporter of modernism who was associated in particular with the New York School of Painting in the period after 1945. He was born to Russian immigrant parents and grew up in the Bronx. After a brief period as a student of painting at the Art Students League in New York, Greenberg went on to study literature at Syracuse University, graduating with a bachelor's degree in 1930. He began writing art and cultural criticism in 1937, notably for the *Partisan Review*, of which he became Editor in 1940. His essay of the previous year, 'Avant-Garde and Kitsch', set out his credentials as a Trotskyite–Marxist critic. As a curator and writer he was the key supporter of Abstract Expressionism after the War, exchanging his earlier Trotskyite intellectual allegiance for a more philosophical, formalist approach to abstraction. In 1950 he taught at Black Mountain College, a progressive art school in North Carolina. He published a monograph on Matisse in 1953 and another on Hans Hofmann in 1961, the same year in which his

first collected volume of reviews and articles, *Art and Culture: Critical Essays*, appeared. His popularity as a critic diminished greatly in the final decades of his life, although his formalist approach was to have an important influence on the work of the three major art critics Michael Fried, Rosalind Krauss and T.J. Clark.

PUBLICATION HISTORY

Art and Culture: Critical Essays

First published: 1961
Original language: English
Editions to date in original language: Two (one British, one American)
First translation: Spanish, 1979
Other languages: Chinese, French, Italian, Portuguese

Clement Greenberg's *Art and Culture* was first published in hardcover in 1961 by the Beacon Press, Boston. A first paperback edition appeared in 1965 and was reprinted, most recently in 1992. A British edition was published in 1973 by Thames & Hudson.

A Spanish translation was made by Justo G. Beramendi as *Arte y cultura: Ensayos críticos* (Barcelona, G. Gili, 1979; Madrid, Paidós, 2002, 2011). It has also been translated into Portuguese by Otacílio Nunes, available as an electronic publication for download as *Arte e Cultura: Ensaios críticos* (Vitória, Brazil, Ática). It was first translated into French by Ann Hindry and published by Macula, Paris, as *Art et culture: Essais critiques* in 1988, reaching an eighth edition in 2006. It appeared in Italian, with an introduction by Gillo Dorfles, as *Astratto,*

figurativo e così via (Arte e cultura) (Turin, Allemandi, 1990 and 1991). A Chinese translation by Xinlong Zhang was published by Yuan-Liou Publishing, Taipei City, in 1993.

FURTHER BOOKS BY CLEMENT GREENBERG

Joan Miró, New York (Quadrangle Press), 1948.
Matisse, New York (Harry N. Abrams), 1953.
Hofmann, Paris (Georges Fall), 1961.
Three New American Painters, exh. cat., Regina (Norman Mackenzie Art Gallery), 1963.
Post-Painterly Abstraction, exh. cat., Los Angeles (Los Angeles County Museum of Art), 1964.
J. O'Brien, ed.: *Clement Greenberg: The Collected Essays and Criticism*, 4 vols., Chicago; London (Chicago University Press), 1986.
Homemade Esthetics: Observations on Art and Taste, Oxford; New York (Oxford University Press), 1999.
R.C. Morgan, ed.: *Clement Greenberg: Late Writings*, Minneapolis (University of Minnesota Press), 2003.

BOOKS ON CLEMENT GREENBERG

D.B. Kuspit: *Clement Greenberg: Art Critic*, Madison (University of Wisconsin Press), 1979.
T. de Duve: *Clement Greenberg entre les lignes*, Paris (Dis Voir), 1996.
F. Rubenfeld: *Clement Greenberg: A Life*, New York (Scribner), 1997.
A.G. Marquis: *Art Czar: The Rise and Fall of Clement Greenberg*, Boston (Museum of Fine Arts), 2006.
J. Harris: *Writing Back to Modern Art: After Greenberg, Fried, and Clark*, New York (Routledge), 2005.

FRANCIS HASKELL (1928–2000)

BIOGRAPHY

Francis Haskell was the son of Arnold Haskell, a well-known British dance critic, and his Russian wife, Vera Saitzoff. He was educated at Eton and then at King's College, Cambridge, where he studied history under Nikolaus Pevsner. He taught at Cambridge from 1954, and from 1962 to 1967 was Librarian of the Fine Arts Faculty. His *Patrons and Painters* was published in 1963. In 1967 he was elected Professor of the History of Art at Oxford University, a post he held until his retirement in 1995. He gained international recognition not only for the series of books that he published, including *Taste and the Antique: The Lure of Classical Sculpture, 1500–1900* (with Nicholas Penny; 1981), and *History and Its Images: Art and the Interpretation of the Past* (1993), but also for his engaging and entertaining style of lecturing.

PUBLICATION HISTORY

Patrons and Painters: A Study in the Relations Between Italian Art and Society in the Age of the Baroque

First published: 1963
Original language: English
Editions to date in original language: Three (two British, one American)
First translation: Italian, 1966
Other languages: French, German, Portuguese, Spanish

Patrons and Painters was first published by Chatto & Windus, London, in 1963; an American edition was issued the same year in New York by Alfred A. Knopf (reprinted by Harper & Row, 1971 and 1980). A second revised and enlarged British edition was published by

Yale University Press in 1980, and reached its fourth printing in 1998. It was translated first into Italian by Vincenzo Borea in 1966 as *Mecenati e pittori: Studio sui rapporti tra arte e società italiana nell' età barocca* (Florence, Sansoni). A Spanish translation by Consuelo Luca de Tena was published in 1984 as *Patronos y pintores: Arte y sociedad en la Italia del Barroco* (Madrid, Cátedra), followed by a French edition in 1991 by Fabienne Durand-Bogaert, Andrée Lyotard-May and Louis Evrard as *Mécènes et peintres: l'art et la société au temps du baroque italien* (Paris, Gallimard). A German translation by Alexander Sahm, with a postscript by Werner Busch, appeared in 1996 as *Maler und Auftraggeber: Kunst und Gesellschaft im italienischen Barock* (Cologne, DuMont). The most recent translation, into Portuguese by Luiz Roberto Mendes Gonçalves, appeared as *Mecenas e pintores: Arte e sociedade na itália barroca* (São Paulo, Editora da Universidade de São Paulo, 1997).

FURTHER BOOKS BY FRANCIS HASKELL

Géricault, London (Knowledge Publications), 1963.
An Italian Patron of French Neo-Classic Art, Oxford (Clarendon Press), 1972.
Rediscoveries in Art: Some Aspects of Taste, Fashion and Collecting in England and France, Ithaca (Cornell University Press); London (Phaidon), 1976.
with N. Penny: *Taste and the Antique: The Lure of Classical Sculpture, 1500–1900*, New Haven (Yale University Press), 1981.
The Painful Birth of the Art Book, New York; London (Thames & Hudson), 1987.
Past and Present in Art and Taste: Selected Essays, New Haven (Yale University Press), 1987.
History and Its Images: Art and the Interpretation

of the Past, New Haven; London
(Yale University Press), 1993.
*The Ephemeral Museum: Old Master Paintings
and the Rise of the Art Exhibition*, New Haven;
London (Yale University Press), 2000.

ARTICLES ON FRANCIS HASKELL

C. Hope: 'On Francis Haskell', *New York Review
of Books* 47 (24th February, 2000).
N. Penny: 'Francis Haskell (1928–2000)',
The Burlington Magazine 142 (May 2000),
pp.307–08.
P. Griener: 'Francis James Herbert Haskell (April
7, 1928 – January 18, 2000)', *Zeitschrift für
Kunstgeschichte* 64 (2001), pp.299–303.

'Scritti in ricordo di Francis Haskell: Giornata
di studio alla Fondazione Giorgio Cini… 4–5
November 2000', *Saggi e memorie di storia
dell'arte* 25 (2001), pp.287–363.
W. Hardtwig: 'Der Historiker und die Bilder.
Überlegungen zu Francis Haskell', in: H.
Berding, ed.: *Hochkultur des bürgerlichen
Zeitalters*, Göttingen (Oxford University
Press), 2005, pp.136–53.
B. Toscano: 'Wittkower, Longhi, Haskell e la
fortuna storico-artistica del papato Borghese',
in *idem*, ed.: *Arte e immagine del papato
Borghese (1605–1621)*, San Casciano (Libro
Co.), 2005, pp.11–16.
G. Wimböck: 'Francis Haskell (1928–2000)', in
U. Pfisterer, ed.: *Klassiker der Kunstgeschichte*,
Munich (C.H. Beck), 2008, pp.226–38.

MICHAEL BAXANDALL (1933–2008)

BIOGRAPHY

Michael Baxandall was a specialist in
Italian Renaissance art noted for his use
of linguistics as an interpretative tool. After
reading English at Cambridge under F.R. Leavis,
Baxandall studied art history at the universities
of Pavia in Italy and Munich in Germany,
before taking up a fellowship at the Warburg
Institute in London, where he embarked on a
Ph.D. under E.H. Gombrich. In 1961 he became
Assistant Keeper of Architecture and Sculpture
at the Victoria and Albert Museum, London, but
returned to the Warburg Institute as a lecturer
four years later. His 1971 book *Giotto and the
Orators* was based on his research at the Warburg
on language as a condition of aesthetic response,
and was followed the next year by his *Painting
and Experience in Fifteenth Century Italy*. He

was the Slade Professor of Art at Oxford in
1974–75. His earlier experiences at the Victoria
and Albert Museum led to the publication of
The Limewood Sculptors of Renaissance Germany
in 1980. Thereafter he held posts in the United
States at Cornell University, from 1982, and then
at the University of California, Berkeley from
1987 to 1996. His 1985 book *Patterns of Intention:
On the Historical Explanation of Pictures* was
published to widespread acclaim. *Tiepolo and
the Pictorial Intelligence* of 1994 was co-authored
with Svetlana Alpers. This was followed by
Shadows and Enlightenment, in 1995, and a
collection of essays, *Words for Pictures*, in 2003.

PUBLICATION HISTORY

Painting and Experience in Fifteenth Century Italy: A Primer in the Social History of Pictorial Style

First published: 1972
Original language: English
Editions to date in original language:
Two (British)
First translation: German, 1977
Other languages: Croatian, Dutch, French, Italian, Portuguese, Spanish

Painting and Experience in Fifteenth Century Italy: A Primer in the Social History of Pictorial Style was first published by the Clarendon Press, of Oxford University Press, Oxford in 1972. The first paperback edition appeared in 1974, and was reprinted six times. A second edition with a new preface by the author was published in 1988. The first translation was made into German, as *Die Wirklichkeit der Bilder: Malerei und Erfahrung im Italien des 15. Jahrhunderts*, and published by Syndikat in Frankfurt in 1977. Translations into Italian and Spanish appeared the next year as *Pittura ed esperienze sociali nell'Italia del Quattrocento* (by Maria and Piergiorgio Dragone; Turin, Einaudi) and *Pintura y vida cotidiana en el renacimiento: Arte y experiencia en el Quattrocento* (by Homero Alsina Thevenet; Barcelona, Gustavo Gili).

It was translated into French, by Yvette Delsaut, as *L'oeil du quattrocento: L'usage de la peinture dans l'Italie de la Renaissance* and published in Paris by Gallimard in 1985. A Dutch translation by Léon Stapper appeared the next year as *Schilderkunst en leefwereld in het Quattrocento: Een inleiding in de sociale geschiedenis van de picturale stijl* (Nijmegen, SUN). A Portuguese translation by Maria Cecília Preto R. Almeida was published in São Paulo in 1991 by Paz e Terra. It was translated into

Croatian in 1996 by Igor Zabel (Ljubljana, Studia Humanitatis).

FURTHER BOOKS BY MICHAEL BAXANDALL

German Wood Statuettes, 1500–1800, London (Her Majesty's Stationery Office), 1967.
Giotto and the Orators: Humanist Observers of Painting in Italy and the Discovery of Pictorial Composition, 1350–1450, Oxford (Clarendon Press), 1971.
The Limewood Sculptors of Renaissance Germany, New Haven; London (Yale University Press), 1980.
Patterns of Intention: On the Historical Explanation of Pictures, New Haven; London (Yale University Press), 1985.
with S. Alpers: *Tiepolo and the Pictorial Intelligence*, New Haven; London (Yale University Press), 1994.
Shadows and Enlightenment, New Haven; London (Yale University Press), 1995.
Words for Pictures: Seven Papers on Renaissance Art and Criticism, New Haven; London (Yale University Press), 2003.
Episodes: A Memory Book, London (Frances Lincoln), 2010.

BOOKS AND ARTICLES ON MICHAEL BAXANDALL

A. Langdale: 'Art History and Intellectual History: Michael Baxandall's work between 1963 and 1985', Ph.D. diss. (University of California, 1995).
A. Langdale: 'Aspects of the Critical Reception and Intellectual History of Baxandall's Concept of the Period Eye', *Art History* 21 (December 1998), pp.479–97.
A. Rifkin, ed.: *About Michael Baxandall*, Oxford (Blackwell), 1999.

T.J. CLARK (1943–)

BIOGRAPHY

Timothy James Clark graduated from Cambridge University in 1964 and received his Ph.D. from the Courtauld Institute of Art, London, in 1973. He lectured at the University of Essex from 1967 to 1969. During his time as a senior lecturer at the Camberwell School of Art in London (1970–74) Clark published the two books that established his international reputation: *The Absolute Bourgeois: Artists and Politics in France, 1848–1851*, and *Image of the People: Gustave Courbet and the 1848 Revolution* (both 1973), which together were seen as founding a new, strongly Marxist approach to art history. In 1974 Clark accepted a position at the University of California, Los Angeles, two years later becoming a founding member of the Caucus for Marxism and Art of the College Art Association. After four years as Chair of the Fine Art Department at Leeds University, Clark accepted a position at the School of Fine Arts faculty at Harvard University. In 1985 Clark published *The Painting of Modern Life: Paris in the Art of Manet and His Followers*, and three years later joined the Department of Art History at the University of California, Berkeley. His 1999 *Farewell to an Idea: Episodes from a History of Modernism* showed a broadening of his focus from nineteenth-century art to include in particular the work of Picasso and Pollock.

PUBLICATION HISTORY

Image of the People: Gustave Courbet and the 1848 Revolution

First published: 1973
Original language: English
Editions to date in original language: Four (one British, three American)
First translation: Italian, 1978
Other languages: French, Spanish

Image of the People was first published in London by Thames & Hudson, and in New York by the New York Graphic Society in 1973. It has gone through regular reprintings, the American version transferring to Princeton University Press in 1982, and to the University of California Press, Berkeley, in 1999, with a new introduction.

The first translation was into Italian, by Renzo Federici, as *Immagine del popolo: Gustave Courbet e la rivoluzione del '48*, (Turin, Einaudi, 1978). It appeared in Spanish in a translation by Helena Valentí as *Imagen del pueblo: Gustave Courbet y la revolución de 1848* (Barcelona, Gustavo Gili, 1981). A French translation by Anne-Marie Bony was published by Art Edition in Villeurbanne 1991 as *Une Image du Peuple: Gustave Courbet et la Révolution de 1848*. A new French translation, by Anne-Marie Bony and Françoise Jaouën, was published under the same title by Les Presses du Réel, Dijon, in 2007. It also exists in an English spoken recording for audio cassette, produced by the Royal Blind Society in West Sussex in 1996.

FURTHER BOOKS BY T.J. CLARK

The Absolute Bourgeois: Artists and Politics in France, 1848–1851, London (Thames & Hudson); Greenwich CT (New York Graphic Society), 1973.
The Painting of Modern Life: Paris in the Art of Manet and His Followers, London (Thames & Hudson); New York (Knopf), 1985.
Farewell to an Idea: Episodes from a History of Modernism, New Haven (Yale University Press), 1999.
with I. Boal, J. Matthews and M. Watts: *Afflicted Powers: Capital and Spectacle in a New Age of War*, New York; London (Verso), 2005.

The Sight of Death: An Experiment in Art Writing, New Haven; London (Yale University Press), 2006.

BOOKS AND ARTICLES ON T.J. CLARK

F. Jameson: 'Political Painting: New Perspectives on the Realism Controversy,'

Praxis 1/2 (Winter 1976), pp.225–30.
C. Mercer: 'Public Subjects and Subject Politics,' *Social History* 9/3 (October 1984), pp.361–68.
J. Harris: *Writing Back to Modern Art: After Greenberg, Fried, and Clark*, New York (Routledge), 2005.

SVETLANA ALPERS (1936–)

BIOGRAPHY

A scholar of Dutch Baroque art and one of the founding figures of the 'new art history' – an approach to the study of art that emphasises social and historical context – Svetlana Leontief Alpers received her Ph.D. from Harvard University in 1965, and went on to teach at the University of California, Berkeley. In 1977 she published the ninth volume in the catalogue raisonné of Rubens, *The Corpus Rubenianum Ludwig Burchard*. In 1983 she founded the journal *Representations* with Stephen Greenblatt, the same year that her work *The Art of Describing: Dutch Art in the Seventeenth Century* appeared. She went on to publish on Rembrandt and Rubens, and co-wrote a book with her colleague at Berkeley, Michael Baxandall, entitled *Tiepolo and the Pictorial Intelligence*. She retired from Berkeley in 1994, where she was subsequently made Professor Emerita.

PUBLICATION HISTORY

The Art of Describing: Dutch Art in the Seventeenth Century

First published: 1983
Original language: English

Editions to date in original language: Two (one British, one American)
First translation: Italian, 1984
Other languages: Dutch, French, German, Portuguese, Spanish

The Art of Describing was first published in 1983 by the University of Chicago Press, and also by John Murray in London. A paperback edition appeared simultaneously, published by Penguin Books, London, reprinted in 1989.

Several translations have appeared. In 1984 an Italian version by Flavio Cuniberto was published in Turin by Bollati Boringhieri as *Arte del descrivere: Scienza e pittura nel Seicento olandese*. A German translation by Hans Udo Davitt appeared the next year as *Kunst als Beschreibung: Holländische Malerei des 17. Jahrhunderts* (Cologne, DuMont). A Spanish translation by Consuelo Luca de Tena was published in 1987 by Hermann Blume, Madrid, as *El arte de describir: El arte holandés en el siglo XVII*. It appeared in Dutch in 1989 as *De kunst van het kijken: Nederlandse schilderkunst in de zeventiende eeuw*, translated by Christien Jonkheer (Amsterdam, Bakkar). A French edition appeared the following year, translated

by Jacques Chavy as *L'art de dépeindre: La peinture hollandaise au XVIIe siècle* (Paris, Gallimard), simultaneously with a Portuguese edition, translated by Antonio de Pádua Danesi as *A arte de descrever: A arte holandesa no século XVII* (São Paulo, Editora da Universidade de São Paulo).

FURTHER BOOKS BY SVETLANA ALPERS

Rembrandt's Enterprise: The Studio and the Market, Chicago (University Press);

London (Thames & Hudson), 1988.

with M. Baxandall: *Tiepolo and the Pictorial Intelligence*, New Haven; London (Yale University Press), 1994.

The Making of Rubens, New Haven; London (Yale University Press), 1995.

The Vexations of Art: Velázquez and Others, New Haven; London (Yale University Press), 2005.

ROSALIND KRAUSS (1941–)

BIOGRAPHY

Rosalind Krauss is an American art critic and theorist, and co-founder of the journal *October*. Krauss graduated from Harvard in 1969 with a dissertation on the work of the sculptor David Smith, which was published as *Terminal Iron Works* in 1971. She began writing art criticism in the mid-1960s, contributing to magazines such as *Art International* and *Artforum*, demonstrating an allegiance to Minimalism. Dissatisfied with the approach of *Artforum*, for which she served as Contributing Editor from 1971 to 1975, she resigned in 1976 to found *October* with Annette Michelson. In 1977 she completed the catalogue raisonné of the sculptures of David Smith. Krauss joined the faculty at Hunter College, New York, in 1974, and eventually held the title of Distinguished Professor, before leaving to take a position at Columbia University in 1992. She has curated a number of important exhibitions, including shows on Joan Miró (Solomon R. Guggenheim Museum, 1972), Richard Serra (Museum of Modern Art, 1985–86), and Robert Morris

(Solomon R. Guggenheim Museum, 1994), all in New York. Krauss's early criticism was informed by her one-time mentor Clement Greenberg, but she went on to reject his formalist approach in favour of a range of methodologies drawn from structuralist linguistics, deconstruction and psychoanalytic thought. This theoretically-driven, interdisciplinary attitude to art history became characteristic of *October* during the 1970s and 1980s. The critical writings of Georges Bataille proved influential, as did the work of Roland Barthes, whose series of lectures 'The Neutral' was translated by Krauss with Denis Hollier. More recently, Krauss has utilised the philosophy of Stanley Cavell to tackle the problem of the 'medium' in contemporary art.

PUBLICATION HISTORY

The Originality of the Avant-Garde and Other Modernist Myths

First published: 1985
Original language: English
Editions to date in original language: One
(American)
First translation: French, 1993
Other languages: German, Italian, Russian,
Spanish

Rosalind Krauss's selection of articles, many of which first appeared in *October* magazine, were put together for publication by MIT Press in 1985 as *The Originality of the Avant-Garde and Other Modernist Myths*, which was reprinted for the tenth time in 2002. The first translation was into French by Jean-Pierre Criqui as *L'originalité de l'avant-garde et autres mythes modernistes* (Paris, Macula, 1993). A Spanish translation by Adolfo Gómez Cedillo was published in 1996 as *La originalidad de la vanguardia y otros mitos modernos* (Madrid, Alianza). A German translation by Jörg Enninger, with a foreword by Herta Wolf, was published in Amsterdam and Dresden in 2000 as *Die Originalität der Avantgarde und andere Mythen der Moderne* (Verlag der Kunst). A Russian translation by A. Matvyevoi appeared in Moscow in 2003 as *Podlinnost avangarda i droogie modernistskie mifi* (Moscow Arts Magazine). Elio Grazioli translated it into Italian for Fazi, Rome, as *L'originalità dell'avanguardia e altri miti modernisti* (2007).

FURTHER BOOKS BY ROSALIND KRAUSS

*Terminal Iron Works: The Sculpture of David
Smith*, Cambridge MA (MIT Press), 1971.
*The Sculpture of David Smith: A Catalogue
Raisonné*, New York (Garland), 1977.
Passages in Modern Sculpture, Cambridge MA
(MIT Press), 1977.

L'Amour fou: Photography & Surrealism, exh. cat.,
London (Hayward Gallery), 1985.
The Optical Unconscious, Cambridge MA (MIT
Press), 1993.
with Y.-A. Bois: *Formless: A User's Guide*, New
York (Zone Books), 1997.
The Picasso Papers, Cambridge MA (MIT Press),
1999.
Bachelors, Cambridge MA (MIT Press), 1999.
*'A Voyage on the North Sea': Art in the Age of
the Post-Medium Condition*, London
(Thames & Hudson), 2000.
Perpetual Inventory, Cambridge MA (MIT
Press), 2010.
Under Blue Cup, Cambridge MA (MIT Press),
2011.
with Y.-A. Bois, B.H.D. Buchloh, H. Foster
and D. Joselit, *Art Since 1900: Modernism,
Antimodernism, Postmodernism*, London
(Thames & Hudson), 2004 and 2012.

BOOKS AND ARTICLES ON ROSALIND KRAUSS

D. Carrier: *Rosalind Krauss and American
Philosophical Art Criticism: From Formalism
and Beyond to Postmodernism*, Westport CT
(Praeger), 2002.
D. Siedell: 'Rosalind Krauss, David Carrier,
and Philosophical Art Criticism', *Journal of
Aesthetic Education* 38/2 (Summer 2004),
pp.95–105.
D. Raskin: 'The Shiny Illusionism of Krauss and
Judd', *Art Journal* 25/1 (Spring 2006), pp.6–21.

HANS BELTING (1935–)

BIOGRAPHY

Hans Belting is known for his innovative work in the fields of both Byzantine and contemporary art. He was trained as a Byzantinist at the universities of Mainz and Rome, completing his dissertation in 1959. He subsequently held a fellowship at Dumbarton Oaks, Washington, DC, and taught as Assistant Professor at the University of Hamburg, and then as Professor at Heidelberg. In 1980 he followed the controversial Hans Sedlmayr as Chair in art history at the University of Munich, a post he held until 1992. His move away from medieval and towards modern art coincided with his co-founding of a research program for art history and media studies at the School of New Media at Karlsruhe, where he taught until his retirement in 2002. He has held numerous academic positions, including the directorship of the International Research Center for Cultural Studies (IFK) in Vienna. In addition to holding an honorary chair at the University of Heidelberg and an honorary degree from the Courtauld Institute of Art, London, he is a member of the American Philosophical Society, the American Academy of Arts and Sciences and the Order pour le Mérite for Sciences and Arts.

PUBLICATION HISTORY

Bild und Kult: Eine Geschichte des Bildes vor dem Zeitalter der Kunst

First published: 1990
Original language: German
Editions to date in original language: One
First translation: English, 1994
Other languages: French, Italian, Polish, Spanish

Hans Belting's *Bild und Kult: Eine Geschichte des Bildes vor dem Zeitalter der Kunst* was published by C.H. Beck in Munich, 1990. This was followed by ten subsequent printings, with the most recent being published in 2011. The first translation, into English by Edmund Jephcott, was published as *Likeness and Presence: A History of the Image Before the Era of Art* by the University of Chicago Press in 1994. A new edition in paperback appeared in 1996. A French translation by Franck Muller was published in 1998 by Les Editions du Cerf, Paris, as *Image et culte: Une histoire de l'art avant l'époque de l'art*, a second printing of which appeared in 2007. It was translated into Italian by Barnaba Maj as *Il culto delle immagini: Storia dell'icona dall'età imperiale al tardo Medioevo* (Milan, Carocci, 2001), and into Spanish by Cristina Díez Pampliega and Jesús Espino Nuño as *Imagen y culto: una historia de la imagen anterior a la era del arte* (Madrid, Akal, 2009). A Polish translation by Tadeusz Zatorski as *Obraz i kult: Historia obrazu przed epoka sztuki* was published in Gdansk in 2010.

FURTHER BOOKS BY HANS BELTING

Die Basilica dei SS. Martiri in Cimitile und ihr frühmittelalterlicher Freskenzyklus, Wiesbaden (Frank Steiner), 1962.
with R. Naumann: *Die Euphemia-Kirche am Hippodrom zu Istanbul und ihre Fresken*, Berlin (Mann), 1966.
Studien zur benevanantischen Malerei, Wiesbaden (Frank Steiner), 1968.
Das illuminierte Buch in der spätbyzantinischen Gesellschaft, Heidelberg (C. Winter), 1970.
Die Oberkirche von San Francesco in Assisi: ihre Dekoration als Aufgabe u.d. Genese e. neuen Wandmalerei, Berlin (Mann), 1977.
with S. Dufrenne, S. Radojcic, R. Stichel and I. Sevcenko, *Der Serbische Psalter: Faksimile-*

Ausgabe des Cod. Slav. 4 der Bayerischen Staatsbibliothek München, Wiesbaden (Reichert), 1978–83.

Die Bibel des Niketas: Ein Werk der höfischen Buchkunst in Byzanz und sein antikes Vorbild, Wiesbaden (Reichert), 1979.

Das Bild und sein Publikum im Mittelalter: Form und Funktion früher Bildtafeln der Passion, Berlin (Mann), 1981.

Il medio Oriente e l'Occidente nell'arte del XIII secolo, Bologna (CLUEB), 1982.

Das Ende der Kunstgeschichte?, Munich (Deutscher Kunstverlag), 1983.

with D. Eichberger: *Jan van Eyck als Erzähler: frühe Tafelbilder im Umkreis der New Yorker Doppeltafel*, Worms (Werner'sche Verlagsgesellschaft), 1983.

Max Beckmann: Die Tradition als Problem in der Kunst der Moderne, Berlin (Deutscher Kunstverlag), 1984.

Giovanni Bellini, Pieta: Ikone und Bilderzählung in der venezianischen Malerei, Frankfurt am Main (Fischer Taschenbuch), 1985.

Kunstgeschichte: Ein Einführung, Berlin (Reimer), 1986.

with D. Blume, *Malerei und Stadtkultur in der Dantezeit: Die Argumentation der Bilder*, Munich (Hirmer), 1989.

Die Deutschen und ihre Kunst: Ein schwieriges Erbe, Munich (Beck), 1992.

with C. Kruse: *Die Erfindung des Gemäldes: Das erste Jahrhundert der niederländischen Malerei*, Munich (Hirmer), 1994.

Das unsichtbare Meisterwerk: Die modernen Mythen der Kunst, Munich (Beck), 1998.

Identität im Zweifel: Ansichten der deutschen kunst, Cologne (DuMont), 1999.

Beiträge zu Kunst und Medientheorie: Projekte und Forschungen an der Hochschule für Gestaltung Karlsruhe, Stuttgart (Hatje Cantz), 2000.

Bild-Anthropologie: Entwürfe für eine Bildwissenschaft, Munich (W. Fink), 2001.

with D. Kamper and M. Schulz: *Quel corps? Eine Frage der Repräsentation*, Munich (W. Fink), 2002.

Das Echte Bild: Bildfragen als Glaubensfragen, Munich (C.H. Beck), 2005.

Florenz und Bagdad: Eine westöstliche Geschichte des Blicks, Munich (C.H. Beck), 2008.

with A. Buddensieg: *The Global Art World: Audiences, Markets, and Museums*, Ostfildern (Hatje Cantz), 2009.

ARTICLES ON HANS BELTING

O.K. Werckmeister: 'Jutta Held's "Monument und Volk" und Hans Belting's "Bild und Kult"', in: *Georges-Bloch-Jahrbuch des Kunstgeschichtlichen Seminars der Universität Zürich* 2 (1995), pp.7–11.

Y. Michaud: 'Historiens d'art aujourd'hui: Hans Belting,' *Connaissance des Arts* (1999), p.561.

C.S. Wood: Review of Hans Belting, *Bild-Anthropologie*, *Art Bulletin* 86 (2004), pp.370–73.

L. Vargiu: 'Hans Belting e lo sguardo dell'etnologo', *Ricerche di Storia dell'Arte* 94 (2008), pp.29–34.

E. Celven: 'Man and Image: Hans Belting's Anthropology of the Image and the German Bildwissenschaften,' in J. van den Akkerveken, B. Baert and A.-S. Lehmann, eds.: *New Perspectives in Iconology: Visual Studies and Anthropology*, Ghent (ASP), 2011, pp.143–61.

Author Biographies

COLIN AMERY is a writer and historian with a long-standing history of involvement in conservation. He is an Honorary Fellow of the Royal Institute of British Architects and for twelve years was Director of the World Monuments Fund in Britain. He chairs the Fabric Advisory Committee of St George's Chapel, Windsor Castle.

CARMEN C. BAMBACH is Curator of Drawings and Prints at the Metropolitan Museum of Art, New York, and was Andrew W. Mellon Professor from 2010 to 2012 at the Center for Advanced Study in the Visual Arts, National Gallery of Art, Washington, DC. She is the author of *Drawing and Painting in the Italian Renaissance Workshop: Theory and Practice, 1300–1600* (1999) and *Un' eredità difficile: I disegni ed i manoscritti di Leonardo tra mito e documento* (2009).

JOHN ELDERFIELD curated *Matisse: Radical Invention, 1913–17* (2010) and *De Kooning: A Retrospective* (2011) at the Museum of Modern Art, New York, where he is Chief Curator Emeritus of Painting and Sculpture. He is also a consultant for exhibitions at the Gagosian Gallery, senior adviser to the website Art.sy, and is preparing an exhibition of Cézanne's portraits to be shown in London, Paris and Washington, DC.

ALEXANDRA GAJEWSKI is a Senior Researcher at the Centro de Ciencias Humanas y Sociales, CSIC, Madrid. She has taught at various London universities, at the Victoria and Albert Museum, London, and as Visiting Assistant Professor at the University of Michigan. She is a Fellow of the Society of Antiquaries. Her research concentrates on art and architecture in medieval Europe between the twelfth and fourteenth centuries, especially on questions of monasticism, cult, patronage and the role of women.

BORIS GROYS is the Global Distinguished Professor of Russian and Slavic Studies at New York University and Senior Research Fellow at the Karlsruhe University of Arts and Design. His publications include *History Becomes Form* and *Going Public* (both 2010). He curated the Russian Pavilion at the 54th Venice Biennale (2011).

JEFFREY HAMBURGER is the Kuno Francke Professor of German Art and Culture at Harvard University. A fellow of the Medieval Academy of America, the American Academy of Arts and Sciences and the American Philosophical Society, he has published widely on the history of medieval manuscript illumination, mysticism and image theory, as well as the art and architecture of female monasticism.

PAUL HILLS lectured at Warwick University from 1976 to 1998 and was appointed Visiting Professor at the Courtauld Institute of Art, London, in 2003. He has lectured on Renaissance art at international venues including Harvard University, the Prado, the Louvre and the National Gallery in London. His books include *Venetian Colour: Marble, Mosaic, Painting and Glass, 1250–1550* (1999) and *The Light of Early Italian Painting* (1987).

ANNA LOVATT is Lecturer in Modern and Contemporary Art History at the University of Manchester. Her research focuses on drawing in the context of post-Minimal and Conceptual art and she is completing a book on the subject. She has published in *Artforum, Art History, October, Oxford Art Journal* and *Tate Papers*.

SUSIE NASH is the Deborah Loeb Brice Professor of Renaissance Art at the Courtauld Institute of Art, London, where she has taught since 1993. She has published on panel painting, manuscript illumination, sculpture and other media from across northern Europe in the fourteenth and fifteenth centuries.

LOUISE RICE, Associate Professor of Art History at New York University, is a specialist in the art and architecture of Baroque Italy. She is the author of *The Altars and Altarpieces of New St. Peter's* (1997) and in her current research focuses on aspects of seventeenth-century Roman print culture.

RICHARD SHONE is the author of a number of books on French and British art, including *Bloomsbury Portraits* (1976), *The Post-Impressionists* (1979), *Walter Sickert* (1988) and *Sisley* (1993). He contributed to the exhibition catalogue *Sensation* (1997) and organised *The Art of Bloomsbury* for the Tate Gallery (1999). He was appointed Editor of *The Burlington Magazine* in 2003.

JOHN-PAUL STONARD is an art historian and former Contributing Editor of *The Burlington Magazine*. His book *Fault Lines: Art in Germany 1945–55* was published by Ridinghouse in 2007. He has worked as a Visiting Lecturer at the Courtauld Institute of Art, London, and from 2010 to 2011 was a Senior Fellow at the National Gallery of Art, Washington, DC. He has published widely on modern and contemporary German and British art, and is a regular contributor to *The Burlington Magazine*, *The Times Literary Supplement* and *Artforum*.

DAVID SUMMERS has been the William R. Kenan, Jr. Professor of Art Theory and Italian Renaissance Art at the University of Virginia since 1984. He taught at Bryn Mawr College and the University of Pittsburgh in Pennsylvania before accepting an appointment to the Center for Advanced Studies at the University of Virginia in 1981. His publications include *Vision, Reflection, and Desire in Western Painting* (2007) and *Real Spaces: World Art History and the Rise of Western Modernism* (2003).

RICHARD VERDI OBE was the Director of the Barber Institute of Fine Arts at the University of Birmingham from 1990 to 2007. He has curated many exhibitions, including *Saved!: 100 Years of the National Art Collections Fund*, which featured around four hundred masterpieces that spanned four thousand years of art history. His publications include *The Barber Institute of Fine Arts* (2006) and *Cézanne* (1992).

MARIËT WESTERMANN became Vice President of the Andrew W. Mellon Foundation in 2010, after serving as Associate Director of Research at the Clark Art Institute in Williamstown, Director of New York University's Institute of Fine Arts, and Provost of New York University Abu Dhabi. She has published widely on Netherlandish art, particularly the history of painting.

CHRISTOPHER S. WOOD is Professor of the History of Art at Yale University. He has taught as a visiting professor at the University of California, Berkeley, Vassar College in New York and the Hebrew University, Jerusalem. He is the author of *Albrecht Altdorfer and the Origins of Landscape* (1993), *Forgery, Replica, Fiction: Temporalities of German Renaissance Art* (2008) and (with Alexander Nagel) *Anachronic Renaissance* (2010).

ALASTAIR WRIGHT is Fellow in Art History at St John's College, Oxford. Previously he taught at Princeton, and has been the recipient of a number of awards including a fellowship at the Getty Research Institute. His publications include *Matisse and the Subject of Modernism* (2004) and *Gauguin's Paradise Remembered: The Noa Noa Prints* (2010). His research interests include Neo-Impressionism and the work of Ford Madox Brown.

Credits

PICTURE CREDITS

20 Fratelli Alinari Museum Collections–Petit Parisien Archive, Florence; 23 The British Library, London; 26 RMN–Grand Palais (Institut de France)/Gérard Blot; 30 Biblioteca Berenson, Villa I Tatti–The Harvard University Center for Italian Renaissance Studies, Florence, courtesy the President and Fellows of Harvard College; 35 The British Library, London; 42 Ullsteinbild/Rudolf Dührkoop; 45, 50 The British Library, London; 54 National Portrait Gallery, London; 57, 61 The British Library, London; 66 Permission The Estate of Nikolaus Pevsner; 69 RIBA Library Photographs Collection; 72 Faber & Faber; 76 Carl Mydans/Time Life Pictures/Getty Images; 81, 84 Digital image, Museum of Modern Art, New York/Scala, Florence; 88 Topfoto/Ullsteinbild/Emil Bieber; 93, 96 Harvard University Press; 102 Courtesy the Cecil Beaton Studio Archive at Sotheby's; 105, 109, 112 John Murray Publishers; 116 Leonie Gombrich/Warburg Institute; 119, 122, 123 Phaidon Press; Images; 128 Leonard Mccombe/Time Life Pictures/Getty Images; 131, 135 Beacon Press; 138 Fred W. McDarrah/Time Life Pictures/Getty; 140 History of Art Department, University of Oxford; 145, 147 Courtesy Random House; 150 Max Whitaker; 153, 159 Oxford University Press; 162 Courtesy Kay Baxandall; 164 Ballesteros/epa/Corbis; 167, 171 Thames & Hudson Ltd., London; 176 Courtesy Svetlana Alpers; 181, 185 University of Chicago Press; 190 Courtesy Rosalind Krauss; 193, 197 MIT Press; 202 Felix Grünschloss; 205, 211 Verlag C.H. Beck.

EDITORS' ACKNOWLEDGMENTS

The editors are indebted to all those who supported the original publication of the essays in this volume in *The Burlington Magazine*, in particular to the Azam Foundation for financial support. Bart Cornelis and Jane Martineau provided considerable editorial input, and Kate Trevelyan endorsed and supported the project from its inception; we are very grateful to them, and to Anne Blood, Alice Hopcraft and Bébhinn Cronin for their valuable work and assistance. Thanks also to Paul Crossley, Caroline Elam, Linda Goddard, Alexander Nagel, Satish Padiyar, Nicholas Penny, Patricia Rubin, Betsy Sears and Christopher Wood for their advice and guidance, and to Katherine Graham for valuable research assistance. For their admirable work in editing and producing this volume, the editors offer wholehearted thanks to Jacky Klein and Celia White of Thames & Hudson.

Index

Page numbers in *italic*
refer to the illustrations

abstraction 59, 121, 124–25, 127
Adorno, Theodor 121, 137
 Dialectic of Enlightenment
 134
Alberti, Leon Battista 178,
 183–84, 187
Algarotti, Francesco 143
Alpers, Svetlana 16, 154–55,
 176, 253–54
 The Art of Describing 16,
 177–89, *181*, *185*, 253–54
L'Amour de l'Art 9, 55, 238
Angelico, Fra 8, 158
Les Annales Archéologiques 22
Antal, Frederick 14, 144, 151
Art Bulletin 152, 161
Art Journal 84–85, 161
Art Nouveau 10, 68, 72, *72*,
 73, 74
Artforum 192, 194, 196, 254
Arts and Crafts Movement
 68, 70, 73
Augustus of Saxony 143
avant-garde art 120–21, 124,
 129–39 *see also* Greenberg;
 Krauss

Bacon, Francis 184
Balzac, Honoré de, *Les
 Paysans* 172
Bandinelli, Baccio 37, 40, 41
Banham, Reyner, *Theory and
 Design in the First Machine
 Age* 75
Barberini family 142–43
Barney, Matthew 209
Baron, Hans 157
Baroque 9, 14, 44–47, 49–51,
 59, 67, 133, 141–49, 239, 253
 see also Haskell
Barr, Alfred H., Jr. 10–11, 70,
 76, 84, 240–41
 *Matisse: His Art and His
 Public* 10–11, 77–87, *81*,
 241
 *Picasso: Fifty Years of His
 Art* 77, 240
Barthes, Roland 195, 198, 254
Bartolomeo, Fra 36, 39
Bataille, Georges 195, 254

Baudelaire, Charles 27, 165, 168
Baudrillard, Jean 198
Bauhaus 68, 70, 74
Baxandall, Michael 14–15, 16,
 150, *162*, 181, 250–51
 Giotto and the Orators 154,
 155, 160, 161, 250
 A Grasp of Kaspar 160
 *The Limewood Sculptors
 of Renaissance Germany*
 155, *157*, 250
 *Painting and Experience
 in Fifteenth Century Italy*
 14–15, 19, 151–63, *153*,
 159, 250, 251
 Patterns of Intention 157, 250
 Shadows and Enlightenment
 152, 250
 Words for Pictures 160, 250
Behrens, Peter 10, 74
Bell, Clive, *Art* 19
Bellini, Giovanni 56, 158–59,
 237
Bellori, Giovanni Pietro, *Lives
 of the Modern Painters,
 Sculptors and Architects*
 147
Belting, Hans 17–18, *202*,
 256–57
 Bild und Kult 17–18, 158,
 203–15, *205*, *211*, 256
 Das Bild und sein Publikum
 206
 Das Echte Bild 204
 *Das Ende der
 Kunstgeschichte* 206
 *Die Erfindung des
 Gemäldes* 211
 Florenz und Bagdad 212
Benjamin, Walter 47, 208
Berenson, Bernard 8, 9, 12, 17,
 30, 43, 104, 110, 233–35, 243
 *The Central Italian
 Painters* 32, 233
 *The Drawings of the
 Florentine Painters*
 8, 31–41, *35*, 233–34, 243
 The Florentine Painters 32,
 233
 *The Study and Criticism
 of Italian Art* 32, 33, 34
 The Venetian Painters 32,
 233

Berger, John 122
 Ways of Seeing 112–13
Bernini, Gian Lorenzo 51,
 100, 108, *109*, 147, *147*
Bildwissenschaft ('visual
 studies') 13, 122, 125, 213
Blunt, Anthony 85–86
 Poussin 19
Boas, George 97
Bock-Weiss, Catherine,
 *Henri Matisse: A Guide
 to Research* 78
Bode, Wilhelm von 33
Boehm, Gottfried 213
Boethius 25
Bois, Yve-Alain 200
Boon, Karel G. 97
Borch, Gerard ter 51, 189
Borromini, Francesco 74, 147
Botticelli, Sandro 34, 39, 106,
 107, 160
Boucher, François 107
Boucicaut Master 91, 92
Bourdieu, Pierre 161
Bouts, Dieric 91, 100
Bowness, Alan 165, 169, 174
Braque, Georges 58
Bredekamp, Horst 122, 213
Brenk, Beat, *The Apse, the
 Image and the Icon* 214
Breton, André 11, 85
Broederlam, Melchior 95
Bronzino 41
Brown, Peter 214
Bruegel, Pieter 189
Brunel, Isambard Kingdom 73
Bryson, Norman 79, 126
 Vision and Painting 117–18
Burckhardt, Jacob 49, 51,
 142, 235
Burden, Chris 209
Burgess, Guy 86
Burlington Magazine, The
 5, 31, 48, 55, 56, 57, 70, 85,
 104, 161, 165, 237
Byzantine art 7, 17, 59–60,
 204–06, 210, 212, 256

Cagnacci, Guido 143
camera obscura 16, 182–83,
 187, 189
Canaletto 143
Capella, Martianus 25

Capitalism 171, 173
Caravaggio 179
caricature 123
Carrier, David 200
Cassirer, Ernst 92, 242
 *Philosophie der
 symbolischen Formen* 52
Castagno, Andrea del 32, 37
Caumont, Arcisse de 22
Cézanne, Paul 9–10, 55–65, *61*,
 72, 79, 111, 121, 237
Champfleury 165, 168
Chardin, Jean-Baptiste-
 Siméon 58, 61–62, 80, 189
Chartres cathedral 25
Chateaubriand, François
 René, Vicomte de, *Génie
 du christianisme* 22
Chave, Anna 199
Christ 17, 108
Christianity 7–8, 21–29, 108,
 126, 203, 210, 214
 see also Mâle
Christina, Queen of
 Sweden 149
Christus, Petrus 91, 100
Cimabue 60
cinema 126–27
Clark, Kenneth 12, 13, 14,
 33, 39, *102*, 237, 243–45
 Civilisation 104, 112, 115, 244
 The Nude 12, 13–15, *105*,
 109, *112*, 245
Clark, T.J. 15–16, 113, 124, 161,
 164, 248, 252–53
 The Absolute Bourgeois
 165, 168, 174, 252
 Image of the People 14,
 15–16, 165–75, *167*,
 171, 252
 *The Painting of Modern
 Life* 175, 252
Classical, the 45, 52, 90, 100,
 104, 106, 110, 111, 160
classicism 49, 52, 57, 104,
 106–08, 111, 114, 130, 133, 141,
 146, 189
Coleridge, Samuel Taylor 86
Comenius, Johann 184
*Commission des Monuments
 Historiques* 22
Comte, Auguste 48
Conceptual art 127, 135

connoisseurship 5, 8, 12, 31–37, 43, 114, 130, 233
 see also Berenson
Constable, John 121
Coremans, Paul 94, 101
Cortona, Pietro da 146, 147
Courbet, Gustave 15, 59, 108, 111, 165–75, *171*
Courtauld Institute of Art, London 161, 168, 169, 245, 252, 256
Cranach, Lucas 111
Crary, Jonathan 122
Crespi, Luigi 33
Crimp, Douglas 194
Croce, Benedetto, *L'Estetica* 47
Crosnier, Augustin-Joseph, *Iconographie Chrétienne* 22
Crowe, Joseph Arthur 33
Cubism 58, 82, 121
cult images 158, 203, 204, 208, 210, 213–14 *see also* Belting

Damisch, Hubert 124
Daumier, Honoré 60
Davies, Martin 95, 97, 101
de Kooning, Willem 111
de la Mare, Richard 70
Debord, Guy 137
 The Society of the Spectacle 173
Degenhart, Bernhard 35–36
Delacroix, Eugène 59, 60, 108
Delaissé, Léon M.J. 90, 97, 101
Demus, Otto, *Byzantine Art and the West* 204–06
Denis, Maurice 57
Derrida, Jacques 195, 198
Deutscher Werkbund 68
Didron, Adolphe-Napoléon 24, 25
 Iconographie Chrétienne 22
Donatello 37, 106, 107
'double roots of style' 43–44
Drebbel, Cornelis 182
Duchamp, Marcel 138, 195
Durant, Sam 191
Dürer, Albrecht 90, 106, *123*, 235, 241, 242
Dutch art 16, 60, 177–89, 253
 see also Alpers

Eco, Umberto 120
Eisler, Colin 95
Eliot, T.S. 91, 132
 Notes Towards the Definition of Culture 137
Elsen, Albert 196–98
Encyclopedia of World Art 146
Enlightenment, The 126
Eribon, Didier 123

Ettlinger, L.D. 104, 108
Expressionism 75, 111
Eyck, Hubert van 11, 90
Eyck, Jan van 11, 85, 90, 91, 94–95, *96*, 98, 99, 100, 110, 179, 183, 184, 188, 189

Faber & Faber 70, 239
Fantin-Latour, Henri 13
Fascism 114, 132, 133
Fauvism 80
feminism 86, 113, 162, 196, 198, 199
Ferri, Pasquale Nerino 34
Ferrucci, Francesco di Simone 38
Fiedler, Konrad 48, 120
film 19, 126–27
Finiguerra, Maso 39
First World War 44, 78, 80, 231, 235
Flam, Jack 78
 Matisse: The Man and His Art, 1869–1918 87
Fleming, John 154
Flemish art 11, 89–100, 178–79, 180 *see also* Panofsky
Florence 8, 31–41, 100, 142, 154, 157 *see also* Berenson
Fluxus 127
formalism 9, 10, 16, 43–53, 61–62, 87, 99, 110, 124, 136, 138, 165, 174, 192, 196, 198, 235, 247–48, 254 *see also* Fry; Greenberg; Krauss; Wölfflin
Foucault, Michel 194, 195
Freedberg, David
 The Power of Images 18, 212
Freud, Sigmund 123, 126, 169, 170, 173
Fried, Michael 19, 192, 248
 Absorption and Theatricality 19
Friedländer, Max J. 99, 103
Friesz, Othon 58
Fromentin, Eugène 177, 178
Fry, Roger 9–10, 12, 15, 48, 52, 54, 79, 110, 115, 158, 237–38
 Cézanne: A Study of His Development 9–10, 55–65, *57, 61*, 237–35
 Vision and Design 9–10, 58, 237
Futurism 75

Gaudí, Antoni 75
Gauguin, Paul 56, 58, 72, 237
Geertz, Clifford 161, 182
Geffroy, Gustave 64
Gere, John 40
Géricault, Théodore 108

Gesamtkunstwerk 27
Gheyn, Jacques de 182–83
Ghirlandaio, Domenico 39, 40, 160
Giacometti, Alberto 16, 195, 196
Gide, André 83
Gilson, Etienne 121
Gimson, Ernest 73
Giorgione 59, 63, 107, 114
Goeller, Adolf 51
Goes, Hugo van der 110
Gogh, Vincent van 58, 121, 237
Goldschmidt, Adolph 67, 92, 241
Gombrich, E.H. 12–13, 16, 46, 47, 103, *116*, 157, 161, 185, 188, 189, 200, 207, 245–47, 250
 Art and Illusion 12–13, 15, 19, 47, 117–27, *119*, 122, *123*, 155, 166, 245–46
 The Sense of Order 121
González, Julio 195, *197*
Goodman, Nelson 120
 Languages of Art 118
Gothic 7–8, 22, 45, 51, 108, 110 *see also* Mâle
Gothic Revival 209
Gowing, Lawrence 188–89
Goya, Franciso 56
Goyen, Jan van 50
Gozzoli, Benozzo 8
Grafton, Anthony 188
Grand Tour 143
El Greco 57, 60, 65
Greenberg, Clement 13–14, 92, *128*, *138*, 192–94, 195, 196, 200, 247–48, 254
 Art and Culture: Critical Essays 13–14, 16, 129–39, *131*, *135*, 192, 247–48
Gropius, Walter 10, 68–70, 72, 74
Groys, Boris 114–15
Gumbrecht, Hans-Ulrich, *Production of Presence* 208

Hadjinicolaou, Nicos 168, 171
 Art History and Class Struggle 166
Happenings 127
Haskell, Francis 14, 15, *140*, 249–50
 History and Its Images 14, 249
 Patrons and Painters 14, 141–49, *145*, *147*, 156, 249
 Taste and the Antique 14, 249
Hauser, Arnold 14, 144, 151, 171
 Social History of Art 15, 166
Hazlitt, William 115

Heal, Ambrose 73
Hecht, Hans 67
Hegel, Georg Wilhelm Friedrich 13, 26, 46, 47, 124, 177, 200, 206
Heidegger, Martin 121
Held, Julius 97, 98
Hildebrand, Adolf 47
 Das Problem der Form in der bildenden Kunst 48–49
Hodler, Ferdinand 72
Hoffmann, Josef 74
Hogarth Press 9, 56, 238
Holmes, Megan, *Fra Filippo Lippi: The Carmelite Painter* 158
Honorius Augustodunensis, *Speculum ecclesiae* 24
Honour, Hugh 154
Hooch, Pieter de 60
Hood, William, *Fra Angelico at San Marco* 158
Hoogstraten, Samuel van 185
Hooke, Robert 184
Horkheimer, Max, *Dialectic of Enlightenment* 134
Horne, Herbert P. 34
Horta, Victor 72, *72*
Hugo, Victor 22, 24, 26–27
 Notre-Dame de Paris 25
Huizinga, Johan 142
humanism 12, 92, 95, 100, 103–04, 124, 152, 155, 157–58, 178, 179, 181, 182–83, 188, 189, 200
Huygens, Constantijn 182–83
Huysmans, Joris-Karl 24, 27

iconography 7–8, 11, 16, 21–22, 31, 86, 90, 92, 93, 95, 99, 178, 180, 188, 189, 231, 241
 see also Mâle; Panofsky
icons 7, 17, 18, 204, 206
 see also Belting
Impressionism 10, 48, 60, 63, 71, 80
Index of Christian Art 28, 93
Ingres, Jean-Auguste-Dominique 59, 108
inscriptions, in Dutch paintings 182, 186, 187
installation art 127, 201, 207
International Socialism 133
International Style 68
Italy 14–15, 31–41, 56, 141–49 *see also* Baxandall; Berenson; Haskell; Renaissance

James, Henry, *The Golden Bowl* 166

Johns, Jasper 188, 195
Johnson, Philip 70, *84*
Jongh, Eddy de 180, 187
Judd, Donald 195

Kalf, Willem 59, 189
Kant, Immanuel 49, 51
Kaufmann, Thomas
 DaCosta 188
Kautzsch, Rudolf 67
Kepler, Johannes 182, 183,
 188, 189
kitsch 132–37, 39 *see also*
 Greenberg
Klee, Paul 11
Koninck, Philips 186
Krauss, Rosalind 16–17, 124,
 190, 248, 254–55
 *The Originality of the
 Avant-Garde and Other
 Modernist Myths* 16–17,
 191–201, *193*, *197*, 255
 *Passages in Modern
 Sculpture* 191–92, 194
 Perpetual Inventory 201
 Terminal Iron Works 191, 254
Kris, Ernst 123, 245
Kruger, Barbara 175
Krüger, Klaus, *Das Bild als
 Schleier des Unsichtbaren* 210
Kruse, Christiane 211
Kubler, George, *The Shape
 of Time* 19
Kuhn, Thomas S., *The
 Structure of Scientific
 Revolutions* 119
Künstle, Karl 28

Lacan, Jacques 169
Landino, Cristoforo 160
Langdale, Allan 158, 161
Lanzi, Luigi 33
Le Corbusier 68, 74
Leavis, F.R. 152, 250
Lemonnier, Camille 113
Leonardo da Vinci 8, 12, 34,
 38–39, *159*, 243–44
Leoni, Ottavio Maria *147*
Levey, Michael, *Early
 Renaissance* 154
Lévi-Strauss, Claude 118, 170
LeWitt, Sol 16, 194, 195
Limbourg brothers 92
Lippard, Lucy 199
Lippi, Fra Filippo 158
Loos, Adolf 74
Loran, Erle 62

Macherey, Pierre 172
Mackintosh, Charles Rennie
 10, 73, 74
Mackmurdo, Arthur H. 72

MacLean, Donald 86
Maidalchini, Olimpia 149
Maillol, Aristide 11, 85
Mâle, Emile 7–8, 11, *20*, *26*,
 148, 231–33
 *L'art religieux du XIIIe
 siècle en France: Etude
 sur l'iconographie du
 Moyen Age et sur ses
 sources d'inspiration*
 7–8, 9, 15, 21–29, *23*, 231–32
 *Religious Art in France: The
 Late Middle Ages* 29, 99
Malevich, Kasimir 129, 130
Malraux, André 121
Mander, Karel van 98
Manet, Edouard 13, 47, 59, 60,
 104, 113, 121, 175, 179
Mannerism 8, 46, 67
Mantegna, Andrea 32, 58
maps 185–87
Mariette, Pierre-Jean 34
Marin, Louis 188
Marinetti, Filippo 129, 130
Marx, Karl 137, 170
Marx, Roger 78
Marxist art criticism 14, 15,
 124, 132, 134, 144, 158, 161,
 165–74, 198, 200, 247, 252
 see also Clark, T.J.
Masolino 85
mass culture 132–34, 137–38
Massys, Quentin 92
Master of the Aix
 Annunciation 100
Master of Flémalle 11, 91, 94,
 99–100
Matisse, Henri 7, 10–11, 58,
 77–87, 110, 111, 121, 237,
 240, 247
Medici, Lorenzo de' 154, 157
Medici, Marie de' 149
medieval art 21–29, 203–15
Meiss, Millard 93, 97
Mellan, Claude *147*
Memling, Hans 91
Merleau-Ponty, Maurice
 121, 194
Michelangelo 8, 32, 34, 37,
 40–41, 100, 107, 108, 110,
 178–79, 241
Michelson, Annette 194,
 254
Middeldorf, Ulrich 152,
 161
Miedema, Hessel 180
Milan, Duke of 160
Minimalism 194, 199, 254
Mitchell, W.J.T., *Picture
 Theory* 18, 212
modernism 10, 13, 16, 46–47,
 68, 74, 75, 78, 165, 188, 192,

194, 195, 196, 201, 204, 209,
 247 *see also* Fry; Greenberg;
 Krauss; Pevsner
Mondrian, Piet 124–25,
 179, 188
Monet, Claude 56
Montelupo, Raffaello da 41
Moore, Henry 111
Moreau, Gustave 78
Morelli, Giovanni 32, 33, 34,
 39, 43
Moroni, Paola 31
Morris, Robert 194, 199
Morris, William 10, 68, 70,
 71, 73, 209
Moxey, Keith 118
Mulvey, Laura 113
Munch, Edvard 72
Museum of Modern Art,
 New York 70, 77, 79, 82, 85,
 86, 198, 240
Muthesius, Hermann,
 Das Englische Haus 70

National Gallery of Art,
 Washington, DC 12, 126,
 196, 244, 246
Nazarenes 209
Nazis 10, 67, 71, 132, 157, 239,
 242
Nead, Lynda 113–14
Neo-classicism 52, 133, 141
Neo-Impressionism 80
neo-Kantianism 49, 92, 242
Neri, Dario 31
Netherlands 11, 89–101,
 177–89 *see also* Alpers;
 Panofsky
New Left Review 169, 173
Nicolson, Benedict 77, 79, 83,
 110, 112
Nietzsche, Friedrich 121
Nochlin, Linda 198, 199
nudes 12, 65, 103–15, 143
 see also Clark, K.

October 194–95, 200, 254, 255
Oertel, Robert 37
Olbrich, Joseph Maria 74
Orley, Bernard van 92
Ottley, William Young, *The
 Italian School of Design* 34
Owens, Craig 198–99

Pächt, Otto 97–98, 101, 180
Panofsky, Erwin 11–12, 14,
 16, 17, 28, 29, 46, 52, 80–82,
 88, 180, 183, 199, 200, 212,
 241–43
 *Early Netherlandish
 Painting* 11–12, 89–101,
 93, 96, 242

Paoletti, John, *Art in
 Renaissance Italy* 163
Parshall, Peter 98
Partington, Angela 199
Pater, Walter 115
patronage 156, 210
 see also Haskell
Penguin Books 154, 239,
 244, 253
Penny, Nicholas 14, 111, 249
performance art 127, 196,
 207, 209
'the period eye' 15, 157, 161,
 162–63
Perrot, Georges 21
perspective, distance-point
 183–84
Perugino 106
Pevsner, Nikolaus 10, 66,
 239–40, 249
 Academies of Art 68
 The Buildings of England
 series 10, 70, 74, 239
 *An Enquiry into Industrial
 Art in England* 68
 *Die italienische Malerei
 vom Ende der Renaissance
 bis zum ausgehenden
 Rokoko* 67
 Leipziger Barock 67
 *Pioneers of the Modern
 Movement* 10, 67–75, 69,
 72, 239–40
Phaidon 152, 244, 246
Phidias 106
photography 19, 36, 126, 127,
 179, 189, 194, 195, 200
Picasso, Pablo 11, 16, 58,
 77–79, 111, 188, 194, 195, 198,
 237, 240, 252
Picturesque movement 75
Piero della Francesca 39, 58,
 100, 106, 163, 244
Pinder, Wilhelm 10, 67, 71
Pisanello 159
Pissarro, Camille 60, 65
Podro, Michael 154–55
 Critical Historians of Art 124
 Depiction 124–25
Poelzig, Hans 74
Pointillism 80
Pollaiuolo, Antonio del 32,
 38, 39, 106
Pollock, Jackson 16, 195, 199,
 200, 252
Polyclitus 106
Pontormo, Jacopo da 8, 41
Pop art 135
Pope-Hennessy, John 154
positivism 47–48, 92, 166, 191,
 195, 200
Post-Impressionism 72, 237

postmodernism 7, 17, 192–95, 195–96, 199, 200 *see also* Krauss
poststructuralism 16, 19, 118, 124, 175, 191, 194, 195, 198, 200 *see also* Krauss
Pouncey, Philip 35
Poussin, Nicolas 57, 58, 60, 147
Pozzo, Cassiano dal 146, 147
Praxiteles 106, 107
Pre-Raphaelite Brotherhood 49, 209
Primitives, Italian 60, 64
Proust, Marcel 24, 27
Prudentius, *Psychomachia* 25
Pugin, A.W.N. 22, 75

Radke, Gary, *Art in Renaissance Italy* 163
Raphael 32, 106, 107, 109, 125
Rauschenberg, Robert 192
Raynal, Maurice 78
Read, Herbert 48
Realism 80, 108, 166, 168
Reformation 21, 71, 208
religious art and architecture 7–8, 17, 21–29, 106, 108, 157–60, 204, 208, 210, 214 *see also* Belting; Mâle; Panofsky
Rembrandt 9, 57, 62, 64, 111, 253
Renaissance 8, 14–15, 17, 31–41, 52, 95, 106, 133, 142, 151–63, 178, 180, 207, 208, 210, 215, 233–34, 235, 237, 250 *see also* Baxandall; Berenson
northern Renaissance 11, 90
transition from Renaissance to Baroque 44–52
Renoir, Pierre-Auguste 56, 104, 108, 111
Rewald, John 85
The History of Impressionism 19
Reynolds, Joshua 115, 177, 178
Richardson, John 77, 80, 84
Richardson, Jonathan 34
Richter, Jean Paul 33, 34
Richter, Ludwig 43
Riegl, Alois 17, 46, 92, 120, 123, 124, 179, 199, 208, 209
Historische Grammatik der bildenden Künste 51–52
Spätromisches Kunstindustrie 19, 46
Stilfragen 46
Ringbom, Sixten, *Icon to Narrative* 152
Robertson, Giles 161

Rodin, Auguste 16, 108, 111, 194, 195, 196, 197, 198
Romanticism 111, 133, 137
Rome 14, 141, 142–43, 146–47
Rosenberg, Harold 192
Rosenblum, Robert 198
Rouault, Georges 111
Rousseau, Henri 72
Royal College of Art, London 68
Royal Society 185
Rubens, Peter Paul 59, 60, 64, 104, 107, 114, 253
Rubin, Patricia, *Images and Identity in Fifteenth-Century Florence* 162–63
Rubin, William 198
Ruskin John 115, 118, 200, 209

Sacchetti, Marcello 146
Saenredam, Pieter 184, 187, 189
Salmon, André 78
Sansovino, Andrea 9, 37
Sant'Elia, Antonio 75
Saussure, Ferdinand de 195, 198–99
Saxl, Fritz 12, 28, 94, 242
Schapiro, Meyer 62, 93, 124
Schelling, Friedrich Wilhelm Joseph von 51
schijnrealisme ('apparent realism') 180
Schinkel, Karl Friedrich 67
Schlosser, Julius von 120, 125
Die Kunstliteratur 18, 152
Schmitt, Annegrit 36
Schmitt, Jean-Claude 207
Schneider, Pierre 85
Schongauer, Martin 100
Scott, Mackay Hugh Baillie 73
Sebastiano del Piombo 40–41, 65
Second World War 75, 82, 94, 121, 123, 136, 231, 239, 245, 247
Sembat, Marcel 78
Serra, Richard 16, 195–96, 254
Shakespeare, William 86, 91
Shapley, John 161
Shearman, John, *Mannerism* 19, 154
Sherman, Cindy 175
Siedell, Daniel 192, 195, 200
Signac, Paul 11
Signorelli, Luca 39
Siqueiros, David Alfaro 11, 85
Situationist International 173
Sluijter, Eric Jan 182
Sluter, Claus 100
Smith, David 191, 199, 254
Smith, Consul Joseph 143
Socialist Realism 114

Spengler, Oswald 132, 137
Stalinism 132, 133
Steen, Jan 56, 187
Steinberg, Leo 121, 192–94
Stella, Frank 47
Stewart, Peter 214–15
Stieglitz, Alfred 11
structuralism 16, 127, 174, 191, 194, 195, 198, 199, 200, 254
style, history of 17, 37, 43–53, 151–52
Summers, David, *Michelangelo and the Language of Art* 161
Surrealism 195
Symbolism 27, 72

Taine, Hippolyte 47–48
technology 115, 120, 124, 126–27, 129, 134
Telford, Thomas 73
theology 7–8, 21–29, 180, 209–10, 212
Thompson, E.P. 106
Tiepolo, Giovanni Battista 146, 156, 250, 253
Tietze, Hans 37
Tietze-Conrat, Eva 37
Tintoretto 59, 60, 65
Titian 51, 60, 107, 114
Tivoli, Italy 43
Tolnay, Charles de 93
Toorop, Jan 72
Trapp, Frank 82
Turin–Milan Hours 94, 96, 97

Uffizi, Florence 34, 40, 41, 114

Vasari, Giorgio 33, 34, 37–38, 85, 100, 178, 200, 207, 245
Velázquez, Diego Rodríguez de 179
Velde, Henry van de 10, 72
Venice 14, 37, 59, 60, 64, 141, 143, 146–47
Venturi, Adolfo 34
Vermeer, Jan 186, 187, 188–89
Veronese, Paolo 59
Verrocchio, Andrea del 35, 38
Victoria and Albert Museum, London 154
Vienna school of art history, second 47
Vincent of Beauvais, *Speculum maius* 24, 25, 29
Vlaminck, Maurice de 58
Vöge, Wilhelm 92, 241
Vollard, Ambroise 55, 58

Voysey, Charles Annesley 10, 73
Vuillard, Edouard 11

Waal, Henri de 93
Wackernagel, Martin 142
Lebensraum des Künstlers in der florentinischen Renaissance 152
Wagner, Richard 27
Warburg, Aby 8, 18, 28, 29, 92, 99, 123, 126, 212, 215, 242, 245
Gesammelte Schriften 18
Warburg Institute, London 12, 18, 155, 161, 245, 246, 250
Watkin, David, *Morality and Architecture* 10, 75
Weber, Max 208
Welch, Evelyn, *Art and Society in Italy 1350–1500* 161–62
Weston, Richard 70
Weyden, Rogier van der 11, 91, 94, 100
Wilde, Johannes 41
Winkler, Friedrich 95, 97
Wittkower, Rudolf
Architectural Principles in the Age of Humanism 18, 152
Art and Architecture in Italy 1600–1750 148
Wölfflin, Heinrich 9, 10, 15, 16, 17, 18, 42, 67, 92, 99, 110, 120, 124, 180, 235–37
Die klassische Kunst (Classic Art) 19, 49, 52, 155, 160, 235
Die Kunst der Renaissance 45
Kunstgeschichtliche Grundbegriffe (Principles of Art History) 9, 43–53, 45, 50, 199–200, 235–36
Renaissance und Barock 45–46, 235
Wood, Christopher S.
Anachronic Renaissance 210–11
Forgery, Replica, Fiction 210–11
Woolf, Virginia 56, 237, 238
Worringer, Wilhelm 209
Abstraktion und Einfühlung 51–52
Wright, Frank Lloyd 11, 74, 85

Zeitgeist 10, 26, 71, 73, 74, 75, 161
Zola, Emile 24, 27
Zuccaro, Taddeo 40